Doing Science + Culture

Doing Science + Culture

Edited by
Roddey Reid and Sharon Traweek

Routledge
New York London
2000

Published in 2000 by

Routledge
29 West 35th Street
New York, NY 10001

Published in Great Britain by
Routledge
11 New Fetter Lane
London EC4P 4EE

Routledge is an imprint of the Taylor & Francis Group
Copyright © 2000 by Routledge

Printed in the United States of America on acid-free paper.

Library of Congress Cataloging-in-Publication Data
Doing science + culture / edited by Roddey Reid and Sharon Traweek.
 p. cm.
 Includes bibliographical references and index.
 ISBN 0-415-92111-2 — ISBN 0-415-92112-0
 1. Science—Social Aspects. I. Title: Doing science + culture.
 II. Reid, Roddey, 1952– III. Traweek, Sharon.

 Q175.5.D65 2000
 306.4'5—dc21 99-056916

Contents

Acknowledgments

The publication of these collected essays is the fruit of various collaborations that stretch back to 1993, when we first staged a conference on interdisciplinary studies of science, technology, and medicine. These efforts have enjoyed institutional and individual support from many quarters. First and foremost is the University of California Humanities Research Institute, which in 1993 sponsored the "Located Knowledges" conference at UCLA and in the winter and spring quarters of 1996 hosted the "Postdisciplinary Approaches to Technoscience" residential research group. The unstinting support and encouragement of HRI directors Mark Rose and Pat O'Brien will always be in our eyes as an example of what bold leadership in the humanities can do in the United States, particularly in times of public controversy and institutional change. Our six-month residence at the HRI under Pat O'Brien's generous custodianship especially gave ample opportunity to appreciate the institute's unparalleled resources and the qualities of its staff: we want to thank Assistant Director Deborah Massey Sanchez for her energetic organization of planning, budget, and the group's day-to-day needs; Mia Larson for keeping track of our complex scheduling of events; DeeDee Nunez, who made arrangements for visiting scholars and guaranteed that the residency at the HRI housing was an enjoyable one; and Christine Aschan for helping us fully exploit the scholarly resources of the HRI and the University of California, Irvine, campus.

Members of the research group and scholarly and scientific participants in the colloquia and workshops it hosted deserve particular thanks: Anne Balsamo, Karen Barad, Charles Bazerman, Mario Biagioli, Lisa Bloom, Lisa Cartwright, Adele Clarke, Rich Doyle, Joan Fujimura, Akhil Gupta, Sandra Harding, Jed Harris, Val Hartouni, John L. King, Karin Knorr-Cetina, Emily Martin, Constance Penley, Ted Porter, Paul Rabinow, Molly Rhodes, Vernon Rosario, Vivian Sobchack, Knut Sorenson, Carole Vance, and Steve Woolgar. Mario Biagioli, who helped organize these undertakings before leaving California, was an invaluable collaborator. The anthology also owes its existence to other colleagues: Linda Brodkey, Gerald Feldman, Donna Haraway, and Peter Reill. Lisa Bloom provided crucial support throughout the entire enterprise.

We thank Bill Germano of Routledge for supporting this project, Amy Reading for her experience and efficient editorial oversight, and Krister Swartz for making the production process go as smoothly as possible.

Finally, during various stages of the project we enjoyed funding from the following sources: the University of California Humanities Research Institute; the Center for German and European Studies of the University of California, Berkeley; the Abe Fellowship Program of the Social Science Research Council and the American Council of Learned Societies, with funds provided by the Japan Foundation Center for Global Partnership; the Academic Senates of the University of California at San Diego and Los Angeles; and the Japanese government's Ministry of Education.

Introduction

Researching Researchers

Roddey Reid and Sharon Traweek

The present collection of essays marks a particular moment in the interdisciplinary study of science, technology, and medicine in that globalized region of residence and work called the United States. This publication takes place at a juncture marked by the slow dismantling of the infrastructure of scientific research dating from the Cold War, public controversies over scholarly studies of scientific practices, and changes in U.S. higher education. The hope of the editors is that the essays not only bear witness to the peculiar institutional, national, and global contexts in which they were written but also constitute compelling responses to the evolving environment in which researchers engage in committed study of past and present practices of knowing the natural and social world. We welcome comment from within and outside the U.S. academic infrastructure on the substance of these essays and on their underlying assumptions and preoccupations, which derive from that same institutional and national context.

If the environment in which physics, evolutionary biology, psychology, pharmaceutical research, radio astronomy, bioinformatics, cybernetics, psychiatry, public health, and genetics are practiced—from wet and computer simulation labs to research protocols, funding networks, scientific journals, and databases to classroom teaching and popular culture—is for us an object

of reflection, so, too, are the contexts in which we study them. Here we must contend with the legacy of the peculiar histories of the humanities and social sciences within U.S. higher education (prestige, public mission, styles of research and pedagogy, and so on); with research sites such as archives, libraries, field sites; with the infrastructure of funding, publishing, and professional networks; with interdisciplinary programs from women's studies and science studies to cultural studies and queer studies; with rapidly evolving student constituencies; with the restructuring of colleges and universities mandated by budget cutting and political pressures; and with the dismantlement of affirmative action policies. We want to claim that the practices of cultural studies and interdisciplinary studies of science and medicine of the last twenty years reflect both these contexts—of doing science and of doing research on science—and are well positioned to deal with the challenges they pose to the routine understandings of how knowledge is produced.[1]

Doing Science + Culture brings together interdisciplinary essays researched and written from within those two contexts. This is not the first anthology to do so,[2] but it is our contention that it is unique in offering concrete case studies together with thoughtful reflection on what it means to do cultural studies of science, technology, and medicine today in the United States. We think these essays display a tone, a way of launching ideas, and a relation to knowledge production in general that readers can take away and use to further the formulation of their own ideas and projects.[3]

Collaborations and Interdisciplinary Practitioners

This anthology is the culmination of collaborative work between the editors that began in 1991 and has included also the active participation of Mario Biagioli. The three of us came from various backgrounds (computer science, visual studies, history of science, literary studies, cultural history, anthropology of science, feminist epistemology, and cultural studies), training (cultural theory, fieldwork, archival research, linguistic apprenticeships, and iconographic and textual analysis), and prior United States institutional experience (from private research universities and engineering schools to liberal arts colleges and land-grant and public research universities on the West and East Coasts and in the Midwest and the South). We believe that the unusual mix of our cross-disciplinary and cross-institutional experiences laid the foundation for the three of us to explore together ways for furthering committed, interdisciplinary inquiry in the United States into scientific, technological, and medical practices.

Our initial project involved organizing an international conference in May 1993 at UCLA titled "Located Knowledges: Intersections between Cultural, Gender, and Science Studies." Its goal was to stage a conversation between these three interdisciplinary fields.[4] The conference led to a resident research group, "Postdisciplinary Approaches to the Technosciences," which the editors convened winter and spring quarters of 1996 at the University of California Humanities Research Institute in Irvine, California. Many articles in this collection derive from the activities of that group. The weekly seminars and colloquia at the Humanities Research Institute were especially helpful in the way of extended discussions of participants' professional biographies from initial training in graduate school to career and institutional trajectories along different time lines and in different settings. In short, participants considered at length the process of production of *themselves* as nonconventional practitioners of their fields (anthropology, history, literary studies, political science, sociology) and as interdisciplinary pedagogical and research selves.

These collaborative activities allowed the editors to measure fully the opportunities and limits of doing cultural studies of science, technology, and medicine in a changing institutional environment and public arena. For example, at present, the spaces and venues for interdisciplinary teaching and research are unevenly distributed in the United States: contributors and editors alike agree that throughout the 1990s it has been far easier for interdisciplinary or cultural studies scholars to find an academic publisher than to find gainful employment. Today, as in the past, foundations and research institutes have been more welcoming to interdisciplinary scholars and teachers than many departments, chairs, and academic deans in the humanities and social sciences (Gulbenkian Commission 1996, 97).[5] Faced with the introduction of corporate quality management principles of accountability and cost-benefit analysis by university administrators and with calls by politicians, business leaders, and distance learning entrepreneurs for major restructuring of state-funded colleges and universities, across all disciplines many departments are uncertain of their mission within higher education and what their charge is to fellow citizens. Moreover, in the post–Cold War era, even as the United States emerged as the unique superpower, globalization has placed all national economies and cultures under great pressure and has sapped the long-standing role of universities as the guardian and purveyor of culture and knowledge to the nation-state (Readings 1996; Gulbenkian Commission 1996).[6] Finally, at present, a potentially serious split in institutional commitment to new forms of inquiry and pedagogy is opening up in U.S. higher education between public and private centers of learning as

resources are redistributed from recently defunded state universities to private institutions (and some public ones as well) flush with their new capital gains.[7]

Past and Present Traditions: The Cold War Is Over

Thus what emerged out of the conference and the research group was a "diagnosis of the present" that has shaped and tempered many of the present essays: namely, that it no longer makes sense to conduct the business of studying science, technology, and medicine as usual. The three sections into which the contributions fall—transnational science and globalization, emerging subjects and subjectivities (of researchers and research alike), and postdisciplinary pedagogies and curricula—are all indicative of this shift, as are several threads woven through them: the return of the question of ethics (the issue of social accountability) and what may be called the identity politics of disciplinarity. These topics and threads have received scant attention during recent debates on science studies, even as, in our view, the polemics were driven precisely by anxieties stemming from these very same issues.

We think it is important for readers to bear in mind how in what might be called, roughly, the Euro–North American tradition, social transitions have almost always involved epistemological and ontological wars. These date from medieval disputes over realism and nominalism, down to the nineteenth-century conflict between idealism and positivism, and continuing in the realism/relativism debates of the twentieth century. It would seem that the inherited discourse in that region of the world requires disputation in these terms.

This long-established "tradition" leads to understanding our project also in the context of a second but more recent one, namely, the Cold War, which came to an end in 1989; not so much in terms of the often cited anxieties of dwindling funding for all academic programs (which presumably fuel the "science wars") but simply as a fact of historical record. The Cold War is over, and it is over in different ways in different parts of the world. This history and the consequences of the end of the Cold War in the context of globalization vary considerably from one region to another; as contributor Itty Abraham reminds us, on the one hand in many cases little has changed with respect to the flows of arms, aid, capital, and repatriated profits, while on the other, global-

ization and the end of superpower rivalry have brought in other cases both new opportunities and new vulnerabilities.[8]

For U.S.-based science and medicine, the period 1945–1989 can now be seen as a visibly distinct era whose history remains to be written; its own narratives of science, technology, and medicine are part of that same record and are ripe for scrutiny. The generation of young men who founded entirely new fields or subfields and came to occupy positions of influence in science, technology, medicine, government, and private industries during or after World War II has now retired. Their archives are beginning to be made available to researchers and the public (Lowen 1997). Since 1989, and in many cases, since circa 1975, their disciples have been facing a quite different set of circumstances that have challenged their expectations of inheriting the same system of brilliant careers, rewards, and professional and social recognition (Hackett 1990, Traweek [this volume]; Bender and Schorske 1998).

Profound shifts in transnational political economy and ecologies of knowledge production have inscribed those expectations and the older accounts of science, technology, and medicine with the indelible markings of the Cold War, in which they first arose (Harvey 1989; Lyotard 1984). Although interdisciplinary and cultural studies of science, technology, and medicine may be faced with the legacy of spent positivist narratives, they should not be burdened with supplying the linear narrative of a new period or successor paradigm. In our view such an account would simply reproduce Cold War positivism's optimism. The present moment is one of turbulences with which these older narratives are poorly equipped to cope. Conversely, it has become clear that these same accounts did much to simplify and impart a particular order to forms of knowledge of the Cold War period.

Modernity and the Ordering of Knowledge Production

What recent studies of science and medicine tell us over and over is that the complexity and material densities of institutional changes and new orders of knowledge production literally escape many of the old categories whose proponents, whether of the left or the right, are often reduced to telling abstract tales of moral and intellectual decline that, if the science wars have been any indication, have enjoyed persistent appeal throughout the 1990s in the United States, Europe, and elsewhere.[9] Their nostalgia is for a world we now historicize as modernity. For some time now, "modernity" or "the modern" have become

in and of themselves objects of renewed inquiry conducted in many fields in terms of political economy, art and literary history, visual culture, epistemology, and theories of postcoloniality, to name just a few.[10] It would appear that those late moderns long for a set of aesthetic and research practices understood to have been based on an ethics of craft (work as vocation and skilled labor involving intense apprenticeships in labs, fieldwork, archives, reading rooms, or libraries; individual mentoring; restricted circulation of specialized knowledges among select colleagues; and so on); for the distinct territories and identities of disciplines (even as they evolve); for conventional narratives of intellectual and scientific subjectivity (from modest witnesses to isolated genius); for the contemplative detachment achieved through epistemological mastery; and for the patriotic certainties of stable nation-state citizenship even within "international" science or scholarship.

Obviously, modernity is not the affective and scholarly position from which many of us in cultural studies of science, technology, and medicine wish to do what we do. To be sure, if modernity is "over," it also persists in and around us, including in our own work. Simply *willing* ourselves into "thinking differently" is neither our goal nor our expectation; that we will leave to surviving remnants of late modern intellectual avant-gardism. Rather, the goal is one of taking very seriously the present moment in which we work, practicing and experimenting with ways of engaging with it intellectually, ethically, and as citizens in increasingly globalized economies and cultures.

The recent past (the Cold War, decolonization, development, late modernity) and the present (the post–Cold War, postcolonialism, "after development," "after modernity") are currently being interrogated from multiple spaces. And for some time now, cultural studies has been writing and teaching multiple narratives from those many spaces within the present world.

More than "Two Cultures": The Spaces of Interdisciplinarity

The frequent reference in commentaries on the science wars to C. P. Snow's 1959 "The Two Cultures" lectures, while perhaps hackneyed, can lead directly into the articulation of these multiple spaces and narratives. At the height of the Cold War, Snow's lectures mapped two opposed forms of knowledge production from within the space of the British educational system and the end of decolonization. Literature and engineering (and later, biotechnology) were evaluated and opposed by Snow in terms of their ability to provide proper training for bureaucrats and social and scientific experts. According to Snow,

these professionals were destined to manage the former colonies and colonized populations in the future in the context of the capitalist West's international rivalry with the Communist bloc.

It would seem that certain commentators wish to view the U.S. and European science wars of the 1990s as merely another battle between the "two cultures." The current "two cultures" discourse assumes a division of labor: humanities researchers are critics who write commentaries on art and ideas, while scientists, engineers, and physicians find out facts about the real world and fix real problems. More succinctly, the humanities are for reflection and the sciences are for investigation. Trouble occurs when people trained to do one job try to do the other. New departures in social sciences further muddy the picture. In other words, cultural studies of science, technology, and medicine violate this division of labor and violate our conventions of expertise.

These new multiple spaces within the postcolonial world are interdisciplinary and fall under the rubric of cultural studies, broadly defined. We want to be very clear about this: here, cultural studies is understood as both a practice and a promise of interdisciplinarity attentive to epistemologies, asymmetries of power, and forms of embodiment at issue in knowledge production, be it in the life and physical sciences, social sciences, humanities, or outside academic and research centers. *Interdisciplinarity* is a widely circulated term, if not always a widely circulated practice. When practiced, as often as not, it stands for the conflictual meeting of disciplines in colloquia, conferences, and even programs that clash and then go their separate ways, reaffirmed in their disciplinary identities and the prerogatives of their respective research and pedagogical traditions. In this fashion, *interdisciplinarity* might be termed the practice of disciplinarity observed in the appearance of its breach (Weber 1987, 167, n. 2; Gulbenkian Commission 1996, 47).[11] *Interdisciplinarity* interests us here only to the very degree it interrupts business as usual, allows new objects of study to emerge, furnishes new resources for scholarship, and asks new questions not only of practitioners of science, technology, and medicine but also of those researchers who claim to study them.

Cultural studies as scholarly and pedagogical practices has a much-discussed genealogy that goes back to the 1960s and is associated with centers of research and teaching in the U.K. (from polytechnics and the Centre for Contemporary Cultural Studies at the University of Birmingham to Sussex University and Cambridge University) but since the 1960s can be found in local versions throughout much of the English-speaking world, including the United States, and in South and East Asia. From the outset its work was both text-based and fieldwork-based research: that is to say, it had a joint ancestry

in theories and methods in the humanities and social sciences. If in cultural studies the fieldwork component has been less acknowledged, it has now returned in the form of "second-wave" laboratory and field studies (particularly evident in the work of recent Ph.D.s) that are not afraid to expand the scope of their inquiry to include popular culture.[12] Indeed, over the years cultural studies has had the salutary effect, on the one hand, of bringing committed scholars trained in the humanities (fields conventionally dedicated to serving as guardians of the [usually elite] cultural past) to study contemporary popular culture and society and, on the other, of introducing modes of text-based analysis as tools for social science research while expanding the objects of ethnographic study to "nonexotic" practices of institutional and everyday life at "home."[13]

However, this history of cultural studies' practices—its canons, traditions, and academic territories—interests us less here than cultural studies as a *promise*, a placeholder for a space of engaged experimentation with those we study and with our own research selves. For many contributors to this anthology and other practitioners of interdisciplinary research, cultural studies stands as a vector, a direction, an inevitable drift that their own research materials and present contexts have imposed upon their thinking, scholarship and teaching, and careers.

Thus, for example, one contributor's work has taken her from an interdisciplinary graduate program in cultural studies and social science (communication) to an English department that had transformed itself into a cultural studies program for engineering students to, most recently, a job as senior researcher with Xerox PARC in Silicon Valley. Then there is the cultural studies scholar (not in this anthology) who published an interdisciplinary feminist analysis of U.S. and U.K. polar expeditions, and who, in quest of employment, has had to build a disciplinary identity for herself as an art historian and art critic through various postdoctoral fellowships at Brown and Stanford; she now teaches women's studies and visual culture in Japan. Another contributor has moved from fieldwork studies to a long-term commitment to transforming the graduate classroom into a laboratory of sorts for generating new interdisciplinary knowledges of science and medicine as chair of a department in a major center of scientific research in the United States; still another's research took her from a feminist and queer research interest in a popular comic strip to interrogating conventionally understood disciplinary and cultural boundaries between established research psychology, psychiatry, literary criticism, modernist fiction, and mass culture. One scholar has shifted from literary studies to analyzing visual media to fieldwork involving the social worlds of

public health, which in turn led to invitations to serve as a consultant to a pol-
icy research group and an ad agency involved in health education campaigns.
The point of these examples is that, like many of their interdisciplinary-
minded colleagues, none of the contributors has "stayed put" in terms of the
research traditions of their original fields. Rhetoricians and philosophers are
now observing scientific labs, anthropologists are studying at home, sociolo-
gists are doing fieldwork abroad, and historians and literary critics are no
longer simply custodians of the past but investigators of the present. As a con-
sequence, both researchers and their research are no longer the same. The new
work violates established definitions of theory, practice, data, and policy.
Hence, in our view, that exciting mix of data, analysis, speculation, and sur-
prise that characterizes the best work emanating from this experimental space.
Hence, too, the discomfort of some colleagues.

If researcher and research change, so too does the rapport between them.
For example, what happens to this relation when a noted feminist film scholar
such as Constance Penley does a field and textual study of *Star Trek* and NASA
as a cultural coproduction from the position of a fan of both the TV series and
the space administration (Penley 1997, 3)? What challenges does that work
offer not only to the ingrained detached elitism that underwrites so much
work in the humanities in the United States and to ethnography's recom-
mended field methods but also to a tradition of committed inquiry called
"cultural critique"? What are the epistemological, ethical, and political risks
involved? What new lines in inquiry become possible? What other questions
are foreclosed? What kind of knowledge does this produce?

Colleagues' discomfort can take the form of various accusations of im-
proper perspective: scholars in the humanities regularly accuse interdiscipli-
nary cultural studies practitioners of "presentism." Of eclectic or
inappropriate approaches: some social scientists claim to discern a lack of
"method," while others complain of an "aestheticization" of the social sciences.
Of taboo theories and subjects: using so-called French theory or looking for
issues of gender, race, and so forth in the wrong places. Or of improper mate-
rials or focus: one anthropologist was told that analyzing publicity posters
made by a major research lab does not constitute studying science; another
that the only site of science studies that counts is the lab and the funding and
publishing networks that connect them. Of anti-intellectualism: one re-
searcher who investigated epistemological prerogatives of researchers, includ-
ing those in social science and the humanities, in relation to middle-class
entitlements and identities was accused of being a "self-hating academic." Fi-
nally, of inappropriate interdisciplinarity: even self-avowed interdisciplinary

scholars don't want their settled certainties disturbed, as when, for example, the editors of a major cultural studies journal rejected an invited manuscript cowritten by a contributor to this volume and a practicing scientist on rethinking how the immune system and allergens operate in the context of changes in national and global food production. The reason? The editors claimed that the article took the methods and findings of scientific research too seriously.

In our view, cultural studies of science should be understood as a name for these experimental research and pedagogical practices in the United States at this time. It is nothing less than that but also nothing more: for us, it would be meaningless to enunciate a grand new synthesis or reconciliation for all time of the methods, theories, topics, and research materials from the twenty or so fields that now study the practices of science, technology, and medicine. Even if we wished to do so, the drift and pull of cultural and scientific vectors would repel our efforts.

Forming Our Book's Contents

It is the editors' hope that *Doing Science + Culture* will function as an extension of experimental, interdisciplinary space to the pages of the academic anthology. In this introduction we have sketched a general frame for interdisciplinarity "after modernity," but in the end it will be for readers to spin it for themselves and deal with the world of turbulences as they see best in their local situations.

We think these sections organize articles in a provocative way; many essays could have been grouped in any of the three sections, but we believe that the organization as it stands is a meaningful one. The essays in the first section, "Transnational Science and Globalization," expand the focus of the introduction on the U.S. context to include the movements of people, material resources, and knowledges that underwrite scientific practices within and across borders of nation-states and regions. Thus Sharon Traweek's "Faultlines" proposes a further historicization of the post–Cold War present "after modernity" in terms of major shifts in regional knowledge and intellectual centers both within Japan and the United States and between the North Atlantic and the Pacific Rim. Her essay asks the question, Once these transformations are duly noted and registered, what ways of thinking of the past and present scientific practices are no longer possible? And what new forms of thinking become possible?

The ramifications of these shifts become clear in Joan Fujimura's study of transnational genomics in Japan and the United States. In tracing the story of how transnational science remains a resource for nationalist agendas under the guise of technoscientific cosmopolitanism, her essay disrupts some of the defining narratives of East and West that frame both East Asia area studies and the history and philosophy of science. These categories both name cultural, national, and regional differences and reify them; however, in the context of globalization of knowledge production, these terms are stretched to the breaking point by the large numbers of scientists, technicians, and researchers working outside their own regions and countries. The questions of "modernity" (of which Western-dominated science is a token) and nationalism return in Itty Abraham's investigation of postcolonial "big science" in the case of the physical site chosen for the Giant Metrewave Radio Telescope (GMRT) built in India near Pune in 1996. The manner in which Indian scientists resolve contradictory strands in postindependence thinking about Indian science affords Abraham the opportunity to reopen the question of the narrative of modernity and how it emerges transformed in the postcolonial landscape produced by the design and execution of large scientific projects. Fujimura's and Abraham's essays both ask the question: Is there an afterlife to modernity and its nationalisms? What are its locations, and what scientific and technical forms does it take?

If the production and circulation of knowledge in the last thirty years force us to question established accounts of scientific practices, to re-ask old questions, and to come up with new categories for studying the past and present, they also enjoin us to explore the emergence of new subjects, specifically, the simultaneous construction of researchers and their fields, and those subjects, topics, and informants they study. Once again, this double construction of researchers and research applies both to the practitioners of science and to those who study them. Such is the goal of the section "Emerging Subjects." For example, the internationally popular comic *Wonder Woman* and its author, Harvard-trained psychologist William Marston, are Molly Rhodes's research subjects. The sexual and gender queerness of the comic itself, its hostile reception by psychiatrists and critics alike, and the extraordinary vagaries of Marston's career (inventor of the polygraph, Hollywood consultant, and research psychologist whose book *The Emotions of Normal People* was published in the International Library of Philosophy and Scientific Mind, alongside books by Wittgenstein, Piaget, Adler, Hulme, and I. A. Richards) give Rhodes ample leave to interrogate the boundaries among science, academic researchers, and mass culture. The very nature of her topic requires of her a sustained interdisciplinary

mobility and the skills and sensibilities of an archivist, historian, literary critic, sociologist, and feminist theorist.

The respective positioning of researcher and research subject or object has long been underwritten by a dynamics of self and other. Work in interdisciplinary cultural studies of science and medicine makes these dynamics visible (especially those entailed by researchers studying other researchers), forces them to shift, and sometimes even throws them into crisis. While many of the essays in this volume operate in this fashion to some degree, the remaining essays in the second section enact them directly. His own field and professional experience of studying the public controversy over antismoking campaigns affords Roddey Reid the opportunity to explore the challenges posed to the standard research and fieldwork narrative and its conventional epistemology, identity politics, and ethics by researchers studying "across" other middle-class professionals — in other words, what it means when the other isn't predictably and stably "other." The essays by Jackie Orr and Emily Martin dramatize the challenges that arise when the difference between research self and other further dissolves. Both articles explore the emergence of new technoscientific selves "after modernity" by the establishment of official new psychiatric diagnostic categories — respectively, panic disorder and manic-depression. By performing genealogies at once social and autobiographical, they push the envelope of acceptable research sites and materials and conventional research narratives: they take readers to earlier historical moments of twentieth-century modernity — the Great Depression and the dawn of the Cold War — and to heterogeneous sites of knowledge production and the production of subjects — from the experience of watching Gulf War television coverage and the reading of high modernist novels to archival work and fieldwork in cybernetics, psychiatry, pharmaceutical companies, and patient support groups in "postmodern" Orange County, California, to marginal "nonmodern," "irrational" cultures of the Deep South and of Amish communities in southeastern Pennsylvania.

To the archive, field, library, text, and autobiography as sites for doing cultural studies of science of the first two sections, the last section, "Postdisciplinary Pedagogies and Programs," adds the institutional settings of classroom, laboratory, department, and academic division. These, too, are spaces of engaged experimentation with what we study and our research selves, and they impose their own set of constraints. These constraints are the real-world differences between small colleges still committed to traditional liberal arts and sciences education and universities and engineering schools, with their deeper disciplinary divisions and tensions tied to research and funding traditions; the questions of public service and citizenship; and the impact of new, engaged

scholarship, especially stemming from feminist epistemology. In his essay "Mainstreaming Feminist Critiques into the Biology Curriculum," developmental biologist Scott Gilbert lays out for readers the local conditions that favor combining feminist critique and undergraduate laboratory work in pedagogical practice: the older mission of social responsibility enjoined upon the liberal arts and sciences, which is especially strong at Swarthmore College, with its Quaker tradition; and a strong history of feminist analysis of biology by trained scientists from within the field. The essay offers provocative examples of successful pedagogical strategies and of how working "after modernity" can be enabled by drawing upon older marginal traditions of modernity itself as resources. Teaching and conducting research in the field of physics at both a liberal arts college and a research university, Karen Barad has to deal with not only the very different impact feminism has had on her field but also a long troubled debate over social responsibility stemming from World War II. In "Reconceiving Scientific Literacy as Agential Literacy," her pedagogical and intellectual strategy involves reviewing the history of concepts of scientific literacy from that time as bankrupt and out of date and proposing an alternate literacy and pedagogy *for science majors and nonmajors alike* based on an epistemological and ontological frame derived from a marginalized strand of modern thought, namely the theories of Niels Bohr. She reviews various pedagogical approaches that have worked well in the lab and classroom, and argues that understanding science in "complex intra-action with other practices" makes not only better citizens but also better scientists.

In these two essays, the classroom and lab stand as spaces relatively open to controlled pedagogical, epistemological, and ethical experimentation under the instructor's authority. Matters are quite different when it is a question of departmental and divisional reforms, as in Anne Balsamo's and Michael Fischer's essays. Here other opportunities and constraints obtain. In "Engineering Cultural Studies" Balsamo introduces readers to the challenges and ironies of teaching cultural studies of science at Georgia Institute of Technology in a former English department that committed, in so many words, disciplinary suicide by dissolving and renaming itself the School of Literature, Communication, and Culture in 1990. Nine years after restructuring, the transformation is still a project-in-progress: old disciplinary loyalties and styles of thinking persist even in the most committed interdisciplinary members, nourished first by the very marginalization of the humanities in the engineering school that prompted innovative rethinking of the mission of the department in the first place; second, by difficulties encountered in assessment and evaluation of faculty interdisciplinary research; and third, by the competition for students and

funding. This particular situation in turn involves a constant trying out of professional positions and selves from one class to another, one meeting to another, something Balsamo terms "identity switching," the very condition, in her view, of the interdisciplinary scholar and teacher.

Part ethnography and part internal memo, Michael Fischer's article focuses on very recent reforms implemented at MIT of the graduate curricula of the Program in Science, Technology, and Society (STS). For a program that had traditionally brought together historians, anthropologists, and philosophers of science, Fischer outlines a new multitiered curriculum of core, foundational, and topical courses now in place and whose goal is at once interdisciplinary in the strong sense and inclusive. Integrating colloquia, workshops, and flexible course modules focused on fields (physics, biology, and so on) and defining historical "events" for science studies scholars (the scientific revolution, the Pasteurian revolution, and so on), and recent theories and research in committed cultural studies scholarship, the curriculum takes powerful advantage of the institutionally secure position of an established program to experiment with an unusually intense, socially dense collaboration among STS faculty and, more strikingly, with "cross-school" courses jointly taught by program members and MIT scientists and engineers. This mode of collaboration stems directly from advantageous local conditions and clears a new space of pedagogy that, according to Fischer, is nothing less than the transformation of the classroom into a laboratory for new research agendas and design, not only in interdisciplinary studies of science, technology, and medicine but, as in the case of Gilbert's biology lab and Barad's physics lab, also in the sciences themselves. Here, the classroom becomes at once the field, the archive, the library, and the text—a hybrid space of judgment and assessment but also of experimental investigation.

Conclusion

In our view, the essays collected in this volume are as good as the uses to which they can be put. If they make possible new forms of thinking, provoke unforeseen lines of research, or simply help readers engage in refreshing ways with how we come to know what we know about the natural and social worlds, we will consider the anthology a success. This is not an immodest goal at a time when much academic and public discussion, especially in the United States, has been dominated by appeals to epistemological fundamentalism and calls for intellectual loyalty oaths in the name of good citizenship. It is our hope

that these essays give readers, especially graduate students, a sense of what can take place within interdisciplinary or cultural studies of science, technology, and medicine, namely committed experimentation with those we study and with our own research selves. It is an intellectual space, which at its best allows the pursuit of exciting ideas to take precedence over the defense of academic territory, the narrow building of careers, or the comforts of a glib avant-gardism. After all, in the present world "after modernity," there is much to learn and much to do. To be sure, in a climate of polemics, thoughtful interdisciplinary reflection is hard to come by and, on the part of novice scholars, requires stamina and even courage as careers are now being put on the line. The risks are there, but many of us feel that the force of circumstance and drift of events leave little choice but to follow skeptical inquiry where it leads as it pushes us toward a deeper engagement with the scientific, cultural, and social turbulences that mark the end of the 20th century.

Notes

1. The preceding paragraph contains the first of many lists to which we have recourse throughout the introduction in order to argue our positions. Here and elsewhere, we insist on jamming together, for the purposes of launching new discussion, elements that are usually kept quite separate.

2. For example, see Aronowitz, Martinsons, and Menser 1996; Crimp 1989; Gray 1995; Penley and Ross 1991; Rosario 1997; and Star 1995.

3. For an extended statement coauthored by a physicist and a historian of science about the production of knowledge and ideas that shares much with our own, see Fortun and Bernstein 1998.

4. The papers were later published as a special issue of *Configurations: A Journal of Literature, Science, and Technology* 2, no. 1 (winter 1994).

5. For example, the Consortium of Humanities Centers and Institutes lists over one hundred member organizations in the United States, Canada, and Europe that encourage interdisciplinary research among fields in the humanities and social sciences.

6. On the fate of the university as guarantor of national culture in the context of globalization, the decline of the nation-state, and academic quality management, see Readings 1996. For a helpful overview of post–World War II developments in academic fields in (Western-dominated) knowledge production, see Gulbenkian Commission 1996.

7. It is important to remember that in this context the sites of contention over interdisciplinarity and cultural studies scholarship are not so much, as the science wars polemics might lead one to believe, the pages of journals but rather pragmatic venues

such as departmental or campus committees controlling hiring, promotion, and access to resources.

8. This situation has prompted certain scholars, including Abraham, to call for allying cultural studies and area studies in a joint interdisciplinary project that, on the one hand, would take cultural studies beyond its largely noncomparative, Euro–North American cultural frame and, on the other, would foster new methodological departures in area studies. See Lee 1997.

9. The science wars are the latest theater of the ongoing culture wars in the United States and elsewhere. The beginning of the science wars may be conveniently dated from 1991, when the Institute for Advanced Study's governing board turned down the appointment of French sociologist Bruno Latour. At the outset, some thought that the rage that linked up certain kinds of scholarship with everything that in the eyes of some was wrong with the United States and the world would make only a momentary, embarrassing appearance and be gone. Since then, the science wars have since mutated and spread to the United Kingdom, France, Europe, Brazil, and Japan.

10. See Appadurai 1996; Crary 1990; Haraway 1989, 1991; Jameson 1991; Latour 1995; Rouse 1996; Spivak 1990; Traweek [this volume]; and Williams 1983.

11. Filmmaker and theorist Trinh T. Minh-ha makes the following skeptical observation about interdisciplinarity:

> This notion is usually carried out in practice as the mere juxtaposition of a number of different disciplines. In such a politics of pluralist exchange and dialogue the concept of "inter-" (trans)formation and growth is typically reduced to a question of proper accumulation and acquisition. The disciplines are simply added, put next to one another with their boundaries left intact; the participants continue happily to speak within their expertise, from a position of authority. It is rare to see such a notion stretched to the limits, so that the fences between disciplines are pulled down. Borderlines remain then strategic and contingent, as they constantly cancel themselves out. (1992: 138)

12. For the sciences, see Casper 1998; Cussins 1996; Dumit 1995; Helmreich 1998; Laughlin 1993; and Redfield 1995.

13. For an engaging assessment by social scientists of cultural studies at the Birmingham Center see Lave et al. 1992; on cultural studies' influence on ethnography, see Gordon 1995.

To be sure, this crossover didn't await the arrival of a cultural studies advance party. Already, an early form of interdisciplinarity was practiced in U.S.-based area studies founded during the Cold War (Gulbenkian Commission 1996). And in science studies, by the late 1970s laboratory studies and qualitative social science (cultural anthropology, ethnomethodology, grounded theory, symbolic interactionism) began using theories and methods commonly found in text-based fields while the humanities started experimenting with fieldwork (see Gusfield 1976; Knorr-Cetina 1981; Latour and Woolgar 1979; Lynch 1985, and Traweek 1988). What often got left out of most, but not all, of these early interdisciplinary ventures was the persistent pursuit of questions of the play of power, discourses, access, marginalization, and exclusion in the production and circulation of knowledges in relation to particular groups within the social body. The point is that the "drift" toward interdisciplinarity was emerging in many research arenas.

Works Cited

Appadurai, Arjun. 1996. *Modernity at Large: Cultural Dimensions of Globalization.* Minneapolis: University of Minnesota Press.

Aronowitz, Stanley, Barbara Martinsons, and Michael Menser, eds. 1996. *Technoscience and Cyber Culture.* New York: Routledge.

Bender, Thomas, and Carl E. Schorske, eds. 1998. *American Academic Culture in Transformation: Fifty Years, Four Disciplines.* Princeton, N.J.: Princeton University Press.

Casper, Monica. 1998. *The Making of the Unborn Patient: A Social Anatomy of Fetal Surgery.* New Brunswick, N.J.: Rutgers University Press.

Crary, Jonathan. 1990. *Techniques of the Observer: On Vision and Modernity in the Nineteenth Century.* Cambridge, Mass.: MIT Press.

Crimp, D., ed. 1989. *AIDS: Cultural Analysis/Cultural Activism.* Cambridge, Mass.: MIT Press.

Cussins, Charis. 1996. "Technologies of Personhood: Human Reproductive Technologies." Ph.D. diss., University of California, San Diego.

Dumit, Joseph. 1995. "Minding Images: PET Scans and Personhood in Biomedical America." Ph.D. diss. University of California, Santa Cruz.

Fortun, Mike, and Herbert J. Bernstein. 1998. *Muddling Through: Pursuing Science and Truths in the Twenty-first Century.* Washington, D.C.: Counterpoint.

Gordon, Deborah A. 1995. "Conclusion: Culture Writing Women: Inscribing Feminist Anthropology." In *Women Writing Culture,* edited by Ruth Behar and Deborah A. Gordon. Berkeley and Los Angeles: University of California Press. 429–42.

Gray, Chris Habels, ed. 1995. *The Cyborg Handbook.* New York: Routledge.

Gulbenkian Commission. 1996. *Open the Sciences: Report of the Gulbenkian Commission on the Restructuring of the Social Sciences.* Stanford, Calif.: Stanford University Press.

Gusfield, Joseph. 1976. "The Literary Rhetoric of Science." *American Sociological Review* 41:16–34.

Hackett, Edward. 1990. "Science as a Vocation in the 1990s: The Changing Organizational Culture of Academic Science." *Journal of Higher Education* 61:241–79.

Haraway, Donna J. 1989. *Primate Visions: Gender, Race, and Nature in the World of Modern Science.* New York: Routledge.

——— . 1991. *Simians, Cyborgs, and Women: The Reinvention of Nature.* New York: Routledge.

Harvey, David. 1989. *The Condition of Postmodernity: An Enquiry in to the Conditions of Cultural Change.* London: Blackwell.

Helmreich, Stefan. 1998. *Silicon Second Nature: Cultivating Artificial Life in a Digital World.* Berkeley and Los Angeles: University of California Press.

Jameson, Fredric. 1991. *Postmodernism: or, The Cultural Logic of Late Capitalism.* Durham, N.C.: Duke University Press.

Knorr-Cetina, Karin. 1981. *The Manufacture of Knowledge: An Essay on the Constructivist and Contextual Nature of Science.* Oxford: Pergamon.

Latour, Bruno. 1995. *We Were Never Modern.* Translated by Catherine Porter. Cambridge, Mass.: Harvard University Press.

Latour, Bruno, and Steven Woolgar. 1986. *Laboratory Life: The Construction of Scientific Facts*. Princeton, N.J.: Princeton University Press.

Laughlin, Kim. 1993. "Writing Bhopal: Rhetorical Perspectives on India, Environmentalism, and the Politics of Disaster." Ph.D. diss., Rice University.

Lave, Jean, Paul Daguid, Nadine Fernandez, and Erik Axel. 1992. "Coming of Age in Birmingham: Cultural Studies and Conceptions of Subjectivity." *Annual Review of Anthropology* 21: 257–82.

Lee, Benjamin. 1997. "Between Nations and Disciplines." In *Disciplinarity and Dissent in Cultural Studies*, edited by Cary Nelson and Dilip Parameshwar Gaonkar. New York: Routledge.

Lowen, Rebecca S. 1997. *Creating the Cold War University: The Transformation of Stanford*. Berkeley and Los Angeles: University of California Press.

Lyotard, Jean-François. 1984. *The Post-Modern Condition: A Report on Knowledge for the Universities Council of the Government of Québec*. Translated by Geoff Bennington and Brian Massumi, 1979. Reprint, Minneapolis: University of Minnesota Press.

Lynch, Michael. 1985. *Art and Artifact in Laboratory Science: A Study of Shop Work and Shop Talk in a Research Laboratory*. London: Routledge and Kegan Paul.

Penley, Constance. 1997. *NASA/Trek: Popular Science and Sex in America*. London: Verso.

Penley, Constance, and Andrew Ross, eds. 1991. *Technoculture*. Minneapolis: University of Minnesota Press.

Rabinow, Paul. 1996. *Essays on the Anthropology of Reason*. Princeton: Princeton University Press.

Readings, Bill. 1996. *The University in Ruins*. Cambridge, Mass.: Harvard University Press.

Redfield, Peter W. 1995. "Space in the Tropics: Developing French Guyana, Penal Colony to Launch Site." Ph.D. diss., University of California, Berkeley.

Rosario, Vernon A. 1997. *Science and Homosexualities*. New York: Routledge.

Rouse, Joseph. 1996. "Philosophy of Science and the Persistent Narratives of Modernity." In *Engaging Science: How to Understand Its Practices Philosophically*, 43–67. Ithaca, N.Y.: Cornell University Press.

Spivak, Gayatri Chakravorty, with Sarah Harasym. 1990. *The Post-Colonial Critic: Interviews, Strategies, Dialogues*. New York: Routledge.

Star, Susan Leigh, ed. 1995. *Ecologies of Knowledge: Work and Politics in Science and Technology*. Albany: State University of New York Press.

Traweek, Sharon. 1988. *Beantimes and Lifetimes: The World of High Energy Physicists*. Cambridge, Mass.: Harvard University Press.

Trinh T. Minh-ha. 1992. *Framer Framed*. New York: Routledge.

Weber, Samuel. 1987. *Institution and Interpretation*. Minneapolis: Univiversity of Minnesota Press.

Williams, Raymond. 1983. "Modern." In *Keywords: A Vocabulary of Culture and Society*. New York: Oxford University Press.

Faultlines

Sharon Traweek

About 125 years ago west European intellectual debates, modes of argument, and classifications of knowledge began to circulate globally through the new research universities that were established on the European model in most of their then current and former colonies, as well as in some countries eager to emulate the powerful Europeans. Smart, educated people around the world began to learn to have the same standards and tastes in the arts, sciences, and ideas. We also learned to believe that our local knowledges were vernacular, decidedly provincial, and "anecdotal," if not exactly primitive. The name of this set of assumptions about single, universal standards for beauty, truth, and logic has come to be called "modernity."

As we launch our new debates, modes of argument, classification systems, and modes of inquiry, we have come to see the provinciality of those ideas once thought to be universal or, alternatively, exhibiting the highest universal standards. Our violations of the boundaries of the disciplines violate, too, the nineteenth-century hierarchies of those nation-states. One hundred years later some are building ideas in those despised borderlands, without hierarchies, binary oppositions, or categorical thinking. Some political economies, careers, and universities are also moving away from those models, using other organizing strategies. What follows is a sketch of an argument on how knowledge is

being defined and made at the edge of the times and places called modernity, all within the confines of my allotted 10,000 words. My gloss on the histories of these ideas are matched with political economies, university structures, careers of professors, and the world of the arts, all of which I see as tightly interwoven. I am particularly interested in the periods when these arrangements become unstable. How do the new patterns and symbols emerge, enabling us to see new compositions and find them satisfying? Who made these new tools, and what do they displace?

The Industrial and Information Revolutions and the Knowledges They Engender

Many economists agree that by 1975 Germany and the United States, then the richest countries of the world, had begun moving away from manufacturing-based and toward information-based economies, where computing is crucial; these countries' manufacturing industries have been increasingly sent to the "third world," where educational systems are now adequate for producing substantial numbers of industrial workers and industrial managers (as the U.S. and Japanese educational systems were designed to do well over one hundred years ago). The richest countries are now trying to revise their own educational systems so that they can generate information workers and managers instead.

In financial terms this transition in global political economy is marked by the rapid decline in nation-states' ability to control their currencies' exchange rates; computing begins to facilitate the stunning expansion in daily worldwide currency flows, utterly unregulated by nation-states. Subsequent decades see massive innovations in "financial instruments" worldwide. The era is also marked by rapid escalation in the global circulation of popular culture and the marketing of that culture, as well as in the global circulation of human populations of all social positions.

Many political economists also argue that the United States, especially, is about twenty-five years into a political, social, intellectual, and cultural revolution that might be akin to the turmoil at the beginning of the Industrial Revolution in England. In that period other countries, once smug that their worlds were more stable, have since entered into this turmoil. Germany, due to the costs of unification, is moving more slowly in this direction than it was before the end of the Cold War; Japan is increasing its pace.

I want to recall, for a moment, that earlier revolution. That is, along with the development of a factory system in Manchester, England, from 1775 to

1850, there were many dislocations and realignments of political, social, intellectual, cultural, and economic priorities, criteria, and resources, followed by similar changes throughout England. Cities quintupled in size, new religions formed to comfort the migrants, and social classes took shape, as did new forms of cultural production, constituting and reflecting the new kinds of personae and social worlds that their audiences were experiencing. Similar but interestingly different shifts occurred in France and Germany circa 1825–50, and eventually these practices spread to Japan, Russia, and the United States during the last thirty years of the nineteenth century. They have continued to spread to every industrializing region of the world.

These changes occurred differently in different regions of the same country; places that were once insignificant or peripheral became central in a new way. Similarly, relations between these formerly peripheral sites in various countries themselves became powerful webs of connections, surpassing the influence of older ties. Small towns in the New England region of the United States became sites for textile factories, drawing on rivers for power and the local surplus farming population (mostly women) educated well enough for industrial labor. In Japan the same thing was happening at the same time in the farming areas at the edge of the fertile Kanto plain around Tokyo. Textile manufacturing using women factory workers remains a standard device for beginning industrialization, whether in Indonesia or Mexico. The factories continue to be built first where the local population is least in a position to object.

I have become interested in how these massive shifts in political economy affect the kinds of questions intellectuals begin to find interesting at such periods, the kinds of resources amassed to investigate their questions, the kinds of curricular and pedagogical changes generated, and the new modes of investigation. That is, what else is going on when there is a change in what counts as a good question, an interesting mode of inquiry, way of teaching and learning, and the infrastructure needed for pursuing these emerging forms of knowledge making? Who resists these changes; how do they resist?

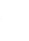

For instance, many historians have argued that a relationship exists between the kinds of physics and physicists encouraged at Manchester University and the Industrial Revolution, begun in Manchester. Others have said the same about the new kinds of historical research being developed in Germany a few years later. Similarly, the emergence of the academic field of anthropology has been historically situated in that political economy. Intellectually and culturally, during the 1820s, 1830s, and 1840s there are clear signs of new kinds of expertise, new kinds of curricula, new kinds of careers, and new kinds of ideas for those who were studying the phenomenal and social worlds. Those once

new forms are still in place today in our universities' current organization of disciplines, curricula, examinations, and criteria for promotion.

By the second half of the nineteenth century the richest industrial areas had already begun to turn the rest of the industrializing world into their customers, exporting equipment, techniques, institutions, and social structures globally for manufacturing, finance, government, public health, education, research, transportation, and so on. Simultaneously, a set of initiatives emerged among researchers in various fields to identify universal standards, measures, and criteria for evaluating what had previously been studied as discrete, diverse phenomena. Those in the humanities focused on defining universal standards of beauty in the form of great books and masterpieces of art and music.

The French mathematician and philosopher Auguste Comte coined the word *positivism* in the 1830s to describe a way of thinking he expected would bring a host of practical benefits to society. The word embraced a certain kind of logic, a certain kind of observation, a certain kind of experimentation, a certain kind of measurement, and a certain kind of analysis. A specific model for the presentation of research began to be widely used in all fields. All of these changes have produced a world we have called "modern."

Modernity and Industrial Political Economy

Most people in Europe and North America associate the word *modern* with current, as opposed to traditional, practices. That usage began about 1585 in England, but its meaning then was to differentiate the current approaches from the earlier, medieval and ancient ways. Professional historians of Europe consider the "early modern" period to begin with the Thirty Years' War of the seventeenth century (1618–48); a mercantile economy begins to thrive in Europe, leading to the formation of new markets, new financial instruments, and new modes of exchange and capital accumulation, as well as the emergence of nation-states to regulate these new economic practices. With "voyages of discovery" many of the emerging European nation-states began to build their worldwide empires; the competition for empires characterized much of the nation-state period. The imperial countries and the nations emulating them controlled empires for the next three centuries. Cities and their bourgeois cultures enlarged and became more complex. Historians argue that the early modern period extends to the French Revolution, and that the "modern" history of Europe begins in 1815 at the end of the Napoleonic Wars, when an in-

dustrial political economy was launched. Often the "modern period" refers to the entire three and a half centuries since 1648.

Art historians have long used the terms *modern* and *modernist* to define a shift during the late nineteenth century away from "classical" subject matter in the arts and toward formal questions about the representation of human visual or aural processes. In the visual arts these questions took the form of experiments that would later come to be called impressionism, pointillism, and cubism. Debates about how to represent the human perception of space and light shaped the visual arts of the industrial world for about seventy-five years; those debates (and the artifacts associated with them) are usually referred to as modernism.

[margin note: Modernity in Art]

In the same time period literary artists were concerned with issues in the representation of narrative time, as, for example, in the work of Virginia Woof, James Joyce, and Thomas Pynchon. Composers like Arnold Schoenberg and Anton von Webern were concerned with the representation of time and harmony. "Postmodernists" and "poststructuralists" characterize modernism as having certain defining features, including a commitment to the notion of universal standards in logic, values, and aesthetics, standards that now appear to be actually based on specific European traditions.

[margin note: L.t]

Of course, many intellectuals, academics, and researchers have not heard of these phenomena and these labels. Many of those people strongly identify with west European modernist values and goals, and they strongly object to the belated news that the modernist period ended four decades ago. Many young intellectuals learned to love the modernist aesthetic during the post–World War II period. Most became familiar with the ideas and aesthetics of modernism when that style moved into popular culture during the 1950s, just as modernist architectural forms and furniture designs became mass produced. When their incomes permitted, they decorated their bodies and their houses modernly. They did not know that the style was already dying, like Camille, when they fell in love with it.

[margin note: Modernity into pop culture]

Although few elite artists have produced modernist art since the 1960s, modernist music, painting, architecture, history, and literature obviously are not defunct. We are surrounded in our cities, museums, libraries, and university curricula by modernism's monuments and practices, which remain lucrative. Obviously, my date for the end of modernism refers to the cutting edge, or the most innovative changes. Many aspects of society remain immersed in the earlier values and activities, just as in the eighteenth century many parts of English society remained agricultural thirty to fifty years after the Industrial

Revolution began. Consider, for example, the provincial, largely agrarian world depicted in Jane Austen's novels, sited not many miles from the center of the concurrent industrial revolution. Even so, the readership Austen relied upon for her romantic tales was itself a creation of that industrial revolution: the new middle classes defined themselves in part by a domestic world managed by literate women. Attachment to a certain romanticized nostalgia actually marks the emergence of a new ethos. Further instances of nostalgia defining a new ethos abound: William Morris and the Pre-Raphaelites in England, the Green brothers and the Craftsman style in California architecture, and the folk craft movements in Japan all could have happened only in rapidly industrializing societies.

Was it Noël Coward who said that nostalgia is what happens when you lose your sense of irony? By now, with or without irony, modernism has become a retro fad among the cognoscenti (including teenagers) around the world. The most influential of the arts auctioneering firms, such as Sotheby's, have begun to sell surviving modernist works in furniture and the arts at very high prices.

Arts and Sciences at the End of Modernity

To recapitulate, most researchers use *modern* and *postmodern* to refer to the social, political, artistic, economic, and intellectual, features of two distinct historical periods in western Europe. In all these arenas the transition out of the modern period occurs between 1960 and 1975. Arts of the second period, 1960 to the present, are considered postmodern, although during the past decade and a half the term *contemporary* has been often invoked to name the period that comes after modernism.

By the early 1960s a new set of questions began to attract the attention of intellectuals and artists; many in the arts, humanities, and sciences began to challenge the modernist focus on representation and universality. Those activities and artifacts associated with the end of modernism have usually called attention to the process of how the appearance of certain spatial, temporal, or harmonic unities are created. For example, the 1960s saw a strong interest in the "flatness" of the actual surface of images, and in the 1970s much painting focused on reflective surfaces and on images that referred to other images. Visual artists who worked in that period, like the Fluxus group, Helen Frankenthaler, Morris Graves, Robert Irwin, and James Turell, remain influential today; those who are alive have continued to be innovative over the subsequent decades.

Because architects work at the intersection of the elite arts, the business *Architecture* world, and public culture, I will illustrate my point with examples from architecture. Architectural postmodernists often called attention to the process of invoking architectural devices from other periods and places; some became intrigued with formulating queries about the details of intersecting surfaces. For example, during the 1960s many architects decided to disrupt the smooth, sleek, regular, reflective surfaces associated with modernist architecture. Some, like Arata Isozaki in Tsukuba and Michael Graves in San Diego, chose to reintroduce classical motifs ironically; Isozaki notes he imagined how his buildings for the center of a new science city would look as ruins. Others, like Renzo Piano in his design for the Pompidou Center in Paris, concentrated at first on puncturing the facades with different, often playful shapes. Yet others began to use local traditional design motifs in their work, rejecting the global uniformity of modernist architecture and design; that movement has been labeled "regional vernacular."

A few also designed buildings to reveal the means of constructing those smooth, modernist facades used all over the world. Frank Gehry, for one, began to use mass-produced industrial materials openly and inventively, playfully calling attention to the mass production of modernist design. These 1960s movements all had their analogs in the other arts—painting, sculpture, music, dance—and in the subsequent thirty-five years, of course, these different approaches, at first labeled "deconstructionist," have all been modified, revised, and challenged. The strategies themselves—puncturing facades, revealing the means of production of dramatic effects, exposing the industrial underpinnings of aesthetic claims, or quoting from the classics and the vernacular, whether ironic or earnest—have actually been part of the standard repertoire of artists around the world for centuries, but they had not been dominant strategies for some time in the high-status art cultures of the European tradition.

These developments in the arts have their parallels in the social, life, and physical sciences, as well as in the humanities, not to mention the changes in global political economy. For example, in the sciences the dominant conceptual strategy during the modernist period was to develop theories and design experiments that investigated or displayed simplicity, stabilities, uniformities, taxonomies, regularities, hierarchies, and binaries. During the 1960s those aesthetic criteria began to be displaced by another set; increasingly, researchers in the sciences preferred to investigate complexity, instabilities, variation, transformations, irregularities, diverse organizational patterns, and spectra, and a new set of tools were developed to help them conduct those searches.

During the phase shift away from modernist queries about universals, representation, perception, and experience, new queries emerged about disparate intersecting surfaces. The modernist preoccupation with stable states ended with a new interest in transitions. Much of the most interesting intellectual work of the last generation has occurred at the multiple interfaces of the disciplines of the mid-nineteenth century. How might these conceptual, cultural shifts away from modernism be related to the changes in political economy that usually take place in the same communities?

Crossing National and Disciplinary Borders

Nation-states have also been defined, in part, by their capacity to control economic activities within their borders; economists now agree that no nation-state has been able to control its currency's exchange rate for a generation. (The official declaration of this fact was made during the Bretton Woods Conference of 1973.) Nation-states have also been the primary patron of the arts, universities, and basic research for the past three centuries, especially in Europe and North America. That patronage has been significantly eroded during the last generation, and particularly since the end of the Cold War. What is the fate of those modern knowledges nation-states once needed, developed, and applied, now that other forms of political economy are replacing them?

As these nation-states and the traditional disciplines come to be seen less as "natural kinds" and more as historically situated, how will our interpretive strategies, our modes of inquiry, and the very details of our work change? How will our curricula change? To answer that I believe we need to be able to characterize accurately the transition away from the domains of modernity; this task has just begun.

By the mid-1940s the negative social aspects of the positivist mode of thought had begun to be apparent; however, it was given a late-life boost by Cold War ideological activities. By the early 1960s the difficulties of exporting positivist thinking beyond North America and Europe revealed the cultural specificity of what had initially been taken to be universal. Various intellectuals began to write and publish critiques of positivism in the late 1950s and the early 1960s: Roland Barthes, Jacques Derrida, and Michel Foucault in France, Watt and Williams in Great Britain, Norman O. Brown in the United States, and a host of "others" in the former colonies of Britain, France, and the United States. A few began to develop alternative explanations for how humans construct ideas about the phenomenal and social worlds in which we live.

Universals at the Beginning of the End of Colonial Empires

Unlike the modernists, those who began to locate the modernist mentality historically were strongly influenced intellectually, politically, and often personally by the decline of the European colonial empires. For the French this meant the wars in Algeria and Indochina; for the English it was the establishment of Israel, the revolution in India, and the Suez war. This transition in the post–World War II European political economy began to bring to an end the Euro-American-Japanese colonialist confidence that began with the Victorians in England during the mid-nineteenth century.

By "colonialist confidence," I mean a sense that western European (later adopted and developed by north Americans and Japanese) ways of thinking, governing, manufacturing, making art, religious practices, and so on were the apex of such activities around the world, and would continue to be so. Most Europeans (and proto-Europeans) also believed in a sort of sociocultural Darwinism: that all human activities evolve; that all earlier forms exist in the present in those societies that arrested their development at various historical moments; and that the Euro-American cultures uniquely have avoided this arrested development, and hence have evolved more perfect ways of making ideas, art, things, religion, values, and selves. Thereby, western European practices have become the world standard for all human endeavor. The history of those practices constitutes the history of these exceptional developments.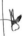

I think that ethos saturates the work of a set of 1950s positivists called structuralists and hence locates their work historically. Claude Levi-Strauss, a French theorist of kinship and cognition, Jean Piaget, a Swiss theorist of human cognitive development, and Noam Chomsky, an American linguistic theorist studying grammar, were developing systems of thought that radically narrowed the scope and focus of positivist analyses in order to preserve their successes. These structuralists all believed that (1) there are innate, universal "structures" in human minds that lead us to think in certain patterns; (2) those innate brain structures probably lead humans to construct binaries/dyads/linked pairs; and (3) our brains seem structured to think in the following pattern: thesis, antithesis, synthesis. That is, human minds work by universal principles, and our brains must represent both the world and our ideas of it according to certain universal patterns; variation can occur only within those constraints. All these intellectuals confidently assumed that their own European conceptual strategies and classification schemes defined a universal standard. Any deviance from that standard was used to locate the others, relative to

the Europeans (and those around the world who adopted their strategies); it certainly did not revise the standard.

Eventually, a great deal of counterevidence emerged from around the world in all three fields. The grand schemes, having been severely delimited, then often became useful to researchers. Meanwhile, all that counterevidence led to a lot of speculation about how to generate more adequate theories in the "human sciences" and about the very concept of "innate structures of mind." Of course, the idea of finite, simple, innate mental structures has a very long history in European thought. Obviously the structuralists' work was of enormous interest to people trying to model thought in computers, and much of the research on the structuralists' ideas made use of mainframe computing. Frustrations in trying to generate computer-based grammars led to major shifts among those working in artificial intelligence; three or four other approaches emerged during the early 1970s, one of which, "neural nets," eventually dominated the other approaches.

Historicizing Taxonomies and Universals: Foucault and Kuhn

During the late 1950s and the 1960s that colonialist confidence of the positivists, structuralists, and modernists became, for a few people at least, a subject of study rather than just a pervasive ethos, as it had been since the mid-nineteenth century. For example, Michel Foucault argues that during certain periods there is a consensus among intellectuals about a finite set of important topics, how to constitute an interesting question about those topics, and how to investigate the questions posed. He called these temporal clusters "epistemes." Many other intellectual historians about that time were making similar assertions; for example, in the history of science field, among others, Thomas Kuhn was developing his notion of paradigms.

Thomas S. Kuhn and Foucault do not study practices beyond the Euro-American and do not ask whether the Euro-American practices can or should be revised by contrasting practices around the world. They are able to regard the Euro-American practices of the previous hundred years as historically situated, culturally located, not universal standards free of the specific conditions of their making. It is exactly this idea that so offends many Euro-American intellectuals even today, four decades after Kuhn's and Foucault's ideas were developed. Foucault argued, as did Kuhn, that epistemes change not because the topics are exhausted or the questions solved but because the very notion of what constitutes an interesting topic, question, or mode of investigation changes,

fundamentally. Foucault also argues that the ways topics, questions, and investigations are constituted are consistent with the prevailing political and economic concerns.

I would place Foucault, Kuhn, and many of their peers at the intersection of the structuralists and the poststructuralists. Like the structuralists, they and many others working in the 1960s and 1970s still believed in the efficacy of simple, abstract models for describing and explaining human action. For example, the notion of epistemes and paradigms is not necessarily inconsistent with the structuralists' concern with innate structures of mind. However, attention shifted to a very different set of questions: (1) how are epistemes internally consistent, and (2) what leads to epistemic change? The location of Levi-Stauss's, Piaget's, and Chomsky's concerns was "mind"—whether social or individual cognition—relatively unaffected by local circumstance (historical, political, or economic). The newer questions are about the specific conditions in which our various ways of making sense develop; it is now assumed that those conditions must be known before we can successfully identify any sorts of patterns.

Foucault and Kuhn developed the core of their ideas in the late 1950s and early 1960s, and over the next three decades they each did a series of historical studies explicating them. Many other researchers have challenged these concepts, but they have proved remarkably resilient. Foucault's ideas generally have more implications that Kuhn's; to be fair, Kuhn never claimed to be discussing anything other than the history of science and was often annoyed by people applying his ideas to other domains of human action. On the other hand, the specific details of Kuhn's historical research have been far more resilient than Foucault's.

How Modern Became Retro:
Launching the History of Modernism

As I said earlier, many now agree that the period from about 1870 to about 1965 marks a coherent set of concerns among intellectuals working in the European tradition, whether in the arts, literature, science, or theater. This modernist episteme was marked by a concern with identifying universal human standards of aesthetics and logic, a preoccupation with certain aspects of the human perception of visual space and time, and a focus on individual minds as the locus of innovation. Preference was given to explanations that displayed simplicities, stabilities, uniformities, taxonomies, regularities, hierarchies, and binaries.

Jean-François Lyotard has argued that the modernist period is characterized by a preoccupation with "meta-narratives," large explanatory schemes that aim to explain everything. Examples include the work of Charles Darwin, Karl Marx, and Sigmund Freud, as well as of Levi-Strauss, Piaget, and Chomsky. The physicists' theories-of-everything also fit within the modernist episteme.

Many poststructuralists begin to concentrate on defining the specific historical, political, and economic location of the modernist fixation on universals in logic, aesthetics, and so on. In fact, many would now argue that those so-called universals were located quite specifically in European colonialism and imperialism—that these questions emerged and were defined and explicated during the modern period between the "voyages of discovery" and the "end of empire" and sponsored by dominant nation-state governments. They argue that these "universal standards" were European standards applied to the entire world; they also argue that this effort to put European standards in worldwide circulation was bound to lead to Europe being situated as the highest achievement of the so-called universal standards. In the history of science this preoccupation with universal standards obviously is linked to the nineteenth-century research emphasis on universal standards of measurement, that research activity which was strongly connected to the utility of world standards for industrial products.

At this point I would like to introduce a caveat. Just because we can locate the specific historical conditions in which certain questions emerge and tools develop for answering those questions, the questions, tools and solutions are not somehow regarded as trivial or necessarily false. Understanding the historical conditions helps us to understand why so many human resources were focused on a specific, delimited range of questions and why certain tools and solutions were strongly preferred to others. We can specify the ways that resources were allocated toward certain questions, tools, and solutions, and how other approaches did not receive resources. We can acknowledge the utility of some of the ideas while asking what other kinds of useful knowledge was not pursued.

From the Human Condition to Multiple Subjectivities

In a four-volume history of sexuality published from 1976 to 1984 (1978–1986 in English), Foucault argued that the social roles and social identities of heterosexuality and homosexuality emerged only during the modern period, specifically in mid-nineteenth century Victorian England. Before then there

were most certainly same-sex and mixed-sex acts, but he argues that there were no social roles or identities necessarily associated with those acts. In this argument he parallels gender studies research on the enormous human cultural variation in roles and identities concerned with human sexuality.

Foucault made another move: he began developing arguments that in each episteme, different forms of subjectivity are cultivated; that is, our personal sense of identity, emotions, physicality, tastes, commitments, rationality, and so on are strongly shaped by our social, political, economic, and intellectual milieu. His work, done primarily in the 1950s and 1960s, has been extremely influential, generating a huge amount of research in many countries. Obviously, Foucault's exploration of epistemic subjectivities was a direct challenge to the structuralists' commitment to innate structures of mind. It also revises the Marxist notion of class consciousness. In addition it undermines the modernist notion of "genius," as well as Freudian ideas about human emotional development. In the several decades since these ideas were first formulated, many have studied the historical conditions under which various forms of subjectivity have developed around the world. The modernist notion of a universal human condition has shifted to the multiple subjectivities that humans display.

This French research on subjectivities is very different from the older Frankfurt school approach to mass culture, which focused on the manipulation of groups of people the researchers usually saw condescendingly as working class, uneducated, and/or childlike. By contrast, many poststructuralists are concerned with how forms of subjectivity might be correlated historically with various specific forms of political economy; they are also interested in how these forms and their variants emerge in even the most sophisticated. That is, we are all a part of our times in specifiable ways.

Modernist forms of inquiry had located subjective practices in the private domain, separate from its dyadically paired complement, the public. The public domain was the site for politics, objectivity, and abstraction. Certain kinds of people (such as women and ethnic minorities) were seen as more engaged in private, domestic concerns and less capable of abstraction, objectivity, and political debate. Poststructuralists have challenged that distinction, emphasizing the study of how practices are allocated into domains labeled as public or private. Just as feminists had argued that the personal is political, poststructuralists argued that the personal is public, and vice versa.

Of course, many outside this circle of western European poststructuralists were developing related arguments; I am thinking, for example, of an influential group of American cultural historians working in California, such as Carl Schorske, with his study of the fin de siècle Viennese intellectual culture, and

Paul Robinson, with his study of the distinctively American reception to Freud's ideas. Similarly, during the 1970s many American feminists, especially anthropologists, thoroughly investigated the gender ideologies saturating the public/private distinction in both intellectual and social life. Similar studies emerged around the world, both historicizing and spatially situating modernity in Europe and its former colonies. Nonetheless, I want to emphasize in this essay that many of the influential studies marking the end of the global centrality of European modernity were also products of western Europe.

Regional Faultlines

At the zenith of European and European-inspired colonialism and imperialism, universities in the European model were established all over the world. Their purpose was not to compete with the European centers of knowledge making, but to train consumers and practitioners of that knowledge, who would send their best ideas, samples, and students to Europe for evaluation. In that way most universities outside Europe became beacons during the late nineteenth century for the message of a Euro-centered modernity. As Europe itself became less powerful, those universities located at the edge of the old empires, perhaps not surprisingly, moved to take up the responsibility of maintaining and propagating that universalist modernist message.

Those institutions, to their considerable frustration, have found their new centrality stunningly short-lived, at least in historical terms. New ideas, new modes of inquiry, new models of argument, and new classifications of knowledge have emerged outside the network of these older institutions at the edge of the old empires. I want to end this essay with an exploration of the academic ecology that began to emerge when a Euro-centered image of modernity ended. That ecology has undergone extensive changes in the last two or three decades, changes I take to be fundamental. I will focus on the situation in the United States, but comment on similar changes taking place in other countries, especially Japan.

Until the 1980s the northeastern U.S. universities and research laboratories almost completely dominated their national research and intellectual communities (as did those in Japan's Kanto region). The generation currently in leadership positions at those universities only now is becoming aware that its future does not look like its past, or the future it expected. Similar processes are at work around the world, such as in England, Norway, and Sweden, to mention but a few examples.

At the beginning of this century, northeastern U.S. universities, like Japanese universities in Kanto, commanded almost all their nation's academic research resources—funding, laboratories, universities, faculty, students—as well as all decision making about resources. They also did most of the amassing of resources. During times of expansion, in benevolence and self-interest, they did sometimes distribute some of those resources to other regions, thereby enlarging their own spheres of influence. In the decades immediately following World War II they were able to both expand and consolidate their authoritative control over their nations' university and research infrastructures. Their power was coextensive with the modernist nation-states that had supported them.

However, for reasons I will explicate below, by the 1980s those modernist universities no longer controlled the allocation of most resources and were not creating resources, and their own resources were not necessarily greater than those of many other places. By the mid-1990s new agents were finally in a position to deny key resources to these institutions. The leaders in these once-dominant regions are often only now realizing the extent of the ecological changes that have occurred during the past generation. The heirs apparent to those leaders in regions of declining influence seem also to have only recently begun to notice that the worlds they expected to inherit have actually already lost their old ecologies.

The regional shift in decision making about resources for research going on in various parts of the world is accompanied by a shift in awareness of the geography of knowledge making. The worldview of the institutions in the northeastern United States, as well as in the Kanto region in Japan, has been centered on the north Atlantic. The key geographical reference points in their map of intellectual life have been a few institutions of the northeastern United States and western Europe; every other place has been seen as peripheral to that north Atlantic sector of the world.

Until this worldview came to be powerfully challenged, it was not even recognized as being regionally and geographically defined. That is, the criteria for the focus on north Atlantic sites was seen as based on a notion of "quality" taken to be universal, much like the modernist ideas described at the beginning of this chapter. The northeast United States and the Kanto plain in Japan were not seen as regions among others, but as part of a higher class, a smaller world defined by those special universal qualities rather than by location.

Of course, this presumption has been practiced in various places around the world for at least two thousand years. The north Atlantic presumption was preceded by a London-Paris axis, which in turn had many predecessors in

western and central Europe, and before that in the Mediterranean. Tokyo's fascination with the north Atlantic is the successor to many other stories linking Japanese intellectuals to Asia; and before Tokyo was the dominant Japanese node, there were links from Kyoto, and before that from Nara, to mention but a few.

When such regions become powerful, they erase their humble origins. Synecdochically, they alone come to stand for all. For example, the history of the northeastern United States has been considered U.S. history, not a regional history; the same could be said of southeastern England, north-central France, north-central Italy, the Kanto plain, and on and on. Similarly, the accents of the middle classes from these areas came, during the age of national television broadcasting, to represent the national standard; voices from other regions were heard as dialects and accents.

The relative power of different regions in different parts of the world to make knowledge and to define what is innovative and important knowledge is changing again. As that happens, ways of viewing the world and ways of speaking about the world also change their status. What was once seen as "standard" (as "unmarked categories") now suddenly looks locked in time and place. Other areas once seen as having exotic or weird ways of being in the world come to be seen as sophisticated and worldly.

Institutions in the United States outside the northeastern region and in Japan outside the Kanto plain have long held worldviews that included other parts of the world besides the north Atlantic. One of those alternative worldviews has been focused on the Pacific Ocean, rather than the Atlantic. Demographically, politically, socially, financially, intellectually, and culturally, that view of the world is now becoming extremely powerful; it will probably become the successor to that long list of Archimedean reference points I mentioned a few paragraphs earlier. As that happens, what was once labeled exotic or highly unusual will become the new standard, and the once proper, unmarked regions, their accents, and their views of the world increasingly will be seen as quaint and "historical," suitable for cultural touring.

Before WWII Europe Is the Center of Global Knowledge Making

Until at least 1945, American universities were in a "colonial" relationship to those in Europe; Japanese universities were in that position until about 1980. That is, on average, "state-of-the-art" knowledge was produced in Europe and only read about and taught in the United States and Japan. If an American or

Japanese wanted to become a producer of knowledge and recognized as such, the person went to Europe to study and work. As resources developed in the United States, and later in Japan, it became possible for her to return home to work and still have her papers read (and perhaps published) by the Europeans because those Americans and Japanese had forged relationships there.

After World War II all that changed rather quickly for the American physical sciences, of course; the American biological and social sciences had also moved into leadership positions by the late 1950s and 1960s. The humanities in the United States only began moving out of Europe's dominating shadow in the 1980s, and the process is far from complete. For instance, American literature was first taught regularly in university English departments in the United States only during the 1970s, and teaching American literature that is not written from within European approaches is still highly contested in those departments. Similarly, specialists on western European history dominated history departments in the United States until about 1980; they now hold about one-third of faculty positions in history. Interestingly, humanities researchers in the United States are often not aware that their colleagues in the sciences have not had Europe as their singular reference point for at least one generation, and in many cases two generations—over fifty years. For Japanese universities I estimate that all these dates can be moved forward about thirty years.

Similarly, American scientists are often startled to discover that those in the humanities can still get doctoral degrees, get published, and be promoted for explicating to their American colleagues the research being done in Europe. Many first-rate European scholars in the humanities can remain uninformed about American developments in their fields. To cite a parallel situation, until the 1990s social scientists in Japan could get doctoral degrees, be published, and be promoted for explicating to their Japanese colleagues the research being done in both Europe and the United States. Leading European and American social scientists are often still comfortable not knowing anything about Japanese scholarship in their research area, although that is beginning to change in a few subfields.

To recapitulate: twenty-five to fifty years ago U.S. universities became sites for making state-of-the-art knowledge in the physical, biological, and social sciences, although the humanities have often remained consumers of knowledge made elsewhere. (Interestingly, the kind of humanities research for which Americans recently have become world famous usually concerns issues of gender, race, and ethnicity, as well as public and popular culture.) The changes that scholars in the humanities are just beginning to experience happened so long ago in the sciences that there is actually very little institutional memory

now of how Americans practiced the sciences before 1942 in their period of what I am calling "colonial dependency on Europe." There is even little memory of how recently the change happened. The gap between the sciences (physical, life, and social) and the humanities in American universities is defined, in my opinion, by the years in which the different disciplines have ended their intellectual dependence on Europe. By contrast, parallel events in Japan are discussed and debated extensively.

New Kinds of Knowledge Made by New Kinds of Researchers at New Kinds of Universities

Worldwide, the very kinds of knowledge being produced, taught, and read began to change during the post–World War II period (and again in the late 1970s, but I will return to that later). During World War II new kinds of knowledge were identified as necessary for military success. That knowledge ranged from that needed for new weapons, new defenses against new weapons, and new ways of forming citizen armies to that needed to organize large-scale operations, new ways to govern, new forms of government, and new ways for governments to communicate with its citizens. These new kinds of knowledge became the basis for new lines of inquiry, just as American universities were changing into powerful sites for producing state-of-the-art knowledge.

In fact, these revised institutions also became the leading global sites for the production of these new kinds of knowledge, especially in the physical, biological, and social sciences. Often the young men (and they were almost all men, not women) who had worked during and just after the war on the large-scale, interdisciplinary, mission-oriented projects (e.g. the Manhattan Project, operations research, and the occupation of Japan) and developed these new knowledges, as well as new strategies for making knowledge, themselves became the leaders, at a very young age, of these emerging research fields at American universities. Those fields of inquiry had barely existed, if at all, before World War II, not just in the United States, but anywhere. By 1950 those subjects were being inserted into the curricula and the old disciplines had to adapt to those subjects, rather than the other way around. The disciplines most affected were the physical sciences, engineering, economics, political science, psychology, and sociology. The professional schools—law, management, medicine, public health, and public policy—were also strongly affected.

The young people who had launched these fields of inquiry did not inherit a globally powerful research infrastructure; they built it and remained in

charge of it the rest of their careers. Since the youngest were only twenty-five to thirty-five years old in 1945, they first began to retire only in the mid-1970s, and many—now at seventy-five and older—still have a major influence on current decision making in their fields. Recall that in the United States fixed retirement ages—except for a very few occupations like airline pilots—have been illegal for about a decade.

An analogous set of changes is underway in Japan, again about thirty years after the changes in the United States. During the 1960s the central government decided to develop an array of national research institutes; it also arranged for the creation of several "research cities" where these institutes would be located. The first, a laboratory for high-energy physics, was launched in the early 1970s; there are now nearly twenty, and more are planned. At these institutes research specialties are brought together that remain completely separated in the United States, generating new inquiries. Many countries around the world are now establishing ways for government, university, and industry researchers to work together; each country's way of doing that is distinctive, as is Japan's.

During the mid-1980s some of these institutes began to pressure the government to allow them to have graduate students. Eventually, the Graduate University for Advanced Study (Sokendai) was established for that purpose; the students work both at the various institutes and at the campus in Hayama City, Kanagawa Prefecture. Sokendai now actively encourages students to do work that is at the interface of at least two institutes. However, the humanities are not represented as yet, and the biological and physical sciences are most visible. I know of no comparable institution in any other country. Sokendai is not an isolated invention: in the 1990s many Japanese universities restructured their departments into interdisciplinary programs, creating opportunities for new kinds of teaching and research collaborations. A quick glance at the Ministry of Education's website, exploring the structure of universities in Japan, reveals many interdisciplinary programs and fewer traditional programs.

Authoritative Sites for the Production of Knowledge

These new institutes and university programs are not under the control of the traditionally powerful universities in Japan. (The conventional hierarchy begins with the former imperial universities of Tokyo, Kyoto, Osaka, Nagoya, Tohoku, and Hiroshima.) During the planning stages it appeared that faculty from these schools would keep the institutes bound to the hierarchy, but that

has not happened. In several cases the international reputations of researchers now at institutes certainly exceeds that of the faculty at any university; this represents a fundamental revision of the geography of knowledge in Japan in one generation.

Universities in the northeastern United States (bounded, roughly, by Boston, Chicago, and Washington, D.C.) continued to dominate academic research in all fields during the thirty years from 1945 to 1975. That is, on average, state-of-the-art knowledge was produced in the Northeast and only read and taught about in other regions. Just as all American universities had been in a colonial relationship to the Europeans before 1945, after 1945 universities outside the northeastern United States were in a colonial relationship to the institutions in that area for a generation in the physical sciences, ending in the 1960s and 1970s. The emphasis on the Northeast continued in the biological and social sciences until the 1980s, and ended in the humanities during the 1990s.

For example, almost all of the American producers and consumers (teachers and students) of knowledge got their undergraduate and graduate education at northeastern universities. Because of that about half of all current faculty members at the "top" universities in the United States got their doctorates before 1975 in the Northeast. Many also would have spent at least the beginning of their careers believing that to be outside the Northeast was to be in exile, anxiously awaiting an invitation to return, fearing that to be outside the northeastern universities condemned them to being seen as second rate, at best. Again, this stopped first in the physical sciences, then the biological and social sciences, and is only now stopping in the humanities.

Traditional Professorate

Before exploring the changes in the American professorate over the past thirty-five years, I would like to characterize the professorate in place at the time those changes began. University faculty were generally white Protestant men from two kinds of families. In upper-class families first sons usually managed the family's assets, and second sons became military or church leaders; it was conventionally third sons who became connoisseurs of the arts, leaders of philanthropic institutions, or university faculty. In certain upper middle classes the men joined the "professions" of medicine, law, ministry (usually Episcopalian), and college faculty; they identified with their expertise and with their professional guilds.

[margin annotations: "This is interesting b/c feminist Studies almost does not exist in Schools on the east So does that mean feminist Studies in not "really" academic or are some schools In the west changing it?"]

Traditionally, those in the professions have served as advisers to those in the upper classes; for that reason the upper-class sons who became university faculty were seen as moving down the social ladder, unlike their brothers exercising leadership in churches and in the military. That is, leadership has been associated with the upper classes and expertise with the upper middle classes. This division of labor and the social groupings around leadership and expertise were globally widespread long before the Industrial Revolution. Recall, for example, the official distinctions in eighteenth-century France. Similarly, during the Tokugawa period in Japanese history (the seventeenth through the nineteenth centuries) society was divided officially into the aristocracy, the samurai, farmers, and merchants (in that order of social rank). The samurai class provided not only warriors but also other kinds of experts, such as scholars, artists, educators, and administrators.

These distinctions have existed worldwide for at least a millennium; of course, they have an even longer history in China and India. They continued all through the industrial period, and they appear to be continuing into the emerging information-based political economy. Certainly, in cultures all over the world and throughout these millennia people who do not have these social backgrounds have become aristocrats, as well as military, religious, governmental, and educational leaders; they usually have been incorporated into these existing social frameworks, rather than revising them. What is unusual about the past fifty years is the emergence of faculty with different kinds of social origins and aspirations; the frameworks have been changing.

A New Professorate Emerges circa 1975

These characteristics of the professorate in the United States first changed in 1945 due to the famous G.I. Bill of Rights, which among other provisions provided funding for college education to military veterans after World War II. Similarly, during the Allied occupation of Japan after World War II, many parts of society gained access to higher education for the first time. The rate of college attendance in the United States among men in the cohort aged eighteen to twenty-five jumped from an average of about 3 to 5 percent in the 1930s to about 15 percent in the late 1940s. It appears that the G.I. Bill of Rights veterans who became faculty were concentrated in the newer fields, especially in the physical sciences and the social sciences, just as those in Japan who were the first in their families to gain access to higher education were likely to become engineers and natural scientists.

The regional and class hierarchies of American universities began to change again around 1965, for various reasons. First, Lyndon Johnson's "Great Society" programs included funding for middle-class students to attend college, so such students did not need either family funds or scholarships to attend college. The proportion of the college-age cohort (people aged seventeen to twenty-five) who were attending college increased dramatically, from circa 15 percent in 1960 to circa 35 percent in 1975 and circa 50 percent in 1995. That funding came under increasing scrutiny by 1990, and although the system remains in place, the funds are not expanding at the earlier rates. In 1950 there were about 100,000 Japanese college students; in 1995 there were about 3.2 million representing 42.5 percent of their age cohort. After a plateau from 1975 to 1990, the numbers have been rising steadily in Japan.

Secondly, the baby boomer generation in the United States (those born 1946–64) is huge, demographically—about four times larger than the adjacent cohorts. The baby boomers were also raised in a much wider area of the United States than the previous generation. The geographical distribution of where U.S. college-age cohorts attend school shows dramatic change in this period. As this generation prepared for college, many of them had no interest in attending schools in the northeastern United States, as had most of those educated before 1965. The earliest boomers were ready for college circa 1963, and the university system expanded all over the United States to accommodate them, swelling the market for faculty enormously, especially in 1960–75. The last of the boomers finished college by the late 1980s and graduate school by the mid-1990s.

The baby boomer generation in Japan is about twenty years younger than their American counterparts. As middle school and high school students they have collectively revised Japanese pedagogies and curricula far more than their predecessors. Interestingly, a significant minority of this cohort actually has refused to go to school; another minority has routinely insulted and even assaulted the most strict disciplinarians among their teachers. Their choices in colleges and regions appear to be following patterns similar to their American counterparts. For twenty years they have been called *shinjinrui*—a derogatory term meaning "a new breed"—by their elders. In 1999 at a public ceremony in Tokyo marking Coming of Age Day for twenty-year-olds, most of the young people chatted away with their friends or on their cell phones, enraging the official speakers. The solution? Next year the event will be voluntary. Even ten years ago that would not have been discussed as a solution, but as part of the problem.

Finally, the usually expanding economies of Japan and the United States were able to support a major expansion of the university infrastructure. In the

United States this occurred especially outside the Northeast. That expansion ended circa 1975–80 with the end of the Vietnam War and the end of the post–World War II economic expansion in the United States. In about 1975 the first of the boomer generation became university faculty and researchers. This emerging cohort of faculty is quite different demographically from earlier generations of U.S. faculty vis-à-vis ethnicity, gender, region of birth, region of education, educational level of parents, occupational status of parents, and so on. The ethos of being a faculty member seems to me quite different, too.

About 1975 the expansion of the infrastructure stopped in both countries. Those in the United States seeking their first faculty and research positions after 1975 were moving into a working world very different from their teachers. Furthermore, in 1975 the university infrastructure in the United States no longer looked like that of 1950 or 1960—that is, the "best and the brightest" faculty were not necessarily in the Northeast, nor the best resources for research and teaching. Finally, it was not necessary to be in the Northeast to have access to the best resources or to become a powerful decision maker about those resources. A similar shift has begun in Japan.

Students Change, and They Change Their Majors

Changes in the professorate have been accompanied by major shifts in what kinds of knowledge undergraduates and graduate students wanted. University administrators in science and engineering claim that from 1945 to the end of the 1960s about half of all science and engineering students wanted to study some aspect of the physical sciences and their applications; during the 1970s the same proportion wanted to study computer science and electrical engineering; by the 1980s that 50 percent wanted to study biological sciences and technologies; and in the 1990s half those science and engineering students are studying environmental sciences and technologies.

There are also strong shifts among the social science students over the past fifty years: political science to organizational and cognitive psychology, then sociology and anthropology, followed by economics; the focus now is on social policy studies. Until about 1980 the other 50 percent of students could be relied upon to study the other disciplines in rather predictable patterns. This began to change about 1975.

When a large college cohort shifts its interests that strongly every decade or so, institutions must either refuse to meet the demand or be quite flexible. American universities have been flexible in accommodating these shifting

tastes among the students; European and Japanese universities have restricted access to the most popular areas of study. American university department faculties show the archaeology of these preferences by their demographic bulges: when there were many students, the departments were allowed to hire many faculty, usually at the junior ranks; when enrollments dwindled, the new faculty positions in those departments declined, but the tenured faculty remain.

The cohort reaching college in the United States now is the smallest since 1965. Except in the far West—where numbers remain strong because of migration from other parts of the country and because children of immigrants who settled in the western states are attending college in far greater numbers than expected—application and enrollments are down all over the country, especially in the Northeast. The declines in enrollments mean declines in fees paid to universities by tuition and government-subsidized student loan programs, usually on the scale of 10 to 20 percent, sometimes greater. Again, the declines in fees are affecting the universities most in the Northeast and least in the far West.

Declines in enrollments have also been accompanied by declining interest in many traditional topics of study. At the northeastern universities, which are most heavily invested in those disciplines and subfields, faculty are highly motivated not to encourage interest in new lines of inquiry: their own investment would be devalued, and they do not have the resources to hire many faculty with the new research specialties. The array of disciplines that students study in U.S. universities has begun to change, and the subfields graduate students want to pursue has begun to shift powerfully.

As we consider all these changes among students and the professorate, we should remember that every one of the changing groups I have described in this section is on campus now. These groups represent at least five academic generations: the post–World War II innovators and their protégés (who now are leading the universities), the Lyndon Johnson Great Society generation of the late 1960s, the Vietnam veterans and the returning women of the 1970s; the new wave of the children of immigrants in the 1980s; and the children of the baby boomers during the 1990s. We all know that there can be as many as five biological generations alive in a family; similarly, there are five or six academic generations studying and teaching in universities today. Those who were undergraduates in 1950 are now nearing seventy, and they are often still in leadership positions; the undergraduates of 1998 are likely to still be holding leadership positions in 2050. All these generations' concerns are being negotiated daily on our campuses.

Regional and Disciplinary Authority in Making Knowledge

At UCLA the list of interdisciplinary research "centers" is longer than the list of the traditional disciplinary departments, as is true at most highly ranked American research universities. However, the departmentally based disciplines still appear to control the definition of intellectual authority: even faculty positions funded through the centers usually require disciplinary affiliation. Many faculty firmly situated in the disciplines smugly announce to their students that very few with an interdisciplinary degree can get good jobs. They are profoundly misinformed.

Interdisciplinarity first became de rigeur in the universities during the 1950s, when "mission-oriented" research came to be lavishly funded in the sciences, as it has continued to be. Cold War sensibilities led to funding "area studies" then, too, so that the national government could be well informed about the regions of the world that might become war zones. By the 1970s these interdisciplinary centers were joined by ethnic, popular culture, STS (science, technology, and society), urban, and women's studies. The temporal centers are launched in the 1980s: medieval, Renaissance, and seventeenth- and eighteenth-century studies, along with the new centers for cultural studies. Environmental studies centers emerge in the 1990s. These interdisciplinary centers reflect fifty years' worth of research and curricular work. (Almost all historicize and investigate that old European tradition, rather than openly eulogize it.) They are supported first by the upper reaches of university administrations, donors, and private foundations. As they become more established, government funding agencies begin to support them.

The most established northeastern universities have resisted responding to these demographic and disciplinary shifts; governmental research funding agencies have resisted funding these new lines of inquiry (with the exception of funding cognitive sciences since their inception); and the older research journals and presses, mostly based in the Northeast, have resisted publishing these new researches. Where then do the resources for these new researches, researchers, and institutions emerge? Private foundations have a long history in this country of funding innovative research that addresses an emerging need in the society.

Thus over the past generation there has been a shift in fields of inquiry and in the social characteristics of faculty at universities in the United States, along with a shift in funding structures. The academic regional ecology had changed drastically by the mid-1990s; there was no longer an audience that assumed

that the dominance of universities in the Northeast was natural, appropriate, and necessary. However, many of the faculty in leadership positions in various traditional disciplines would still prefer to act as if that were the case.

Similar changes have occurred in Japan, although the crucial dates in these transitions are 1955, 1975, and 1995. The differential regional ecology of Japan had changed by the mid-1990s. There is a much smaller audience that assumes Kanto, or the Tokyo region, dominance is natural, appropriate, and necessary. However, many faculty in leadership positions in their disciplines still prefer to act as if that were so.

Further research is required to establish exactly how the kinds of knowledge being produced, taught, and read in universities began to change circa 1975. We must also ask what were the supports for new webs of relations among once peripheral sites. During the last four decades of challenges to the foundations of modernism our universities have remained structured by departments, curricula, and research specializations that are profoundly modernist. Why and how has this happened? Meanwhile, what are the strategies for the next twenty years while some currently influential leaders of once dominant disciplines in formerly powerful sites try to maintain their decaying ecologies? Can we be surprised that their protégés and followers have become fundamentalists who want to eradicate heretics?

Faultlines

At several points in this text I have used the metaphor of faultlines, the lines between tectonic plates where earthquakes are likely to happen as the plates move past each other. This geologic theory from the 1960s and 1970s is a favorite of mine, perhaps because I have spent so much of my life in Japan and California, well-known fault zones. I found myself feeling quite anxious when I lived in areas like New York City and Boston where people do not realize they are living on or near active faultlines and have made no public or private preparations for earthquakes. I began to wonder why in some places we attend to our faults, and in other places we do not. The double entendre of "faults" is present in many languages, including Japanese, French, and English, along with the multiple meanings of lines, gaps, and expectations. My essay has been about how to examine such lines, gaps, expectations, and faults in the ecologies of our minds.

Notes

There are no endnotes to this essay because I chose to use my allotted 10,000 words in the text. The interpretation presented in this essay is elaborated in a newly completed book manuscript currently entitled *Who Knows?* Those who seek references for my statements can look for that publication, or contact me by e-mail at traweek@history.ucla.edu (Since there are several other works in place or in progress using that title, I know it will be changed.) I have included here an alphabetical list of authors whose works I consider suggestive of the tale I am telling in the text. Some are emblematic of the modernity project, while others have engaged in historically locating this latest form of modernity. Avid readers will be able to tell at a glance what important texts are missing from my list, but after all, it is mine.

I am acutely aware of the parochialism of my list by almost any criterion: discipline, subfield, nationality, ethnicity, gender, region, genre, decade, and so on. I am certain that a cultural history of this particular modernity written a decade or a century from now will be far less so, as would anyone's work now written in another location than mine. Of course, that future bibliography of modernity would be just as located in a specific place, time, and practice as mine.

On modernity see the work of Michael Adas, Louis Althusser, Benedict Anderson, Arjun Appadurai, Talal Asad, Gaston Bachelard, Roland Barthes, Georges Bataille, Franz Boaz, Pierre Bourdieu, Norman O. Brown, Noam Chomsky, Rey Chow, James Clifford, Jonathan Crary, Lorraine Daston, Gilles Deleuze, Jacques Derrida, Joseph Dumit, Emile Durkheim, E. E. Evans-Pritchard, Johannes Fabian, Lewis Feuer, Paul Feyerabend, Paula Findlen, Michael M. J. Fischer, Michel Foucault, Joan Fujimura, Peter Galison, Gerald Geison, Jack Goody, Andrew Gordon, Antonio Gramsci, Félix Guattari, Donna Haraway, Sandra Harding, H. D. Harootunian, David Harvey, N. Katherine Hayles, Steven Heims, Eric Hobsbawm, Richard Hofstadter, Robin Horton, Lynn Hunt, Chung-lin Hwa, Luce Irigaray, Margaret Jacob, Martin Jay, Robert Kargon, Thomas S. Kuhn, David Landes, Bruno Latour, John Law, F. R. Leavis, Timothy Lenoir, Claude Levi-Strauss, Lucien Levy-Bruhl, Jean-François Lyotard, Donald MacKenzie, Roy MacLeod, Susan McClary, Leo Marx, Carolyn Merchant, Trinh T. Minh-ha, Masao Miyoshi, Chandra Mukerji, David Noble, Patricia O'Brien, Aiwa Ong, Roger Penrose, Jean Piaget, Andrew Pickering, Michael Piore, Theodore Porter, Mary Louise Pratt, Paul Rabinow, Peter Redfield, Nathan Reingold, Paul Robinson, Martin Rudwick, Charles Sabel, Edward Said, Marta Savigliano, Simon Schaffer, Londa Schiebinger, Carl Schorske, Samuel Schweber, James Scott, Steve Shapin, Miriam Silverberg, Knut Sorensen and Jon Sorgaard, Gayatri Chakravorty Spivak, David Spurr, Peter Stearns, Brian Stock, George Stocking, Diana Strassmann, Marilyn Strathern, Michael Taussig, E. P. Thompson, Stephen Tyler, Ulf Hannerz, Walter Vincenti, Roy Wagner, Ian Watt, Hayden White, Steven Weinberg, Raymond Williams, and Norton Wise, among others.

The data on universities, students, the professorate, and generational cohorts are taken primarily from the Japanese Ministry of Education, the U.S. National Academy of Sciences, the U.S. National Science Foundation, and the European Organization for Cooperation and Development (OECD).

Postcolonial Science, Big Science, and Landscape

Itty Abraham

As late as 1836, and convincingly, Constable was saying [Fourth Lecture at the Royal Institution]: "painting is a science, and should be pursued as an inquiry into the laws of nature. Why ... may not landscape painting be considered as a branch of natural philosophy, of which paintings are but the experiments?"

—Raymond Williams, Keywords

In a volume dedicated to science studies, why "landscape"? Clearly I don't refer here to a mode of painting, though in the genre of landscape painting we can find many traces of the project that I would like to discuss. Landscape has never been about—simply—the representation of the pristine and unspoiled, much as that may have been the ideological project of painters, photographers, and art critics alike.[1] W. J. T. Mitchell helps us isolate what I want to refer to when he notes, "Landscape might be seen more profitably as something like the 'dreamwork' of imperialism, unfolding its own movement in time and space from a central point of origin and folding back on itself to disclose both utopian fantasies of the perfected imperial prospect and fractured images of unresolved ambivalence and unsuppressed resistance."[2]

The postcolonial, as a specific moment of the modern, bears more than a few traces of the imperial. Elsewhere I have argued that producing the postcolonial as an instance of, but distinct from, modernity-as-a-Western-thing is the product of the nationalist desire to produce spaces marked by a specific set of signs, unambiguously signifying the indigenous-authentic, scientific, and up-to-date.[3] The difficulty of ever overcoming this ambiguity, I suggest, is one source of a specifically postcolonial violence. Violence is necessary in order to generate boundary conditions that allow the postcolonial modern to be

49

known "at first glance"—the utopian fantasy of the postcolonial state—yet as I will argue in this instance, the ambivalence generated by this project never quite goes away: resistance continues to haunt dreams of scientific prowess.

Mitchell reminds us of the centrality of "seeing" in the making of imperial landscapes. This is inevitably a doubled vision, at once the gaze of the masculine explorer seeing a virgin territory to be mapped and thus known, made legible and thus available for a new script, but always cycling back on itself as it inevitably encounters the signs of the irrational, defiantly natural, and discursively incommensurable.[4] Early Indian state makers took the imposition of a proper gaze very seriously. Soon after independence, the country was divided up into four zones and teams were sent off to record visually the changes that political change had wrought. The well-known photographer Sunil Janah, for example, was sent to western Bengal to document the taming of the flood-prone Damodar River through the building of the Damodar Valley Corporation. The Italian filmmaker Roberto Rossellini was even subsidized by the state to record, sympathetically it was hoped, the industrial transformation of traditional India.[5] Through the 1950s and 1960s, the state-owned Films Division of India produced miles of film stock to be culled into four-minute segments for its weekly documentaries. These films stand today as testament to the vision that was to be postcolonial India: a self-reliant, independent, virile, and above all, monumental state.

What is explicitly marginalized in these views is any sense of what was there before. Voice-overs and perspective shots stress what is to become—the spatial present is always represented as a temporal past. The visual records the yet-to-be-modern as a fitful presence; it appears as a ghostly stain on its film stock, a shifting background that never quite goes away. While John Constable may have wanted to see landscape painting as a kind of science, my purpose here, over a century and a half later, is to turn that relation around. What I want to explore in this article is a view of landscape and its cohabiting "fractured images" through the lens of one of the key constituents of the postcolonial—modern science.

Postcolonial Science

What does postcolonial science look like? Let's examine India's most recent "big science" project—the Giant Metrewave Radio Telescope (GMRT)—built near the city of Pune and completed in 1996. The telescope's worldwide website flags immediately three key signposts to help orient this artifact in relation to the performance of modern science in India.

Power. According to the National Center for Radio Astronomy, which de-signed and built this artifact, GMRT "when completed, will be the world's most *powerful* radio telescope operating in the frequency range of about 50 and 1500 MHz (megahertz)" (italics added); "the multiplication or correlation of radio signals from all the 435 possible pairs of antennas or interferometers over several hours will thus enable radio images of celestial objects to be syn-thesized with a resolution equivalent to that obtainable with a single dish 25 kilometre in diameter!"

Site. "The site for GMRT . . . was selected after an extensive search in many parts of India, considering many important criteria such as low man made radio noise, availability of good communication, industrial, educational and other infrastructure nearby, a geographic altitude sufficiently north of the geo-magnetic equator in order to have a reasonably quiet ionosphere and yet be able to observe a good part of the southern sky as well."

Design. The telescope was built to operate on this wavelength "because man-made interference is considerably lower in this part of the spectrum in India compared to the developed world," and "GMRT is a totally Indian pro-ject. The construction of 30 large dishes at a relatively small cost has been pos-sible due to an important technological breakthrough achieved by Indian Scientists and Engineers in the design of light weight, low cost dishes . . . [a breakthrough called] the SMART concept—for Stretch Mesh Attached to Rope Trusses."[6]

Each of these elements of description, taken by itself, may not seem so distinc-tive. However, when they are juxtaposed to each other, another historical and spatial form emerges. In particular, written through the fabric of the description of this telescope, through the tropes of site, design and power, is a framing of the artifact in a distinct discursive economy of postcolonial modernity.[7]

A picture emerges of a "giant" telescope that is, above all, powerful. It will be the largest of its kind, the most powerful in its class, and its equivalent would be so large (a 25-kilometer dish) that it can never be built; in short, it can be ranked against telescopes from other parts of the world and come off looking good. The GMRT is staking a claim to be at the forefront of interna-tional experimental science. Second, and less obviously, this telescope makes these claims against a feeling that countries like India do not belong at the cut-ting edge of international science, a claim that is often made in relation to the absence of major experimental facilities in the country—the sine qua non of international big science. This anxiety shows up in the need to justify why this Indian artifact belongs. Thus we are informed that other sites in the world are less suitable for this kind of telescope, that this wavelength cannot be exploited

in developed countries due to excessive amounts of "man made radio noise," that there are important discoveries to be made using this wavelength; in short, that India embodies a unique niche for this work. Finally, the telescope situates itself firmly within the tradition of postcolonial science. Building on the claims already made, the telescope further represents its distinctiveness by suggesting how utterly ingenious (smart) Indian scientists are, how special inventions (SMART) were necessary for the telescope to be built, how the country was scoured for suitable sites for the telescope, how it combines low cost and unique qualities unmatched anywhere else in the world, and most important, how indigenous the whole project is.

How did these features come to mark a particular trajectory of scientific practice in India? How do we understand the (open and unstated) anxieties of Indian scientists operating on the periphery of world science? What meaning do we give modern science when performed against the histories of political and social change in India? In what follows, I offer some answers to these questions.

Nation, Science, Modernity

Since the nineteenth century the discourses of nation and science in India have been deeply imbricated through the relay of modernity. One influential view sees this link as follows[8]: Responding to (and believing) orientalist and British colonial representations of India as a site of tradition, superstition and backwardness, bourgeois anticolonial nationalists sought the legitimacy of their claims to political self-representation through two principal modes. The first, loosely associated with Gandhi, was the inversion of negative representations of India into positive ones: thus, economic backwardness translated into a claim that capitalist industry was harmful, that tradition was a source of popular cultural and social strength, and that superstition was an alternative form of understanding the world incommensurate with modern rationality. Modern science could only be seen as Western science. Its introduction to India brought with it all the traces of its imperialist birth, and thus it had to be rejected. This was an articulation of uniqueness and singularity through the historicization of Indian knowledge about India: a knowledge that, by definition, could not be surpassed.

The second, loosely associated with Nehru, was to see in modern science and technology (the two words were coterminous) the means to escape exactly these conditions of colonial underdevelopment. Modern science brought with

it the possibility of transforming individual lives and landscapes, of overcoming the accretions of ossified habit and outdated custom, of making the country economically powerful through industrialization. In this view, if British colonialism had been made possible through their deployment of powerful technological instruments and modern techniques, then Indian futures would be liberated by exactly the same means, since—and this was critical—science and technology was a part of human patrimony, not belonging exclusively to any person or nation. This view explicitly saw India as one among many nations, saw internalist histories as all that was wrong with Indian pasts, and saw in the forms of modern rationality, science, and technology the global zeitgeist. Nehru's support for science was qualified only by one factor. It had to be science that worked for the state. This was science for national development. In the process of making the postcolonial state, these three overarching concepts—science, nation, modernity—fused into one another.

We see these dominant representations of science reappear all through the literature. One approach to science studies in India is dominated by traditional historians.[9] They have looked at the relationship of the colonial state to scientific institutions and discovered that it is not possible to generalize easily about the state's relationship to science, except to note that this relationship changed over time. The colonial state clearly used science in a number of ways, most not unexpected. Thus, from the eighteenth century onward, the techniques of science were used to further colonial domination: cadastral, trigonometric, and topographical surveys, botanical and zoological mapping exercises, were used to exploit and better control the colony. "Native" sources of science and technology like small-scale steel makers, coastal boat builders, designers of irrigation systems, agricultural habits, and artillery, were studied by the colonial power, and in some cases (most notably, battlefield rockets) these techniques were exported back to the metropole. In the nineteenth century, especially as issues of public health began to acquire greater importance, colonial scientists began to develop modern medical techniques for use in the tropics (and then to export them back home); scientific approaches were also used to improve agricultural yields, to decide what kinds of crops should be grown, and to increase the resistance to disease of important commercial crops like tea.[10] Also in the nineteenth century, as the relationship of colonial domination to knowledge began to be reflexively conceptualized, the colonial state began to identify, and in some cases eliminate, native or local sources of knowledge that seemed threatening or difficult to comprehend through contemporary codes of scientific practice. *Dais* (midwives), and *hakims* (wandering mendicants), both repositories of certain kinds of local knowledge, were particular targets of colonial surveillance.

This valuable historical work allows to see in more detail both the Nehru-
vian vision—modern science as a colonizing force—and traces of the Gand-
hian position—valuable indigenous knowledge snuffed out by marauding
outsiders. It develops an argument that sees the colonial relationship to sci-
ence as inherently instrumental and thereby prefigures the close relation be-
tween colonial scientific institutions and postcolonial systems of scientific
knowledge production. It helps us understand why the term *colonial science* is
understood primarily as a reference to applied rather than basic research, and
thereby helps us trace the origins of the presumed inferiority of the colony in
the hierarchy of knowledge production even as it points to the long history of
modern science as a transnational practice. Most important for our purpose, it
inaugurates the idea of "state scientists"—science workers whose larger pur-
pose and objectives were drawn from the imperatives of state needs.

In this body of work on "colonial science," the scientists themselves are
nearly always of European origin, with occasional reference to local assistants,
thus begging the question of race and science. The issue of race is much more
insistently a focus in another, more explicitly poststructural, stream of writing
on science in the colonial world, in two ways. The first tendency could be cate-
gorized as recuperative. Historians have searched out Indian scientists whose
work was modeled on, spoke to, and conformed with the practices of science
in Western countries.[11] From the middle of the nineteenth century onward, it
was possible to find these figures, usually working alone or with little assis-
tance, ignored and often rejected by the colonial scientific establishment but
capable of producing important results in a variety of fields. This genre of
writing has a strong affinity with other modes of colonial discourse. By identi-
fying practitioners of science who operated outside the institutions of modern
science but were comprehensible within it, a strong case could be made for an
incipient modernity of India strangled by colonial power. But already we see
ourselves drawn into a endless shuttle between science and modernity.

The other poststructural writing on science is less about scientists than it is
about race, knowledge, and the formation of the nationalist imaginary. Here
the idea of science is taken to stand in for colonial power and especially its as-
sumed underlying condition of rationality; resistance, appropriation, and
translation become the key terms in understanding the domination of other
kinds of knowledge by the authority of science, its making of a postcolonial-
to-be native elite, and the hybridities and ambivalences of ensuring that West-
ern knowledge remains authoritative in other settings.[12] The nationalist elite
represented by Nehru was deeply invested in the making of Indian modernity
according to standards accepted elsewhere: they took the idea of science and

tried to make it work for them in a number of ways. Thus the idea of science as an authoritative register filtered quickly into domains other than the explicitly anticolonial. Gyan Prakash shows how religious controversies were adjudicated in scientific terms—indeed, controversies raged over whether Hinduism could be translated into science.[13] But if culture became, again and again, the terrain over which the critical battles over the nation were being waged, modernity was the prize that was being fought over. For Indian nationalists (and cultural workers and artists) following Gandhi, it became essential to argue that there was or could be an authentic Indian modernity, to discount the anxiety that it merely mimed Western forms. Not surprisingly, whether there can be a distinctive local variant is still the fault line of many a political and cultural war today.

The problem with the deep imbrication of science and the modern in the making of the Indian nation was the double vision that was necessary to pull this legerdemain off. Science was valued (or hated) for its modernity—that was generally agreed. The idea of modernity itself, however, was not without its own problems. In the postcolonial world in particular, the modern was associated with a particular place, a place that was surely not India. The making of modern India—the nationalist project—rested on the intertwined condition of science and the modern. This provoked an inevitable anxiety: What would this do to the idea of India? The nationalist project had to be an essentialist one, it had to claim India as its teleology; that was, after all, the final demand of the anticolonial struggle. But if India was to be subsumed into the modern—a Western modern, especially—what would remain of that distinctive element, India? In short, if modernity was so closely associated with the West, what did one understand by the idea of the Indian modern? A particular practice of Indian science appeared to allow for this double vision to be sustained—to hold all these contradictions together.

Using Landscape for Science

In preindependence India, one of the leading centers of scientific research was the Tata Institute of Science (now called the Indian Institute of Science) in Bangalore, then a sleepy cantonment town in southern India. The institute had been set up in the early twentieth century with funds donated by one of the country's wealthiest capitalists, Jamshedji Naoroji Tata, with the intention of creating a center for applied work in the sciences. It was assumed the center would produce knowledge that would serve the nation. In 1933 the first Indian

Nobel Prize winner in a scientific field, C. V. Raman, was appointed the first Indian director of the institute. Raman used this opportunity to make a break with former scientific associates in Calcutta (where he had done his major work on the scattering of light and identified what is now called the Raman Effect).[14] By the early 1940s, the rift had grown to the extent that Indian physics could be said to be divided between two camps of scientists with separate academies of science and corresponding journals. The groups were regionally concentrated: Raman and his group were headquartered in Bangalore at the Indian Institute of Science, while the other group, dominated by the astrophysicist Meghnad Saha, Satyen Bose (of Bose-Einstein statistics), and others, was resident in the universities of Calcutta and Allahabad.[15]

Into this fray stepped Homi Jehangir Bhabha, a theoretical physicist based at Cambridge University. Bhabha had returned to India in 1939 to spend a holiday with his family and had been stuck there ever since due to the outbreak of World War II. In 1942, uncertain when the war would end and allow him to continue his work, Bhabha joined the Indian Institute of Science. The position he filled had been created for him. The founders of the institute were, like Bhabha, members of the small Parsi community; he was even related to them by marriage. The Dorab Tata Trust endowed a Readership in Cosmic Ray Physics to help Bhabha continue his research and gave him a generous grant to buy equipment.[16] Raman was pleased that Bhabha had come to his center, because his reputation preceded him and because he had rejected the offer of a chair of physics at Allahabad University.

Bhabha's best known work was in the theoretical modeling of cosmic ray showers, work he had done at Cambridge, independently and with Werner Heitler. Cosmic rays are streams of charged particles reaching the earth from outer space. As primary cosmic rays (mostly protons and alpha particles) meet the upper atmosphere, they collide with other nuclei and produce secondary cosmic rays consisting of protons, neutrons, mesons, electrons, and high-energy gamma rays. These particles in turn react with nuclei lower in the atmosphere, a process that continues until the initial energy of the primary cosmic ray is dissipated. These sequential showers of cosmic rays follow certain patterns of scattering; Bhabha had modeled one form of this scattering and had predicted the process would produce new elementary particles like muons.[17] For this work he would be made a Fellow of the Royal Society (U.K.) in 1942, also the year he joined the Indian Institute of Science.

The phenomenon of cosmic rays had been discovered by Victor Hess early in the twentieth century but had been named as such by Robert Millikan, the Caltech physicist. Millikan, as it happened, had delivered a series of lectures at

the Bangalore institute in 1939.[18] Millikan's visit to India was driven less b interest in that country than by a desire to study the relationship of latitude to cosmic rays. Cosmic rays, being charged particles, are affected by the earth's magnetic field. Directly above the magnetic equator, however, primary and secondary cosmic rays can be observed much closer to the ground with little interference due to the shape of the earth's magnetic field. In other words, in higher (magnetic) latitudes, observations of cosmic rays have to be carried out at much higher altitudes. Closer to the equator, the effort expended to observe these rays is much less. Bangalore lies very close to the magnetic equator (3° N).

Influenced by Millikan, on the one hand, and realizing the potential of using cosmic ray studies for the observation of new particles on the other, Bhabha began experimental observations of cosmic ray showers as some of his first work after coming to Bangalore. Due to the lack of ready-made scientific equipment in India (especially for the kind of measurement he wanted to do) and the difficulty of getting supplies from abroad during the war, his group of scientists scoured the markets and scrap metal merchants of the city, looking for material (oscillators, servomotors, triodes, and amplifiers) that could be turned to other uses. Their first experimental apparatus consisted of jerry-rigged measuring equipment, including Geiger counters, that would be sent aloft using U.S. Air Force planes stationed in Bangalore. They pioneered the use of high-altitude natural balloons and later developed their own plastic balloons to carry measuring equipment up to heights of 50,000–75,000 feet.

The onset of these experiments suggests a number of shifts. First, experimental work marked a significant move away from Bhabha's best-known work. He had always been one of the outsiders at Cambridge, a theoretical physicist where there was a pride of experimentalists. Now Bhabha was engaging directly in experimental work, expanding his repertoire of experience and expertise, and working toward providing the experimental proofs of his own theoretical work: closing a scientific circle, so to speak. Second, the experimental instruments for measuring cosmic rays—the Geiger counter instruments, measurement apparatus, and the high altitude balloons—were cobbled together using a variety of instruments and objects lying close at hand. While the apparatus was by no means successful at first run, the lack of resources had led to the need for skilful and innovative design based on the first principles of physics. The apparatus worked and provided scientifically acceptable data with repeated trials, even as it looked completely unlike more commonly used equipment and thus betrayed its hybrid origins.

Third, the experiments were predicated on a particular location. This was why Millikan had come to Bangalore in the first place. High-altitude balloon

experiments were best carried out close to the magnetic equator, where low-energy particles were screened off by the earth's magnetic field and high energy cosmic rays could be observed with less background interference.[19] Also, "the special advantages that India offered for cosmic ray work [were] the availability of a wide range of latitudes from magnetic equator in the south to 25 degree north magnetic latitude in Kashmir, [all] within the boundaries of a single country."[20] In the days before it was feasible to build large particle accelerators, observing the natural formation of high-energy cosmic ray showers proved a cheap and effective way of understanding the behavior and establishing the existence of new nuclear and subnuclear particles. For countries like India, which would never be able to afford accelerators or supercolliders of the order necessary to compete with the major Western and Japanese labs, studying cosmic rays with energies as high as 10^{20} billion electron volts (eV)—much higher energies than manmade particle accelerators can produce—gave them a unique opportunity to derive scientific results that would be credible in international scientific circles. They could do it because of their ingenuity and their location. The first signs of postcolonial science were at hand.

Bhabha did not stay in Bangalore long. He and Raman were too much alike (and too ambitious) for both to remain in the same establishment. Using family connections again and leveraging them to obtain considerable state funds, Bhabha managed to raise the resources to build a new center of physics and mathematics in Bombay, his natal city and the country's First City. The center would be called the Tata Institute of Fundamental Research (TIFR).[21] Once settled in Bombay, Bhabha would become the First Scientist of the new nation, heading the atomic energy commission, overseeing the state's science policy, and helping make decisions at the highest political level. Bhabha's importance as an unelected "science czar" has never been matched since.[22] His creation of TIFR and his careful political and financial support of it meant that in a remarkably short period of time the Indian scientific community had a new center to add to Calcutta and Bangalore.

While the Bombay scientists continued to work within the constraints of being Third World scientists, they realized they now had an important new tool to help overcome this condition. The idea that the Indian landscape could be manipulated to enable new kinds of science became a vital consideration in the work they began to do. Two examples of postcolonial science stand out in particular: neutrino detection experiments in a disused gold mine at Kolar, and the building of a radio astronomy telescope at Ooty.

Starting in the early 1950s, it was realized that going deep underground would allow the detection of neutrinos, uncharged particles of zero mass that

are created during the decay of other particles. The existence and properties of elementary particles are usually detected by the induced decay of other particles and nuclei: this is one of the functions of large accelerators.[23] Creating observatories deep underground allows high-speed neutrinos that are part of cosmic ray showers to be detected without the huge amounts of power that artificial accelerators need. Surrounding detection equipment with bedrock allows other elements of cosmic rays to be screened out, absorbed, or deflected while not disturbing the path of neutrinos, which can pass through practically anything due to their zero mass and charge. Experiments conducted at depths of up to 9,000 feet included detecting muons, determining the flux of cosmic ray neutrinos and energy spectrum of muons, and testing the expected behavior of neutrinos against actual observations.[24] The Kolar mines, never a great source of gold to begin with, had been excavated more and more intensely (and had thus grown much deeper) even as the mine operators grew increasingly doubtful of finding anything of economic value. Notwithstanding (or rather, because of) this shortcoming, the value of this manmade landscape was, for the TIFR scientists, the perfect extension of a model that would allow them to more than compensate for their location on the periphery of world science.

In the early 1960s, a group of young Indian radio astronomers based in the United States wrote to various Indian scientific agencies applying for research positions. Only TIFR responded and offered them the opportunity to start a radio astronomy center.[25] In the end, only one of the three, Govind Swarup, actually returned to India. Swarup's first major project fitted exactly the patterns we have identified above. He proposed to build a radio telescope that was "specially designed for lunar occultation observations of very distant radio galaxies."[26] Based on the well-accepted notion that the best way of determining the position and size of radio sources was through lunar occultation, but working against the constraint that the moon only scans a small part of the sky each day, TIFR radio astronomers decided to build a very large steerable telescope.

It is uncanny how close the words Swarup used to describe the Ooty telescope in 1967 are to the description of the GMRT thirty years later in the tropes of design, site, and power. The Ooty radio telescope, a 500-meter-long parabolic cylinder, was to be "placed on a hill slope having the same inclination to the horizontal as the latitude of the station. This configuration will permit tracking of radio sources for roughly 8 hours a day by a simple motion of the antenna around its mechanical axis. . . . [As a result of this design] the radio telescope [has] a collecting area equivalent to a 500 feet diameter dish and will be amongst the *most powerful in the world.* . . . This design utilizes to the maximum advantage *the location of India* which is close to the earth's geographical

equator. *The radio telescope is being constructed entirely in India*" (italics added).[27] The only difficulty was finding a hill with an angle of slope equal to its latitude. A group of scientists and assistants fanned across the Niligiri Hills in south India, and eventually found a hill meeting these criteria. Again, the Indian landscape had come to the rescue of science. Twenty years later, Swarup would be the brains behind the GMRT as well.

Professor Bernard Peters, referring to the balloon experiments, later pointed out that the research helped "to instil in young Indian scientists the confidence that in spite of innumerable obstacles such as financial stringency, lack of technical experience and lack of traditions in experimental sciences, they could by means of hard work and devotion and by means of their own ingenuity achieve scientific results of the very first order, in no way inferior to those obtained elsewhere."[28] In other words, as the idea of internationally credible self-reliant experimental science slowly became a conceptual possibility for the young physicists and mathematicians working at TIFR, their practices coincidentally provided a convenient and consistent point of entry into political debates around the national question.

The line between the laboratory and the world outside was being reformulated in a completely new way. The impact of the first cosmic ray experiments in Bangalore is not so important in scientific or personal terms as the interpretation given to the activities conducted there. What became possible was for the scientists at the Institute of Science/TIFR to construct an image of their own work that mapped perfectly onto a dominant image of nationalist thought. Laboratory practice in the scientific world was being given tangible expression in political terms—it could be seen as self-reliant, autonomous, and Indian, operating under harsh conditions of "financial stringency" and "lack of traditions," and finally, it was successful according to an objective (international) standard. So successful was this mapping that it may be legitimately asked, Who seduced whom? The laboratory in colonial India was now producing the concrete expression of the scientific state that was yet to be. The metonymic move from the laboratory to the state produced a state that could work like a laboratory—it appeared to give hard proof to the idea that all that was needed for a strong, independent postcolonial state was, in Nehru's phrase, to "make friends with science."

The double vision referred to above—the need to be modern and Indian at the same time—seems to have been finessed. The first Bangalore cosmic ray experiments, followed by Kolar neutrino detection and the Ooty radio telescope, and now the GMRT, all firmly rooted in and dependent on the Indian landscape, appear to be the epitome of an independent, national science that

was successful in international terms. But there is an irony here. In their fore-grounding of India's physical resources and geographic location as the stimu-lus to their ingenuity, the TIFR scientists could be described as performing "colonial science." If the value of the colony is read through its representation as a fecund and static entity available for scientific and explorative inquiry, was it any different for Bhabha and his group? While writing a very different script for their work, both the TIFR and the colonial scientists' scientific raw mater-ial was the same qualitative essence: their common question, What can India do for science?

"Fractured Images": Moments of Resistance

So far I have argued that a group of Indian scientists, based at the Tata Institute of Fundamental Research (TIFR) in Bombay, established a pattern of building scientific experiments and artifacts that depended upon physical features of the environment to compensate for the lack of resources relative to science con-ducted in the West. I argue that these experiments provided a means for resolv-ing one of the central contradictions of the national question, thus helping consolidate science as a key feature of a desired Indian modernity.

The Indian scientists may have been trying to establish something else en-tirely. Their eyes were fixed on the far away centers of world science, especially in physics, centers that, following World War II, moved toward a logic of prac-tice whose shorthand is "big science." As Nobel Prize–winning physicist Wolf-gang Panofsky put it, "We simply do not know how to obtain information on the most minute structure of matter (high energy physics), on the grandest scale of the universe (astronomy and cosmology), or on statistically elusive re-sults (systematic genetics) without large efforts and large tools. The evolution of technical and scientific fact has driven the changes, not a change in motiva-tion or ethics of the scientific leaders."[29]

No matter how reliable this view, it points to how a number of scientific fields changed irrevocably after the war. Not surprisingly, Indian scientists felt they could not compete on an equal financial footing with this new mode of scientific practice. But they had an additional burden to bear. The very ability of Third World scientists to do first-rate experimental science has often been questioned from another standpoint, as the following representative quota-tion makes only too vivid: "As I have seen many times, those who come from cultures far from the circle of modern Western rationalism seem to be im-pelled to plunge directly into the most profound problems of the Universe, of

Matter, or of Life, never bothering about lesser, more accessible and more practical problems."[30] But to be "practical" is not easy when what counts as useful science also demands access to expensive, highly valued, and carefully guarded "beamtimes."[31] However, this was the world the Indian scientists belonged to, and the world they wanted to be accepted as full partners of.

Natural features of India had become, willy-nilly, the silent allies of postcolonial science. Features both positive and negative, from slopes of hills, bedrock thousands of feet below the surface, to the proximity of the magnetic equator to low manmade interference, became the means by which Indian scientists would force those elsewhere to take them seriously. But in their search for more appropriate landscapes to deploy strategically, we detect another process at work. The natural features of the country they would search out were hardly ahistoric pristine forms that could be taken for granted. The gaze of the scientists seeking to give dominant meaning to the external world—making landscapes—through their experiments suffers from intense tunnel vision. For example, even as Kolar had been largely abandoned by the mine company, it was still home to lines of workers living in greatly strained circumstances in and around the site; even as the Nilgiris offered up a range of hills to choose from, it was also the home of an indigenous people, the Todas, whose opinion of a radio telescope straddling their everyday routes and lives is not recorded in the scientific minutes. Indian scientists would have us look outward to appreciate the enormous difficulties they face being accepted in the West—as scientists. However, if we turn our attention to the context in which they live and work, to the landscape they claim to represent, we see a complex social world with rules and forms of knowledge existing quite independent of science.

For example, in the official album commemorating the twenty-fifth anniversary of TIFR are a number of photographs of the Ooty radio telescope. Most are as you would imagine them: taken from a low angle facing upward, the scientific artifact-telescope filling the frame, resplendent steel and manly girders stretching over the hill into the horizon. But one of the photographs in the collection makes us look again. It is entitled, "Another View of the Ooty Radio Telescope."

We see in the foreground of the photograph, indeed nearly filling half the frame, a South Indian temple with its profusion of gods, demons, celestial animals, and other unscientific objects. To the right of the temple lies what we have been promised, the telescope, but this is a very different view of it. The telescope uneasily occupies the same frame as what it is, in the nationalist imaginary, supposed to replace. The relative size of the two objects, however, leave that conclusion very much in doubt. What is this picture doing here? If

you ask a TIFR scientist this question, the most common response will be an uncertain laugh, and perhaps the comment that in India science must live to learn with the unscientific, and that only in India is this juxtaposition possible. But that is an answer more likely to be given to the (assumed secular, skeptical, and modern) social scientist or ethnographer. Let's take another look at another landscape.

When India decided to conduct a nuclear test underground in 1974, the Atomic Energy Commission, in consultation with the Indian Army, chose a "closed area with a sparse human population," the army testing range in the Thar Desert in western India. One of the scientists described the experience:

> An unexpected bonus as we readied the site for the experiment was our discovery of the great beauty of the desert and its denizens. The Thar bubbled with life. Magnificent peacocks and small spotted deer followed us frequently but at a safe distance as if trying to figure out the meaning of our presence in their domain. The Bishnois [a nomadic group] for many centuries have acted as the guardians of the animals of the desert, in keeping with their religious beliefs and this has made the animals remarkably unafraid. . . . I do not recall anybody falling ill during that period. This must have been a result of the hygienic conditions under which we operated as also the beneficial qualities of the desert air which was clean and unpolluted.[32]

Immediately following this passage is a description of the last-minute preparations for the nuclear test and then, "right in front of us, the whole earth rose up as though Lord Hanuman had lifted it." There is no trace of irony in the text for our movement, in just a moment, from a description of an Edenic desert landscape scattered with "magnificent peacocks" and "small spotted deer" and looked after by a centuries-old community, all living in wonderful harmony in a clean and unpolluted world where illness does not happen, to a hypermodern world populated by only two species, hawks and doves, marked by nuclear explosions and radiation sickness. The author even notes that the lack of above-ground radioactivity following the test came as a surprise—"we had expected some leakage." Minutes following the test, the scientists were in their helicopter, heading for Delhi and national acclaim. When the scientist looks out of the window of the helicopter, all he sees is "the newly formed crater of Pokhran . . . still in the process of sinking." There is no further mention of the desert "bubbling with life" and its fauna, and what may have happened to them.

The "sparse" human population turns out to have another role as well. The memoir I have been quoting from also reports that the atomic scientists had had a great deal of trouble finding a suitable site for the underground test. Without much knowledge of their environment, the scientists dug holes at random, only to find water "gushing out at a comparatively shallow depth." After repeated failures to find a dry spot in the desert, they turned to local villagers to ask if they knew of "any abandoned dry wells" in the area. "An old villager took us to one such place. Once again a few days were lost in assessing the spot but eventually the old man was proved right." If there was no irony in the previous juxtaposition, the slippage in this passage, acknowledging the limited purview of modern science, is even less noticed. A once-bare landscape dotted with animals and nomads now turns out to have villagers as well. Not only that, but these villagers possess privileged local information, unavailable to the scientists and their modern measuring instruments. Where did these villagers come from? Where did they acquire their "local knowledge"? What happened to them after the test? The official narrative remains silent on these questions. All we are left with is a set of suppositions about a faraway landscape that are increasingly undone by the text. Led to expect a "closed area" with few people, we find ourselves in a world that is full of life, with its own rules of sociality girded by independent forms of knowledge. Yet when we leave this place, last seen through the window of a helicopter following a nuclear test, it may in fact have become the deserted space the scientists imagined before they arrived—a desert landscape.

Finally, if we look more carefully at the published results of TIFR balloon flights, it soon becomes apparent that not all flights were completely successful. In one summary of flight data from 1950, results of flights made include "main line gave way about 50 minutes after launching," "plates lost at sea" (twice), and "plates not recovered." Further, the results obtained by the flights were sometimes affected by extrascientific problems. One article dryly reports, "Unfortunately the [equipment] was tampered with by the finders on several occasions and developed defects on others."[33] Who were these "finders"; what were these "defects"?

Ideally, once the cosmic ray balloons reached their planned altitude, they would stop rising and drift at approximately the same height. As they did this, brass plate recorders measured "hits" of cosmic rays. Eventually the gondolas (aluminum cylinders that contained the equipment) would be released (there were a number of ways for this to happen) from the balloons and would drop by parachute down to earth, where they would be recovered. In practice, things did not always work this way. Even though the scientists had mobile teams armed with shortwave radios following the balloons, as the quotations above show, some gondolas got away.

In response to this problem, inscribed on the shiny surface of the aluminum canister was a reassuring message in English:

Do Not Be Afraid.
Reward Rs. 75/-.
This is a Scientific Instrument
Keep in Shade
Send Express Telegram to
BALLOONS
Hyderabad
Phone no. 71543

Damaged equipment suggests that some of the finders, presuming they could read what was written on the gondola, could neither afford the money to send a telegram for science, nor cared to, a 75-rupee reward notwithstanding. One imagines that other uses were seen for metal canisters and silk parachutes, that the intended purpose of such an experiment was not acknowledged.

But why should these finders be "afraid," as the message informs us? Prakash reminds us that while the response deemed appropriate for the nascent nationalist bourgeoisie when faced with the majesty and power of Western science was awe, for the colonial subaltern it was something much more akin to amusement. In his study of the colonial museum, he shows how subalterns reinscribed the codes and substance of science into other, more familiar and banal registers.[34] For the postcolonial scientists, far distant from the worldviews of peasant and subaltern, all they could imagine was that superstitious and irrational Indians would destroy their scientific equipment out of fear of the unknown. But suppose we imagine other possibilities, namely, that the "finders" were not impressed by the forms of science, that they did not see silver cans dropping out of the sky as signs of the magical or supernatural? Suppose it was not a problem of modernity as imagined by the scientists, but belonged in a purely political register? In short, perhaps these objects were indeed recognized at once—not as differently alien, but as belonging to the state rather than the people. Could "tampering" be read as a form of resistance?

These are only a few of the many scientific encounters with "India" in the archives of state science. Gradually we begin to see that these kinds of encounters—postcolonial appropriations of landscapes—were fraught with tension for the *scientists*, a tension that could rarely be expressed or admitted directly. The world of science, neatly ordered, logical and coherent, with well-known rules for success and achievement, found it exceedingly difficult to come to

terms with an India that appeared to teem with signs of the irrational and irreverent. The authority of modern science depends on it being immediately recognizable as science. But could that recognition always be counted on or follow automatically? The aporia of postcolonial science lies in the question it dare not ask: Is it true that in the last instance, science will only be known by an act of force, not understanding?

The postcolonial project sought to transform the contemporary social world in order to produce a future with naturalized signs of development and modernity. This implies that the location of the modern boundary, the line between being and becoming, was always a constraint central to the self-understanding of those within the project. This boundary was historically and socially produced, and as we have seen in these cases, it could hardly be taken for granted. The space where science's authority was paramount could not be known a priori but always had to be engendered through political force. Thus to know where this boundary was, and to keep it in place, was central to the politics of postcolonial science. At this moment, however, science is reduced to power. This is not just knowledge driven by the desire to know or the aesthetics of a good proof, but knowledge for and by a powerful state.

Big Science and Landscape

What about the term *big science*? Isn't one doing damage to historical specificity by taking an idea that belongs properly to Western science and inserting it in a frame that it is far removed from? Surely no experiments conducted in India could ever hope to match in spectacle, impact, importance, and expense what has been done at the Stanford Linear Accelerator Center, the Fermilab, the Human Genome Project, or what would have been done with the supercollider in Texas? Probably not. But there are other reasons to think of big science differently.

First, location: How differently do we see Western science when we foreground the international circuits it works through and occupies? Perhaps when we see big science in other settings, we understand better the particularity of the kinds of science we assume are the most normal forms of scientific practice. Just comparing the formation of CERN and KEK in Japan with U.S. scientific systems has done that already. Adding new cases, especially from the Third World, better understanding transnational flows of scientific equipment, students, results, and ideas, brings science studies into alignment with studies of other such flows: How different is this one?

Second, context: using the term allows us immediately to situate science in relation to the world outside. Of course Bruno Latour and his colleagues have helped us to do that already, but what "big science" always brings in its wake is the state. The use of large amounts of public funds for building science implies a discourse that must speak the language not of science but of public good. But what is that? In this world, big dams, national security, public health, and outdoing the Soviets will trump the sheer quest for knowledge every time. The close proximity of knowledge for state ends aligns science with other less admired relationships with the same properties: think of censorship and intelligence.

Finally, the difference of science. Asking questions of context must bring with it questions of boundaries. In a setting where the self-assured identity of science is not taken for granted, we can see more easily what lies between science and the outside, the processes that make science different, the rules and codes by which science makes itself distinguishable. The margins of the scientific world expose the play and power of knowledge-worlds in contention—in other words, we can learn a lot about science where it appears less developed.

The TIFR scientists seeking to transform the complexity of the world around them into a simpler register that compensates for being on the margins of the scientific world are thus participating in a practice as old as science itself. Their relationship to landscape is complex—it is both subject and object to them, it reaffirms their location(s), and through their grounded practice, science makes the nation modern. By incorporating landscape into science, they socialize nature, just as their larger project was to naturalize science.

But we cannot stop here. By going beyond science's self-representation, by asking to see what lies beyond the boundaries of science, we see, even if in partial or contingent form, its "fractured views," the consequences of its social power. The landscape made by science is not barren until represented by its codes: indeed the landscape viewed by science *depends* upon a partial view that excludes, forcefully, the living, their environment, and their historical memories. This is an unequal struggle in many respects, but more often than not it is the lived environment that forces science to accommodate itself, not the other way around.

Notes

An earlier version of this article was presented at the conference "Materializing Cultures: Science, Technology and Medicine in a Global Context," Stanford, California, May 1–3, 1998. My thanks to the participants, especially Steve Feierman, Mike Fischer, Sharon Traweek, and Gabrielle Hecht, for their support. Many thanks to Alana Rosenberg for her help with gathering this material and tracking down references.

1. See the essays in W. J. T. Mitchell, ed., *Landscape and Power* (Chicago: University of Chicago Press, 1994).

2. W. J. T. Mitchell, "Imperial Landscape," in Ibid., 10

3. Itty Abraham, *The Making of the Indian Atomic Bomb: Science, Secrecy and the Postcolonial State* (London: Zed Books, 1998), esp. chap. 1.

4. The idea of double vision is drawn from Homi K. Bhabha. See his "Interrogating Identity" in *The Location of Culture* (New York: Routledge, 1994).

5. Rossellini left the country with his Indian producer's wife. What he captured on film, however, is less impressive, never getting beyond the tradition-modernity dichotomy. See his docudrama *India* (1958).

6. All quotes from *http://www.ncra.tifr.res.in/page/gmrt/gmrt.html* (1).

7. The notion of postcolonial modernity is elaborated in Abraham, *Making of the Indian Atomic Bomb*, chap. 1.

8. Partha Chatterjee, *Nationalist Thought and the Postcolonial World: A Derivative Discourse?* (London: Zed Books, 1986).

9. For the most thorough study see Deepak Kumar, *Science and the Raj, 1857–1905* (Delhi: Oxford University Press, 1995). There is also a large body of work that deals with science in premodern India. I have chosen not to deal with that material, as my interest is in modern science and its practices. For references see Zaheer Baber, *The Science of Empire: Scientific Knowledge, Civilization, and Colonial Rule in India* (Albany, N.Y.: SUNY Press, 1996).

10. See David Arnold, *Colonizing the Body* (Berkeley and Los Angeles: University of California Press, 1993), and Daniel R. Headrick, *The Tools of Empire: Technology and European Imperialism in the Nineteenth Century* (New York: Oxford University Press, 1981). See also the references in Kumar, *Science and the Raj*.

11. A masterful example is S. Irfan Habib and Dhruv Raina, "The Introduction of Scientific Rationality into India: A Study of Master Ramachandra—Urdu Journalist, Mathematician, and Educationalist," *Annals of Science* 46 (1989): 597–610.

12. Gyan Prakash, "Science 'Gone Native' in Colonial India," *Representations* 40 (fall 1992): 153–78.

13. Gyan Prakash, "The Modern Nation's Return in the Archaic," *Critical Inquiry* 23, no. 3 (spring 1997).

14. For a longer discussion of Raman and the Rawan Effect, see Abha Sur, "Aesthetics, Authority and Control in an Indian Laboratory: The Born-Raman Controversy on Lattice Dynamics," *Isis,* forthcoming.

15. Robert Anderson, *Building Scientific Institutions in India: Saha and Bhabha* (Montreal: McGill/Queen's University Center for Developing Area Studies, 1975).

16. TIFR file, Dorab Tata Trust, Tata Archive, Bombay.

17. See H. J. Bhabha and W. Heitler, "The Passage of Fast Electrons and the Theory of Cosmic Ray Showers," *Proceedings of the Royal Society* 159A (1937), 432 ff., and "On the Penetrating Component of Cosmic Radiation," *Proceedings of the Royal Society* 164A (1938): 501 ff. See also B. V. Sreekantan, "H. J. Bhabha: His Contributions to Cosmic Ray

Physics," and Virendra Singh, "H. J. Bhabha: His Contribution to Theoretical Physics," in *Homi Jehangir Bhabha: Collected Scientific Papers,* ed. B. V. Sreekantan, Virendra Singh, and B. M. Udgaonkar (Bombay: Tata Institute of Fundamental Research, 1985), esp. xiv–xv, xxviii–xxix.

18. "Visit of Dr. R. A. Millikan to India," *Science and Culture* (Calcutta) 5, no. 7 (January 1940):413.

19. Bernard Peters, "The Primary Cosmic Radiation," Presidential Address of the Physics Section, Indian Science Congress, Agra, 1956. Reprinted in *Science and Culture* 21, no. 10 (April 1956):576–89, esp. 581.

20. B. V. Sreekantan, "H. J. Bhabha," xvi.

21. TIFR file, Dorab Tata Trust.

22. Some have come close, e.g., Vikram Sarabhai, M. G. K. Menon, Raja Ramanna, Satish Dhawan, B. D. Nag Chowdhury, and now Abdul Kalam.

23. See Sharon Traweek, *Beamtimes and Lifetimes: The World of High Energy Physicists* (Cambridge, Mass.: Harvard University Press, 1992).

24. M. G. K. Menon et al., "On the Possibility of Experiments with Natural Neutrinos Deep Underground," *Physics Letters* 5, no. 4 (15 July 1963):272–74; Menon et al., "Cosmic Ray Intensity at Great Depths and Neutrino Experiments," *Il Nuovo Cimento* 30, no. 5 (1965):1208–19; C. V. Achar et al., "The Intensity and Angular Distribution of Cosmic Rays Far Underground," *Proceedings of the Physical Society (1964),* 86, 1305–15; C. V. Achar et al., "The KGF Neutrino Experiment," Ninth Symposium on Cosmic Rays, Elementary Particles and Astrophysics, Tata Institute of Fundamental Research, Bombay, December 1965; S. Miyake et al., "Cosmic Ray Intensity Measurements Deep Underground at Depths of (800–8400) m.w.e, Il." *Nuovo Cimeto,* 32, no. 6 (1964):1505–23.

25. Anderson, *Building Scientific Institutions.*

26. Govind Swarup, "A Large Radio Telescope for Observation of the Radio Galaxies Using the Method of Lunar Occultation," Ninth Symposium on Cosmic Rays.

27. All quotes ibid.

28. Bernard Peters, "Bhabha and Cosmic Rays," *Science Reporter* (New Delhi) 3, no. 10 (October 1966):455–57

29. Wolfgang Panofsky, "SLAC and Big Science: Stanford University" in *Big Science: The Growth of Large Scale Research,* ed. Peter Galison and Bruce Hevly (Stanford, Calif.: Stanford University Press, 1992) 145.

30. This is only one of a number of similar comments that can be gleaned from autobiographies and interviews of Western scientists. Walter M. Elsasser. *Memoirs of a Physicist in the Atomic Age,* New York: Science History Publications (1978), 162.

31. Traweek, *Beamtimes and Lifetimes.*

32. This and all quotes that follow are taken from Raja Ramanna, "Pokhran," in *Years of Pilgrimage* (Delhi: Viking, 1991), 88, 90–91.

33. H. J. Taylor et al., "High Altitude Balloon Experiments and Measurement of the Heavy Primary Radiation Flux at the Geomagnetic Equator," *Proceedings of the Indian Academy of Sciences* 36, sec. A (1952):41–45.

34. Gyan Prakash, "Science 'Gone Native.' "

Transnational Genomics
Transgressing the Boundary between the "Modern/West" and the "Premodern/East"

Joan H. Fujimura

Science and technology have come to play increasingly important roles in defining the daily lives and bodies of people across the globe and the cultures and societies within which they live. A technoscientific project called the Human Genome Project (HGP), or more generally genomics, has been described by some as the most socially transforming science since the Manhattan Project produced the atomic bomb.

The term *genomics* refers to the new world that molecular genetic sciences, information sciences, and their institutional affiliates—the human genome projects in the United States, Japan, and Europe—have created. (See the appendix for a brief description of the American and Japanese projects.) This new world includes the scientific projects being conducted across the globe, the transformation of genes into commodities with major investments and high profit expectations by biotechnology companies and venture capitalists, present and potential medical applications, and social, legal, and ethical concerns about the consequences of these technologies.

In addition to dramatically changing the production of knowledge in biology, transnational genomics has begun to transform understandings of life, bodies, disease, health, illness, relatedness, identities, "nature," and "humanness," as well as the practical handling of affairs surrounding them.

These revisions, while they occur across global contexts, do not happen in the same way everywhere.

Japanese science provides a locus for studying the transnational production of knowledge. The genesis and circulation of genomic science is a multidirectional process, and Japanese scientists and publics are major participants in the production of global genomics. At the same time, they are located within a complex web of relationships that have links to a history of Japan as a country occupied militarily by the United States and maintained until today as an ally and military base in old Cold War politics. Japan also occupies a place in race and gender politics, where it has played the little brother to the American big brother, the feminine to the American masculine (Igarashi 1998; Kondo 1997). These postwar relations are also embedded in a set of Japanese discourses about prewar Japan's relations with the "West" and specifically "Western" technology.

Transnational genomics provides a site to explore the place of culture in science and the place of science in culture in terms of both the production and consumption of technoscientific knowledge.[1] In this article, I use two examples to make the following points: first, through the transformation of biology, scientists are reinventing "nature" and "culture" on the one hand, and the "East" and the "West" on the other. While some authors in science studies continue to debate the science-society, nature-culture divides, biologists have already crossed these boundaries to remake nature and culture, science and society. Although some may not necessarily accomplish exactly what they intend and others do not even know what they intend, biologists do have some power to transform nature and materiality, and they have created new notions and technologies that have already changed how people live their lives.[2]

Second, my discussion also addresses debates within (and outside) Japan on "Japanese uniqueness." This debate has taken various forms in twentieth century Japanese history. In the modern era, "Japanese culture" was represented as authentic and pure, in danger of violation by "Western" technologies. My examples demonstrate that "modernity" and "tradition" are not simple binaries. The two can exist together, each even creating the grounds for the existence of the other, especially in this period that is often called postmodernity.

Third, in the postmodern era, Japanese culture has often been represented as "robotic" by Western media and politicians, who view Japanese technological successes as threats to the supremacy of "Western modernity." Japanese genomics replays this threat to Western dominance in the examples I discuss. Nationalist rhetorics, as articulated in both Japan and the United States, sit side by side with transnational collaborations in genomics.

Fourth, I address the problem of the theoretical language we use to talk about cultural and historical practices and processes. How do we talk about science, culture, and history in ways that do not reduce their complexities, heterogeneities, and dynamisms? In discussing the aims and desires of contemporary Japanese scientists, I explore the ways in which culture and imagination become part of technoscientific and cultural production. In particular, I consider rhetoric that claims that Japanese culture makes Japan particularly attuned to the new biology. I use this account to continue the debate over the analytical reification of culture, either as a theoretical tool with which to understand the depredations of modernity, or as the hard and fast product of scientists' and others' discourses.

I continue next with a discussion of discourses on Western technology and Japanese culture in order to contextualize my respondents' understandings of Japan and transnational genomics. I then present a brief chronicle about the early days of Japanese genomics to demonstrate the nationalism and transnationalism that helped to create both the Japanese and American human genome projects. The final section focuses on the rhetorics of the East and the West in transnational genomics. I argue that cultural discourses are not an entity autonomous from the material practices and products of science and technology.

Technology, Science, and Culture in Japan

Debates about premodernity, modernity, postmodernity, and nonmodernity in Japan are intertwined with discussions of culture and technology and of Japan's relationship to the West. The premodern is often represented as a time/space when/where "Japanese culture" reigned supreme. Although technology and science were being imported from the West in the mid-nineteenth century, for example, the technologies and sciences were said to have been carefully translated through Japanese culture so as to make the foreign native and in order to allow the "Japanese self" to merge with these importations. Japanese culture is represented as the source of a firm, unshakable self-knowledge, and technology as the foreign, Western object that requires translation through culture. In this discourse, everything brought from outside becomes translated through a unique Japanese culture that differs from other cultures around the globe.

The modern period is often represented as a time when serious conflicts between modernization and Japanese culture arose. Debates about importation

of Western science and ambivalence about modernization began in the late 1800s (Harootunian 1970; Pyle 1969), although the discourse of certainty in the "inviolate" Japanese culture continues in the language of Japanese exceptionalism until circa 1910. Then Japanese intellectuals began to criticize intensively the modernization of Japan and its attendant introduction of Western knowledge and technologies during the Meiji era (1868–1912, when Japan was transformed into a modern industrialized nation-state). The critics argued that technological progress through measurable improvement of efficient production came at a price; that is, it came to take precedence over unique Japanese aesthetic and cultural forms.

According to Tetsuo Najita, this discourse criticizing modernization for its cultural pollution was embedded in an early-twentieth-century Japanese discourse of "cosmopolitanism."[3] This cosmopolitan discourse placed Japan in a larger global context, but again within a globalism informed by a notion of fixed nation-states with fixed, bounded cultures.[4] Thus, Japan was represented in this discourse as the only Asian nation to industrialize and therefore as the nation with the responsibility to other Asian nations to "clarify its cultural identity as a nation outside the ordering cultural framework shaped by 'Western' nations" (Najita 1989, 10). This discourse was framed by Japanese intellectuals like writer Natsume Soseki, who then argued that technology was overwhelming Japanese culture and producing a pervasive "nervous exhaustion" in place of social well-being and happiness. Tanizaki Junichiro argued that the knowledge accompanying Western technology—that of administrative law and modernist institutions, applied science and positivist epistemologies—produced a form of "self-colonization." The result, in their eyes, was that Western technology was transforming Japanese culture to produce a crippled personality and a crisis of culture in Japan. This crisis had to be dealt with not only for the sake of Japan but also for the sake of other Asian nations.

In the postwar period, modernization theory reversed this earlier discourse by arguing that the Meiji Revolution demonstrated the distinctiveness of Japanese culture. The argument was that Japan demonstrated its cultural exceptionalism by being the first Asian nation to achieve technological excellence and industrialization. For better or worse, Japan's early modernization was aided by "authentic Japanese values" or a "Tokugawa religious" ethic (group harmony and loyalty, individual and collective achievement) (Bellah 1985), a pattern of psychological dependence in relationships (Doi 1973, 1986), and a vertically stratified society (Nakane 1970). These values and patterns purportedly made it possible for the Japanese to be effective in the organized processes of high-growth economics. In contrast to these social scientists,

writers like Mishima Yukio and Kobayashi Hideo argued that culture was epistemologically and ethically different from the politics and technologies of modernization. They invoke the prewar discourse's notion of Japanese culture as a pure, authentic sphere to criticize the new consumer culture of high-growth economics and its accompanying bureaucracies (Ivy 1995; Pincus 1996).

Postmodernity is often discussed as an extension of the modern past, and the differences between the two are only matters of degree and quality. Here again, the main question has been whether or not rapid modernization and high-growth economics have actually helped Japanese social and cultural life; never mind whether it has helped Western social and cultural life, as Miyoshi and Harootunian (1993) point out. Or have they instead created a homogenized and harried consumer culture with few intellectual or social benefits? Are the Japanese people better off, happier? And what are the interests of the State in this postmodern period? Are its interests and actions in line with the social well-being of its constituents?

Recent studies of Japan have begun to question and complicate these early representations of Japanese culture and the Japanese self.[5] These studies interrogate how what is called Japanese culture has been and is being constituted, reconstituted, deconstructed, and challenged. They critique the earlier literature on the Japanese self as yet another example of orientalism.[6] In contrast to both premodern and modern discourses, these histories and ethnographies discuss the local, located, and contingent courses of events, actions, and practices rather than static generalizations about Japanese social, cultural, and identity categories.[7]

At the same time, the earlier representation of "Western" science imposing its frames of knowledge on "authentic" "Eastern" culture in these debates about Japanese modernity is recapitulated in some recent social and cultural studies of science. Some critics have represented genomics as an English-dominated, European and North American–framed and oriented project that is increasingly becoming globally distributed. Non-Euro-Americans are said to participate in this project either through adopting its methods, practices, and theoretical frames or through their roles as research objects and testing sites for theories, methods, and products generated in Euro-America. I examine this assumption through an analysis of the Japanese human genome project and argue in contrast that the genesis and circulation of genomic science is a multidirectional process. My study instead argues that West and East, both sciences and cultures, are being (re)constituted by scientists and nonscientists involved in genomic sciences.

This historical set of discourses is the context within which I analyze the following two cases of scientific imagination and entrepreneurship in Japan.

In one case, culture never appears in the discussions of science and nation. In the second case, nation and culture are made synonymous by my respondent, who strategically uses the notion of culture to do particular kinds of work. In so doing, he simultaneously constitutes his representation of Japanese and Western cultures, but in broad brush strokes.

Building the Japanese Human Genome Project: Early Days

Although the American Human Genome Initiative is often spoken of as the beginning of genomics, its birth was in part an outcome of a transnational effort by Akiyoshi Wada, a Japanese scientist and then a professor at Tokyo University, to promote interest in and raise funds for building DNA sequencing machines.[8] In 1981, a few years before James Watson's version of the American human genome project was conceived, Wada was appointed chairman of a project on the "extraction, analysis, and synthesis of DNA," a project supported by the Japanese Science and Technology Agency (STA).[9] The project was meant to reduce the tedium of biological wet lab research and to engage support from companies involved in the development of robotics, electronics, computers, and material science (Wada 1987; Wada and Soeda 1986). Wada's idea was to automate existing protocols used in sequencing DNA in molecular biology rather than invent entirely new approaches. According to his testimony, he was not thinking of a human genome project at that time, even though he did at times talk about sequencing the whole human genome with his machines. He was interested in building machines that automated DNA analysis including, for example, machines for separation, sequencing, and frame reading, robotics for chemical reactions, and informatics hardware and software tools. His idea was that these machines should be assembled together to facilitate scientific production in a manner similar to the factory production of automobiles. That is, these machines would work together in a big factory that could sequence millions of nucleotides every day. Wada did manage to convince several companies to join his team. Seiko, Fuji Photo, Toyo Soda, Hitachi, and Mitsui Knowledge Industries joined in the effort.

In 1986 Wada decided to promote an international DNA sequencing effort in an attempt to consolidate international support for his project. In Japan *gaiatsu* is an established strategy where foreign support is generated in order to encourage internal support for a project, often a project that requires changes in established ways of doing things.[10] Wada's goal was to goad the Japanese government to support both his project and basic science through pressure

from foreign countries. The Japanese government, specifically the Ministry of Finance, had been relatively conservative about funding basic science projects of all kinds, and most of the technological developments in Japan had come from private industrial funding.

In late 1986 Wada traveled to the United States to help move his international DNA sequencing project forward. At that time, a national coordinated effort to map and sequence the human genome was just beginning to be discussed by members of the National Institutes of Health (NIH), the Department of Energy (DOE), and the now defunct Office of Technology Assessment (OTA).[11] Wada visited these organizations and several national laboratories in the United States, including the Los Alamos National Laboratory, where the American major genome database GenBank was then located. He states that his intention was to promote collaborations between American and Japanese scientists, especially at a time when trade and economic tensions were very high between the two countries.

Instead of using Wada's efforts to promote an international project, U.S. scientists and technocrats (including biologist James Watson, biologist Walter Gilbert, Senator Pete Domenici, and Congressman David Orey) used it to promote a national project. Domenici and Orey used Wada's efforts in the context of international trade competition to argue that the United States had to create its own genome project in order to compete with Japan and that Japan already had a five-year lead on the United States. At a time when the Japanese economy was booming due in part to sales of Japanese products in the United States and when Japanese monies were being used to purchase property there, American rhetoric about this scientific project transformed it into yet another assault on America's self-image as the dominant power. As policy analyst Robert Cook-Degan (1994, 218) puts it,

> American perceptions of the Japanese genome project as a biotechnological Trojan horse—a premeditated assault on one of the remaining bastions of U.S. preeminence—were grounded more in loose historical analogies with automobile manufacture and electronics than in direct observation of the policy process. The Japanese genome program as a scientific effort was largely the result of [Japanese] scientists aspiring to join the international ranks. Industrial partners were, at least in the opening phase, more reluctant participants than instigators. The genome program was more a dream of what Japanese science could become than a cornerstone in some grand economic plan.

Genomic science then became another arena of national competition in the rhetorics and practices of American and Japanese technocrats and politicians.

And these nation-states became strategic arenas for scientific entrepreneurs to promote their projects. Science is politics by other means (Latour 1987).

But in the Wada story, neither nation raised the concept of culture or cultural differences in their discussion of genome science. For them, genomic science was modern science whether in Japan, the United States, or Europe. Genomics was not culturally inflected or implicated in these early discussions.

In the next example, by contrast, culture and cultural differences are brought in and woven into discussions of national programs of genomic sciences.

Building the Japanese Human Genome Project: The 1990s

Professor "Suhara" (a pseudonym), a leading molecular biologist in Japan, has been instrumental in making the Japanese human genome project a reality. Suhara was very influential in convincing the ministry to fund this research and in constructing the project in its present form. Many of the researchers I spoke with in Japan call him "Mr. Molecular Biology."

Suhara envisioned the genome project as more than the investigation of human genes. For him, it also represented the installation of a new science for twenty-first-century Japan. In his view, Japanese biological laboratories were not well integrated into information networks with laboratories and international databases in the United States and Europe. One of Suhara's primary missions was to create an infrastructure of such "thick lines" of communication, which he accomplished in the first phase of the genome project (1991–96).

Suhara believed that genome informatics, that is, biology by using computing technologies, would soon become the "second standing point" of biology. Traditional, or wet lab, biology would decrease in importance in comparison. With this in mind, he and his colleagues created a separate institutional and budgetary structure to fund genome informatics and computational genome analysis as a prominent feature of the Japanese genome project. In contrast, wet lab molecular genetics had taken precedence over bioinformatics early in the American human genome project.

Suhara's rationale was based on national competition as well as "scientific progress." At the beginning of the 1970s, a time when molecular biology was becoming firmly established as the "new biology" in the United States and Europe, Japanese biologists were not interested. In Suhara's estimation, this lack of an early investment in wet lab molecular biology had left Japan behind the United States in the field, and he worried that the same situation would repeat

itself in the new era of genome informatics. Thus, in 1990 Suhara planned and argued for Japanese genomics to focus more resources on genome informatics, a field in which Japanese and American bioinformaticians were beginning at about the same level of investment, expertise, and experience relative to their national budgets and personnel.[12]

Due to Suhara's efforts, the Japanese project was planned with specific reference to, and in direct competition with, the American project. The desire to establish Japan in a competitive position vis-à-vis the United States was part of the plan of their science, and computer bioinformatics was regarded as the place where Japan could make its mark. In contrast, bioinformatics in the United States has had to fight for its place as something more than a "handmaiden" (according to respondents) to wet lab biology (Fujimura 1998).

This national competition was steeped in some of the terms of the technology and culture debates that I discussed above. Japan has achieved at least equality with the United States in the realm of information technology. Indeed, in David Morley and Kevin Robins's (1995) chapter "Techno-Orientalism: Japan Panic," Japan has become known as the most machine-loving country in the world. Beyond the automobile industry, Japan has also excelled in the production of robotics, imaging techniques, cybernetics, artificial intelligence, and simulation technologies like virtual reality. But technology has been a key symbol in "Western" modernity since the Industrial Revolution. Thus, Japan's technological power, and especially its information technology, is represented by American and European media as a threat to Western modernity, to its notion of Western superiority, and to the very boundary that has stood between the "premodern/East" and the "modern/West."

Morley and Robins argue that American and European media have responded to this threat with an ingenious twist of "Western" Orientalism. In "Western" Orientalism, "Japan" has now become like a robot controlled by technology, while Euro-America has maintained its humanism in the face of increasing technology. Here then battles among national identities return us to the early-nineteenth-century debates about superiority and cultural integrity. In Euro-American media representations, the "West" maintains its cultural integrity in the face of increasing technological development, while "Japan" has lost its humanity and soul to technology. Were they to be reincarnated and exposed to this rhetoric, Japanese intellectuals of the early twentieth century would have had their worst fears confirmed. But Suhara, as we shall see, turns this argument on its head by reconstituting the nature/culture and the East/West binaries.

A Discursive Production of the "East" and the "West" and "Nature" and "Culture"

In explaining the significance of the human genome project, Suhara produced a fascinating narrative about the "East" and the "West" as well as about "nature" and "culture":

> The most interesting [aspect] of the human genome project . . . is in helping to understand life, helping to understand what man is. We are collecting huge amounts of information on the genome which is the record of our history, and similarly, records of the histories of plants, animals, fish and insects. We'll be able to understand our past history by analyzing genomes. . . .
>
> The important [thing] in the Human Genome Project is that the concept of humans will slowly be changed as we understand more about the histories written in the human genome. I think people will share a sense [of our place in nature] and forget about human dignity. Too much stress has been placed on human dignity [in the West]. It's much easier for us [in Japan] to accept [man's place in nature] because we have not been brought up under the influence of Christianity. Most Japanese are either Buddhist or Shinto, and they have a much wider view of all living things. They don't put man as the representative of God to be placed above all the other living things. This attitude is very firmly imprinted during our childhood.
>
> [The Japanese have a] much cooler concept of man. We look at man as one [among other] living creatures. By slowly changing the concept of life, I think . . . our attitudes toward technology [and toward] making use of the human genome project will be slowly changed, particularly in Asian countries where the majority of people are not living under the influence of Christianity or [Islam], but under the influence of Buddhism or Confucius or Shinto.
>
> Everybody's bound to the contract [with one God] in the Christian community. You don't have to change this [Christian] social contract. But you do have to get better views on what man is by taking the flow of information from the human genome project and extend the thought on evolution to man, that a man is a result of a process of nature, has very close ties with other living things, and has to live together [with them] on earth. Culture plays the most important role in accepting evolution and the life of man among other lives.

The discipline of anthropology has been caught in a whirlwind of controversy over its central organizing concept, culture. The notion of culture

has been criticized, articulated, rearticulated, rejected, defended, and embraced. In contrast to these agonistic struggles, Suhara produces a clear definition of culture: it is a set of values imprinted in our early years which then governs how we act in the world. Religious differences between "Eastern" and "Western" cultures explain why the "Christian/West" values humans above other animals. He then uses his notions of East and West as resources to criticize Western actions and attitudes and to promote his view of "Asian" values and attitudes, which he in turn used and uses to promote genomics research in Japan.

Suhara subverts the Orientalist trope where tradition and religion are attributes of the "premodern Orient," while science and modernity are attributed to the "modern Occident." In Suhara's rhetoric, there is no Western and Eastern science. Instead, there is only science. It is not science that is the problem in the West, it is culture. Its culture does not allow the West to benefit from the fruits of its own technologies. Indeed, culture and science are in direct conflict and contradiction in the West.

Suhara's rhetoric is that the West will eventually have to change its concept of humans and other animals when more is known through genomics. He predicts a (re)turn to nature/immanence in the more animistic sense of a Buddhism that has been heavily influenced by Shinto.[13] Although Suhara is interested in the potential medical payoffs and products proclaimed by many American technocrats as *their* reason for promoting genomics, his rhetoric engages more the potential transformation of Western cultural values.

Unlike early-twentieth-century critics of the Meiji adoption of Western technologies, Suhara does not see the adoption of molecular biological technologies as an adoption of Western cultural views. Indeed, in his view, these technologies are resisted in the West precisely because they (or at least their rhetorics) threaten to impose evolutionary biological knowledge over what he calls "cultural knowledge."

Suhara appeals to a view of "the Japanese" as sharing a common culture steeped in a Buddhism and a Shinto that are, in his perspective, radically different from Christianity. This notion reminds me of Marilyn Ivy's (1995) work on nostalgic appeals to premodernity that make up discourses in some quarters of Japan on cultural purity and identity. Ivy examines the spaces in Japan where efforts to distinguish the nation-state "Japan," the people "the Japanese," and "Japanese culture" from "the West" and "the rest" take on the form of nostalgia, of appeals to "the Japan" of "premodernity" (Nihonjin-ron literature, cf. Befu 1993). But in fact Ivy insists that Japan and the West (Euro-America) are coevally or coincidentally modern. The one is implicated in the other. The

nostalgic literature or Nihonjin-ron discourses of cultural purity and unique-ness then contradict the realities of multiple border crossings and transna-tional interchanges in trade, fashion, and science.

Ivy's argument is that particular discourses in Japan are currently repre-senting modernity, defined as foreign intrusion, as the threat to a (re)con-structed Japanese cultural purity and identity. But Suhara's rhetoric argues that modern science in fact is congruent with what he calls traditional Japan-ese cultural values and that these "traditional Asian" values are critical to the success of science. Indeed, in Suhara's rhetoric, Japan and Asia will become the leaders of a modernity that is based on religious and scientific understandings that show the "Christian West" to be premodern, irrational, and "traditional." (Japan is the current leader in East Asia in genomics, and Suhara uses Japan to stand in for the "East."[14])

Ironically, this transformation will happen because of molecular genetic technologies first developed in the West. The ability to develop cutting-edge technologies that will, in his eyes, be instrumental to this transformation was developed in a culture that will change as a result of the cutting-edge knowl-edge that it produced. Genomics knowledge will make Western culture consis-tent with Asian culture and sensibilities; "Christianity will have difficulties in changing the concept [of man] in the near future when we know about the basic structure of the human genome, but still, that time will come."

Although Suhara's notion of culture appears at first to be very undertheo-rized, he uses it in a very strategic way to weave a representation that reinvents the West as the place of tradition and the East as the forefront of a scientific modernity. In contrast to the discourses discussed in Ivy's work, Suhara is pro-moting modernity through nostalgia; that is, he uses tropes that Ivy would call "traditionally Japanese"—Buddhism, Shinto, and their attendant views of nature—to promote Japanese science and modernity. Tradition and moder-nity are not binaries for Suhara (or for Ivy). Suhara is making a distinction be-tween Japan and the West not for purposes of maintaining Japanese "Otherness," a Japanese national and cultural identity, but instead to build what he considers to be a new, better, more progressive, more scientific moder-nity in the East and the West. Suhara's rhetoric is part of a larger discourse where Japan is transgressing the borderline between the "modern/West" and the "premodern/East." Thus, while Ivy's account helps us to understand the production of authenticity as a reaction to the depredations of modernity in contemporary Japan, Suhara's rhetoric uses this authenticity to promote the emblem of modernity, that is, science.

Conclusions

My purpose here has been to use respondents' accounts of culture, science, and technology to think through issues of modernity, tradition, nationalism, and transnationalism.

Nationalism is alive and well in both American and Japanese genome projects. However, these examples show how genomic science is simultaneously transnational and national. It is transnational in its global flow of ideas, information, materials, protocols and practices, and people.[15] It is transnational because entrepreneurs from each nation used other nations to promote their own projects, and in the shape that each national project took as each developed in relationship with and contradistinction to the others.

Genomic science is also transnational in terms of the efforts of biologists who, through technology, are redefining culture and nature in quite interventionist fashions. Scientific objects, technologies, and practices are both producers of society and culture and products of culture and society. They are transformative in ways that are not predetermined or predictable by cultural location. Transnational genomics have already changed medical decisions on the parts of doctors and their "clients" in Japan, the United States and elsewhere. Science in Japan is not Japanese science, it is transnational science. Similarly, transnational genomic sciences owe part of their existence to actions that were locally based in Japan.

Debates in Japan have centered for over a century on whether or not Japan could import Western sciences and technologies and their material objects and practices without importing their attendant epistemologies and administrative structures, which have been regarded as constituting "Western culture." Could "Japanese culture" retain its integrity? These debates assumed that there was and is an essential, bounded Japanese culture that would be violated by Western ideas. This discourse also assumed a desire to maintain Japanese culture as it had been conceived by these intellectuals in conversation with each other.

I argue that "culture" is not an entity autonomous from materialities. Assuming that changing a culture is a negative outcome, those who worried about the dangers to Japanese culture in early-twentieth-century discourses about modernization were correct to be worried. Materialities, among many other things, do change cultures.[16] And cultures change materialities. However, I want to interrogate their concept of an autonomous Japanese culture that could be corrupted by materialities adopted from elsewhere. In contrast, I prefer to use the notion of culture to refer to specific practices located in

space and time. For me, culture is both a heuristic device for discussing local and global actions and movements and a concept that is being continuously produced through actions and discourses about these actions.

In the examples discussed in this article, imaginaries, meanings and understandings of the East and the West, of culture and nature, of science and society shape and are being shaped by the people and practices engaged in genomics research. "Culture" in these examples is at once a rhetorical device in international competitions and a set of discourses and practices being shaped by genomics practitioners and visionaries. Suhara's rhetoric, for example, plays into the history of debates on culture and technology in Japan. He uses ideas and arguments that have been made at various points in history and combines them in new ways to produce his vision for genomics in Japan and the world. His rhetoric has been useful to him in attracting support for the Japanese human genome project. Genomic science is clearly in conversation with other cultural discourses, contemporary and historical.

My discussion of transnational science then does not assume two distinct, closed systems within their (also assumed closed) cultural contexts that somehow meet and combine or intersect. It does not assume that either science is so different from each other or that each has its own distinctive coherence and rationality. Instead, I see in my investigations Japanese sciences that are the results of the weaving of particular strategies and practices.

Taking seriously Appadurai's admonishment that fantasy is a social practice, I argue that it is critical that we pay attention to these practices of scientists as social actors and the worlds they are imagining.

> Fantasy is now a social practice, it enters . . . into the fabrication of social lives for many people in many societies. . . . This is not a cheerful observation, intended to imply that the world is now a happier place with more "choices" (in the utilitarian sense) for more people, and with more mobility and more happy endings. (Appadurai 1991, 198)

Suhara and other scientists are participating in rebuilding culture and society and not just in the practice of a limited view of science. Genomic scientists are building maps of genomes, national identities, and notions of culture. Although one could argue that genomic maps are first-order products and notions of national identities and culture are by-products, it may be that second-order effects are greater than those of first-order products—or that first- and second-order effects are inseparable. Social and cultural organization may not be first-order objects of the everyday practice of scientists, but they are clearly

tools manipulated in their efforts to produce genomes and other such "scientific" knowledge.[17] Both their manipulation of these tools and their specifically "scientific" products have consequences for the constitution of society and culture. Politicians, political philosophers, sociologists, and anthropologists may mark their territories and themselves as the makers and keepers of society and culture, but sciences and technologies have already demonstrated their powers in (re)making culture and society.

New technologies and their accompanying rhetorics are dramatically changing our lives. Change happens on location and involves many other actors, events, and contingencies. Given this, what is the best theoretical language for us to use to talk about the complexity on the ground? How do we talk analytically about science and culture in useful ways? How do we conceptualize the relationship between scientific practice and its rhetorical invocation of culture? Additionally, assuming that we do not want to give up on the notion of culture, what are the terms for usefully discussing culture?

This article attempts to provide several answers to these questions. First, it attempts to analyze culture and science in terms of located practices. This does not mean that one examines only particularity. Scientific practices rely on flows of knowledge, protocols, people, and materials that demand adaptation to particular local situations. At the same time, scientific protocol itself demands that knowledge be uncodable as "Western," or any other denomination. It demands that it be "universal." It is critical then that we examine the historical and transnational interweaving, cross-cutting conversations that are part of producing local and transnational genomics.

The issue is complicated further by scientists who, in their first-order practices, invoke cultural explanations to intervene at specific times and places in the practice of science. After examining how different actors, events, and historical contingencies together constitute science and society in different instances, I argue that the assignment, assertion, or denial of cultural categories can be studied as part of the production of social and cultural order and conflict.

APPENDIX

The Human Genome Projects

The human genome projects (HGP) have as one of their stated goals to map and sequence the entire human genome—twenty-three pairs of chromosomes (an estimated 3 billion base pairs of DNA) that are a part of every human cell. The HGP has become a convenient focal point for discussions about human genetics and its medical applications as they have developed over the last decade and will continue to develop in the years to come. Prominent figures in American molecular biology have argued for the importance of the HGP as a foundation for progress in biology and medicine. The news media headline the almost weekly reports of "discoveries" of genes for conditions ranging from cystic fibrosis, colon and breast cancers, and heart disease to schizophrenia, alcoholism, homosexuality, television watching, and divorce. While recognizing the potential value of knowing which gene or genes are involved in the initiation and development of conditions such as cystic fibrosis, many social scientists and medical and bioethicists have apprehensions about much of the Human Genome Projects. These concerns range across a spectrum: the privacy of information, the efficacy of genetic screening, the social impact of this information (e.g. discrimination in health and life insurance provisions, in employment, in marriage, and so on), the "geneticization" of social and behavioral "disorders," the constitution of new definitions of disease and health, and the geneticization of "normal" behaviors.

The American Human Genome Initiative

The American Human Genome Initiative was authorized by Congress in 1990 and institutionalized in and funded through the National Institutes of Health (NIH) and the Department of Energy. It is administered through the NIH's National Center for Human Genome Research, currently under the direction of Francis Collins (successor to James Watson). The HGP, by contrast, has been an ongoing effort since the late 1970s involving many scientists, public institutions, private corporations, and national governments to fund and carry out the research of mapping and sequencing human genes, and to develop the basic tools and materials of molecular biological research.

The American project focused its first five years on constructing maps (genetic and physical) of the genome and on finding genes for diseases. We are now into the second five years (1995–2000) of the initiative, in which the focus is on genes for behaviors and on sequencing the genome .

Japanese Genome Projects

The Japanese genome projects are on a much smaller scale than those in the United States or Europe. There are at least five genome projects in Japan, each begun by a different ministry. Japanese ministries are on the order of departments in the American federal government; they are organized into a top-down fashion, and each ministry is highly competitive with other ministries. Thus, when Wada succeeded in convincing the Science and Technology Agency to fund his research on automated DNA sequencers, the other ministries decided that they too needed to build genome projects. The largest project on the human genome is funded and organized by Monbusho (the Ministry of Education, Sport, and Culture). The Ministry of Agriculture has also funded a rice genome project. The Ministry of Health and Human Welfare (Koseisho) began a project later at their National Cancer Institute, focusing on human genes. MITI (the Ministry of International Trade and Industry) is reorganizing its quality control office into a large-scale DNA sequencing laboratory.

The Monbusho Human Genome Center is located in Tokyo. However, Monbusho's human genome project is a much larger entity, with researchers and facilities distributed in universities throughout Japan. The second five-year stage of the project began in 1996.

Besides physical and genetic linkage mapping, structural analysis, cDNA cloning and mapping, and sequencing, a separate program has been set up on computational and informational aspects of biology in both the first and second five-year plans. What is called "genome informatics" has received a substantial portion of human genome funds in Japan.

Bioinformatics

One way to represent genomics is to talk about the transformation of biology into an information science. While this process has been going on for a while, bioinformatics is now happening at a speed and scale unprecedented in the life sciences. Through the major efforts that have been put into the HGP, we now

have and will continue to collect such a large volume of information about gene and protein sequences and their functions that no one can make sense of this information without the use of computers, large databases, particular organizational structures of databases, and different kinds of software for creating and understanding relationships between bits/bytes of information. Genes are represented in computer displays by strings of G, C, T, A's—abbreviations that stand in for amino acids—while some more contextual information about the cell is also included. So genomic knowledge is now stored as strings of letters in databases accessed through computerized information networks crisscrossing the globe. In addition to this sequence information, one can also access physical and genetic map representations that locate particular gene sequences on particular chromosomes. Also available in databases is similar information for the fruit fly, *Drosophila*, the worm, *C. elegans*, the mouse, yeast, and a few other species. Some databases are private and debates ensue today about commercial ownership and uses of genetic information databases.

Notes

1. This article takes from a larger project that uses social and cultural studies of science to address issues of transnationalism, culture, modernity, and multisited ethnography. I am using science as both my ethnographic and historical object and as a site to study how meaning, culture, and nature are produced. My specific scientific object is transnational genomics and especially genome informatics/genome information knowledge and technologies.

2. For example, some women who have been diagnosed as "carrying" BRCA1 or BRCA2 genes, which are thought to cause breast cancer, have chosen to undergo bilateral mastectomies.

3. This discourse has been repeated in recent decades using the language of internationalization.

4. In contrast, recent work in anthropology, history, and cultural studies has argued that culture is not synonymous with nation-state (e.g. Gupta and Ferguson 1992).

5. These include Field 1993; Fujii 1989; Fujitani 1996, 1998; Ivy 1995; Kondo 1990; Morris-Suzuki 1994; Ohnuki-Tierney 1993; Sakai 1997; Tanaka 1993; Traweek 1992; Vlastos 1998; and Yoneyama 1995.

6. See especially Kondo 1990; Ivy 1995; and Sakai 1997; see also Said 1979.

7. These anthropologies and histories of Japan are being used by some anthropologists to reformulate the organization of area studies.

8. Wada's family has been steeped in the scientific establishment in Japan for generations (Cook-Degan 1994, 213–14).

9. James Watson, together with Francis Crick, won the Nobel Prize for their work proposing a double-helix structure of DNA.

10. *Gai* is "foreign" or "outside," *atsu* is taken from *atsuryoku*, or pressure.

11. 1986 was the pivotal year in the United States for discussions of a proposal to organize a coordinated effort. A meeting was held at the Santa Fe Institute in March 1986, and a debate at the Cold Spring Harbor Laboratories in May, and only thereafter did the effort speed up (Cook-Degan 1994; Fortun 1993).

12. See Fujimura 1998 on bioinformatics in the human genome projects.

13. See Ketelaar 1990 on the conflicts between Buddhism and Shinto in Japan. Through this process, Buddhism transformed into a more immanent view of spirituality.

14. At the time Suhara said this, Japanese newspapers were debating whether the Japanese government should apologize and pay some retribution to the Korean women who were used to "service" Japanese soldiers during their occupation of Korea. When we step outside of Suhara's laboratory, his image of Japanese culture as noninvasive and harmonious becomes a beautiful but problematic neo-japonesque dream. It may still be possible that a human genome project could change the concept of life in Asian countries, but will it happen if Japanese genomics is initiator? Suhara's vision of a transnational Asian modernity may run into trouble when faced with the history of Japanese nationalist incursions into East and South Asia.

15. Wada, for instance, studied protein structure in the United States in Paul Doty's laboratory at Harvard University from 1954 to 1956.

16. A vivid example of these two-way (many-way?) transformations is Donna Haraway's (1997) chapter on the historical transformations of kinship categories in the twentieth-century United States. See especially her charts on pages 219–29.

17. For example, see Duster 1999 on the forensic use of race categories as defined in FBI crime statistics in the design of experiments and production of molecular genetic and neurological "data" on violence in the African-American community. By using socially defined race categories to produce genetic identifiers, hematology studies of antigen reactions by race, and neurological accounts of propensities toward violence, biologists are both producing the molecular genetics of racialized identification and reproducing or confirming the construction of African Americans as a biologically defined racial category—while simultaneously denying that race has any legitimacy as a category in biological science.

Works Cited

Appadurai, Arjun. 1996. *Modernity at Large: Cultural Dimensions of Globalization.* Minneapolis: University of Minnesota Press.

Befu, Harumi. 1993. "Nationalism and Nihonjinron." In *Cultural Nationalism in East Asia: Representation and Identity,* edited by Harumi Befu, University of California Institute of East Asian Studies Research Papers and Policy Studies, no. 39, 107–35. Berkeley and Los Angeles: University of California Press.

Bellah, Robert. 1985. *Tokugawa Religion: The Cultural Roots of Modern Japan.* New York: The Free Press.

Clifford, James. 1997. *Routes: Travel and Translation in the Late Twentieth Century.* Cambridge, Mass.: Harvard University Press.

Cook-Degan, Robert. 1994. *The Gene Wars: Science, Politics, and the Human Genome.* New York: W. W. Norton.

Doi, Takeo. 1973. *The Anatomy of Dependence.* Tokyo: Kodansha.

———. 1986. *The Anatomy of Self.* Tokyo: Kodansha.

Duster, Troy. 1999. "The Premature and Ill-Conceived Burial of Race in Science." Paper presented at the Wenner-Gren Symposium on Anthropology in the Age of Genetics: Practice, Discourse, Critique, Teresopolis, Brazil, June 1999.

Field, Norma. 1993. *In the Realm of a Dying Emperor: Japan at Century's End.* New York: Vintage Books.

Fortun, Michael. 1993. "Mapping and Making Genes and Histories: The Genomics Project in the United States, 1980-1990." Ph.D. diss., Harvard University.

Fujii, James A. 1989. "Contesting the Meiji Subject: Soseki's 'Neko' Reconsidered ('I Am a Cat')." *Harvard Journal of Asiatic Studies,* 49, no. 2 (December):553–75.

Fujimura, Joan H. 1998. "The Practices and Politics of Producing Meaning in the Human Genome Project." *Sociology of Science Yearbook* 19, no. 1:49–87.

Fujitani, Takashi. 1996. *Splendid Monarch: Power and Pageantry in Modern Japan.* Berkeley and Los Angeles: University of California Press.

———. 1998. "Minshushi as Critique of Orientalist Knowledges." *Positions* 6, no. 2 (fall):303–22.

Gupta, Akhil, and James Ferguson. 1992. "Beyond 'Culture': Space, Identity, and the Politics of Difference." *Cultural Anthropology* 7:6–23.

Haraway, Donna. 1997. *Modest_Witness@Second_Millennium_FemaleMan©_Meets_Oncomouse™: Feminism and Technoscience.* New York: Routledge.

Harootunian, H. D. 1970. *Toward Restoration: The Growth of Political Consciousness in Tokugawa Japan.* Berkeley and Los Angeles: University of California Press.

Igarashi, Yoshikuni. 1998. "The Bomb, Hirohito, and History: The Foundational Narrative of United States-Japan Postwar Relations." *Positions* 6, no. 2 (fall): 261–302.

Ivy, Marilyn. 1995. *Discourses of the Vanishing: Modernity, Phantasm, Japan.* Chicago: University of Chicago Press.

Ketelaar, James Edward. 1990. *Of Heretics and Martyrs in Meiji Japan: Buddhism and Its Persecution.* Princeton, N.J.: Princeton University Press.

Kondo, Dorinne K. 1997. *About Face: Performing Race in Fashion and Theater.* New York: Routledge.

———. 1990. *Crafting Selves: Power, Gender, and Discourses of Identity in a Japanese Workplace.* Chicago: University of Chicago Press.

Latour, Bruno. 1987. *Science in Action: How to Follow Scientists and Engineers through Society.* Cambridge, Mass.: Harvard University Press.

Miyoshi, Masao, and H. D. Harootunian. 1989. Introduction to *Postmodernism and Japan*, edited by Miyoshi and Harootunian, vii–xx. Durham, N.C.: Duke University Press.

———, eds. *Japan in the World.* 1993. Durham, N.C.: Duke University Press.

Morley, David, and Kevin Robins. 1995. *Spaces of Identity: Global Media, Electronic Landscapes and Cultural Boundaries.* London: Routledge.

Morris-Suzuki, Tessa. 1994. *The Technological Transformation of Japan: From the Seventeenth to the Twenty-first Century.* Cambridge, England: Cambridge University Press.

———. 1995. "The Invention and Reinvention of 'Japanese Culture.' " *Journal of Asian Studies* 54, no. 3 (August): 759–81.

Najita, Tetsuo. 1989. On Culture and Technology in Postmodern Japan." In *Postmodernism and Japan,* edited by Masao Miyoshi and H. D. Harootunian, 3–20. Durham, N.C.: Duke University Press.

Nakane, Chie. 1970. *Japanese Society.* Berkeley and Los Angeles: University of California Press.

Ohnuki-Tierney, Emiko. 1993. *Rice as Self: Japanese Identities through Time.* Princeton, N.J.: Princeton University Press.

Pincus, Leslie. 1996. *Authenticating Culture in Imperial Japan: Kuki Shuzo and the Rise of National Aesthetics.* Berkeley and Los Angeles: University of California Press.

Pyle, Kenneth B. 1969. The *New Generation in Meiji Japan: Problems of Cultural Identity, 1885–1895.* Stanford, Calif.: Stanford University Press.

Said, Edward. 1979. *Orientalism.* New York: Vintage.

Sakai, Naoki. 1997. *Translation and Subjectivity: On "Japan" and Cultural Nationalism.* Minneapolis: University of Minnesota Press.

Shapin, Steve, and Simon Schaffer. 1985. *Leviathan and the Air-Pump: Hobbes, Boyle and the Experimental Life.* Princeton, N.J.: Princeton University Press.

Tanaka, Stefan. 1993. *Japan's Orient: Rendering Pasts into History.* Berkeley and Los Angeles: University of California Press.

Traweek, Sharon. 1988. *Beamtimes and Lifetimes: The World of High Energy Physicists.* Cambridge, Mass.: Harvard University Press.

———. 1992. "Border Crossings: Narrative Strategies in Science Studies and among Physicists in Tsukuba Science City, Japan." In *Science as Practice and Culture,* edited by Andrew Pickering. Chicago: University of Chicago Press.

Vlastos, Stephen, ed. 1998. *Mirror of Modernity: Invented Traditions of Modern Japan.* Berkeley and Los Angeles: University of California Press.

Wada, Akiyoshi. 1987. "Automated High-Speed DNA Sequencing." *Nature* 325 (26 February): 771–72.

Wada, A., and E. Soeda. 1986. "Strategy for Building an Automatic and High Speed DNA-Sequencing System." In *Proceedings of the 4th Congress of the Federation of Asian and Oceanic Biochemists*, 1–16. London: Cambridge University Press.

Yoneyama, Lisa. 1995. "Memory Matters—Hiroshima's Korean Atom Bomb Memorial and the Politics of Ethnicity." *Public Culture* 7, no. 3:499–527.

Wonder Woman and Her Disciplinary Powers

The Queer Intersection of Scientific Authority and Mass Culture

Molly Rhodes

Searching High and Low: Introducing Wonder Woman

A commercial medium often assumed to exist solely for a juvenile and "low-brow" audience, comic books have been largely ignored by academic scholarship. There are some exceptions within the fields of American studies—for instance, the work of Thomas Inge—popular culture studies, where writers gather in a Comic Arts subdivision of the Popular Culture Association, and cultural studies, with work by writers such as British author Martin Barker. But most contemporary scholars working in the history of science, technology, and medicine would probably not expect an argument that U.S. comic books have a place within the twentieth-century history of science, technology, and medicine. Nevertheless, they do; and one comic in particular, *Wonder Woman*, will show us how. One of seven U.S. comic books to enjoy continuous publication since the medium's 1940s inception, *Wonder Woman*'s monthly stories presently are distributed by the media conglomerate DC Comics/Time Warner. The comic sells in every English-speaking nation and is translated for export to numerous countries, including Japan, Indonesia, Spain, Mexico, France, and Germany. In addition to "her" comic book appearances, this amazon body floats globally throughout commodity culture in commercial tie-ins

and Internet subcultures—graphic novels, children's games, records, costumes, makeup kits, refrigerator magnets, place mats, plastic cups, coffee mugs, T-shirts, caps, posters, action figures, dolls, and reruns of a 1970s syndicated television series starring Lynda Carter, all of which are lovingly detailed in fan e-mail news groups and websites dedicated to the superhero sister of Superman and Batman. The "mass" of *Wonder Woman*'s textual body in this postmodern era is indeed amazing, and attests to a hegemonic status.

Feminist historians Elaine Tyler May and Susan Faludi have both glossed this amazon's power as part of the "Rosie the Riveter" phenomenon—the U.S. government's instrumental use of popular culture during World War II, the re-shaping of dominant American gender paradigms to place women into wartime industries. Even a cursory glance at the amazon's stars-and-stripes uniform in the 1940s comic confirms Tyler May and Faludi's readings, rein-forced by the periodic War Bond ads placed at the end of stories as well as by the heroine's mythic purpose. Wonder Woman, amazon princess Diana, is summoned by Aphrodite and Athena to help defeat Nazis, to "help save Amer-ica—the last stronghold of *freedom* and *democracy!*" (Sensation Comics no. 6, "Summons to Paradise," 1). However clear the instrumentally patriotic nature of this text, the kind of cultural power embodied by *Wonder Woman* is not femininity created only for World War II. The comic-book heroine is also pro-pelled by powerful discourses of science, reform, and sexuality. Traces of Won-der Woman's early discursive build persist within the first production period of the comic, 1941–48, and become evident when reading her "Amazing Ama-zon Adventures" alongside some equally striking scientific writings by her offi-cial creator, Dr. William Moulton Marston, a Harvard-educated lawyer with a Ph.D. in psychology. Scripted with Marston's neurologically based theories of emotion, *Wonder Woman* emerged within a surprising national network of academic intellectuals, reform ideologies, science, and mass culture, a network focused not on what kind of cultural objects would further a short-term na-tional war effort, but on the long-term resolution of national social ills through new forms of cultural literacy.

In short, the 1941 amazon heroine is sent off to war not just with evil Nazis but to be an agent in a culture war *within* the United States. Marston's scien-tific writings and published commentary on *Wonder Woman* by his U.S. intel-lectual contemporaries—Cleanth Brooks, Robert Heilman, Walter Ong, and Fredric Wertham—show that this amazon body is not simply a figure of "American" cultural hegemony, but in fact is tied to and part of an historically complicated debate about what cultural forms should be upheld as U.S. hege-monic norms. Not coincidentally, this debate specifically delimits these norms

for and through female sexuality, norms that are defined through scientific and moral discourses of reform. Within the writings of Brooks, Heilman, Ong, and Wertham, Wonder Woman's mass cultural amazon body both disturbs and marks norms of sexuality and gender roles as pivotal for their varied schemes of national cultural health, as "she" is charted within larger discourses of science, education, moral behavior, and criminology.

Uncovering this lively site of interchange, I will first locate Marston and his scientific writings within a larger U.S. intellectual and scientific landscape before turning to his theories as inscribed onto the pages of *Wonder Woman*. Within those theories we will find formations that both challenge and rein-scribe a normative construction of U.S. gender and sexuality. The specifics of Marston's revisions and challenges to those norms come into relief when jux-taposed to the readings of *Wonder Woman* generated by his intellectual con-temporaries, who heatedly engage what I call Marston's "deviant science." "Deviance" here should not be understood as a negative social quality as it has been represented in earlier twentieth-century U.S. sociological and psycholog-ical writing, but as a term reclaimed by contemporary queer theory. Method-ological terms such as "deviant historiography" and "perverse presentatism" have been offered by contemporary queer feminist scholars who are develop-ing a new history of sexuality by examining the medical and scientific dis-courses that permeate the twentieth century.[1] I close my essay with the question of the lesbian subject within the 1940s *Wonder Woman*, as the amazon is surrounded both by Marston's deviant science and by more theoretically fa-miliar models of psychoanalysis. Noting a complementary agenda for cultural studies of science, technology, and medicine and for queer theory because of science and medicine's pervasive presence in modern sexuality, I argue for the treatment and instrumental use of contemporary theory within a larger trajec-tory of intellectual and cultural history, and emphasize that an interdiscipli-nary cultural history of psychology is crucial for the advancement of our knowledge of modern sexuality.

Wonder Woman's "Creation" in the Disciplinary Networkings of Dr. Marston

In William Marston's case, normalizings of feminine sexuality may initially seem quite deviant for us as contemporary readers, as they prescribe the "lov-ing submission" of all subjects to a female figure who closely resembles a dom-inatrix—she who induces "passions" through her own emotional state of

"captivation." Marston's emphasis in his scientific work and in *Wonder Woman* on "normal emotion" through the "emotional re-education" performed by Amazonian captivators may seem decidedly unhegemonic, as the forms of sexuality that are emphasized and normalized have little to do with a domestic, familial structure centered on heterosexual reproduction. But Marston's post–World War I emergence as both scientist and mass-culturel producer occurs within ongoing white middle class bids for the expansion and preservation of American capitalism, what Donna Haraway (1989) has called "the therapeutics of labor: human engineering" (61). Through the advice of different kinds of scientific and social experts, therapeutic engineering sought to eliminate social conflict, secure the national welfare, and advance "Western" civilization. With this explicit reform agenda, the work of these experts often crossed scientific work with new popular culture forms. While these links are now being explored in cultural studies work on science, technology, and medicine,[2] earlier readings of mass culture or science often missed the intersections that have existed between academic science, political reform movements, the history of sexuality, and mass-culturel productions, links that Marston's career represents so well. Instead, if these realms were treated at all, they were presumed to be divided, subsumed within what Andrew Ross identified in *No Respect* (1989) as "the historically fractious relationship between intellectuals and popular culture" (5). However, Marston's instrumental involvement in science and mass culture indicates a relationship historically different from that claimed by Ross.[3]

As a mid-century scientist, scholar, writer, and entrepreneur, Marston's intellectual productions are quite astounding. His career as a writer ended with *Wonder Woman*, which he was writing when he died in 1947 of cancer after bouts with polio, but it began at Harvard University in the early 1900s in the psychology laboratory set up by William James. At Harvard his focus on subjectivity and the body developed through his coursework on philosophy, criminology, education, and theories of emotion. His army service during World War I enabled him to refine polygraph techniques that would be the first to be used in a U.S. trial and involved him in the psychological "rehabilitation" of returning combat veterans.[4] His emphasis on gender evolved both while he was working at the Bedford Hills Clinic, a mental hospital run by the progressive Edith Spaulding, who pioneered the experimental cottage-based women's prison, and also while he taught and ran psychology experiments with the women students at Radcliffe—including Elizabeth Holloway, a master's student who became his wife and intellectual partner. After she finished her M.A. in psychology and they both completed law degrees, they coauthored a 700-

page textbook with C. D. King called *Integrative Psychology*. After finishing his Ph.D. in psychology, Marston worked for the National Committee on Mental Hygiene, studying school children in New York City and prison inmates in Texas. Between 1917 and 1934 he published twelve scholarly articles and books on lie detection, color theory, and emotion. Simultaneous with this academic work, both Dr. and Mrs. Marston immersed themselves in emerging popular texts, she in editing for *McCall's* and *The Encyclopaedia Britannica*, and he in writing an entire oeuvre of "lowbrow" literature, including hundreds of articles for the Hearst newspaper and magazine syndicate, two popular psychology texts—*Try Living* (1934) and *March On!* (1941)—advising readers how to be happy, a novel entitled *Venus with Us: A Tale of the Caesar* (1932), a book with screenplay writer Walter Pitkin on how to generate "healthy and appealing screenplays" called *The Art of Sound Pictures*, numerous mystery novels authored under different pen names, a book giving a nostalgic look at vaudeville, and, of course, seven years of the *Wonder Woman* comic book scripts.

With such a diverse résumé, we might wonder about Marston's academic status while he adventured in all these popular forms. His writing circulated as wholly legitimate academic science, having the weight behind it of a Harvard-trained Ph.D. licensed to practice and teach law and psychology, which he did at a number of universities, including New York University, Columbia University, the University of Southern California, and American University. *The Emotions of Normal People* was published in England and the United States in 1928 as part of a prestigious series of texts edited by British psychologist C. K. Ogden, called the International Library of Philosophy and Scientific Mind. This series places Marston's text in the company of prominent twentieth-century intellectuals such as Wittgenstein, Piaget, Adler, Hulme, and I. A. Richards.[5] *The Emotions of Normal People* establishes his theory of emotional normalcy as dependent on the presence of a captivating female, theory that thirteen years later he directly inscribed into *Wonder Woman*.

Amazonian Contests: Prescribed Normalcy Deviance through the Female "Sex" in The Emotions of Normal People

Marston himself linked his progressive-era science and World War II amazon in an article he called "Why 100,000,000 Americans Read Comics," published in the 1945 winter edition of the *American Scholar*. Here he declares that his first involvement with comic books was as an academically authorized "emotional re-educator," "acting in the role of the reformer . . . retained as a consult-

ing psychologist by comics publishers to analyze the current shortcomings of monthly picture magazines and recommend improvements" (8). *Wonder Woman* was a direct result of those "recommended improvements." Marston narrates how he persuaded comics publisher M. C. Gaines to try putting out a comic with a female superhero, and highlights his view that gender reconstructed through mass culture is the key site for social reform: "It seemed to me, from a psychological angle, that the comics' worst offense was their bloodcurdling masculinity" (8). Marston suggests the comics revise their gender paradigms for both male and female readers:[6] "It's sissified according to exclusively masculine rules to be tender, loving, affectionate and alluring. 'Aw, that's girl stuff!' snorts our young comics reader. 'Who wants to be a girl?' And that's the point; not even girls want to be girls so long as our feminine archetype lacks force, strength, power" (8). He concludes that the solution for this situation is *Wonder Woman*: "Women's strong qualities have become despised because of their weak ones. The obvious remedy is to create a feminine character with all the strength of a Superman plus all the allure of a good and beautiful woman"(8–9).

Wonder Woman's superpowers, however, are inspired as much by Marston's progressive-era psychological work as by the "bloodcurdling masculinity" of 1940s comics. In fact, for Marston it is the former that makes the latter visible. His 1928 scientific tract *The Emotions of Normal People* outlines a theory of the body called "the psychonic theory of consciousness" that highlights the role of sexuality in achieving his view of potential American cultural prowess. Calling for what he names the "love leadership" of women, Marston writes in his conclusion,

> Women have already undertaken participation in public life, though not yet with satisfactory results, at least in America. It should be an important part of the emotional re-educator's constructive programme for women to offer emotional analysis of existing political and social methods and procedures. (396)

Explicitly advocating an agenda of social reform, this "emotional re-educator's constructive programme" marshals particular forms of what we now call queer sexuality,[7] forms centered around the emotions of "captivations and "passion" engendered by female "love leadership." These sexualizing emotions are grounded not in a binary of masculine/feminine and homo/hetero identity, but are explicitly bound to the amazon body, and the powers and pleasures offered by that body's disciplinary realm. Marston elaborates on the powers of bondage performed by women in his outline of the constitution of normal emotional states through the "psychonic theory of consciousness." The

psychonic theory of consciousness stems from neurology, sketching out a relation between neurons and consciousness. Marston argues that consciousness can be physically located in the energy generated between two neurons firing, a space he calls the psychon. The psychon is impacted by another bodily force, called "motation," the body's sense of moving through physical space. Combined, these two forces generate different sorts of emotions, "simple" and "complex." It is in his explanation of the complex "love emotions" passion and captivation that Marston offers up the powers of the female body for emotional—and therefore social—normalcy. This normalcy rests in the successful management of what he defines as "simple emotions"—dominance, submission, inducement, and compliance—that embody potential reactions to or an assertion of power. The psychonic theory of consciousness rests upon the principle that the human organism must learn how to manage power relations without experiencing abnormal emotions. Marston writes in his introduction, "I do not regard you as a 'normal person,' emotionally when you are suffering from fear, rage, pain, shock, desire to deceive, or any other emotional state whatsoever containing turmoil and conflict" (1–2). States of passion and captivation forestall the generation of these abnormal emotions.

This position is counter to many schools of thought contemporary with Marston, especially behaviorism, which normalizes fear and pain as primary stimulus motivators; psychoanalysis, in its scripting of anxiety and fear as the central and regular forces in the psychic life of the unconscious; modernist theories that normalize suffering as part of the human condition; and also Marxist plans for revolution that see turmoil and conflict as necessarily part of the working-class seizure of the modes of production. In line with other "upbeat" liberal U.S. progressives like his friend Teddy Roosevelt, Marston wants people to be happy. His bid for the truth value of his work is explicitly grounded in an offering of normalizing pleasure to the modern world. As he says in the introduction to his 1930 popular psychology text *Try Living*, people should "Live, Love, Laugh and be Happy!" (1).

A scientific alignment between happiness and love is forged in Marston's formulation of the "love emotions," captivation and passion. Captivation is a force of domination, while passion stems from desires to submit to a dominator. Marston instructs that these two "complex love emotions" are only mistakenly confused and are distinct: captivation "is the active, attracting aspect," while passion indicates "a longing to be subjected" (1930, 103). These emotions affect both body and soul, manifesting physical and psychic sexual attractions. Captivation is "normally" feminine: "We have also observed that the human female organism possesses a double physiological love endowment, capable of

building up both active and passive love emotion patterns" (1928, 356). The male body apparently lacks this "doubleness," and is "normally" equipped only for "submission." Marston hereby comes up with a scientific normalization of the dominatrix, a fairly deviant move for him to make within a progressive-era field dominated by an international eugenics.[8] The dominant strain of U.S. psychology until after World War II, eugenics strongly condemned any forms of nonreproductive sex and specifically diagnosed bondage as perverse, anti-social sadomasochistic sexuality. An attractively lurid example of such condemnation comes from the pages of Dr. Maurice Chideckel's popular 1938 psychology text *Female Sex Perversion, the Sexually Aberrated Woman as She Really Is*, published by the New York Eugenist Society. Chideckel announces in chapter 24, "Sadism in Women: A Most Abnormal Perversion," that "sadism is a most unnatural perversion in woman because of her inherent passivity," except "for women schoolteachers or policewomen," for whom "sadism is a very common perversity" (169–70).

But for Marston the eugenist's exception is the rule, as the results of some of his fieldwork with college students (1928, 306–9) attest.[9] Placed in the "Love" chapter, the chart inventories answers to such questions as "Enjoys being subjected by sophomores? Enjoys subjecting freshmen? Submits to man or woman? Choice of unhappy master (M) or happy slave (S)?" and makes no negative judgments of "perversion." If there were any remaining doubt about the "queerness" of Marston's model of the "normal emotions" captivation and passion, we need only read his concluding comments on "emotional re-education," which sounds like a call to abandon what we now call the closet:

> The only practical emotional re-education consists in teaching people that there is a norm of psycho-neural behavior, not dependent in any way on what their neighbors are doing, or upon what they think their neighbors want them to do. People must be taught to love parts of themselves, which they have come to regard as abnormal. (1928, 391)

In Marston's therapeutic scene, the open sexualization of "normal people" is necessary, is normal, and requires the promotion of a physiological understanding of the body/subjectivity. Instead of spoken truths in a confessional psychoanalytic session, we have diagrams of the space between nerve endings, prescriptions of physical activity, and the patient's self-discovery of her/his own bodily pleasures. Pleasures and desires that have been closeted are revealed not so that they may then be redirected into a "normal" familial libidinal economy, but so that the patient understands they are "completely normal." Marston

makes clear that the body in need of a "cure" is the social body, which creates the need for "re-education" in the first place.

This instruction occurs gradually through the "love leadership" of the progressive era's New Woman, who provides "emotional re-education," a redefining of normalcy for patients, shifting their self-concept away from social givens and toward her body. Marston proposes an understanding of the body as made up of impulses of dominance and submission that, if acted out with love instead of fear, rage, or deception, will grant them "normalcy." The individual body is understood to also be the social body, as Marston calls for the "love leadership" in the social world to bring about the "emotional re-education" of all. His progressive-era construction configures sexuality with political, liberal reformist aims to counter the claim that women have "inherent passivity." Through *Wonder Woman* Marston circulates this scientific reform project into an expanding wartime arena of mass culture.

Reforming Amazons and "Captivating" Femininity

Reading *Wonder Woman* in light of Marston's theories, we quickly see that his scripting of the amazon body is organized around his science of "normal" subjectivity. In the comic book narratives, this progressive science normalizes otherwise "deviant" forms of sexuality for its juvenile audience, as the amazons enact "the Laws of Aphrodite." The inscription of the principles of captivation and passion explains the dynamic most frequently noted in *Wonder Woman* by contemporary comic book historians Ron Goulart and Michael Fleisher, namely a prevailing appearance of bondage and torture scenes. Wonder Woman is forever being tied up, bound with ropes and chains, and tortured, as well as rescuing other women from the same scenarios with her famous golden lasso. Elongated panels frequently display an amazon in chains, showing her straining against bondage. This sexualized display is built into a kind of amazonian discipline. To assert her role as captivator, she must break ropes, straps, or chains placed on her body by a villain. The women on Paradise Island in fact undergo vigorous physical and psychic training to resist the restraining domination by another, and wear heavy metal bracelets at all times to maintain an amazon body.

The force of captivation, however, comes from more than the brute strength of domination that allows the breaking of chains and escape from torture scenes. "Loving submission" to Aphrodite is essential, as the chains of female power rise up to the Olympian clouds. She is the ultimate "love leader," according to the

comic, and inspires her subjects to perform "emotional re-education" in her name. Goddess of love—not of female reproductive powers—Aphrodite reigns supreme over all Amazons, though she is usually invisible, a symbolic presence through gifts of power granted to the Amazons, including immortality, protection from Hercules, Mars, and other patriarchs, Queen Hippolyte's super-strength-giving magic girdle, and Wonder Woman's truth-inducing magic golden lasso. In return the women of Paradise Island must follow her "love leadership" by obeying her laws, which technically prohibit the presence of men on Paradise Island and explicitly forbid any submission or marriage of an amazon to a man. Amazons serve Aphrodite as her agents, enlisted in a struggle against the god of war, Mars, for the possession of human souls in "Man's World" and throughout the universe, spreading an ethic of love via the "normal" relations of dominance and submission.

As the comic constructs Aphroditic captivation and teaches "love leadership," it regularly delivers a passionate male suitor for Wonder Woman, Air Force Col. Steve Trevor. Because Wonder Woman is attracted to Steve but prohibited by amazon law from marrying him, their interaction is a continuous source for Marston's play with amazonian femininity, "Man's World" masculinity, dominance, and submission. A 1945 story line (published in Sensation Comics No. 46) entitled "The Law Breaker's League" directly illustrates this play. In this episode, Steve is granted special psychic-physical powers through the present of a magic orb held by a criminal redhead named Ferva Shayne. Echoing Marston's neurologically based psychonic theory of consciousness, the magic orb magnifies brain waves sent to muscles in one's body, rendering Steve stronger than our amazon heroine. Ferva believes that if Steve is physically stronger than Wonder Woman, he can finally exercise dominance over her, compelling her to marry him. Ferva rather strikingly informs her villain Rodriguez Callabos that old-fashioned domesticity is the only possible way Wonder Woman can be subdued:

> Wonder Woman is our real menace. Nobody can kill that wench, but Trevor can subdue her! Once she marries him the mighty Amazon'll become a meek housewife who will never bother us. If Trevor becomes stronger than Wonder Woman, she'll go ga-ga over him and stay at home as he commands. (5)

Steve unwittingly follows Ferva's plot, accepting the new powers and exerting physical dominance over Wonder Woman. He picks her up and twirls her around, declaring, "Now I can boss you around, ha ha!!" (7). Wonder Woman responds with ambivalence, telling him, "No man can boss an Amazon," while

secretly thinking to herself, "But Steve's new strength is thrilling!" Steve increases his physical hold, grabs her wrists, and says, "Whenever I asked you to marry me, you've always brushed me off. This time I'll make you listen." (8). The amazon replies, "So this is what it feels like to be bossed by a strong man." In a close-up of her face, she contemplates this new dynamic: "Some girls love to have a man stronger than they are to make them do things. Do I like it? I don't know—it's sort of thrilling. But isn't it more fun to make the man obey?" By the close of the narrative, Wonder Woman refuses domestication and reasserts her amazonian status as dominant, as captivator. When Steve says, "I'll release more brain energy into my muscles—then you'll marry me," she responds, "No, I won't, Steve—I've discovered that I can never love a dominant man who's stronger than I am!" (12). As a proper masculine role model, Steve then submits to her "love leadership" and breaks the magic orb over his head while declaring, "If you prefer me weaker than you, to heck with this gadget!"

Other narratives outline the proper, "normal" relations of women among themselves, echoing the "inter-class College Girl Survey" from Marston's "Love" chapter in The Emotions of Normal People. Part of a "normal" woman's feminine cultivation of captivation also involves a submission to a female captivator. She has to know what passion feels like before she can induce it in someone else. As agents of Aphrodite, the amazons—and especially Wonder Woman—transmit their "Laws of Aphrodite" to other women, both by acting as "love leaders" and by training these other women to be "love leaders" themselves. This feminine bonding takes place in any location where Wonder Woman may travel, but it is explicitly configured in two exclusively female spaces that resonate as progressive-era scenes despite the World War II setting: a woman's prison off the coast of the Amazon's Paradise Island, and a woman's college in "Man's World." The first of these settings, "Reform Island," is basically an Amazonian equivalent of Bedford Hills, the reformatory where Marston worked early on in his scientific career. Modeled on the cottage setting of progressive-era Bedford Hills, Reform Island transforms its subjects differently than does the "monastic cell model" of Michel Foucault's often cited reading of the Panopticon. Discipline does still "proceed from the distribution of individuals in space" through a cellularly constituted body, but not the solitary space of the monastic cell (Foucault 1979, 141). Grouping the women together to model and enact the proper social environment, the Amazon trainer/therapist Mala "transforms, through discipline and love, the bad character traits of women prisoners." (Fleisher and Lincoln 1976, 176). This "love" in Marston's terms is by definition not coercive but compelling in its work of emotional re-education. Indeed, in another episode, Mala announces

that Reform Island is " 'not really a prison,' but rather, 'sort of a college where we teach girls how to be happy!' " (176). This "happiness" again comes from passion induced in a body through bondage, physical and mental (the line between these two categories is fairly indistinguishable in Marston's theory). Upon arriving at the reformatory, prisoners are placed in a "Venus girdle," which, as Michael Fleisher describes, induces "loving submission" via Aphroditic pleasure:

> Every prisoner on Transformation Island must wear a magic Venus girdle—a special belt designed to make the wearer "enjoy living by peaceful principles"—until such time as she can "worship Aphrodite" and "submit to loving authority" without the power of the girdle to help her. (1976, 176)

With the girdle, prisoners do not need to be locked in cells to encourage soul transformation, but the girdle still works at a cellular level, as Queen Desira of Venus explains: " 'Girdles of magnetic gold charge every body with vitalizing currents and harmonize the brain. When brains become normal . . . [they] lose their desire for conflict and enjoy serving others and submitting to loving Authority' " (WW no. 12/3, Spring 1945, "The Conquest of Venus"). The cellular transformation works on the body via the neurological, as in Marston's scientific psychonic theory of consciousness. A 1948 story gives us a particularly vivid image of the impact of this kind of transformation. Villainous leader Eviless, freed from the girdle's power because it was not properly fastened, tries to lead a prison revolt. She announces that the guards have been captured, and tells the group she will release them from their girdles. But they quickly respond, "No, no! We don't want our girdles removed!" (Fleisher 1976, 11). They have been successfully disciplined by Amazon technology, brought into "normal" emotional relations in which they resist submission to harm (Eviless) but embrace submission to Aphrodite and the Amazons.

Out in "Man's World," Wonder Woman undertakes similar transformations of young girls in a girl's school setting. Contemporary historians of sexuality have taken up boarding schools and women's colleges as they generated forms of lesbianism identifiable in a ritualized language of "crushes" and "smashes." These historians see these formations as specific to the progressive era, arguing that administrators later moved to suppress the girls' erotic rituals, fearing their students' sexualities would cause reprisals against their new women's educational institutions (Chauncey 1983; Faderman 1991; Vicinus 1990). But in *Wonder Woman*'s "Holliday College for Girls," these ritualized forms of lesbian sexuality reemerge as students are brought into the Amazon fold, first by Wonder Woman and then by the initiated students. Since their emotions are not as

misaligned as those of their criminal counterparts on Reform Island, the Holliday Girls are not bound by the "Venus girdle"; but their discipline is still bodily, constituted by physical exercise and forms of bondage to promote this exercise. A panel from the March 1944 story line in Sensation Comics (No. 27) shows a "Man's World" girl talking with Amazon scientist Paula Van Gunther. To build her muscles and remind her of her necessary, strength-giving obedience to Aphrodite, she wears heavy chains on her wrists. Anticipating a visit from outsiders, Paula instructs her to remove the chains, feeling their "Man's World" visitors will not understand their meaning. But like the prisoners on Reform Island, the girl is reluctant to be unbound, indicating her pleasure in "loving submission" and faith in its positive pedagogical force on her body.

"Emotional re-education" in "Man's World" is taught not just by Amazons from Paradise Island but also by those women who are emotionally reeducated. Another Holliday Girl, Etta Candy, figures prominently in these 1940s stories as Wonder Woman's main disciple of Amazonian discipline. She models herself after Wonder Woman and like her role model rises as a leader among the other girls in her "Greek" sorority. In the same story with Paula von Gunther and the submitting girl, Etta initiates a new girl, Gay, into their fold, ordering her to dance for her own and the others' pleasure. Gay, who had been in prison and suicidal, learns pleasure in submission and physical activity, transforming herself into a happy Holliday Girl. To reeducate Gay, to teach her that "there is a norm of psycho-neural behavior, not dependent in any way on what [her] neighbors are doing" (Marston 1928, 391), Etta assumes the role of "love leader." Taking on the commanding presence of Aphrodite as she sits in a throne, she orders that Gay name her pleasure: "I command you, neophyte, to tell me the dearest wish of your childish heart" (5). Hesitating, Gay answers that she would like to dance, but never learned how. Soon she happily spins around, thinking to herself "Oh! This is fun!" as the other girls commend her dancing—"Bravo!" "Pretty!" "Nice Work, Gay!" You're good, kid!" Pleasure, bodily pleasure incited by the presence and disciplinary powers of other females, "reforms" Gay into an order of Amazonian discipline and love.

Despite their "deviance," these prescriptions can be clearly read as a bid for hegemony because Marston's theories are based on the psychological discourse of emotional hygiene and normalcy—literally on the grounds of progressive-era prison reform and education—the territories of Maurice Chideckel's fearsome and sadistic "schoolteachers or policewomen" (170). Focused on bodily, cellular emotion and the nonreproductive pleasures of bondage without indictments of perversity, this resexualization competes against the reproductive sexuality of familial discourse. However, I do not

want to hold up Marston's theories as an exemplar for contemporary queer theory and cultural studies. In competition for hegemonic force, Marston's theory naturalizes vertical power relations with his cellular model of subjectivity, a naturalization made more palatable by offering the pleasures of non-reproductive sexuality. *The Emotions of Normal People* even in its title signifies this middle-class discourse of normalization; and as Marston's criminological training strongly indicates, the theory contained within is about disciplining rather than liberating the modern "American" population. The powers offered by *Wonder Woman*, then, should be understood as intentionally part of that disciplinary project, as a middle-class normalizing discourse that explicitly operates through gender and sexuality.

Doctoring Feminine Sexuality: 1940s *Wonder Woman* Received

Marston's bid for normalization in fact put him smack in the middle of a culture war over normalcy. Receptions of *Wonder Woman* authored by other expert guardians of U.S. culture—psychologists and literary critics—assert that the comic book is a "deviant" body, a corrupting mass-culturel formation of femininity that is a threat to national health. Psychologists, psychiatrists, and literary critics, including Cleanth Brooks, Robert Heilman, Walter Ong and Fredric Wertham, all reacted in print to the "Amazon Adventures" of *Wonder Woman*. Published between 1945 and 1954, their negative reviews show their larger concerns for the state of culture in modern American capitalism without mention of World War II. Their ideological perspectives on culture are by no means unitary, ranging dramatically in cultural location and ideological orientation; we have two southern agrarian conservatives, a northern Catholic conservative, and a German Jewish immigrant with Marxist tendencies. But as critics of *Wonder Woman*, they all either mock or reject the normalization of amazonian subjectivity. They contest how and where the gendered female body should be located in culture, and in what forms it should exist. As in Marston's reform plan, feminine sexuality figures social relations and the fate of culture, although the imagination of that fateful outcome varies for each doctor.

　　Literary critics Cleanth Brooks and Robert Heilman respond sharply to Marston's claims of the amazon's curative, hygienic force with a three-page letter to the editor of *American Scholar,* published in spring 1945. Contemporary readers familiar with modern literary history know that Brooks and Heilman helped create a movement called the New Criticism, which was, among other things, a pedagogy that sought a scientific rigor for standardizing the reading

practices of the masses, especially of poetry, through the technique of close reading.[10] Their *American Scholar* letter competes with Marston's defense of comics as a vehicle for cultural literacy, indicated by his declaration that "If children will read comics, come Hail Columbia or literary devastation, why isn't it advisable to give them some constructive comics to read? After all, 100,000,000 Americans can't be wrong—at least about what they like" (Marston 1945, 6). "Literary devastation" certainly is not an acceptable vehicle for Brooks and Heilman; and so their letter rebuts Marston's celebration in a satiric counterargument.

Foundational to the tone of their satire is an ironic occupation of Marston's populist rhetoric. They pretend to agree on the power of comics as presented by Marston:

> Our own research indicates that Brother Marston's article contains a good deal more profit than meets the eye. This we sensed without empiric confirmation, for we were always impressed by the quotation of six and eight digit figures. We are confirmed Gallupians: vox populi vox dei. (248)

Positioning themselves as also engaged in "research," Brooks and Heilman cue theirs readers as to the laughability of Marston's claims, which they frame as simultaneously fictional, "without empiric confirmation," and number-driven, with "the quotation of six and eight figures." After aligning themselves with Marston's populist science, Brooks and Heilman perform a close reading of his writing, looking at its "constants"—in New Criticism, words repeated throughout a piece of writing that cue a reader to the center of the writing's meaning. "In the five significant passages on his legend of a good woman," they write, the "constant" is the regular appearance of the word "alluring." Certainly this "constant" is the captivating woman.

However, Brooks and Heilman have a very different understanding of the powers of captivation; for them it is a corrupting cultural power. They extend their identification as "Brother" empiricists and discuss their own "experiments" with the "alluring" Wonder Woman in *their* "laboratory"—the literature classroom:

> Like Brother Marston, we are teachers. . . . We have applied Brother Marston's phrase "moral educational benefits for the younger generation." In all our classes we now have the aid of two alluring young things clad as "Wonder Woman." Part of the time two alluring young things stand, gracefully poised, on either side of the lecture desk. At least once during each hour

we pause while the two beauties do a modern dance routine, and you have no idea how it livens things up. Our class enrollments are truly marvelous. Our joint seminar in Vedic Mysticism has grown in size from 2 to 367. Who dares say that 367 American university students can be wrong?" (249)

The outrageousness of this story and its straight-man narration counters Marston's popular literary science, his "poetry." "Who dares say that 367 university students can be wrong?" mimics his suggestion that the excitement of "100,000,000 Americans" over the comic book medium indicates its moral and pedagogical superiority over literature. Focusing on Marston's proposed pedagogical force of "moral educational benefits for the younger generation," Brooks and Heilman circle in on the moralism and reform offered in Marston's scene of comic book education. It can be safely assumed that their moralism differs from Marston's project of "love leadership" as indicated by their treatment of the "two alluring young things." Seated at the site of knowledge production and transmission—the classroom—Brooks and Heilman suggest that Marston's "moral" reform program, his "alluring woman" prescribed to fend off "blood-curdling masculinity," is a simply cheap tease:

The climax of each hour comes when our two lovelies reach over and tap us on the head with charming pearl handled hammers, and as the bell of dismissal rings we fall cold (not really, of course). Thus the enemy is vanished; thus do our Wonder Women add, to their allure and their altruistic homilies, a convincing demonstration of power. All in all, we have helped remove the shackles of MAN'S SUPERIORITY, PREJUDICE, AND PRUDERY from lovely woman. (249)

This last phrase borrows an image from *Wonder Woman* published with Marston's *American Scholar* essay. Bursting out of chains, she familiarly enacts the principles of "captivating femininity" surrounded by words that foreground a feminist agenda, breaking "man's superiority, prudery and prejudice." Brooks and Heilman's classroom "experiment" (whether or not they actually performed it) empties out the promotion of female agency in Marston's popularized practice of his deviant science, as the "convincing demonstration of power" of "our two lovelies" is "not really, of course" convincing. Any feminist force of this Amazon body is deflected as trivial with their "bell of dismissal," reinforcing a binary gender division between men (the professors) and women (attractive props for male knowledge).

During the same year—1945—Walter Ong also commented on *Wonder Woman*, both in an article on comic books and fascism published in a issue of the *Arizona Quarterly* and a *Time* magazine article on the social scientists' debates about the influence of comics on young readers. Ong comments with both his moral authority as a Jesuit priest and his academic expertise in literacy. In a less theatrical and more overtly judgmental manner, Ong makes clear his belief that comic book superheroes are fascistic, that they encourage young readers to follow a single individual instead of relying on their own individuality. He calls *Wonder Woman* "Hitlerite paganism," saying that the comic heroine "is only a female Superman, preaching 'the cult of force,' spiked, by means of her pretentiously scanty 'working' attire, with a little commercial sex"(68). Like his New Critic contemporaries, Ong also identifies the "alluring woman" as an attractive but "cheapened version of femininity," as *Time* magazine reports that "Ong finds Wonder Woman sexy." Not surprisingly, his judgment turns moralistic, as he advises that "this is not a healthy sex directed toward marriage and family life, but an antisocial sex made as alluring as possible while its normal term in marriage is barred by the ground rules." Ong insists on a specifically domesticated femininity and sexuality, "directed toward marriage and family," diametrically opposed to Marston's configuration of "normal emotions." He thus directly responds to Amazonian "deviance," rendering that deviance as abject, "antisocial," and definitely not "normal," and assumes its mass-culturel dissemination to be a social hazard.

In addition to these literary criticisms of *Wonder Woman*, the comic received its most intense review from Fredric Wertham, a psychoanalyst who established the Lafargue Clinic in Harlem and linked the new comic books to a rise in violent, sadistic behavior. A Jewish German neurologist with Frankfurt school links who immigrated in the early 1920s, Wertham also critiques comic books as fascistic and sexually "perverse," though he ideologically differs from Ong's conservative American Catholicism, critiquing the violence of capitalism against urban working-class populations, especially African Americans.[11] Wertham's diagnosis of comic books is contained in the infamous *Seduction of the Innocent,* which, published during the era of Cold War McCarthyism, fueled both congressional hearings on comics and the comic book industry's subsequent self-regulation through the Comics Code.

Like Marston, Wertham also wrote with concern for the "bloodcurdling masculinity" of comics, distressed by the abundant scenes of violence against women. But his commentaries on *Wonder Woman* show this concern to be grounded in a completely different and opposing construction of gender, one which sees women as naturally weaker—a rhetoric of women's "inherent passivity" that we

also saw in Maurice Chideckel's eugenist view in *Female Sex Perversion* and similar to Walter Ong's domesticated woman. Unlike Marston's promotion of feminine "force, strength, power" through *Wonder Woman*, Wertham takes the position that comics are especially damaging to girls, as "their Ego-formation is interfered with by the fascination of sadistic comic book heroines" (1955, 199). Of Wonder Woman Wertham writes, "While she is a frightening figure for boys, she is an undesirable ideal for girls, being the exact opposite of what girls are supposed to want to be" (34). And this "exact opposite" resembles the "young lovelies" in the Brooks and Heilman parody, as Wertham pronounces with great indignation, "In no other literature for children has the image of womanhood been so degraded" (234). Wertham echoes Walter Ong's diagnosis of "deviance," a reading of sadism and perversion with parallel construction of what the "normal person" should be. Reacting to a colleague's position that comics "contain a strikingly advanced concept of masculinity and femininity" that renders "unsexed creatures" (66), Wertham counters, "If a normal person looks at the comic books in the light of this statement he soon realizes that the 'advanced concept of femininity and masculinity' is really a regressive formula of perversity. . . . Is it so advanced to suggest, stimulate or reinforce such fantasies. The normal concept for a boy is to wish to become a man, not a superman, and to live with a girl rather than a super-heroic he-man" (233).

This argument over "normalcy" quickly turns into commentary as to what will define cultural progress and "advancement." Wertham writes, "As to the 'advanced femininity,' what are the activities in comic books which women 'indulge in on equal footing with men'? They do not work. They are not homemakers. They do not bring up a family. Mother-love is entirely absent. Even when Wonder Woman adopts a girl there are Lesbian overtones" (233–34). Clearly Wertham's ideas for necessary cultural transformation do not include allowing women out of the domestic sphere, as he claims the absence of "homemakers" and "motherlove." In his distress at "Lesbian overtones," Wertham's imagination of perversity from the perspective of "a normal person" diametrically opposes Marston's position that "people must be taught to love parts of themselves, which they have come to regard as abnormal" (1928, 391). Again we see the rhetorical "normal person" defining this contest over the sexed body of the Amazon.

Deviant Subjects, Normal People, and Histories in 1940s *Wonder Woman*

These criticisms of Wonder Woman's amazon body thus firmly place her within the language of deviance and normalcy, an earlier twentieth-century

discursive battle over who and what will prescriptively define the "normal person." Receptions of this feminine mass-culturel icon by the literary critics and psychoanalyst share a conservative position on gender roles and sexuality, insisting that the feminine subject occupy a domesticated separate sphere. From different ideological positions and disciplinary orientations they thus work in a theoretical and practiced contest for hegemonic normalcy. However, there is one noteworthy difference between the amazonian deviance diagnosed by Wertham and the literary critics. Only the psychiatrist Wertham attends to the "Lesbian overtones" in the comic. Brooks, Heilman, and Ong all register Wonder Woman's deviance within a heterosexual matrix, deviance in a form of "bad-girl" femininity that Ong describes as "spiked, by means of her pretentiously scanty working attire, with a little commercial sex"; she services a male body, as do the wand-wielding "young things" in Brooks and Heilman's fantasy classroom (1928, 68). This difference opens the question of the lesbian subject in relation to the 1940s comic book, an opening that cannot here be fully explored but which will highlight contemporary criticial problems for historicizing the science and sexuality surrounding *Wonder Woman*.

In addition to his notation of "Lesbian overtones," Wertham (1955) gives an extended lesbian reading of *Wonder Woman*. Repressing the comic's prominent running heterosexual romance with Steve Trevor, he focuses on the intense interactions between women in the comic:

> The Lesbian counterpart of Batman may be found in the stories of Wonder Woman and Black Cat.[12] The homosexual connotation of the Wonder Woman type of story is psychologically unmistakable. *The Psychiatric Quarterly* deplored in an editorial the "appearance of an eminent child therapist as the implied endorser of a series . . . which portrays extremely sadistic hatred of all males in a framework which is plainly Lesbian." For boys, Wonder Woman is a frightening image. For girls she is a morbid ideal. Where Batman is anti-feminine, Wonder Woman and her counterparts are definitely anti-masculine. Wonder Woman has her own female following. They are all continuously being threatened, captured, almost put to death. There is a great deal of mutual rescuing, the same type of rescue fantasies as in Batman. Her followers are the "Holliday Girls," the holiday girls, the gay party girls, the gay girls. Wonder Woman refers to them as "my girls." (192–93)

Wertham's description, of course, is intended as an indictment. But his medicalized reading of *Wonder Woman*'s "morbidity" renders a more central visibility to the lesbian dynamic in the comic than is present in either any of the other criticism or even Marston's own writings. In a fairly textbook example of

Foucault's "repressive hypothesis," Wertham unintentionally centers what he wants to exclude in the realm of the normalized, foregrounding lesbianism.

This unintended centering raises the question of how lesbian sexuality relates to Marston's Amazonian "sex," the question of how to best historicize 1940s *Wonder Woman* given its complicated importation of progressive-era gender and sexuality to a World War II text. Certainly there is a strong lesbian dimension to the comic, with its promotion of feminine bonding, captivations, and passions. In the bondage narratives, the comic plainly utilizes models of female friendship that contemporary historians of lesbian sexuality have explored—especially the realm of "crushes" and "smashes" of early twentieth-century girls' schools. But even read in this way, *Wonder Woman*, and Wertham's accusation that the comic is "anti-masculine," force a revision of U.S. lesbian history. Currently scholars characterize lesbian sexuality in this period as coded by the androgynous "manly woman" (De Lauretis 1994; Faderman 1991; Freedman 1988; Newton 1990). Dressed as she is, Wonder Woman hardly fits into this body type. Nor does she conform to the standing current reevaluations of progressive-era New Woman's sexuality, which read her autonomy as ultimately contributing to a new regime of heterosexuality (Chauncey 1983; Freedman 1988). Further, as a text promoting women's involvement in World War II, 1940s *Wonder Woman* should also be tied to what Lillian Faderman calls a subcultural "clarification" of lesbian identity that was "bound to emerge in factories and military units" because of their new same-sex environment (1991, 120). But this "clarification" codes lesbian bodies within the coupled paradigm of butch/femme identity, as Faderman outlines in a chapter entitled "Naked Amazons and Queer Damozels: World War II and its Aftermath." Just as there is nothing visibly androgynous or manly about Wonder Woman, her "girls" sexuality is centered not on coupling but rather on the pleasures of loving domination and submission.

Reading the patterns of deviance and normalcy generated by Marston's theories and *Wonder Woman*'s critics, it is less clear exactly what forms of sexuality are "bound to emerge" from the amazon body, less obvious that what emerges out of this text is a singular "clarification" of sexual identity. As we have seen on Reform Island and with the Holliday Girls, the centrality of female-induced "passion" generates multiple sexualities, legible as "deviant" for Wertham and his colleagues, that are "queer" in our contemporary sense—the fetishes of bondage with chains and clothing, and of course the fetish of the dominatrix herself, potentially desired by all "passionate" subjects responding to her "captivation." The limits on heterosexuality imposed by the Laws of Aphrodite— in Walter Ong's terms, that sexuality's "normal term in marriage is barred by the ground rules"—highlight the lesbian potential of these Amazons. But Marston does not use the word *lesbian* in any of his scientific writings; nor

does he use *bisexual, heterosexual,* or even *sexuality*. Marston's deviant nor-malizings spring not from the historically coinciding interrogations of identity and personality underway in psychoanalysis but from a neurological approach to the body. Sexual behaviors are seen as products of the mutable internal firings of these cells rather than as some kind of personal essence.

Understanding this historical formulation, however, does not necessitate doing away with "lesbian" as a contemporary identity. The specificity of Marston's instrumental inscriptions into *Wonder Woman* most certainly should not negate the possibility of lesbian readings, for to do so would conflate the process of textual production with receptions. And neither is a construction of the lesbian subject in *Wonder Woman* compulsory for all readers, as the erasure of Steve Trevor (the comic's regular, emblematic passionate male) is strictly vol-untary, and in fact requires that a reader be predisposed to do so. It is ironic that it would be the phobic psychoanalyst with conservative gender politics and not the "happily" deviant liberal progressive doctor who would centrally render a lesbian visibility in *Wonder Woman*. But the irony is also entirely appropriate, since psychoanalysis clearly has enjoyed a much more vigorous and enduring presence in U.S. culture than Marston's now archaic psychonic theory of con-sciousness; and the category of lesbianism carries more cultural currency than does the figure of a neurologically disciplined woman emoting a state of Aphroditic captivation. Part of an intellectual struggle over hegemonic norms, Wertham's reading of this Amazon body as lesbian thus highlights for us an in-terplay among theory, interpretation, and the production of sexuality in diver-gent cultural arenas, as well as reinforcing this surprising linkage between comic books and science embodied by our amazon heroine Wonder Woman.

Notes

1. See Terry 1991 for "deviant historiography," and Halberstam 1998 for "perverse presentatism." See also Duggan 1993; Sedgwick 1995; Terry 1995; and Traub 1996 for queer feminist work that engages science.

2. For work on science and mass culture, see Balsamno 1996; Martin 1994; Penley and Ross 1991; Penley 1992, 1997; and Terry 1995.

3. It is important to note that Ross's argument predates his later cultural studies work on science and technology.

4. Marston's polygraph work deserves critical attention. It shares an explicit reform agenda—the elimination of police brutality in witness interrogation. See his *The Lie Detector*.

5. The series includes Wittgenstein, *Tractus Logico-Philosophicus;* Piaget, *Language and the Thought of the Child* and *Judgment and Reasoning of the Child;* Adler, *Dialectic,* Hulme, *Speculations;* and Richards, *Principles of Literary Criticism.*

6. Until the 1950s, readership for comic books was equally divided along gender lines. The medium lost female readers when the Comics Code gutted romance comics narratives. See Barker 1989 and Sabin 1993.

7. "Queer" here refers to forms of sexuality that exceed both normative hegemonic heterosexual categories of sexuality and gender oriented around biological reproduction and the resulting binary definitions of *heterosexual* and *homosexual.* See Sedgwick 1993.

8. Another version of this article attends to racial discourse in "human engineering" and its links to sexuality both in eugenics and Marston's deviant productions. See Rhodes 1997. For related discussions of race and sexuality, see Duggan 1993; Gilman 1993; Hinjosa Baker 1992; Mercer 1994; Terry 1991; and Wiegman 1995.

9. Marston's 1930 book *The Art of Sound Pictures,* coauthored with Walter Pitkin, also explicitly discusses the production of both normal emotion and bondage scenes, with empirical research presented on the galvanic responses of subjects who were shown particular film images while wired to polygraph machinary.

10. See Brodkey 1987; Said 1982; and Wayne 1987.

11. See Rhodes 1997 for a chapter on Wertham and his twenty-year relationship with Richard Wright.

12. Wertham has an even longer homophobic reading of Bruce Wayne and his young "ward." See Medhurst 1991 for related queer batboys.

Works Cited

Balsamo, Anne. 1996. *Reading Cyborg Women: Technologies of the Gendered Body.* Durham, N.C.: Duke University Press.

Barker, Martin. 1984. *The Haunt of Fears: The Strange History of British Horror Comics.* London: Pluto Press.

———. 1989. *Comics: Ideology, Power, and the Critics.* New York: Manchester University Press.

Brodkey, Linda. 1987. *Academic Writing as a Social Practice.* Philadelphia: Temple University Press.

Brooks, Cleanth, with Robert Heilman. 1945. "Letter to the Editor." *American Scholar,* spring.

Chauncey, George Jr. 1983. "From Sexual Inversion to Homosexuality: Medicine and the Changing Conceptualization of Female Deviance." *Salmagundi* no. 58–59 (fall–winter):114–46.

Chideckel, Maurice. 1938. *Female Sex Perversion: The Sexually Aberrated Woman As She Really Is.* New York: Eugenics Publishing Company.

De Lauretis, Teresa. 1994. *The Practice of Love: Lesbian Sexuality and Perverse Desire.* Bloomington: Indiana University Press.

Duggan, Lisa. 1993. "The Trials of Alice Mitchell: Sensationalism, Sexology and the Lesbian Subject in Turn-of-the-Century America." *Signs* 18, no. 4:791–814.

Faderman, Lillian. 1991. *Odd Girls and Twilight Lovers: A History of Twentieth Century Lesbian Life in America.* New York: Penguin Books.

Faludi, Susan. 1991. *Backlash: The Undeclared War against American Women.* New York: Crown Publishers.

Fleisher, Michael L., and Janet E. Lincoln. 1976. *Wonder Woman.* Vol. 2 of *The Encyclopedia of Comic Book Heroes.* New York: Collier Books.

Foucault, Michel. 1979. *Discipline and Punish: The Birth of the Prison.* Translated by Alan Sheridan. New York: Vintage Books.

———. 1990. *The History of Sexuality,* vol. 1. Translated by Robert Hurley. New York: Vintage Books.

Freedman, Estelle B. 1981. *Our Sisters' Keepers: Women in Prison Reform in America, 1830–1930.* Ann Arbor: University of Michigan Press.

———. 1988. *Intimate Matters: a History of Sexuality in the United States.* With John D'Emilio. New York: Harper and Row.

Gilman, Sander. 1993. *The Case of Sigmund Freud: Medicine and Identity and the Fin de Siècle.* Baltimore: John Hopkins University Press.

Goulart, Ron. 1986. *Ron Goulart's Great History of Comic Books.* Chicago: Contemporary Books.

———. 1990. *The Encyclopedia of American Comics from 1987 to the Present.* New York: Promised Land Publishers.

Halberstam, Judith. 1998. *Female Masculinity.* Durham, N.C.: Duke University Press.

Haraway, Donna. 1989. *Primate Visions: Gender, Race, and Nature in the World of Modern Science.* New York: Routledge.

Hinjosa Baker, Kathryn. 1992. "Delinquent Desire: Race, Sex, and Ritual Reform Schools for Girls." *Discourse* 15, no. 1 (fall):49–68.

Marston, William Moulton. 1928. *The Emotions of Normal People.* New York: Harcourt, Brace.

———. 1930. *The Art of Sound Pictures.* New York: Appleton.

———. 1931. *Interrogative Psychology.* With Elizabeth Marston and C. D. King.

———. 1932. *Venus with Us: A Tale of the Caesar.* New York: Sears Publishing Co.

———. 1944. "Why 100,000,000 People Read Comics." *American Scholar* (winter).

"Marston, William Moulton." *The National Cyclopedia of American Biography.* 1980. New York: J. T. White & Co., 37–38.

Martin, Emily. 1994. *Flexible Bodies: The Role of Immunity in American Culture from the Days of Polio to the Age of AIDS.* Boston: Beacon Press.

Medhurst, Andy. 1991. "Batman, Deviance, and Camp." In *The Many Lives of the Batman,* edited by Roberta Pearson and William Uricchio, 149–63. New York: Routledge.

Mercer, Kobena. 1994. *Welcome to the Jungle.* New York: Routledge.

Newton, Ester. 1990. "The Mythic Mannish Lesbian: Radclyffe Hall and the New Woman." In *Hidden From History: Reclaiming the Gay and Lesbian Past,* edited by Martin Duberman, Martha Vicinus, and George Chauncey Jr. New York: Meridian Press.

Ong, Walter. 1945. "Are Comics Fascist?" *Time,* October 22, 67–68.

Penley, Constance. 1992. "Feminism, Psychoanalysis, and the Study of Popular Culture." In *Cultural Studies,* edited by Lawrence Grossberg, Cary Nelson, and Paula Treichler, 479–500. New York: Routledge.

———. 1997. "From NASA to the *700 Club* (With a Detour Through Hollywood): Cultural Studies in the Public Sphere." In *Disciplinarity and Dissent in Cultural Studies*, edited by Cary Nelson and Dilip Parameshwar Gaonkar, 235–50. New York: Routledge.

Penley, Constance, and Andrew Ross, eds. 1991. *Technoculture*. Minneapolis: University of Minnesota Press.

Rhodes, Molly. 1997. "Doctoring Culture: Literary Intellectuals, Psychology and Mass Culture in the Twentieth-Century United States." Ph.D. diss., University of California at San Diego.

Ross, Andrew. 1989. *No Respect: Intellectuals and Popular Culture*. New York: Routledge.

Sabin, Roger. 1993. *Adult Comics: An Introduction*. New York: Routledge.

Said, Edward. 1982. "Opponents, Audiences, Constituencies, and Community." *Critical Inquiry*, September, 1–26.

Sedgwick, Eve. 1993.*Tendencies*. Durham, N.C.: Duke University Press.

———1995. "Shame and Perfomativity: Henry James's New York Edition Prefaces." In *Henry James's New York Edition: the Construction of Authorship*, edited by David McWhirter, 206–39. Stanford, Calif.: Stanford University Press.

Sensation Comics no. 6. (June 1942). New York: National Periodicals Publication.

Sensation Comics no. 27. (March 1944). New York: National Periodicals Publication.

Sensation Comics no. 46. (October 1946). New York: National Periodicals Publication.

Smith-Rosenberg, Carroll. 1990. "Discourses of Sexuality and Subjectivity: the New Woman, 1870–1936." In *Hidden from History: Reclaiming the Gay and Lesbian Past*, edited by Martin Duberman, Martha Vicinus, and George Chauncey Jr. New York: Meridian Press.

Steinem, Gloria, ed. 1972. *Wonder Woman*. New York: Warner Communications.

Terry, Jennifer. 1991. "Theorizing Deviant Historiography." *differences* 3, no. 2:55–74.

Terry, Jennifer, and Jacqueline Urla. 1995. *Deviant Bodies: Critical Perspecitves on Difference in Science and Popular Culture*. Bloomington: Indiana University Press.

Traub, Valerie. 1996. "The Psychomorphology of the Clitoris." *GLQ* 2:81–113.

Tyler May, Elaine. 1988. *Homeward Bound: American Families in the Cold War Era*. New York: Basic Books.

Vicinus, Martha. 1990. "Distance and Desire: English Boarding School Friendships, 1870–1920." In *Hidden From History: Reclaiming the Gay and Lesbian Past*, edited by Martin Duberman, Martha Vicinus, and George Chauncey Jr. New York: Meridian Press.

Wayne, Don. 1987. "Power, Politics, and the Shakespearean Text: Recent Criticism in England and the US." In *Shakespeare Reproduced*, edited by Jean Howard and Marian O'Connor, 18–46. New York: Metheun.

Wertham, Fredric. 1955. *Seduction of the Innocent*. London: Museum Press Ltd.

Wiegman, Robin. 1995. *American Anatomies: Theorizing Race and Gender*. Durham, N.C.: Duke University Press.

"William Moulton Marston," obituary in the *New York Times*, May 3, 1947, L 17.

Researcher or Smoker?
Or, When the Other Isn't Other Enough in Studying
"Across" Tobacco Control

Roddey Reid

To the ethnographic gaze, "civilized people" appear too transparent for study, they seem just like "us"—materialistic, greedy, and purposeful. Because their worlds are down to earth and practical, "our" common sense categories apparently suffice for making sense of their lives.
—Renato Rosaldo, Culture and Truth

[The] point is what does the field unconsciously allow us to do and think? And if the field is no longer about research in the Third World, by outsiders, of non-literate peoples what is it about now and how is that different, in both theory and practice?
—Deborah D'Amico-Samuels, "Undoing Fieldwork"

Taking Your Pulse with Your Finger

In the fall of 1996 the World Health Organization, the World Bank, and the Harvard School of Public Health issued a voluminous report warning that "by 2020, tobacco is expected to cause more premature death and disability than any single disease" (Murray and Lopez 1996). This publication capped a growing preoccupation with smoking as a health hazard by public health officials, nongovernmental agencies, voluntary health organizations, antismoking advocates, the international media, and public opinion in the developed world over the last fifteen years. This interest intensified with the 1996 U.S. presidential campaign and with the proposed tobacco settlement reached between cigarette manufacturers, state attorneys general, and U.S. health officials in June 1997. Indeed, U. S. politicians and public health professionals in the press and in private interviews termed the proposed settlement "the greatest achievement in public health history" (Maugh 1996).[1]

Public concern began to grow dramatically in the early 1980s, following the establishment of secondhand smoke as a hazard to nonsmokers by studies conducted principally in Japan, the United States, the People's Republic of China, and Hong Kong. Smokers were deemed a threat no longer simply to

themselves but to others as well. Concern was further heightened in 1993 when the U.S. Environmental Protection Agency (EPA) published a report that classified "environmental tobacco smoke" as a class-A carcinogen. The cumulative result has been that, as medical historian Alan Brandt (1990) put it, in the United States "the cigarette—the icon of our consumer culture, the symbol of pleasure and power, sexuality and individuality—has become suspect." As a health issue, secondhand smoke has accelerated tobacco control efforts worldwide, and in turn this acceleration has entailed important cultural and social changes in many developed countries, especially the United States, above all in California and New York City.

In the following essay, I'm interested in exploring some of the issues raised for interdisciplinary studies of science and medicine by recent efforts to regulate the production, marketing, and consumption of tobacco products, a highly politicized, public controversy in many countries at the close of the twentieth century. In particular, I wish to examine the peculiar difficulties that face any attempt to research tobacco control in the midst of what has become to be known in the United States as the "tobacco wars," and of a social climate shaped in the United States by the terror many people have of cigarette smoke, smoking, and dying from tobacco-related diseases. As cultural critic Mary Louise Pratt once remarked, obstacles to research and fieldwork are *also* ethnographic facts in and of themselves and need to be taken into account in any study of cultural or social practices (1986, 41). Moreover, to study empirically or discursively the efforts to combat smoking is no simple task when informants, the present researcher, and readers of this essay alike are affected by the controversy at hand. For as cultural historian Henry Abelove put it with respect to an equally volatile public health issue, the HIV/AIDS pandemic, "Trying to know anything about what's most familiar must produce a sense of strangeness, difficulty. It's like taking your pulse with your finger" (1994, 5).

Indeed, what has been intensely at issue while this author has performed fieldwork and presented scholarly papers, especially in the United States, is my embodiment and my relation to truth, as signaled, for example, by the simple fact that scarcely an interview in person or presentation takes place without my being queried as to my status as a smoker or nonsmoker and my sources of funding. Clearly, as the questions of what I do or have done with my body or what some institution or firm hopes to do with the results of my work become ineluctably embedded in the context of my fieldwork and research, so too are questions of identity: "Just who are you?" What's more, if, as Abelove's remarks suggest, studying your "own" culture is like conducting a medical exam of your

body, it is also an examination of a body that is at once familiarly yours and not quite yours (but whose, then?), of a culture that you know well (and which, in some sense, belongs to you) but then again not so well (and perhaps belongs also to someone else very different from yourself). Abelove's comments imply, as well, that just who one is and what one is studying may be different at the end than at the beginning of the cultural self-exam, an exam that is finally not only a self-exam, but an exam of someone else or some other culture.

In this sense, then, does self-study, so to speak, also entail studying "across." And I want to argue that when studying "across" a mode of knowledge production of one's own culture—in this case, U.S. tobacco control—the issues of embodiment, identity, and truth acquire special salience and urgency if one's field—for example, cultural studies—is a discipline of little discipline, at least in the eyes of some informants and colleagues. As I attempted to make sense of these fieldwork and professional encounters, which made clear that there was no "safe" epistemological or ethical position from which to argue for, let alone conduct, the kind of study I had in mind, I came to the realization that current categories in the literature on fieldwork offered little guidance to researchers in such circumstances. It struck me that studying "across" was an understudied practice—and, as a pattern began to emerge from these encounters, that there could be disciplinary and cultural narratives well worth piecing together. In this manner will the experience of doing a cultural studies analysis of tobacco control serve in this essay as an opportunity to revisit some of the practices of identity and disciplinarity that underwrite doing "repatriated" work in the metropolises among middle-class professionals, which is thus neither "up" nor "down" but somewhere in between.

Such is the goal of this essay: to tease out the mutual entailment of issues of embodiment, identity, knowledge, and studying "across" in the study of present-day antismoking campaigns and their implications for interdisciplinary approaches to science and medicine. I attempt a response to the following interlocking questions: to begin with, what does it mean for knowledge producers (researchers) to study "across" and "over" the practices and work of other knowledge producers in developed countries, particularly "at home"? That is to say, what happens to conventional ethnographic assumptions and certainties when the other isn't "other" enough? Second, in what way do issues of embodiment and truth dominate debates over smoking and tobacco control both in the field and in academic encounters? How do these issues inflect the questions of studying "across"? Finally, how do these issues push us toward a more developed practice of interdisciplinary research? Or, conversely, what is it about interdisciplinary studies of science and medicine that often entails the

persistent question, "Who speaks here?" In following these threads of inquiry it is my hope that the present essay will arrive at a better sense of the degree to which various disciplinary and public health assumptions and issues are, in the words of Abelove, both "inside us as well as outside us, voices that constitute us as well as regulate us" (1994, 5).

The work I am conducting is closely related to other attempts to study "across" (and sometimes "up") the practices of medicine, public health, and the life sciences; they belong to traditions of scholarship and fieldwork that have links to antiauthoritarian projects of women's, lesbian, and gay health movements. Important studies have scrutinized the history of public health, medicine, and biological sciences in the United States and abroad and with some urgency have recently paid attention to the framings of bodies by biomedical practices and popular culture concerning human reproduction (abortion, surrogacy, cloning, in vitro fertilization) and HIV/AIDS, embracing everything from policy and legal decisions to drug testing protocols, clinical procedures, and health promotion campaigns. This work stands as some of the most effective examples of interdisciplinary and cultural studies of science and medicine.[2]

In particular, I have been interested in how antismoking campaigns in conjunction with revised health codes and contemporary productions of mass culture are accelerating shifts in current concepts of risk, well-being, and the social body in the United States. Originally trained in French studies, an interdisciplinary, text-based field, I had written a historical study of French discourses on the family before turning to research on tobacco control. At the outset of my present project, I focused on print and visual materials first in the United States (California) and then in France.[3] (The present essay draws on the initial fieldwork done in the United States or with U.S. informants.) After urging by colleagues in anthropology and sociology to interview those involved in the design, production, and evaluation of antismoking campaigns, I undertook fieldwork in these countries in order to understand the collaborative efforts of parties coming from different "social worlds" of public health (epidemiology, public health officials, advertising executives, and antitobacco advocates) who actually had a hand in creating the campaigns that first attracted my attention. In this sense, the "cultures" of public health tobacco control in their intersection with mass culture have been the object of my research. Recently, the project took another turn by including the antismoking campaigns in Japan, and I am now rethinking my work in terms of globalization of concepts of health and risk in developed countries.[4]

My research can thus be understood as a cultural studies approach to tobacco control that is in dialogue with interdisciplinary colleagues in sociology

and anthropology. This essay is a result of that encounter and of a particular research experience. Moreover, this essay stems from one thread of my work, which has been an attempt to steer clear of conventional ways in which contemporary issues like tobacco control are at once studied (and criticized) and placed at a safe remove from the knowing practices and styles of thinking of both the humanities and social sciences. For example, sometimes one can hear the view that the antismoking policies mark another outbreak of puritanism or stand as another example of the cyclical return of moral panics that regularly sweep the United States every twenty years or so (Klein 1993; Laqueur 1995). The first explanation comforts those in the academy who like to picture themselves as too enlightened to fall into such outmoded thinking; the latter carefully avoids examining the specific ways in which tobacco control produces and acts upon what it knows. For the same reasons, these parties often deem antismoking movements rather transparent, requiring little analysis or investigation. The "knowingness" of these responses intrigued me and made me wonder about the cultures of knowledge in my corner of campus. Looking "across" at antismoking campaigns and those who produced them may raise as many questions about how the humanities and social sciences come to know what they know as it does about public health campaigns and the scientific and cultural practices that underwrite them.

Studying "Across": When the Other Isn't Other Enough

Before turning to the peculiar issues raised by studying antismoking campaigns in the context of the U.S. tobacco wars, I want to situate the subject of studying "across" in current discussions on the ethics and epistemology of conducting fieldwork. Most of the literature is in the fields of sociology and anthropology and has questioned many of the concepts and practices of fieldwork widely held in the United States, the United Kingdom, and Europe (field, site, home, informant, fieldworker, rapport, alliance, and so on). Remarkably, in this revisionist literature there has been little written explicitly addressing studying "across" at "home" and its implications for the categories that inform fieldwork and even less on the play of identity, embodiment, and truth this particular kind of fieldwork entails. The term *studying across* (or its equivalent) barely exists in the literature. Moreover, there is not much on the topic either in standard anthologies or in textbooks on fieldwork, participant observation, ethnography, and qualitative interviewing. With few exceptions, most cited examples are from studying "down" (for example, see Adler and Adler

1994; Atkinson and Hammersly 1994; Fine 1994; Fontana and Frey 1994; Marcus 1994; and Denizen and Lincoln 1994a; as well as Burawoy et al. 1991; Rubin and Rubin 1995; and Van Maanen 1988).[5]

The absence of much critical discussion on studying across may come as a surprise in light of the feminist, lesbian, and gay traditions of scholarship cited earlier concerning biomedicine and the life sciences. A partial explanation may be that activist scholars have often undertaken research in direct antagonism to patriarchal and homophobic practices of clinical medicine, medical research, gynecology, psychology and psychiatry, and public health, in which case studying "up" the powerful has perhaps been the tacit understanding of fieldwork practice (see the discussion of Laura Nader's essay below).[6]

Interestingly, there is an unrecognized tradition of discussing the problems of studying across (if not in these terms) in fields whose work does not often involve ethnographic study or interviewing but is largely text- or document-based—primarily history, philosophy, art history, musicology, and literary studies. In these fields, scholars and writers frequently study other scholars, writers, and artists of earlier periods. Reflection on the ethics, politics, and epistemology of studying across (as well as up and down)—in this case, interpreting and translating documents, texts, and artworks—has developed in terms of respect, care, violence, pleasure, desire, appropriation, authorship, plagiarism, intertextuality, discourse, difference, hegemony, hermeneutics, truth claims, and ideologies. These concepts have been a source of debate internationally for many years, especially since the 1970s.[7] The particular debate in anthropology that erupted in the 1980s in the United States came about in part when researchers used these concepts (especially those derived from poststructuralist theory) as tools for highlighting the unspoken colonial and postcolonial prerogatives of white Euro–North American fieldworkers through the examination of the textual dimension of ethnographic practice. In so many words, researchers and ethnographers began to perform versions of indigenous self-studies or studies across of ethnographers and their textual folkways in relation to knowledge production. In this debate question of the identity, embodiment, and truth-saying of the researcher began to emerge, but not without difficulties turning mainly on omissions with respect to gender, which Deborah Gordon highlighted at that time (Gordon 1988).

Still, in these discussions even the most cogent of the revisionist analyses remain committed to the concept of a radical other, positioned either as down or up, as the object of study. It continues to underwrite and authorize the other guiding concepts of studying down or up and serves as the prism through which to interrogate conventional fieldwork and research practices.

For example, in his book *Culture and Truth* (1989) Renato Rosaldo argues in favor of a new turn in anthropology toward cultural studies as a response to ethnographic liberalism's practice of cultural difference that makes the "other" visible, while middle-class researchers themselves tend to disappear in accounts. In order to render researchers visible in their own accounts, he recommends that they weave into their narratives informants' perspective of the ethnographers, with the result that

> [t]he study of differences, formerly in opposition to an invisible "self," now becomes the play of similarities and differences relative to socially explicit identities. How do "they" see "us"? Who are "we" looking at "them"? Social analysis thus becomes a relational form of understanding in which both parties actively engage in the "interpretation of cultures." (206–7)

However, throughout his discussion, never once does Rosaldo entertain the theoretical possibility that "they" could also be, say, other middle-class professionals of the researchers' own culture. Rosaldo's comments remain focused on studying down, whether at "home" or outside the United States and other developed countries, and consequently his welcome discussion of middle-class professional identities of ethnographers still keeps the issue securely within the frame of a sufficiently "other" other. As I will argue below, this frame continues to maintain some of the assumptions of much fieldwork and the liberal model of power that underwrites them invisible.

Or take recent work by James Clifford, who questions the persistence of concepts of bounded field, static location, or the indigenous ethnographer. By his own admission, most of the examples he cites throughout the book are drawn from studying "out" or "down" (Clifford 1997, 82). Committed as he is to a discussion of fieldwork restricted to the discipline of anthropology alone, when he advocates the return of Western anthropology to the metropolises, he means only the study "up" of elite institutions by those conventionally positioned as "informants" in developing regions or countries; and when he reviews the problems entailed by "indigenous" ethnography in postcolonial, globalized contexts, the cases are of studying "down" (immigrant populations, workers, etc.). Importantly, when "home" becomes the "field," an important reversal of perspective is achieved, but the founding ethnographic narrative of radical difference nonetheless tends to persist (Clifford 1997, 29, 79, 84).[8]

In both examples of revisionist thinking on fieldwork, there is a curious omission of any discussion of the theoretical implications of studying "across" or "over"—a fieldwork practice that threatens not so much to reverse the play

of visibility and power between researcher and informants as to shift the whole dynamic entirely. For what happens to the reciprocal identities of researchers and informants/interviewees when, in studying across, the other isn't "other" enough and when, in the words of Deborah D'Amico-Samuels, "the field is anywhere" (1991, 83), and thus the researcher potentially anyone?[9] In other words, in studying across, what happens to the task and burden of translating between cultures—what Karmela Visweswaran has termed anthropology's "impossible object" and its attendant "failed epistemology"— under such circumstances? What is the fate of the researcher's trajectory from discovery of radical difference to the romantic or heroic "bridging" of that difference (through what anthropologists have termed rapport, alliance, complicity, collaboration, what have you), and the final assertion of another difference, that of researchers' credentialed privileges, which structure so many accounts? Just what some of the stakes are when the other isn't "other" enough in studying "across" is succinctly outlined by Akhil Gupta and James Ferguson in an analysis of hierarchies of otherness and field sites in anthropology:

> We have seen that ideas about Otherness remain remarkably central to the fieldwork ritual. But any conception of an Other, of course, has implications for the identity of the self. We will argue that even in an era when significant numbers of women, minorities, and Third World scholars have entered the discipline, the self that is implied in the central anthropological ritual of encountering "the Other" in the field remains that of a Euro-American, white, middle-class male. . . . The hierarchy of field sites privileges those places most Other for Euro-Americans and those that stand most clearly opposed to a middle-class self. Similarly, the notion of going to "the field" from which one returns "home" becomes problematic for those minorities, postcolonials, and "halfies" for whom the anthropological project is *not* an exploration of Otherness. (1997, 17–18)

As Jean Passaro has stated, fieldwork without "Otherness" as its guiding concept leaves it "bereft of readily apprehensible and 'manageable' objects of analysis" (1997, 150).

The tacit commitment to a founding narrative of radical differences in culture, power, or privilege in fieldwork-based disciplines may help explain not only the paucity of explicit discussions in the literature but also why what attempts there are generally enfold themselves back into a discussion of studying up.[10] In fact, a number of essays approach the issue only to veer back to focusing on asymmetrical research relations. Take, for example, Laura Nader's 1972

inaugural essay on studying up. Interestingly, she actually starts out by advo-
cating studying, as she puts it, "sideways," at home and proceeds to recom-
mend dropping anthropology's traditional preference for the underdog (292,
303). However, her essay then moves toward the perspective of studying up as
she focuses on the peculiar requirements for the study of the "powerful" for
the benefit of "citizen-natives" by citizen-scholars who enjoy access rights to
bureaucracies and organizations: nonresident studies, less face-to-face inter-
viewing, and so on. These recommendations represent a substantial break
with fieldwork orthodoxy. Yet in this political scenario, the outlines of the
standard fieldwork narrative persist: the researcher at home is a "native" and
identifies with other "natives" as citizens in an activist alliance against an in-
ternal "other"—the politically and bureaucratically powerful. At the same
time the researcher retains the conventional difference that in the end sepa-
rates her or him from the "natives": the duty and privilege of schooling fellow
citizens in the folkways of dominant institutions. However, Nader doesn't ex-
plore this "difference" from other citizens, nor does she consider the possible
"kinship" ties citizen researchers themselves may have with those they study:
their own middle-class scholars' professional status, practices, and habitus
may put them into closer rapport with those whom Nader deems the power-
ful. The question of the activist's middle-class entitlement and cultural prac-
tices is never posed. In this case we can ask the question, To what degree is the
researcher studying up actually studying across for those who are located
down? How does this inflect the research itself and the researcher's activity?
And to what extent do any of the conventional categories for describing field-
work still apply here?[11]

Twenty-three years later, the late Diana Forsythe replied to the last question
in the negative. Her unpublished paper, "Ethics and Politics of Studying Up"
(1995) stands as one of the few explicit attempts in laboratory-based studies of
scientific practices to explore the implications for ethnographic narrative of
researchers studying researchers in terms of professional training or middle-
class status. Here, the discussion of studying across takes the form of admit-
ting that researchers are actually studying across as much as studying up.
Forsythe writes that

> social worlds of fieldworker and informants may overlap considerably. This
> has the effect of collapsing roles that remain separate in the traditional nar-
> rative. For those who study up under these circumstances, informants may
> also be faculty colleagues, fellow employees of a corporation or of another
> institution, or indeed one's own employer. (10)

Laboratory studies involve fieldworkers "studying those whose work skills are quite similar to their own," and often anthropologists end up being greater participants in activities of informants and find themselves involved in relationships of greater vulnerability. The disappearance of radical social and cultural difference along with the entitlements that derive from studying down outside the metropolises of the Euro–North American developed world constitute a fundamental challenge to the standard understanding of fieldwork practices. As a consequence, Forsythe continues, "the traditional narrative of fieldwork offers little guidance" (19). Here Forsythe directly broaches the unsettling implications of researchers studying other researchers, yet her provocative interrogation remains circumscribed by the frame of studying up with which she began; in the end she returns the discussion to that of fieldworkers studying those more powerful than they, that is, to a focus (at least from the researcher's point of view) on the negative difference of power, if not of culture, that underwrites studying up: "Studying up—particularly from an untenured position—provides one with an opportunity to encounter the reality of doing ethnographic fieldwork in the absence of anthropological privilege" (21). And too little power entails "too much accountability towards one's informants."[12]

Interestingly, throughout the essay, the recurring figure for this asymmetrical relation is the graduate student or assistant professor doing observation in the lab. This suggests that perhaps the relative absence of debate on studying across—even as more and more research is done at home of middle-class dominated institutions and bureaucracies—may also have as much to do with the peculiar circumstances of graduate school training under which most fieldworkers acquire a professional identity and self-understanding through their first experience doing fieldwork as with the deeply ingrained character of the traditional fieldwork narrative: in "repatriated" ethnography, one is no longer always in a position of clear-cut cultural and political privilege, and it is impossible as a graduate student to forget one's subordinate position within academic hierarchies and middle-class settings.[13] Formative experiences that are perhaps peculiar to the Anglo-American model of graduate apprenticeships (Punch 1994, 84) may have left their mark in reflections on fieldwork. In this discourse, it would appear that if one is no longer studying down the old way from a position of guilty privilege, then one must be studying up the new way from a position of unsettling powerlessness. But what happens, then, if one is doing interviews and fieldwork in the absence of *both* radical cultural difference and differences in professional entitlements and privileges? And what becomes of the old professional drama of (lost) innocence and the romance of

marginalization that linger on after graduate school in our definition of the kind of work we do? Finally, if innocence and marginality no longer constitute the conditions of truth-saying of committed inquiry, then what new understanding of research practices becomes possible?

The point of these extended considerations is not whether difference or otherness exists or not but rather to review the roles they are made to play in constructing identities of informants, researchers, and research topics.

In the examples drawn from revisionist writing on fieldwork, there is a striking tendency for discussions of studying across to shift toward studying up and for commentaries on studying up to invoke at some point along the way studying across. The drift of these discussions asks the question, To what degree do they reflect an unflagging investment in a social or professional epistemology—a claim and right to know the other as an exoticized "other"—which entails a conventional model of power in which the asymmetries of oppression, marginalization, and privilege are always clear-cut and fall along a single axis? In turn we may ask, How much has this commitment to an exoticizing otherness actually worked to reduce, in the words of Donna Haraway (1997), the "ethnographic risk" to researchers' sense of self and categories of analysis and contributed to constructing scientists as "hostile natives"? Finally, following Ferguson, Gupta, Passaro, and Weston's lead, we may wonder whether these directional metaphors and the concepts of otherness and whiteness that underlie them remain at all serviceable for grasping the dynamics of any fieldwork setting, past or present.

The Tobacco Wars

Studying tobacco control places epistemological and ethical certainties of fieldwork under considerable stress. For not only does studying across at home dispense with those radical differences in power, privilege, or culture upon which so much ethnographic research is based, but researching a public scientific controversy imposes willy-nilly questions of personal and professional identity, authority, and accountability in a particularly direct way and, as is often the case with health issues, ties them to bodily practices and habits.

Throughout the 1990s in the United States, airwaves and newspaper columns have been filled with coverage of congressional hearings, public health studies, debates, and human interest stories on the hazards of smoking and secondhand smoke. A set of assumptions coupled with a palpable intensity has emerged in public debates and everyday conversation concerning smoking, and together

they have become one of the determining conditions not only of doing field interviews but also of submitting articles for publication and giving papers in professional venues. To give readers a quick overview of the expanding field of epidemiological fact making and cultural work of the tobacco wars, it may be helpful to review briefly some recent developments in the United States. These have been selected with a view to highlighting the powerful mix of policy and legal decisions, legislative acts, scientific findings, and media events that constitute the public struggle over the production and consumption of cigarettes in the United States in the mid-1990s:

1994

April: Henry Waxman (D-CA) holds hearings of the House Energy and Commerce Subcommittee on Health and the Environment in which tobacco industry executives deny under oath that cigarettes are addictive.

1995

January 1: The state of California extends its ban on smoking in enclosed public spaces to restaurants, with the exception of bar areas.

August: The FDA announces a plan to reduce smoking by children and adolescents by 50 percent; President Clinton calls for the forceful recriminalization not only of cigarette sales to minors but also of their consumption by smokers under eighteen. One year later he signs a decree putting the plan into effect.

August: University of California, San Francisco, publishes on the Internet smoking studies suppressed by the Brown and Williamson Tobacco Corporation.

November: CBS News program *60 Minutes* sets off a storm of protest when, bowing to threats of a lawsuit, it decides not to air an interview with a former tobacco industry executive.

1996

May: Scientists report that there is "three-fold increased risk of breast cancer among non-smoking women who had been regularly exposed to tobacco smoke at home and at work" (Brody 1996, A12); researchers reveal that teenage smoking rates among high school students jumped from 27.5 percent in 1991 to 35 percent in 1995 (Stolberg 1996a, A12).

July: Scientists report that children of smoking parents tend to have higher rates of mental retardation (Drews et al. 1996).

August: President Clinton signs a decree declaring nicotine an addictive drug and gives the Federal Food and Drug Administration broad authority to regulate cigarettes and other tobacco products, terming cigarette smoking "the most significant pubic health hazard facing our people" (Stolberg 1996b, A1); some communities begin to ban smoking in public parks (Verhovek 1996, A1).

1997

spring: in view of the increased number of serials and films featuring smokers, the *Washington Post* adds the frequency of smoking to its content ratings in addition to the amount of sex, adult language, and violence.

June: In Washington, D.C., the tobacco settlement is announced; R. J. Reynolds retires Joe Camel ads in the United States after being accused for years of targeting teenagers and children.

July: University of Chicago researchers claim that sons of women who smoked ten or more cigarettes per day during their pregnancy have a fourfold increase in the risk of "conduct disorder" (Nutall 1997); local police begin sting operations against store owners nationwide, and in small towns reports surface of high school officials suspending high school athletes who test positively for nicotine in their urine.

1998

January 1: California bans smoking in all bars and bar areas.

April: The dramatic rise in teenage smoking is confirmed by the CDC (Centers for Disease Control 1998a).

Summer: The tobacco settlement collapses.

November: A weaker version of the settlement is revived and signed.

Bodies in Controversy: Researching U.S. Tobacco Control

Over the last fifteen years, there has been a remarkable politicization of the smoking issue in California and around the United States, which prompted one sociologist of public health, Joseph Gusfield, known for his research on the anti-drunk-driving movement, to comment in 1993 that in the United

States "smoking, drinking, and the use of illicit drugs are high on public health and social control agendas. . . . Yet open discussion of the assumptions behind current restrictive policies toward this trinity of vices is taboo," which amounts to the "silencing of dissent and doubt" in "the hermetically sealed chambers of the present public discourse" (1993a, 983, 992; see also 1993b).[14]

Indeed, it would seem that U.S. tobacco control stands as a particularly intense example of what is called in science studies a public scientific controversy. Brian Martin, who has studied the dynamics of such controversies, reminds us that to conduct research on an emerging dominant discourse or scientific consensus—here, antismoking counteradvertising and those who produce it—automatically courts the accusation of "working for the other side." Even practicing scrupulous symmetrical analysis of both sides of a controversy recommended by conventional science studies does not provide safety from such accusations (Martin 1991, 163–65). In tobacco control what is controversial is less the health hazards smoking poses to smokers (annually, 420,000 inhabitants of the United States are reported dying of tobacco-related causes)—in the language of social studies of science, this is relatively stabilized scientific fact that has been "black-boxed"—than the threat to nonsmokers (it is claimed that annually 50,000 people die in the United States from environmental tobacco smoke).[15] Under such circumstances, taking the empirical risk involved in doing field and archival research with the possible result of "thinking differently," as the French philosopher Michel Foucault once put it, is no simple task.

The mutual entailment of questions of embodiment, truth, and identity was made clear at the outset in presentations and in early face-to-face interviews in 1996 with U.S. researchers, antismoking advocates, and public health officials. In one instance, my status as a smoker or nonsmoker had to be established with an assistant before an appointment could be arranged. This represents an extreme example, but subsequently the issue of whether I was a smoker or not would return periodically in interviews and even more persistently in colloquia and conversations with colleagues about my current work. Often, queries concerning the identity of this author were not limited to bodily practices alone but included routine questions about funding and information sources.[16] For example, in one interview, one California public health official began by asking who funded my work (the Committee on Research, Academic Senate, University of California, San Diego) and later interrupted the interview, asking, "How come you know so much?" I was at pains to convince the interviewee that databases and collections in research libraries as well as Internet access could account for the detailed questions I was posing.

Or again, one year later, when, although I had come with the recommendations of leading public health researchers, the head of a state tobacco control office turned down a long-standing request for an interview, citing among other reasons that "we don't know you." These brief examples suggest that issues concerning one's identity and bodily habits, funding sources, and truth-saying have a tendency to run parallel to one another and at times to intersect and merge in current discourses of antismoking.

Now, in the context of the U.S. tobacco wars, which have revealed repeated instances of tobacco industry funding, on the one hand, of scientific research that questions the results of widely accepted smoking studies, and on the other of political initiatives meant to halt antismoking measures, such suspicion with respect to an inquiring researcher seems amply warranted.[17] Indeed, throughout the 1990s the California campaign has been the object of numerous attempts by the tobacco industry and its political allies such as Governor Pete Wilson, to defund it; the outgoing (1993–98) director of the California Department of Health Services, Kimberly Belshé, a Wilson appointee, was a spokesperson for the tobacco industry-funded group that opposed the antismoking Proposition 99 in 1988 (Ellis 1993).

Moreover, the recurring need to know someone's status as smoker or non-smoker also testifies to the powerful cultural and social role cigarettes have enjoyed in United States culture in the twentieth century. Not only have they always been objects of desire, exchange, and taboo but they have also been thoroughly woven into the lives of users and nonusers alike—from styles of self-presentation and practices of sociability to the very way one makes one's way through the day at home, work, or play to their role as forms of pleasure and self-medication (Klein 1993). Thus in U.S. culture nothing is at once more personally and socially determined than smoking. And when in the tobacco wars participants, observers, and those who fall in between are assigned a very situated body, that of the smoker or nonsmoker, the task is rendered even more complex.

Hence, in one workshop setting, where I gave a paper on the cultural narratives of antismoking ads, before presentations and discussion had begun, everyone in the room was asked by one participant to identify themselves as a smoker, former smoker, or nonsmoker. Unfortunately but perhaps predictably, later discussion of the paper remained largely caught up in personal statements by participants on how smoking had directly affected their lives and those of their cohorts. At another presentation in a different meeting, in reply to a query I made of a member of the audience who had asked "the question" as to how the possible response could affect the reception of my analysis, I got no re-

sponse except that I sounded "defensive." The field and the challenges it presented to the present researcher had clearly expanded to professional settings.

Smoker, Anyone? or, The Crisis of Identity and Truth in Studying across Public Health

In this respect, it would appear that the study of antismoking campaigns and other scholarship on abortion, contraception, women's health issues, and HIV/AIDS share the task of tracking contemporary debates that have entered U.S. mainstream culture in a highly volatile form, which often plays out an identity politics of sorts whereby one's position or relation to, say, safer sex, mandatory HIV testing, child abuse, or abortion can be read off one's bodily practices, appearance, gender, or racial, ethnic, class, regional, or religious background. According to the narrowest version of this identity politics, knowing someone's identity is, in the end, to know enough, and little more needs to be said.[18] This naming of an identity to discredit the speaker or writer is frequently what happens to those in marginal positions outside the mainstream, including—as Kath Weston reminds us—so-called indigenous or native ethnographers studying their own communities (1997, 172–73). Here is where the kinds of knowledges produced by the fieldwork narrative of otherness and the health prevention and public health discourses of tobacco control sometimes intersect.

In a sense, politicized as U.S. public debate may be, the situation at least arguably affords the refreshing opportunity of dispelling any lingering illusions of claims to classical objectivity in the field or archival work (secured by professional experience, method, what have you). Moreover, what is at hand is a reversal of the standard fieldwork narrative in which the informant's body and culture are made increasingly visible while those of the researcher enjoy almost complete invisibility: his or her body and culture are all too visible, and he or she can end up being the object of scrutiny and interrogation.

The present situation is both like and unlike that described by Weston with respect to the native ethnographer who is located somewhere halfway between being *them* and being *us* (1997, 173–74). In the present example, not only is the researcher's body framed and inscribed by the very discourses on smoking he wishes to study, but it also serves as the basis for discrediting his entire research enterprise. It would appear that one of the working assumptions in the United States that often frames the fieldwork question "Are you a smoker?" is that no nonsmoker would be prompted to inquire into the cultural ramifications of

campaigns and ordinances deterring citizens from smoking or taking up the habit.[19] Thus there arises an intractable catch: the researcher's embodiment has to be the "right one," not that of a smoker but, at this time at least in the United States, that of a nonsmoker. For, if I have understood the logic correctly, the nonsmoker's body would presumably serve as the guarantee of the quality of his or her inner thoughts, intellectual processes, ethical commitments, and motivations. Yet if this is so, then there is a double logic operating here, which tends to make disappear not only the researcher but his or her project, all together. It is at this point that the discourse of addiction apparently intervenes. If to be a researcher of antismoking campaigns is perforce to be a smoker, according to the definition of smoking as an addiction, to be a smoker is to disqualify oneself automatically as a researcher, for one's thoughts, desires, and motives no longer belong to a disciplined, inquiring mind but rather are possessed by the imperatives of a craving for tobacco and, by extension, by the tobacco industry, to whose blandishments and products one has already succumbed.[20] In terms of this discourse, then, there can be no such thing as a disembodied researcher of U.S. tobacco control. (And, as I will discuss below, if you aren't identifiably a smoker, you may run the risk of being assigned a deficient inner life all the same, one lacking "compassion.")

Let us pursue the present line of analysis. In studying across tobacco control, the researcher-cum-smoker's body represents *excessive* embodiment (that is to say, the researcher and his or her research is reduced by the discourse of addiction to being the mere expression of physical need), while by implication at least the nonsmoker's or former smoker's body (75 percent of the adult U.S. population, or 83 percent of the adult population in California) represents under- or nonembodiment. In various interviews, professional venues, and media accounts the only adult body under regular scrutiny is often that of the smokers (and in the case of minors, likely smokers). Other forms of embodiment are routinely passed over, excepting that of victims of secondhand smoke, in which case the polluted or polluting bodies of smokers threaten to transform the bodies of nonsmokers into likenesses of their own (see also Reid 1997). Thus in this fashion, the truth-saying authority of the two groups is radically opposed: the invisible or absent body continues to enunciate truth.

The privilege of reading identity off bodies, interiority off identity, and bodies off practices is a complex question, especially in the present context. Compared to other controversial health issues, with smoking reading one's position of smoking off one's practices or background (and vice versa) is perhaps even more difficult; for tobacco control and its restrictions have become so utterly mainstream that tobacco control is not associated with or been seen

by the media as the special purview of smaller U.S. groups or subcultures (people with AIDS, gays, feminists, women's health advocates, etc.).[21] In a sense, the smoking issue involves "everyone" (and that's certainly the claim made by public health officials and antismoking advocates) and therefore "no one"; identifiable parties are hard to come by except for the tobacco industry, voluntary health organizations, health care professionals, and public health officials. This may be why, in the end, dominant discourses seem to insist on a fundamental division between, on the one hand, those who smoke and, on the other, those who do not (especially those groups understood to be most at risk or vulnerable to other's smoke or to the seductions of tobacco advertising—teenagers, children, and fetuses).

Still, the problem, of course, is how do you tag a smoker? Given the persistent numbers of smokers in just about every socioeconomic, ethnic, racial, gender, and sexual group in the United States, it is a daunting enterprise.[22] At first glance, no legible identity emerges with recognizable features. To be sure, there are the smoker's "voice," "cough," "facial lines," and "smell," relentlessly portrayed in counteradvertising, which may identify heavy smokers (perhaps more reliably nowadays, as secondhand smoke declines in closed public spaces), but still, these aren't always very reliable. And then, if to identify regular smokers is hard enough, how do you distinguish social smokers? part-time smokers? or more recently, the growing numbers of cigar smokers? closeted binge or weekend smokers? And in the case of minors, what about *potential* smokers? Conversely, what about never-smokers or *former* smokers (respectively 50 percent and 25 percent of the adult population)?[23] What bodies do they have, and what are their powers of truth-saying?

In any case, some of these difficulties and the paradoxical status of smoking as a social and cultural practice in the present juncture in the United States—done perhaps in fewer and fewer numbers by "others" yet nonetheless to some degree by "all"—may have something to do with the great lengths to which antismoking counteradvertising, the media, and news organizations in the 1990s strove to name smokers and their habit. A great cultural labor has been under way for some time that seeks to distinguish smokers from the rest of "us," the general population. In California, for example, antismoking ads in the early and mid-1990s repeatedly likened smokers to tragically isolated individuals, postmenopausal women or postclimacteric men, shapeless members of the working class, French nationals, the genetically deficient, addicts, serial killers, gangsters, and in a more humorous vein, farting cows (Reid 1997). Great energy has been expended on efforts to construct a smoker's identity and willy-nilly to locate that identity in restricted domains of the social body

(teenagers, people of color, immigrants, and the non–middle class generally) at a remove from the "general population." In other words, the uncertainties of identifying smokers actually may have spurred efforts that have contributed to a pathologizing social discourse both outside and inside the academy and public health. They may have nourished a caricatural politics of truth-saying and identity politics of risk group construction in which what may perhaps be the starting point of epidemiological inquiry ("Who smokes?") inadvertently winds up being the explanatory cause.[24]

The Theater of Concern and the Return to Manageable Objects

In researching tobacco control practices, the ethical, political, and epistemo-logical uncertainties of studying across run high. They are compounded if you are not identifiably a smoker or a paid agent of the tobacco industry, that is to say, a prisoner of addiction or special interest; in which case the state of one's inner thoughts may no longer be questioned by way of bodily habits or fund-ing sources but is sometimes interrogated directly, most often in terms of a lack of "compassion." And if this takes place in an academic setting and disci-plinary issues are at stake in the encounter, the accusation can be followed by strong gatekeeping of the field in question.

For example, in reaction to an invited paper on probabilistic thinking and narratives of risk in antitobacco advertising and health reports delivered to a panel devoted to mapping a new subfield called public cultures of science at the annual meeting of the American Anthropological Association, one of the respondents chose to complain that I had not made clear whether I believed the statistics and could not understand how the social implications of antito-bacco narratives could be given serious consideration when compared to the sufferings and deaths of victims of tobacco. In a second pass through the eight papers that had been presented, the respondent then proceeded to locate them in their respective places within the new domain of the public cultures of sci-ence. The eighth one—on actuarial narratives in tobacco control—was passed over in silence.

Several things require comment. Clearly, the panel involved multiple thresholds: it was at once an attempt to map an emerging area of study and, in the case of this author's paper, the intervention of a researcher from outside the discipline of anthropology. Thus intellectual and field uncertainties were bound to come to the fore, and boundary construction and policing were to be expected. What was interesting, even startling, was the form they took. Here,

the tobacco control researcher was subjected to a form of scrutiny others were not, but interestingly, this time the interlocutor publicly took on embodiment as the compassionate subject by virtue of the author's putative lack of concern for human suffering. The effect was at once to align the speaker and the official discourses of tobacco control (and a particular discipline) with unassailable ethical claims and to remove tobacco control from cultural analysis, thereby shutting down discussion. Once again, a double logic was at work: here, to ask certain questions publicly was tantamount to not showing that you "cared," and not to "care" meant not to qualify as a researcher and, in this case, as a member of a new subfield of anthropology.[25] More broadly, it would appear that to inquire about the cultural ramifications of tobacco control amounts to denying those truth claims all together.

In a sense, the invocation of compassion and care by the respondent could be understood as an attempt not only to substitute the bodies of tobacco victims for the practices of tobacco control as the basis for discussion but also to substitute the perspective of studying down of traditional fieldwork for studying across, and in so doing shift the discussion to more stable epistemological and ethical ground.[26]

Making Strange and the Ethics of Uncertainty

In this final section I'd like to return to Henry Abelove's metaphor of taking one's own pulse for the difficulties of studying the contemporary culture in which one lives. In the manner of those who work in text-based disciplines, I worried Abelove's phrase to make it yield a sensitive instrument for broaching the complexities of studying across, and to make the claim that self-study involves the study of something else that is not quite your own or yourself but is nonetheless intimately linked to you. I was making the implicit argument that there is no self-study that doesn't involve the study of others, and conversely, no version of studying across—more than when you are studying down or up—that doesn't entail the study of yourself and culture, especially when it is middle-class researchers studying other middle-class researchers as is the case in interdisciplinary studies of scientific and medical practices. The issue of otherness and differences in power, privilege, and culture of course remain, and in this particular research setting take on a disciplinary guise: the folkways of those involved in tobacco control (epidemiologists, health educators, medical researchers, lawyers, and media professionals) and those of humanists and social scientists who study them.

What has made studying tobacco control so interesting is how the "field" quickly expanded into academic settings in which preliminary results were presented. The fact that I run up against as many obstacles in encounters with colleagues as with informants directly involved in the controversy suggests— perhaps in a way that complements what D'Amico-Samuels meant—-that in studying across, the field can indeed be anywhere, and that practices and discourses one is trying to understand are located across many social worlds, especially if these worlds are those of middle-class background and professional training. The epistemological and ethical assumptions of antismoking discourses— the politics of truth and identity—are widespread and, as is in the nature of a public controversy, circulate between academe, research sites, media, and popular culture.

This suggests that if tobacco or rather its regulation is one of those "boundary objects," which, according to S. Leigh Star and James L. Griesemer (1989) are objects of research that provoke boundary disputes between fields, it is a particularly volatile and mobile one. This is perhaps another reason that in following, for example, the trajectories of tobacco control discourses, one quickly bumps up against those borders and their assumptions (assumptions that may have more in common than participants will acknowledge) and is pushed toward interdisciplinary approaches to science and medicine. The boundaries in question are between the humanities and social sciences, among epidemiologists, medical researchers, media professionals, and public health officials, and finally between the former and latter groupings of fields.

Embedded in Abelove's words is an alternative ethics and epistemology to that which underwrites the standard fieldwork narrative. When he writes, "Trying to know anything about what is most familiar must produce a sense of strangeness, difficulty," I want to argue that the "strangeness" here is not that of radical otherness and that the "difficulty" is not the difficulty of "failed epistemology" or "impossible object" but that of a different kind of object and different kind of epistemology.

Something akin to this can be found in Sharon Traweek's (1988) meditation on "repatriated fieldwork" (studying high-energy physicists in the United States). She writes,

> It might seem that an American fieldworker would share the common sense cultural expectations of American physicists. Traditional anthropologists have sometimes been suspicious of "repatriated" anthropology, arguing that without strangeness the fieldworker cannot identify the cultural assumptions

of a community; they believe that the shared common sense is transparent and hence invisible.

The premise is surely right, but the cases where it applies are rarer than they may seem. For one thing, repatriated anthropology is just that: one of the main reasons I worked in Japanese labs before returning to SLAC was to acquire strangeness. Within the United States, in spite of the image of the melting pot, regional, class, ethnic, religious, and occupational differences give rise to sharply differing experiences of the world.

Traweek both acknowledges the anthropological goal of producing and studying "strangeness" and, in my view, shifts it toward a fieldwork/research dynamics in which fully manageable and thus knowable objects can no longer be reliably found and studied; for the "field" swarms with too many differences.

In a similar vein, Bruno Latour and Steve Woolgar in their early study (1986) explicitly borrow modified concepts from ethnography; they argue for a different form of "strangeness," a space of *uncertainty* not marked by a narrative of "exoticism":

> Our current position on "ethnography" is slightly different. Its main advantage is that unlike many kinds of sociology (especially marxist), the anthropologist *does not know* the nature of the society under study, nor where to draw the boundaries between the realms of the technical, social, scientific, natural, and so on. This additional freedom in defining the nature of the laboratory counts for much more than the artificial distance which one takes with the observed. This kind of anthropological approach can be used on any occasion when the composition of the society is uncertain. It is not necessary to travel to foreign countries to obtain this effect, even though this is the only way that many anthropologists have been able to achieve "distance." Indeed, this approach may very well be compatible with a close collaboration with the scientists and engineers under study. We retain from "ethnography" the working principle of *uncertainty* rather than the notion of exoticism. (279)

I want to argue that when read together, these passages on studying scientific practices suggest a way to understand "difference" differently and thereby transform the very notions of researcher, research subject, and the ethnographic "distance" between them. In this reconceptualization of research and field dynamics outside the frame of exotic otherness, researchers are no more distant enough than others are other enough: intimacies, ambiguities, and ambivalence abound, as do unassimilable differences and power relations.[27] They

are the very stuff of research and no longer stand as the "noise" that needs to be managed or eliminated by methods, experimental writing, going "home," narrow identity politics, or declarations of good intentions or compassion (Kirby 1993). This vexed space of (research) encounters (from interviews to academic venues to popular culture) resembles what Mary Louise Pratt termed in a later essay in another context "contact zones" (1991). They are zones in which no one and nothing is either innocent or safe, least of all in this case the most cherished disciplinary narratives guiding our research and defining our research selves as we engage with how practitioners come to know the social and natural worlds.

Notes

1. This settlement collapsed in the summer of 1998 under the pressure of partisan politics, a $50 million media blitz by the tobacco industry, and disagreements among public health advocates. It was revived in a weaker version in late 1998.

2. For example, see Abelove 1994; Cartwright 1995; Clarke 1998; Crimp 1989; Epstein 1996; Fujimura 1996; Gilman 1995; Hammonds 1987; Haraway 1989, 1991, 1997; Hartouni 1997; Martin 1987, 1995; Patton 1990; Terry 1989; Treichler 1989; Watney 1987, 1995.

3. The media campaigns were initiated by the California Department of Health Services in 1990 with funding stemming from tax revenues generated by Proposition 99, passed in 1988. Annually, the tax raises about $600 million, 20 percent of which is allocated to tobacco education (2 percent to the media campaign proper). By virtue of its hard-hitting paid advertising deglamorizing smoking, attacking the tobacco industry, and warning the public about the dangers of secondhand smoke, the California media campaigns from their inception have attracted a great deal of attention; in the early and mid-1990s, the comprehensive California tobacco control effort of which the media campaigns were a component was regarded by many public health officials and antitobacco activists nationwide and even outside the United States as a model for tobacco control health promotion (see Bal et al. 1990; Reid 1997).

4. My research has led me to investigate social and cultural issues including the following: the transformation of built public and private space (especially by the concept of secondhand smoke); shifts in definitions of childhood and adolescence introduced by tobacco control; the relationship between expert knowledge and citizens' "common sense"; the elaboration of new social, racial, gender, ethnic, and national distinctions based on smoking; the stigmatization of smoking as a drug addiction and as deviant behavior; and the transfer of health promotion technologies such as "social marketing" (the use of methods of commercial advertising for the promotion of public interest issues) from one cultural context to another.

5. In the United States, older work on the sociology of workplaces, which was associated with Everett Hughes and Donald Roy and appeared in the 1950s, did have some discussions of studying up, down, and across (S. Leigh Star, personal communication). See for example Hughes 1984.

6. For feminist reflections on the issues of alliance and studying across, see Kirby 1993; Newton and Stacey 1995; and Stacey 1988.

7. For defining texts in European and North American cultural theory and criticism on these issues see, in English, anthologies by Adams (1969); Demetz et al. (1968); and Groden and Kreissworth (1994), as well as single works such as Barthes 1975.

An important scholarly literature has grown over the last fifteen years on middle-class culture as such. Some scholars claim that the nineteenth-century middle class was the first social class to come into being in Western Europe and North America whose identity and power resided also in the ability to produce, manipulate, and consume print documents and print culture in general. See Armstrong 1987 and Reid 1993; in anthropology and history, see Anderson 1983.

Readers will remark that the fields I have named are all located within the humanities (history often straddling humanities and social sciences). Roughly speaking, humanities have traditionally spent most of their time studying the past (of which they constitute themselves the custodians) and in so doing, simply through temporal difference as well as through canon and archive construction, they too can project a sufficiently "other" other even at home. This also may account for a certain form of conservatism that stands out in the eyes of social scientists: it is often the "present" (be it mass culture, late capitalism, or postmodernity) that threatens these fields in terms of their self-understanding and the cultures to the study of which they are devoted. Hence the peculiar form their periodic resistance to interdisciplinary fields like cultural studies, which set for themselves something other than the role of guardians of the past and take an active interest in applying both humanistic and social science approaches to emerging social and cultural practices as well as to those of the past. Cultural studies creates discomfort among social scientists, as well, not only by bringing methods of textual analysis to the treatment of social phenomena (a process once termed by one linguist as the "aestheticization of the social sciences") but also by borrowing from social scientists' own fieldwork methods (a growing trend nowadays). Interestingly, some of the earliest applications of literary theory to the social studies of contemporary practices have been by sociologists and anthropologists themselves in early studies of scientific labs dating from the 1970s; see Latour and Woolgar 1979; Lynch 1985; Traweek 1988; in qualitative sociology see also Gusfield 1976.

8. In *Anthropology as Cultural Critique*, revisionist anthropologists George Marcus and Michael Fischer do briefly broach the subject of ethnographic study of other middle-class professionals without reference to a discourse of otherness. However, they do not elaborate what the consequences of dispensing with such a discourse might be (1986, 153–55).

9. I think it is fair to say that in this context, "anyone" should be taken to mean mainly those with university education and access to funding sources and publication venues.

10. Conversely, in terms of the disciplinary imperatives alone (in addition to the political imperatives of "speaking back" by marginalized groups), this may explain one of the attractions of indigenous ethnography: the flip side of a (failed) enabling fieldwork narrative of *radical, exotic difference* would be that of *radical identity*. Yet there, too, in terms of this conventional narrative, fieldworkers encounter another "impossible object" and "failed epistemology": see Kate Weston's meditation (1997) on the impossibility of being both an anthropologist and a member of the gay community. And if in studying "across" the other isn't "other" enough, here, in indigenous ethnography, in studying one's own group or subculture Weston suffers in the eyes of both her colleagues and her community for not being "us" enough for either group. As Weston points out, in these practices of professional and community identity, there is little room for hybridity or a multiply determined self.

11. In an essay published in 1997, George Marcus actually replays the scenario of the ethnographer as citizen-native, but now in the context of globalization. Revisiting the "radical implications of the new theoretical visions and discussions of anthropology's changing object of study" in the context of globalization (89), he converts the compression of the time and space of "here" and "there" by globalization and the resulting mutual "fascination" between globalized fieldworker and globalized informants into an opportunity for multisited research based on self-acknowledged complicity, the new cognitive condition in a globalized world. In this account the old anthropological categories of insider/outsider, rapport, and alliance give way to a complicitous relationship between fieldworker and subjects, based on "an affinity, marking equivalence" (100), of a "shared imagination" (101) and a shared "existential consciousness" that stems from "their mutual curiosity and anxiety about their relationship to a 'third'"—those specific sites of a globalized elsewhere that inflect their interactions (100).

Yet once again the old, much desired collapse of difference (here, the transnational researcher has not only gone native but *is* a (global) native and enjoys the native's "double-consciousness") is accompanied by the equally desired affirmation of difference in which, in this new version of globalized cosmopolitanism, the anthropologist retains the privilege and obligation of articulating these globalized situations: "Complicity here rests in the acknowledged fascination between anthropologist and informant regarding the outside 'world' that the anthropologist is specifically materializing through the travels and trajectory of her multi-sited agenda" (100).

Here, Marcus's globalized, multisited field is, in the end, modeled on the transferential space of Freudian and Lacanian psychoanalysis in which the researcher as analyst occupies the privileged transnational place of the transcendental Other—globalization as master signifier—to the informant/analysand.

12. Although Forsythe doesn't broach the question, what also may be at issue is on the one hand, how social scientists who self-identify as scientists feel looked down upon by physical and life scientists, and on the other how, although they view scientists as colleagues, they often refer to these same colleagues as "them" (see Hess 1992, 13, and Star 1995, 23).

13. This is compounded of course by other factors such as gender, race, class background, and so forth. In Forsythe's essay, the graduate student/assistant professor is gendered female. Elsewhere, Forsythe commented on the peculiar status of female graduate students doing fieldwork in male-dominated settings; in her view their non-threatening status as female graduate students, combined with the sexual dynamics often present between older men and younger women, may account for the fact that many of the most effective ethnographies have been by white female researchers at the beginning of their careers (Forsythe, Bay Area Biology Study Group, November 1994). On the tendency of ethnographers to other the scientists they study and portray themselves as underdogs, see Rouse (1996; 244–45). A further complicating factor is another well-known but rarely acknowledged fact that in terms of career trajectories, in the United States humanists and social scientists are commonly recruited from upper-middle-class backgrounds, whereas many natural scientists and engineers start their careers from more modest beginnings (Ladd et al. 1974).

14. It is interesting to note that a graduate student, otherwise an admirer of Gusfield's, explained the sociologist's position by the fact that he was a smoker. Later, in a public lecture in February 1998 on the smoking controversy, Gusfield stated that he had stopped smoking forty years earlier.

15. For a layperson review of the hazards of smoking and the history of the tobacco industry, see Kluger 1995. On the new model of causality that statistically based epidemiological studies of the effects of smoking introduced into medical discourse, see Brandt 1990. For key studies on secondhand smoke see Glantz and Parmley 1991; Hirayama 1981; and U.S. Surgeon General 1986. On the process of scientific "blackboxing" see Latour 1987.

16. Susan Harding (1991, 375)reports that when she began doing fieldwork on fundamentalist Christians, colleagues quizzed her repeatedly on her background and questioned her motives.

17. An epidemiologist supportive of my research project, before granting further interviews, actually requested from me a public statement in e-mail form attesting to the fact that I had received no tobacco industry funding; he then circulated it to tobacco control advocates in California and suggested that I keep a copy of our correspondence and use it as a way to obtain interviews with other reluctant informants.

Research and public discussion are further hindered by the adoption by the tobacco industry of a strategy recommended by corporate consultants Edward A. Grefe and Martin Linsky that consists of corporations not only borrowing tactics from the tradition of U.S. grassroots organizing but also aggressively appropriating any criticism of public health positions as their own. In so doing the tobacco industry effectively preempts any

"third" or "fourth" position and forcibly maintains public discussion in a polarized form in which two positions alone are sanctioned: theirs or that of antitobacco advocates and public health officials (see Grefe and Linsky 1995). Thanks to Joe Dumit for bringing this reference to my attention.

18. The limits of various essentialist identity politics have been identified and discussed extensively, less so in the fields of public health and health prevention than in feminist, postcolonial, and queer studies. See, for example, Lisa Lowe, "Heterogeneity, Hybridity, Multiplicity: Asian American Differences" (1996); for an early critique of confusion of "risk factors" with "risk groups" in HIV/AIDS discourse see Grover 1987; see also Lupton 1995, 77–105; and Gilman 1995. For a standard epidemiology textbook presentation of these issues see Gordis 1996, 141–62, 183–95.

19. In Japan, which has a very different situation with respect to smoking and tobacco control, the opposite assumptions may obtain. In reference to my research, I have frequently been asked whether I am a smoker; the assumption apparently being that only a *nonsmoker* would care to undertake such an inquiry. On the other hand, in France, I have rarely been asked such questions. Obviously, further fieldwork is in order to clarify this issue.

20. The dominance of the discourse of addiction may be peculiar to the U.S. context; in France, for example, antismoking advocates shy away from a psychopharmacological approach to the issue (Hirsch and Karsenty 1992, 71–74, 113–14).

21. However, ever since a tobacco settlement was tentatively reached in June 1997, the issue of tobacco control has tended to be delegated to lawyers of both sides, state attorneys general, and highly visible health care professionals and tobacco industry CEOs.

22. Here are recent figures from the CDC as of 1994: overall population 25.5 percent, males 28.2 percent, females 23.1 percent, whites 26.3 percent, blacks 27.2 percent; and as of 1987–91: Asian/Pacific Islander 23.6 percent, American Indian/Alaska Native 38 percent, and Hispanic 28.6 percent (Centers for Disease Control and Prevention 1998b and 1998c). There is one group whose reported smoking rates have gone down steadily and are consistently lower than others: those citizens with at least a college education—13.9 percent (Centers for Disease Control and Prevention 1995). This suggests that what may *also* be at issue in antismoking campaigns are the preoccupations of those citizens who are primarily knowledge producers; on the social and identity politics of health campaigns, see Reid 1997, 549–50.

23. In epidemiological studies the definition of a smoker commonly adopted is that of someone who has smoked at least one cigarette in the last thirty days and has smoked at least one hundred cigarettes over a lifetime.

24. On the problems of risk group construction in epidemiology and health promotion see Lupton 1995 and Beaglehole and Bonita 1997.

25. Although many scholars who perform fieldwork do not enact this drama of ethos, the theater of concern remains an unacknowledged practice in U.S. academic settings. Other examples could be cited. One researcher who conducts fieldwork on environmental issues in developing nations recounts repeated instances of being upbraided

by senior colleagues for not demonstrating more palpable emotion, including tears, in presenting her material to the public.

26. It also falls into what Paul Rabinow (1996, 20–21), in referring to the challenges of fieldwork, terms the trap of *ressentiment,* which "requires, demands, fabricates, and defends clearly drawn boundaries between subjects and objects in order to operate," and a "politics of victimage," which "yields a politics of moral superiority."

27. In his reflections on studying scientists in biotechnology, Rabinow (1996, 15–25), like Forsythe, argues there is a partially shared culture between informants and field-workers. He goes on to claim that another commonality between them arises out of parallel experimental practices of problematization and reflective curiosity in social/in-stitutional fields undergoing change. While provocative, his remarks in my view assume an ideal orderliness to the labor of both kinds of research that may be rarer than he al-lows and come close to returning us to a refurbished concept of "rapport" and the ro-mance of cosmopolitanism. This would be the subject of another essay.

Works Cited

Abelove, H. 1994. "The Politics of the 'Gay Plague': AIDS as U.S. Ideology." In *Body Politics: Disease, Desire, and the Family,* edited by M. Ryan and A. Gordon, 3-17. Boulder, Colo.: Westview Press.

Adams, Hazard. 1968. *The Interests of Criticism. An Introduction to Literary Theory.* New York: Harcourt, Brace and World.

Adler, Patricia, and Peter Adler. 1994. "Observational Techniques." In *Handbook of Qualitative Research,* edited by Norma K. Denzin and Yvonna Lincoln, 377-92. Thousand Oaks, Calif.: Sage.

Anderson, Benedict. 1983. *Imagined Communities: Reflections on the Origin and Spread of Nationalism.* London: Verso.

Armstrong, Nancy. 1987. *Desire and Domestic Fiction.* New York: Oxford University Press.

Atkinson, Paul, and Martyn Hammersly. 1994. "Ethnography and Participant Observation." In *Handbook of Qualitative Research,* edited by Norma K. Denzin and Yvonna Lincoln, 248-61. Thousand Oaks, Calif.: Sage.

Bal, D. G., K. W. Kizer, P. G. Felten, H. N. Mozer, and D. Niemeyer. 1990. "Reducing Tobacco Consumption in California." *Journal of the American Medical Association* 264, no. 12:1570-74.

Barthes, Roland. 1975. *The Pleasure in the Text.* Translated by Richard Miller. New York: Hill and Wang.

Beaglehole, Robert, and Ruth Bonita. 1997. *Public Health at the Crossroads: Achievements and Prospects.* Cambridge, England: Cambridge University Press.

Brandt, Alan. 1990. "The Cigarette, Risk, and American Culture." *Daedalus,* fall: 155-76.

Brody, Jane E. 1996. "Swiss Research Links Smoking with Breast Cancer." *New York Times,* May 5, A12.

Burawoy, Michael, et al. 1991. *Ethnography Unbound: Power and Resistance in the Modern Metropolis.* Berkeley: University of Calif. Press.

Cartwright, Lisa. 1995. *Screening the Body: Tracing Medicine's Visual Culture*. Minneapolis: University of Minnesota Press.

Centers for Disease Control and Prevention. 1995. *Smoking and Health Information: Trends in Percentage of Adults by Cigarette Smoking Status*. Washington, D.C.: Government Printing Office.

————. 1998a. "Tobacco Use among High School Students, United States, 1997." *Morbidity and Mortality Weekly Report* 47, no. 12 (April 3):229–33.

————. 1998b. "CDC's Tips: Percentage of Adults Ages 18 Years and Older by Cigarette Smoking Status." www. cdc.gov.

————. 1998c. "CDC's Tips: Smoking Prevalence among US Adults." www.cdc.gov.

Clarke, Adele E. 1998. *Disciplining Reproduction: Modernity, American Life Sciences, and "the Problems of Sex."* Berkeley and Los Angeles: University of California Press.

Clifford, James. 1997. *Routes: Travel and Translation in the Late Twentieth Century*. Cambridge, Mass.: Harvard University Press.

Crimp, Douglas, ed. 1989. *AIDS: Cultural Analysis/Cultural Activism*. Cambridge, Mass.: MIT Press.

D'Amico-Samuels, Deborah. 1991. "Undoing Fieldwork: Personal, Political, Theoretical, and Methodological Implications." In *Decolonizing Anthropology: Moving Further toward an Anthropology for Liberation*, edited by Faye V. Harrison, 68–85. Washington, D.C.: Association of Black Anthropologists and the American Anthropological Association. .

Demetz, Peter, Thomas Greene, and Lowry Nelson, eds. 1968. *The Disciplines of Criticism: Essay in Literary Theory, Interpretation, and History*. New Haven, Conn.: Yale University Press.

Denzin, Norman K., and Yvonna Lincoln. 1994. "The Fifth Moment." In *Handbook of Qualitative Research*, edited by Norma K. Denzin and Yvonna Lincoln, 575–86. Thousand Oaks, Calif.: Sage.

————. 1994b. *Handbook of Qualitative Research*. Thousand Oaks, Calif.: Sage.

Drews, C. D., C. C. Murphy, M. Yeargin-Allsopp, and P. Decouflé. 1996. "The Relationship between Idiopathic Mental Retardation and Maternal Smoking during Pregnancy." *Pediatrics* 97, no. 4:547–53.

Ellis, Virginia. 1993. "Whiff of the State Health Chief's Past Makes Smoking Foes Gag." *Los Angeles Times*, November 23, A3.

Epstein, Steven. 1996. *Impure Science: AIDS, Activism, and the Politics of Knowledge*. Berkeley and Los Angeles: University of California Press.

Fine, Michelle. 1994. "Working the Hyphens: Reinventing Self and Other in Qualitative Research." In *Handbook of Qualitative Research*, edited by Norma K. Denzin and Yvonna Lincoln, 70–82. Thousand Oaks, Calif.: Sage.

Fontana, Andrea and James H. Frey. 1994. "Interviewing: The Art of Science." In *Handbook of Qualitative Research*, edited by Norma K. Denzin and Yvonna Lincoln, 361–76. Thousand Oaks, Calif.: Sage.

Forsythe, Diana. 1995. "Ethics and Politics of Studying Up." Paper presented to the American Anthropological Association, Washington D.C., December.

Fujimura, Joan. 1996. *Crafting Science: A Sociohistory of the Quest for the Genetics of Cancer*. Cambridge, Mass.: Harvard University Press.

Gilman, Sander L. 1995. *Health and Illness: Images of Difference*. London: Reaktion.

Glantz, Stanton A., and William W. Parmley. 1991. "Passive Smoking and Heart Disease: Epidemiology, Physiology, and Biochemistry." *Circulation* 83, no. 1:1–12.

Gordis, Leon. 1996. *Epidemiology*. Philadelphia: Saunders.

Gordon, Deborah A. 1988. "Writing Culture, Writing Feminism: the Politics and Poetics of Experimentalist Ethnography." *Inscriptions* 3/4.

Grefe, Edward A., and Martin Linsky. 1995. *The New Corporate Activism: Harnessing the Power of Grassroots Tactics for Your Organization.* New York: McGraw-Hill.

Groden, Michael, and Martin Kreisworth. 1994. *The Johns Hopkins Guide to Literary Theory and Criticism*. Baltimore: Johns Hopkins University Press.

Grover, Jan Zita. 1989. "AIDS: Keywords." In *AIDS: Cultural Analysis/Cultural Activism,* edited by Douglas Crimp, 17–30. Cambridge, Mass.: MIT Press.

Gupta, Akhil, and James Ferguson. 1997. "Discipline and Practice: 'The Field' as Site, Method, and Location in Anthropology." In *Anthropological Locations: Boundaries and Grounds of a Field Science,* edited by Gupta and Ferguson. Berkeley and Los Angeles: University of California Press.

Gusfield, Joseph. 1976. "The Literary Rhetoric of Science." *American Sociological Review* 41:16–34.

———. 1993a. "Smoke Gets in Your Eyes." *Journal of Health Politics, Policy, and Law* 18, no. 4:983–92.

———. 1993b. "The Social Symbolism of Smoking and Health." In *Smoking Policy: Law, Politics, and Culture,* edited by R. L. Rabin and S. L. Sugarman, 49–68. New York: Oxford University Press.

Hammonds, Evelynn. 1987. "Race, Sex, AIDS: The Construction of 'Other'." *Radical America* 20, no. 6:28–36.

Haraway, Donna J. 1989. *Primate Visions: Gender, Race, and Nature in the World of Modern Science.* New York: Routledge.

———. 1991. *Simians, Cyborgs and Women: The Reinvention of Nature.* New York: Routledge.

———. 1997. *Modest_Witness@Second_Millennium.FemaleMan©_Meets_Oncomouse™: Feminism and Technoscience.* New York: Routledge.

Harding, Susan. 1991. "Representing Fundamentalism: The Problem of the Repugnant Cultural Other." *Social Research* 58, no. 2:373–93.

Hartouni, Valerie. 1997. *Cultural Conceptions: On Reproductive Technology and the Remaking of Life.* Minneapolis: University of Minnesota Press.

Hess, David J. 1992. "Introduction: The New Ethnography and the Anthropology of Science and Technology." In *The Anthropology of Science and Technology,* edited by David J. Hess and Linda Laywe, vol. 9 of *Knowledge and Society,* 1–26. Greenwich, Conn.: JAI Press.

Hirayama, T. 1981. "Non-Smoking Wives of Heavy Smokers Have a Higher Risk of Lung Cancer: A Study from Japan." *British Medical Journal* 282:183–85.

Hirsch, Albert, and Serge Karsenty. 1992. *Le Prix de la fumée.* Paris: Odile Jacob.

Hughes, Everett C. 1984. "The Relation of Industrial to General Sociology." In *The Sociological Eye: Selected Papers,* 524–29. New Brunswick, N.J.: Transaction.

Kirby, Vicki. 1993. "Feminisms and Postmodernisms: Anthropology and the Management of Difference." *Anthropological Quarterly* 66, no. 3:127–33.

Klein, Richard. 1993. *Cigarettes Are Sublime.* Durham, N.C.: Duke University Press.

Kluger, Richard. 1995. *Ashes to Ashes: America's One Hundred-Year Cigarette War, the Public Health, and the Unabashed Triumph of Philip Morris.* New York: Knopf.

Ladd, Carll Everett, Seymour Martin Lispet, and Martin Trow, eds. 1974. *Carnegie Commission National Surveys of Higher Education.* Ann Arbor, Mich.: Inter-University Consortium for Political and Social Research.

Laqueur, Thomas. 1995. "In Defense of Smoking: The Cultural, Spiritual, and Historical Need to Light Up." *New Republic*, September 18 and 25, 39–48.

Latour, Bruno. 1987. *Science in Action.* Cambridge, Mass.: Harvard University Press.

Latour, Bruno, and Steve Woolgar. 1986. *Laboratory Life: The Construction of Scientific Facts.* Princeton, N.J.: Princeton University Press.

Lowe, Lisa. 1996. *Immigrant Acts: On Asian American Cultural Politics.* Berkeley and Los Angeles: University of California Press.

Lupton, Deborah. 1995. *The Imperative of Health: Public Health and the Regulated Body.* Thousand Oaks, Calif.: Sage.

Lynch, Michael. 1985. *Art and Artifact in Laboatory Science.* London: Routledge and Kegan Paul.

Marcus, George E. 1994. "What Comes (Just) after 'Post'?" In *Handbook of Qualitative Research,* edited by Norma K. Denzin and Yvonna Lincoln, 563–86. Thousand Oaks, Calif.: Sage.

———. 1997. "The Uses of Complicity in the Changing Mise-en Scène of Anthropological Fieldwork." *Representations* 59 (summer): 85–108.

Marcus, George E., and Michael M. J. Fischer. 1986. *Anthropology as Cultural Critique: An Experimental Moment in the Human Sciences.* Chicago: University of Chicago Press.

Martin, Brian. 1991. *Scientific Knowledge in Controversy: The Social Dynamics of the Fluoridation Debate.* Albany, N.Y.: State University of New York Press.

Martin, Emily. 1987. *The Woman in the Body: A Cultural Analysis of Reproduction.* Boston: Beacon Press.

———. 1995. *Flexible Bodies: Tracking Immunity in American Culture from the Days of Polio to the Age of AIDS.* Boston: Beacon Press.

Maugh, T. H. II. 1996. "Worldwide Study Finds Big Shift in Causes of Death." *Los Angeles Times*, September 16, A1.

Murray, C. J. L., and A. D. Lopez. 1996. *The Global Burden of Disease.* Summary. Harvard School of Public Health, World Health Organization, and the World Bank. Cambridge, Mass: Harvard University Press.

Nader, Laura. 1972. "Up the Anthropologist: Perspectives Gained from Studying Up." In *Reinventing Anthropology,* edited by Dell Hymes. New York: Random House.

Newton, Judith, and Judith Stacey. 1995. "Ms. Representations: Reflections on Studying Academic Men." In *Women Writing Culture,* edited by Ruth Behar and Deborah A. Gordon, 287–305. Berkeley and Los Angeles: University of California Press.

Nutall, Nick. 1997. "Mothers Who Smoke May Give Birth to Tearaways." *London Times,* July 15.

Passaro, Joanne. 1997. " 'You Can't Take the Subway to the Field!': Village Epistemologies in the Global Village." In *Anthropological Locations: Boundaries and Grounds of a Field Science,* edited by Akhil Gupta and James Ferguson, 147–62. Berkeley and Los Angeles: University of California Press.

Patton, Cindy. 1990. *Inventing AIDS.* New York: Routledge.

Pratt, Mary Louise. 1986. "Fieldwork in Common Places." In *Writing Culture,* edited by James Clifford and George E. Marcus, 27–50. Berkeley and Los Angeles: University of California Press.

———. 1991. "Arts of the Contact Zone." *Profession* 91:33–40.

Punch, Maurice. 1994. "Politics and Ethics in Qualitative Research." In *Handbook of Qualitative Research,* edited by Norma K. Denzin and Yvonna Lincoln, 83–97. Thousand Oaks, Calif.: Sage.

Rabinow, Paul. 1996. *Essays on the Anthropology of Reason*. Princeton, N.J.: Princeton University Press.

Reid, Roddey. 1993. *Families in Jeopardy: Regulating the Social Body in France, 1750–1910*. Stanford, Calif.: Stanford University Press.

——————. 1997. "Healthy Families Healthy Citizens: The Politics of Speech and Knowledge in the California Anti-Secondhand Smoke Media Campaign." Special issue, "Between Life and Death," *Science as Culture* 29:541–81.

Rosaldo, Renato. 1989. *Culture and Truth: The Remaking of Social Analysis*. Boston: Beacon Press.

Rouse, Joseph. 1996. *Engaging Science: How to Understand Its Practices Philosophically*. Ithaca, N.Y.: Cornell University Press.

Rubin, Herbert J., and Irene S. Rubin. 1995. *Qualitative Interviewing*. Thousand Oaks, Calif.: Sage.

Stacey, Judith. 1988. "Can There Be a Feminist Ethnography?" *Women's Studies International Forum* 11, no. 1:21–27.

Star, Susan Leigh. 1995. Introduction to *Ecologies of Knowledge: Work and Politics in Science and Technology*. Albany: State University of New York Press.

Star, Susan Leigh, and James R. Griesemer. 1989. "Institutional Ecology, Translations, and Boundary Objects: Professionals and Amateurs in Berkeley's Museum of Vertebrate Zoology, 1907–39." *Social Studies of Science* 19, no. 3:387–420.

Stolberg, Sheryl. 1996a. "Teenage Smoking on Rise, High School Survey Finds." *Los Angeles Times*, May 26, A12.

——————. 1996b. "Clinton Imposes Wide Crackdown on Tobacco Firms." *Los Angeles Times*, August 24, A1.

Terry, Jennifer. 1989. "The Body Invaded: Medical Surveillance of Women as Reproducers." *Socialist Review* 89:13–43.

Traweek, Sharon. 1988. *Beamtimes and Lifetimes: The World of High Energy Physicists*. Cambridge, Mass.: Harvard University Press.

Treichler, Paula. 1989. "AIDS, Homophobia, and Biomedical Discourse: An Epidemic of Signification." In *AIDS: Cultural Analysis/Cultural Activism*, edited by Douglas Crimp, 31–70. Cambridge, Mass.: MIT Press.

U.S. Surgeon General. 1986. *The Health Consequences of Smoking: Involuntary Smoking*. Washington, D.C.: U.S. Public Health Service.

Van Maanen, John. 1988. *Tales from the Field*. Chicago: University of Chicago Press.

Verhovek, Sam Howe. 1996. "The Great Outdoors Is Latest Battlefield in War on Smoking." *New York Times*, May 5, A1.

Watney, Simon. 1987. *Policing Desire: Pornography, AIDS, and the Media*. Minneapolis: University of Minnesota Press.

——————. 1995. *Practices of Freedom. Selected Writings and HIV/AIDS*. Durham, N.C.: Duke University Press.

Weston, Kath. 1997. "The Virtual Anthropologist." In *Anthropological Locations: Boundaries and Grounds of a Field Science*, edited by Akhil Gupta and James Ferguson, 163–84. Berkeley and Los Angeles: University of California Press.

The Ecstasy of Miscommunication
Cyberpsychiatry and Mental Dis-Ease

Jackie Orr

Screen(ed) Memories

"Fiat ars—pereat mundus" ["Let there be art, and may it conquer the world"] says Fascism and . . . expects war to supply the artistic gratification of a sense perception that has been changed by technology. . . . Mankind, which in Homer's time was an object of contemplation for the Olympian gods, now is one for itself. Its self-alienation has reached such a degree that it can experience its own destruction as an aesthetic pleasure of the first order.
—Walter Benjamin, "The Work of Art in the Age of Mechanical Reproduction"

Wow—that is almost surrealistic!
—Tom Brokaw, for NBC-TV, July 27, 1996

I keep a small TV set in my closet, taking it out mostly for catastrophes. On the midsummer evening of the explosion of TWA Flight 800 in July 1996, I haul out the tube, reattach the antennae, and stare somewhat motionlessly at the screen for several hours. Perhaps anticipating the extraordinary lineup of nation-state spectacle—the summer Olympics followed closely by the 1996 Democratic and Republican National Conventions—I never put the TV back in the closet.

On the night of July 26, I flick on the power only to find myself back in the frenetic, fascinated broadcast of real-time disaster TV—"Olympics Explosion," the screen announces in the lower left-hand corner. Let me tell you what I see.

Everywhere there's red, white, and blue. The red is blood, the white is of ambulances, and the cycling lights on row after row of police cars illuminate the late-night scene in an eerie and cinematic blue. Then, a panoramic shot of Centennial Park in downtown Atlanta, Georgia. The camera now fixes from a distance on a giant video screen backing a raised outdoor stage in the park. Onstage, a man is performing, dwarfed by a video close-up of him performing, projected on the giant screen behind. Then, the image within the frame of the giant video screen startles, automatic reflex, the image shakes to the oscillating frequencies of a blast. Next to the stage—white smoke rising. Within the window of my TV screen I see the televisual framing of an image on another screen registering the brief shock of an explosion. An image within an image, shaken out of its steady framing; a screen within my screen, recording in real time a shattering of the camera's steady gaze.

After the first airing around 3:45 A.M. of this news clip of a giant video image from a music concert in the park registering the bomb's blast, NBC anchorman Tom Brokaw exclaims, "Wow—that is almost surrealistic!" After watching several hours of the repetitious collage of this video and two others, each with a different real-time angle on the explosion; and the frozen video shot of the knapsack presumably containing the bomb before it blew up; and the compulsive replay of another video showing dramatic images of injured people, blood streaming from ears and nose, soaking the left arm of a shirt; after several televisual hours I think, This is not surreal, Tom, this is hyperreal, and turn off the TV toward a now-brief night of bad dreams.

What is hyperreality?

In *The Ecstasy of Communication* (1987), Jean Baudrillard suggests that "we" (and he uses that term loosely) no longer exist in a world where, as Marx and a critical lineage of theorists described, the "drama of alienation" plays out in a theater of commodified social relations. Today, "we" inhabit a hyperreal or virtual world congealed through the fascinating immateriality of screened information flows, electronic sign-values, and speculative exchanges, trapped but without pain in the anesthetized ecstasies of communication.[1] In the simultaneously psychotropic and mundane vertigo promoted by a proliferation of technologically mediated, capital-intensive communication networks and a disappearance of sensible structures of social or historical meaning, Baudrillard marks "an original and profound mutation of the very forms of perception and pleasure."[2] Digital, high-density, laser-grooved sensations. E-mailed eroticism.

Nintendo nimbleness. Windows™ on the world. More than a decade before cyberspace is downloaded into select civilian frontiers of production and leisure-time play, Baudrillard's series of condensed theoretical seizures about capitalism-gone-electric evoke flickering, ghostly images of a hyperreality animated by cybernetic techno-logics, and live-via-satellite phantasms of death and its tele-visual double: real-time catastrophe.[3]

Surrealism, an avowedly political art movement that emerged between world wars, used experimental montages of reality and dream, commodity and body, to disturb the perceptual modes and imaginary economies of mass-produced, middle class postwar European culture. Hyperrealism is something different, something much dangerously closer to the vision Walter Benjamin had some sixty years ago of a seductive aestheticization of politics, culminating in outbreaks of imperialist and highly aestheticized warfare. In his influential essay "The Work of Art in the Age of Mechanical Reproduction," Benjamin gropes toward a historical and materialist theory of mass perception as it forms and is transformed by new techniques of mechanical reproduction, primarily cinema.[4] As I watch late-night disaster TV, five years after the real-time TV miniseries called Operation Desert Storm, I am left wondering about mass perceptions today, in the age of electronic reproduction. How does the "ecstasy of communication"—this rechanneling of social and subjective perceptions through tangled networks of aestheticized information—operate as a fascinating new form of social control?[5] Do fear and anxious dis-ease in the face of such screenings only accelerate the "hype" in hyperreality? Or can they also help to disrupt its seductive circuitings? If one primary form of social power today is electrical, then what might it mean to want to *throw the switch*?

These questions for me converge with the anxieties raised by spending most of my time studying panic—as a new psychiatric diagnostic category, a form of collective social and economic behavior, a state- and military-sponsored Cold War research object, and an individualized experience of floating terror currently managed by the name "panic disorder" and the prescription of a small, white pill. What compels me toward the cultural study of medicine and technoscience is the insistent awareness that I already live in their (force) field. In daily, practical and imaginary ways. What a focus on panic brings to the study of technoscientific fields is an edgy, symptomatic reading of the complex, contemporary ways in which body, psyche, history, culture, power, nature, and political economy together compose the experimental laboratories where technoscientific objects and practices emerge, and make their material and imaginary marks.

My symptomatic reading begins in front of the screen, and will undoubtedly end there, too. Not because there is nowhere else to go, as Baudrillard suggests

in his (self?) portrait of the normalized schizophrenic subject of postmodern capital, a subject who "is now only a pure screen, a switching center for all the networks of influence,"[6] but because the screen-scene is a significant, specific site for the story I want to tell of the technological and perceptual entanglements of bombs and targets, pills and symptoms, shaping the history of what I will call cyberpsychiatry. Emerging out of World War II developments in radar (screen) technologies, cybernetics becomes a cross-disciplinary science of information and communications systems contributing to a host of theoretical and technical advances in computerization, telephonics, and guided missile systems. It is also and explicitly a science of control, with applications in biological, mechanical, electronic, and social fields, including the unruly fields of human perception itself. As I sit before the screen absorbing the late-night flow of information and electronic images produced by real-time disaster TV, I have the uncanny feeling that the knotted feedback loops between my perception of a screen that perceives its self, via several other screens, perceiving the effects of a bomb's explosion, trace the vaguely maddening Möbius strip of a familiar, if partially screened, scene; a symptomatic scene whose dis-ease lies less in the direction of a presumed sociopathic bomb killer or the threat of panic amongst the Olympic crowds, and more in the intricate, electronically informed, technologically mediated structures of perception itself.

Honed in the psychoanalytically inflected study of literary and visual texts, the somewhat perverse methods of a "symptomatic reading" search out the dis-ease, the dis-orderings of meaning in the chattering margins and legible gaps of textual or aesthetic production. When offering a symptomatic reading of the text(ure)s of the social—where the relations between meaning and materiality, representation and what (for want of a better word) we call reality, are tied in a different kind of knot—the status of the "symptom" becomes even more elusive. Is the dis-ease "in" the reading? Is it "in" the social relations? When the reader is also produced in and by the technosocial text(ure)s she reads, then who or what could ever produce a reliable diagnosis? If the symptomatic reader puts the television back in the closet, how can you know what else is in there? If she tells you a pharmaceutical pill is, in part, a historical story, do you know how much of it she's already swallowed? The genealogy of the word *screen* is inscribed in a history of shields and protections: What can it mean to try to read certain features of this social moment through the technological and perceptual mediations of a mechanism of defense?

So. Before becoming a panic theorist, I spent about a year being a pretty panicky subject. I always feel it's necessary to warn people of this: I believe

deeply in the powers of contagion and don't think it works only via germs. I'm a panicky theorist with a specific history—born a half-mile from the Pacific Ocean, eighty miles from the desert, fifteen yards from a three-story steel gray Pacific Gas & Electric substation in the belly of the U.S. military.[7] This is not a confession. These are stories to situate my stories. Context to situate this text and its desires. I'm not saying you shouldn't trust me. I'm suggesting that all private stories come from public histories—C. Wright Mills said this rather eloquently almost forty years ago, and he came from Waco, Texas.[8] So history's usually a good place to begin.

Technoscience Subjects and Cybernetic Perceptions

The only thing that is different from one time to another is what is seen and what is seen depends upon how everybody is doing everything. This makes the thing we are looking at very different and this makes what those who describe it make of it, it makes a composition, it confuses, it shows, it is, it looks . . . and this makes what is seen as it is seen.
—Gertrude Stein, "Composition as Explanation"

I am seeing the TV screen. It is winter, and it is war. You can see it on the screen. The lower left-hand corner says "McDonnell Douglas" and the black-and-white image moves in and out of unfocused grays as the two white lines crossed at the middle grow bigger and bigger, and this is war and I'm seeing it on TV.

The reporter describes now what I have seen: "The so-called 'smart bomb' records its target as it moves in to destroy it . . . effectively constituting the television screen and its viewer as the extended apparatus of the bomb itself. In this sense, by viewing we are bombing, identified with both bomber and bomb, flying through space . . . and yet securely wedged in the couch of one's own living room."[9] In Judith Butler's useful analysis of the "phantasmatic subject" of the U.S.-led war against Iraq, she describes how the perceptual apparatus that *is* the bomb—*because today a bomb is a bomb is not a bomb because a bomb today is also a seeing machine, today a bomb is a bomb is a TV screen is you and is me*—constructs specific kinds of subject-effects. Precisely as the image-screen destroys itself at the moment of the supposed destruction of the target, our identification with the bomb leads to an imaginary experience of a secure and certain military victory. "[A]s viewers, we veritably enact the allegory of military triumph: We retain our visual distance and our bodily safety through the disembodied enactment of the kill that produces no blood . . . securing a fantasy of transcendence . . . through the guarantee of electronic distance."[10]

Butler is offering a description here of the constitution of what I want to call "technoscience subjects"—the dis/embodied effects of physical and mental practices and identifications in which humans are materially, symbolically, interactively transformed through our relations to technologies. To approach contemporary technologies as perceptual apparatuses, embodiments of particular ways of seeing and sensing that themselves reproduce historically specific forms of visibility and nonvisibility, is to extend to the field of so-called technoscientific objects a kind of productivity and symbolic efficacy we tend, with a trained disciplinary gaze, to reserve for human subjects. This is not, I'm hoping, the same as a kind of dumb technological determinism or a fetishism of the object that forgets the social relations embedded in humanly produced artifacts. It is an attempt to remember, however partially and not without a panicky sense of personal dis-ease, that such artifacts and the quite nonsocial features they also embody—the behavior of metals and temperatures, the properties of plastics or electricity—may become complexly, interactively embedded in humans. Technoscience subjects do not simply produce technoscience objects; we also incorporate them, mimic them, and mutate (with) them. And today, not only do humans interpret and perceive technologies, but many technological apparatuses—especially those animated by complex electronic information systems—also perceive and interpret humans in ways that have yet to be fully examined.[11]

It is winter. Again. And it is war. In the January 1943 issue of *Philosophy of Science* three men—a mathematician, an engineer, and a neurobiologist—coauthor a modest proposal entitled "Behavior, Purpose and Teleology."[12] This brief essay argues that certain activities of machines and of humans can be together classified as "purposive behavior"—that is, behavior that seeks after a goal. Both machines and humans can be seen to behave with purpose. Furthermore and most to the point, the same behavioristic analysis can be applied to both kinds of objects: both machines and living organisms can be analyzed using the systematic, mathematicized language of engineering. The feature of purposeful behavior in machines and living organisms that most interests these men is called "negative feedback." They explain, "All purposeful behavior may be considered to require negative feed-back. If a goal is to be attained, some signals from the goal are necessary at some time to direct the behavior."[13] When negative feedback (the emission of signal-messages from the goal directed toward the object trying to attain the goal) controls behavior in machines or living organisms, such behavior is not subject to the ordinary logic of cause and effect but is rather "quite independent of causality." That is, cybernetically governed relations between machines, humans, and other goal-

oriented, communicative devices are not reducible to "causal" relations among discernible variables; they are more properly approached as an interactive network of effects. The men therefore recommend the avoidance of problems of causality in an analysis of purposive behaviors.[14]

The 1943 essay extends conceptually the wartime research of Norbert Wiener and Julian Bigelow (two of its three authors) on how to improve the Allied forces' control apparatus for antiaircraft artillery systems. The problem of how to better attack German bomber planes, together with the development of an atomic weapon, were the two major U.S. technoscientific projects of World War II. The improvement of "fire-control systems"—in which the the firing gun, the pilot, the plane, the moving target, moving machines, and the movements of men were all seen as components of a single system—involved centrally the problem of negative feedback between radar information and the adjustment of gun controls, both human and mechanical.[15] The "purposive behavior" of the system was to accurately target and gun down a moving enemy armed with a lethal bomb. *An enemy is an enemy is a bomb is a plane is a piece of information is a radar screen is a gun is another plane is a pilot is you is me—is a system.* Today, you can see all of this on TV.

It is still winter, and still war, and in December 1943 another article is published, this time in the *Bulletin of Mathematical Biophysics*.[16] One author is a young mathematician, the other a psychiatrist committed to a scientific and experimental psychiatry and the exploration of the logical nature of mind and madness.[17] The two men argue that the human central nervous system, conceived as a net of neurons, can be seen as analogous to a set of logical symbolic propositions. Due to the all-or-none electrical properties of a nerve impulse when it "fires," the human brain and nervous system can be seen to operate as an on-off switching device that can be described quantitatively and follows the same symbolic logic as propositions with their binary, or two-valued, nature.[18] The authors conclude the essay, "In such systems 'Mind' no longer 'goes more ghostly than a ghost.' Instead, diseased mentality can be understood without loss of scope or rigor, in the scientific terms of neurophysiology."[19]

In the decade following the end of World War II, these two articles and their authors become one nucleus of the new science of cybernetics and its interdisciplinary embrace of military operations research, engineering, mathematics, biology, statistics, neurophysiology, and psychiatry. Cybernetics develops a language for systematically and scientifically continuing the project of these two seminal articles: the translation, via suggestive analogies and rigorous quantitative models, of the behavior of cells, living organisms, machines, animal societies, and human group life,[20] "*into terms applicable to all of these entities*" (italics

added).[21] The key operator for cybernetics as a translation machine are the new mathematical sciences of communication and information theory— engineering sciences that construct solutions and materialize new machinery by seeing objects as problems in communication and control.[22] Cybernetics, then, as a seeing machine. Let me tell you what I see it seeing.

Warren McCulloch and Walter Pitts's 1943 article on the productive analogy between neural nets in the central nervous system and the symbolic logic of propositions is a conceptual foundation for the more elaborated analogy between the nervous system and the computing machine that animates much of early cybernetic thought. John von Neumann, a mathematician and leading computer designer in the United States, used the McCulloch-Pitts model to design electrical circuits for a general-purpose digital computer in 1945.[23] The behavior of propositional logic, neurons in the human brain, and computer circuits could all be seen as binary, on-off engineering devices in which information is communicated by passing (YES) or not passing (NO) across a synapse (in the brain) or switching mechanism (in the computer).

In March 1946, the first of ten influential interdisciplinary conferences sponsored by the Josiah Macy, Jr. Foundation and devoted to the new cybernetics, opens with two presentations: the first by von Neumann on the new computing machines, followed by neurobiologist Lorente de Nó on the electrical properties of the nervous system.[24] The circuiting of analogies between the behavior of computers and of the nervous system is central to the cybernetic imagination and its founding desire to define the essential "unity of a set of problems" organized around "communication, control, and statistical mechanics, whether in the machine or living tissue."[25] In particular, the early cyberneticists are convinced that research on computers and the organization of the human brain are one and the same field, that is, "the subject embracing both the engineering and the neurology aspect is essentially one."[26]

For a psychiatrist like Warren McCulloch, who chaired the Cold War series of cybernetics conferences, the implications of such thinking were profound. Cybernetics, with its emphasis on the sending and receiving of message signals, offered the elusive bridge between "psychology and physiology in the understanding of diseases called 'mental.'"[27] With a background in brain research including experimental attempts to map the functional pathways of nerve impulses in the cortex of monkeys and chimpanzees, McCulloch was committed to the practice of a scientific psychiatry, a project he had embraced from his early work in the 1930s at Rockland State Hospital, a New York State mental institution. In his quest to transform the Freudian neurosis into the dysfunction of the physiological neuron, and to translate the immateriality of perception

into the electrochemical flows of binary communication in the brain, McCulloch saw cybernetics as a powerful conceptual and technological ally.

By modeling the brain as a communication/information processing device in which mental behavior is analogous with information flows regulated by internal homeostatic control mechanisms, cybernetics opened the conceptual door to theories of mental disorder as a problem in communication: a breakdown or deviation in the control mechanisms regulating information processing in the nervous system. As no other science before it, cybernetics promised an integration of the mind/body dualism through the materialist metaphors of communications theory.[28] The theoretical unity of mind and body was secured through the notion of circular feedback between "physical and psychological data" circulating in the organism, and between the organism and its social environment. Behavior for the cybernetically inclined psychiatrist "can be understood only if both the biophysical and the symbolic processes are encompassed in one overall system."[29] Cybernetics provided that system.

In the very structure of cybernetic models of the human central nervous system, with its conceptual intimacies between notions of communication or information flow and the imperatives of control and regulation, a kind of engineering ethos permeates the new visions of human brain and behavior. Like any system that is cybernetically organized, mental disorders can and should be open to reorganization through technoscientific interventions premised upon the functional continuities between organisms and machines, animate and inanimate matter, metal and flesh.

Nowhere is the enthusiastic coupling of cybernetic information systems with imperatives of control more symptomatically evident than in the work of sociologist Talcott Parsons, whose functionalist thinking dominated that discipline throughout the 1950s and well into the 1960s. In an address to the American Psychosomatic Society in 1960, Parsons explicitly defines the "basic process of control" in all levels of organization (cultural, social, psychological) as "processes of communication."[30] Human behavior according to Parsons is "subject to a graded hierarchical system of control mechanisms in the cybernetic-information theory sense, and . . . this system constitutes a continuous series extending from the highest levels of the cultural and the social system, through the personality and higher-order organic systems, to organs, tissues and cells. "[31] Parsons speculates that "pleasure" in the human organism operates as a kind of medium of communication, analogous to money in a market economy: the "pleasure system" is thus the key link in the control of the personality system, operating as a regulator through the internalized norms of the superego. Mental health entails the "adequacy of control systems" that bear on

an individual's capacity to perform his or her social functions. Mental disease is a "breakdown of these controls resulting in incapacities."[32] The role of medicine, including psychiatry and related therapies, is as a kind of "second line of defense" of the social system against the failure of primary mechanisms of social control.[33]

Let me summarize three features of an emergent cyber-psychiatry that seem to me most crucial:

1. The "naturalization" of technoscientific interventions into the dys/functions of the brain and central nervous system (CNS), modeled as problems in communication and control. This naturalization takes on a peculiar form, operating first through analogizing the central nervous system with techno-objects like computers (that is, by "technologizing" models of CNS activity), which then "naturalizes" the use of technoscientific techniques to regulate an already techno-natural system: the cybernetic control system that *is* the human brain. The mode of operation and method of legitimation of these regulatory techniques (including but not limited to pharmaceutical drugs) rely on images of mental organization as always already incorporating command-control-communications hierarchies and goals. Control thus becomes incorporated into models of the CNS as an organizational principle, and functional prerogative, of the system itself.

2. The circulation of new images of mind/body wholism constructed through a kind of cybernetic materialism that bridges the conceptual gap between mental states and physiological processes by operationalizing *all* human behavior (including brain behavior like perception, knowing, memory) as the effect of circular information feedback loops. This cybernetic materialism privileges neither physiology nor psychology, but constructs both as systems operations that can effectively *be accessed* through neurological and biochemical processes. The question of cause is displaced by the efficacy of instrumental reengineering.

3. Finally, cyberpsychiatry makes possible but by no means necessary a hegemonic popular understanding of human mental disorders as errors in information flows correctable via technoscientific interventions that normalize communications activity in the brain. In this sense, cyberpsychiatry offers technoscience subjects an imaginary of our interior selves as a kind of cyberspace architectured and inhabited by the screening, storage, transmission and processing of electrochemical and genetic information.

Evolution to Cyborgs—An Experiment in Remote Control(s)

... [T]he boundary between science fiction and social reality is an optical illusion.
—Donna Haraway, "Manifesto for Cyborgs"

For many of us, the first encounter with a cyborg occurred at the movies. On screen we saw images of a man-machine who could stop a truck with his outstretched hand. We watched as he peeled back his own flesh, bloodless, revealing mechanical parts and electric wiring, a human inside that was all high tech. We saw how this man-machine saw: his eye inlaid by a computerized screen of information blinking digital red flows of sensory data. The year was 1984. The movie was *The Terminator*. The man-machine was Arnold Schwarzenegger, and the plot was styled in a science fiction infinity loop of time folding back on itself through sons fathering fathers via imaginary trafficking in cyberdimensions that defy the discontinuity of human death. A year later feminist historian of science Donna Haraway deployed the figure of the cyborg, this mutant creature born at the imploding borders of technoscience and myth, to investigate the complex origins and uncertain futures of contemporary technoscience subjects.[34]

But the first cyborg was actually imaginarily launched in 1960, when the word was coined to describe the "enhanced man" needed to endure extraterrestrial space flight. In the 1960 essay "Drugs, Space and Cybernetics: Evolution to Cyborgs," the cyborg, this emergent hybrid of *cyb*ernetics and *org*anism, is enhanced largely through pharmaceutical drugs and an experimental array of drug delivery systems that target the "self-regulatory control function of the organism in order to adapt it to new environments."[35] The paper, prepared for a symposium on the psychophysiological aspects of space flight sponsored by the U.S. Air Force, focuses on the technoscientific devices "necessary for creating self-regulating man-machine systems" that can operate without the mediation of human consciousness, in synch with the "body's own autonomous homeostatic controls."[36] Interested in the human central nervous system as a largely unconscious and automatically self-regulating mechanism, the authors imagine a science fiction series of equally automatic technological devices for the functional readjustment of the organism through a constant control loop in which "robot-like problems are taken care of automatically and unconsciously." For example, should the unusual stresses of long-term space flight precipitate a psychotic episode in the human organism, they suggest the possible administration of pharmaceutical drugs via remote control from earth.[37]

These speculations are not the ravings of mad scientists. They are state- and military-sponsored applications of cybernetic control theory to human-technological-environmental systems operations. While directed toward dysfunctions in an extraterrestrial environment, the essay also proposes to reveal "a clearer understanding of man's [*sic*] needs in his home environment."[38] On the ground, the essay's coauthors, Nathan Kline and Manfred Clynes, are directors of research at Rockland State, the same New York State mental hospital where Warren McCulloch worked some thirty years earlier. Nathan Kline is today well known as a founding father of U.S. psychopharmacology, leading the Cold War battle to promote the use of pharmaceutical drugs for the treatment of mental disease.

In 1956 Kline published a series of papers on psychopharmacology presented, he states, at "the first major conference on the use of several new pharmaceuticals in the field of mental disease." The book includes findings from his own research at Rockland State with 700 institutionalized research subjects.[39] The set of papers focuses on clinical and laboratory applications of chlorpromazine, a depressant synthesized by Smith, Kline, and French Laboratories, and reserpine, manufactured by Squibb & Sons. The same year, the second in a series of five conferences on neuropharmacology (1954–59) brings together psychiatrists, biochemists, pharmacologists, neurologists, pharmaceutical industry representatives, and government officials from the National Institute of Mental Health, the National Institutes of Health, and the U.S. Army.[40] The conference series is sponsored by the Macy Foundation, overlapping in both time and participants with the series of ten cybernetics conferences. Frank Fremont-Smith, director of the Macy Foundation's medical division, organizes both conference series and appoints Harold A. Abramson, an invited guest to the cybernetics conference, as secretary and later editor of the published proceedings of the neuropharmacology meetings. Conference presentations range from the functional organization of the brain to the effects on animal and human subjects of an array of pharmacological agents, including chlorpromazine, reserpine, serotonin, mescaline, and lysergic acid diethylamide (LSD).[41]

Cyberpsychiatry is not only a set of good—or bad, depending on your position—ideas. It is not only a seeing machine that re-visions mental dis-ease as a problem in communication, a flow of deviant messages in the brain's control center. Cyberpsychiatry is itself a communicative network of individuals, institutional settings, clinical and laboratory research practices, funding structures, epistemological tendencies, and organizational hookups that has contested for technoscientific resources and imaginations, and has historically

communicated its influence far beyond avowed adherents to cybernetics. While instrumentally agnostic vis-à-vis causal models of mental dis-order— its goal is to achieve control, not causal clarity—its modeling of the human brain and behavior as information-processing devices focuses conceptual and technological attention on the traffic in messages constituting (if not precisely causing) human un/consciousness. Where the deviant messages come from— whether essentially physiological, psychological, social, or any interactive combination—is not central. How to control the flow of messages is the goal. Cognitive-behavioral therapies, biofeedback, even psychotherapy, can all be incorporated within cybervisions of mental dis-ease: each can be seen to oper-ate on un/conscious flows of information circulating through the organism.[42]

But the most powerful hookup within cyberpsychiatry's arsenal of control strategies is the development of psychopharmacology as a technoscientific in-tervention to modify "deviant" electrochemical messages in the disordered brain. Cyberpsychiatry helped create the historic and technoscientific condi-tions for the production and popularization today of a new generation of pharmaceutical drugs, "smart drugs" that, like smart bombs, are heralded for their capacity to target specific neurotransmitters (the brain's equivalent to command-control-communications centers) with a clean pharmaceutical hit, creating minimal collateral damage (or "side effects"). The technoscientific imaginary of cyberpsychiatry has found its virtual killing fields in the charged circuits of communication and capital networked through the transnational pharmaceutical industry.

"The Cyborg technique," as Kline and Clynes called their hypothetical ex-tensions of the organism's self-regulating control system through the auxiliary apparatus of pharmacology, together with the materialization of a now-dizzy-ing array of psychopharmacological agents, have created the quite terrestrial conditions for an "evolution to cyborgs"—without ever leaving our quotidian orbit. If the aim of these early cyberspeculations was to design technoscien-tific, particularly pharmaceutical, solutions for the human organism's prob-lems in adapting to a new environment, we might today wonder how the terrestrial application of psychopharmacology promotes psychological adap-tation to new cultural and economic landscapes. If the continuous perfor-mance of social functions is the goal of "adaptation," then what today are our "functions" in Spaceship Society? What social bodies and forces decide what counts as adaptation and evolutionary advance, and what will be called dys-function, in need of technoscientific adjustment?

And, finally, what *really* are the targets of control technologies like cyber-netically guided bombs and cyborg-enhancing pills? Are they really targeting

the communication centers of the individual human brain, and of Iraq's military infrastructure? Or are these technologies also somewhat *hyperreally* aimed at the mass-communicated screenings of a quite social dis-ease? Are bombs today also targeting their own broadcast—a strategic, electronic extension of their attempted explosion? Is the circulation of psychotropic drugs today also aimed at the mass-mediated communication of "healthy" social functioning—a symptomatic cyberdimension of their attempted cure?

The Ecstasy of Miscommunication—Panic, Incorporated

Information passed along a nerve cell's axon is assimilated by the … receiving cell through synaptic connections. Neurotransmitters … diffuse across the space and bind to receptors on the receiving cell, and the message has been delivered. Contemporary neuropharmacology seeks to modify aberrant messages that occur in certain disease states.
—The 1985 Upjohn Company Annual Report

Live on-screen, a young white girl in braids and braces sits on the couch next to her mother. She doesn't know what neural networking activity is, really, but in front of the camera she calmly tells the talk show host and today's home TV viewing audience about her first attacks of panic. The sudden terror, a pounding heart, sweaty palms, shortness of breath—the same dramatic symptoms her mother experienced in her twelve-year battle with panic disorder. The camera swings to a gray-suited man seated in a swivel chair—Dr. Jerrold Rosenbaum, Psychopharmacology Unit chief at Massachusetts General Hospital in Boston, where clinical research on panic has been conducted since the late 1970s, describes panic disorder as a biochemically based disease, explaining how genetic vulnerability to the problem can be passed down through the family. Before the commercial, the talk show host assures home viewers who believe they might suffer from this disabling disorder that they are not alone. For more information, viewers may phone the number (highlighted on the screen) of the Anxiety Research Unit at Massachusetts General. Studio audience applause. A quick shot of a young girl in braids and braces, smiling. Break to commercial.[43]

TV viewers who phone the number are screened as potential research subjects for the Psychopharmacology Unit's clinical drug trials comparing alprazolam (Xanax) and imipramine (Tofranil) in the treatment of panic disorder and depression. The study is sponsored entirely by a private grant from The Upjohn Company, pharmaceutical manufacturer of Xanax. Dr. Rosenbaum's

appearance on the local TV talk show is a tactic for using electronic communications media (here, TV) to educate a potential market of Xanax users, and to widen the pool of potential research subjects for the Psychopharmacology Unit's corporate-sponsored drug trials.[44]

The extraordinarily profitable and well-publicized coupling during the 1980s of the mental dis-ease called panic disorder and its pharmaceutical cure, Xanax, presents an instructive instance of cyberpsychiatry's potential to target a proliferating array of ever more-specific psychiatric symptoms with a proliferating number of pharmaceutical "bullets" aimed at the proliferating networks of known neurotransmitters and their hypothesized functions in electrochemical message-exchange. From the point of view of psychiatric practice, the goal of this cybersystem is the control of symptoms through pharmaceutical targeting of electrochemical communication in the brain and central nervous system. The key feedback effect in the system is between the pharmacological action of different drugs and the "behavior" of symptoms— their appearance, disappearance, and modification. Central to tracking and monitoring such feedback is a symptom-driven classification or coding system for psychiatric diagnosis that attempts to cluster together homogeneous forms of observable symptom-behavior as discrete syndromes or mental disorders.

For cyberpsychiatry, such a language of coding and control begins to develop with the third edition of the *Diagnostic and Statistical Manual of Mental Disorders*, or *DSM-III*, published in 1980. Heralded by some as a welcome revolution in psychiatric diagnosis, and condemned by others as a capitulation to the interests and research agendas of biologically oriented psychiatry and the pharmaceutical industry, the *DSM-III* radically reorganizes the form and contents of psychiatric classification.[45] In contrast to previous diagnostic systems that rely heavily on psychoanalytic concepts of neurosis and unconscious conflict, and draw a significant classificatory border between organic and nonorganic disorders (with the vast majority of diagnostic labels on the nonorganic side), the 1980 *DSM-III* defines diagnostic entities through a professedly "atheoretical" and empirically based method of criteria-specific, operationalized description. Psychoanalytic etiologies and unsubstantiated theories of causality are largely excised. According to the introduction to *DSM-III*, both clinicians and researchers can now share a "common language with which to communicate about the disorders for which they have professional responsibility." Even more importantly, the revisions in *DSM-III* reflect "an increased commitment in our field to reliance on data" as the grounds for understanding and identifying mental disorders.[46]

The Task Force of the American Psychiatric Association, which collectively designed the new *DSM-III*, was not peopled with enthusiastic cyberneticians or covertly controlled by pharmaceutical industry money or interests. Donald Klein, a senior member of the nineteen-member Task Force and author of "the most influential textbook of clinical psychopharmacology in the U.S.,"[47] did propose in 1969 a cybernetic model of mental disease and drug treatment as the best available explanatory paradigm. The psychopharmacological action of psychotropic drugs, he theorized, operates to "normalize control mechanisms" in the case of defective internal homeostatic regulators. He speculated that "the major psychotropic agents may serve this normalizing function if they have the capacity of restoring a pathological positive feedback control circuit to its former regulatory negative feedback state."[48] For the textbook's second edition in 1980, the cybernetic model remains the model of choice.

But Robert L. Spitzer, chair of the Task Force and head of the Biometrics Department at the New York State Psychiatric Institute, had other things on his mind besides cybernetically modulated control circuits. Or did he? In the decade before his work on *DSM-III*, Spitzer experimented with a series of computerized psychiatric diagnostic programs, culminating in a 1974 article, "Constraints on the Validity of Computer Diagnosis." The essay argues that the ultimate obstacle to achieving automated computerized diagnosis lies not with the technological incapacities of computers, but "in the traditional diagnostic system itself."[49] In particular, Spitzer recommends the use of "explicit criteria" for diagnosis and announces collaborative efforts with the National Institute of Mental Health to pursue that goal. "Our current effort . . . is in the direction of a change in the diagnostic system itself with emphasis on simplification, explicit criteria, and limiting the categories to those conditions for which validity evidence exists."[50] In reflecting on the transition in the 1970s from work on computerized diagnosis to the design of *DSM-III*, Jean Endicott, Spitzer's coauthor and also a key member of the *DSM-III* Task Force, says, "We used to laugh and kind of say, okay, we'll stop trying to teach the computer to act like a clinician. And we're trying to teach the clinician to apply logical rules, kind of more like a computer."[51]

The door to computerization of clinical psychiatric diagnosis opened through *DSM-III*'s identification of explicit, symptom-specific criteria demanded something more: an appeal to the "empirical" as the grounds for inclusion/exclusion of each specific criterion, and as the evidence of validity for each discrete diagnostic syndrome. But as Spitzer is the first to recognize, the criteria constituting each *DSM-III* diagnosis were far from empirically based. The "data" on which the validity, or existence, of different syndromes was decided

drew largely on the clinical judgment of the people in the room making deci-sions: "I think we knew that we often . . . were making up these criteria because they seemed really appropriate and useful," Spitzer recounts, "but there are very few instances where the actual choice was empirical. And most people don't appreciate that, but that is the fact."[52]

A curious form of empiricity that does inform the *DSM-III* can be seen in the construction of panic disorder, a new psychiatric diagnostic syndrome in-troduced in the 1980 *DSM*. The earliest argument and empirical evidence for a distinct syndrome clustered around the anxious fear of imminent catastrophe (the anxiety or panic attack) was offered by Donald Klein, member of the *DSM-III* Task Force and theorist of a cybernetic model of mental disease. In 1960, the same year that Nathan Kline and Manfred Clynes were conducting research at Rockland State, Klein designed and carried out a series of psy-chopharmacological experiments at Hillside Hospital, a private New York State mental institution. At that time, research psychiatrists at Hillside had complete control over all medication prescriptions for all patients. They were allowed to engage in systematic human experimentation, including the study Klein published in the early 1960s on the effects of imipramine, an early anti-depressant. Klein administered a single standardized dosage of imipramine to 80 percent of all patients institutionalized at Hillside in order to conduct re-search on the "various patterns of behavioral response" among different sub-populations.[53] His observations that a particular subgroup of anxious patients had their panic symptoms calmed by imipramine became the empirical argu-ment some twenty years later for the inclusion of panic disorder as a new diag-nostic category in *DSM-III*.

Klein conceptualized this kind of experimental method as "pharmaceutical dissection," and proposed it as a valid and reliable way to identify and con-struct the boundaries between mental disorders.[54] Pharmaceutical dissection works as a kind of inductionism in reverse: working backward from drug effect to syndrome, pharmaceutical dissection "reveals" discrete psychiatric syndromes as a function of drug response. Panic disorder "exists" as a distinct psychiatric classification because, in response to imipramine, a specific cluster of symptoms disappears. That cluster constitutes a distinct category by virtue of its observable relation to pharmaceutical intervention.

This is a curious epistemological practice, a symptomatic expression of what might be called "cyberempiricism," in which the boundary, indeed the very existence, of the psychiatric object is defined through information gained by experiments involving the manipulation of technological control systems— here, pharmaceutical drugs. The "information" produced by observing the

feedback effects between drug administration and the behavior of symptoms becomes the empirical grounds for naming and discerning the existence of a dis-ease entity. While in the history of what is called "scientific method" the probing of elusive objects or processes through the prosthetic reach of experimentally in-duced effects is nothing new, what makes cyberempiricism a significant practice is its claim to discover an empirical object in the in-between of drug action and symptom effect. Operationally defined as a set of specific symptoms and given the name of a specific disorder or dysfunction, the mental dis-ease perceived through pharmaceutical dissection appears to be something other than what it actually is within cyberpsychiatry: a functional code linking a particular phar-maceutical treatment with a (relatively) predictable set of symptom-effects.

The enormous profitability, from the point of view of both the pharmaceu-tical industry and psychiatry, of developing a classificatory system that not only conforms to technologies of control but in a quite literal sense is codified around the specific operations of those control technologies, cannot be over-estimated. Two years after panic disorder appears as a new psychiatric classifi-cation, Xanax, manufactured by the Upjohn Company, appears on the market. During the next decade, Upjohn sponsors voluminous clinical research on the efficacy of Xanax, winning an FDA indication for the treatment of panic disor-der in 1990. By the late 1980s Xanax becomes the most popularly prescribed drug in the United States for the treatment of anxiety and panic. By turning its classification system over to the "empirical" demands of a supposedly atheo-retical, data-based model of mental disorder, psychiatry has entered a brave new world of financial, epistemological, and organizational hookups with the speculative terrain of transnational corporate capital.

The case of panic disorder is not representative of the methods used to con-struct all or even most of the diagnostic categories in *DSM-III*. Many of the di-agnostic labels, although stripped of their reference to psychoanalytic concepts, remain beholden to either a long-standing professional consensus as to the existence and symptom profile of the disorder, or to the clinical judge-ments of the small group of psychiatrists and psychologists revamping the *DSM*.[55] But the example of panic is, I suggest, symptomatic of the kinds of in-formation feedback and conceptual-technoscientific traffic now possible within the loose network of practices, epistemological tendencies, and institu-tional sites I'm calling cyberpsychiatry. Magic bullets for every brain misfiring. The rapid, cost-effective control of that most unruly frontier of cyberspace, our technoscientific selves. The swelling of pharmaceutical industry profits tracking the spread of synaptic disorderings. For each aberrant message, its own normalizing cure. The ecstasy of miscommunication.

In-conclusions

Fear, they will say is like shame, quite useless. They will say ... it is enough to conceal behind the screen the deranged signs of desire, to refer threat to the bottom of the screen, simulation. A little snow will be seen. They will believe it is enough, in the fervor of the night, to reestablish speaking. But fear, let there be no secret about it, is as widespread as men's speeches.

—Nicole Brossard, Maouve Desert

It is summer. There is no war. Not, at least, on TV. Instead she sees on the screen in front of her a computerized menu of symptoms, and she clicks the plastic mouse on each one she has experienced in the last four weeks: shortness of breath or smothering sensations? palpitations or accelerated heart rate? dizziness? trembling or shaking? fear of dying? fear of going crazy or of doing something uncontrolled? The interactive computerized diagnostic software scores her responses against algorithms based on research with over 3,000 test subjects, and prints out a lab slip that identifies the positive symptoms and a provisional diagnosis. She takes the white slip with her into the primary care physician's office.

What has set the stage for such a scene, this strangely symbolic interaction with a symptomatic screen?

The computerized diagnostic software is manufactured by the Upjohn Company, the pharmaceutical giant whose fortunes climbed with the astronomical sales of Xanax for panic and anxiety in the 1980s; the software is currently being marketed for use in physicians' offices.[56] Packaged as a mental health screening device for primary care physicians (not psychiatrists), the Upjohn software is one product in a burgeoning field of automated medical diagnostics. The software efficiently utilizes the patient's time in the waiting room to uncover any potentially disturbing psychic symptoms that might configure into a diagnosable disorder. The Pfizer Corporation, another pharmaceutical giant, has designed a related product called PRIME-MD that they give directly, and free of charge, to primary care physicians as a marketing device.[57]

The psychiatric classification system that lends itself to itemized symptom checklists and easily computerized algorithms is based on the fourth and most recent edition of the *Diagnostic and Statistical Manual of Mental Disorders*, published in 1994. With a new introductory pronouncement against the unfortunate term *mental disorder* (which "implies a distinction between 'mental' disorders and 'physical' disorders that is a reductionistic anachronism of mind/body dualism") and with operationalized, symptom-specific descriptions of over 300 differentiated disorders, the *DSM-IV* builds upon the

cyberempirical groundwork laid by *DSM-III* while presenting even stronger claims for the tested reliability and validity of diagnostic categories.[58]

The increased likelihood that diagnosis and treatment of mental disorders will take place in primary care medical settings, rather than in a mental health worker or psychiatrist's office, can be traced to at least three complementary forces: the directions taken by managed care in reducing or eliminating benefits for nonmedicalized forms of mental health treatment; the increasing confidence of primary care physicians in prescribing psychotropic drugs that promise to target ever-more-specific disorders with fewer dangerous side effects; and the growing willingness among many people experiencing psychic suffering to accept biologically based notions of mental disorder, and psychopharmacology as a treatment of choice. The successful medicalization of mental disorders and their treatment is reflected in the fact that by 1996, the majority of prescriptions for antidepressants were being written by primary care physicians.[59] The use of direct-to-consumer mass advertising for prescription drugs, including psychopharmacologicals, has skyrocketed in the last decade, and undoubtedly plays a major role in informing patients of "brand-name" drugs and their promised cures for psychic distress.[60]

Does all this sound a little panicky and paranoid? More like science fiction than social fact? Well. *A symptom is a symptom is a deviant message is an information byte is an electrical impulse is a computerized logic is an automated diagnostic screen is a corporate commodity is a pharmaceutical drug is a normal message is an information byte is an altered electrical impulse is a cure—is a system—is my dis-ease.* You'd panic, too, if it happened to you.

One important social and technoscientific fact about "smart bombs" was quietly announced some months after the official end of the war against Iraq: most of the smart bombs did not hit their targets. If watching the video feed from a smart bomb did indeed, as Butler suggests, create the phantasmatic subject-effect of identifying—from the shared technovision of the nose of a bomb—with a military triumph and the annihilation of the enemy target, there remains the less phantasmatic and far less fascinating fact that the destruction was far from really secured. Both the phantasmatic identification and the facts on the ground have effects. Both count, however differently, in the constructions of technoscience subjects. The effects of becoming technoscience subjects are partially, complexly, an open question: the representations of effective cybernetic control may be a far more sophisticated weapons technology than the actual targeting, firing, and achievement of cybernetic goals. If, as Paul Virilio writes, "weapons are tools not just of destruction but also of

perception ... stimulants that make themselves felt through chemical, neuro-logical processes in the sense organs and the central nervous system," then both the material destruction and perceptual constructions of contemporary techno-weapons play out in the social battlefield of tactic and strategy, of power and its shifting deployments.[61]

Pharmaceutical drugs, which I have presented here as one tactic in a cy-bernetic strategy of control, do not by any measure always fulfill their promise to deliver a smooth biochemical "hit" to symptomatic targets. The contours of mental disease have by no means been adequately compre-hended by the representations or (sometime) reality of relief from psychic suffering provided by psychotropic drugs. Tens of thousands of individuals as well as their friends and family, psychologists, therapists, psychiatrists, so-cial workers, and doctors experience firsthand every year the all-too-visible failure of pharmaceuticals to cure, much less reliably lessen, the sufferings attributed to mental disease.

My desire to tell this story—to compose historically a certain way of seeing, a specific perceptual frame for the emergence today of a psychiatric practice profoundly focused on the neurotransmission of electrochemical messages and the competitive networks of state- and corporate-sponsored funding for research into the biology of mental distress—does not escape its history. A certain pounding heart, a propensity toward chills, tense before the screen ob-serving a catastrophe of unnamed (dis)placements and highly mediated ur-gencies. Nor, in attempting some static noise within the electrosocial circuits of information exchange and communications feedback, does it escape the risk of amplifying the brand-name promises of mental order and control being channeled through magazines, TV talk shows, or popular self-help books by the pharmaceutical industry, and by other people who have mapped other paths out of their own experiences of dis-ease.

But "my" desire and its history are not only that, not mine alone, not re-stricted to the individual possessive grammars of the first person singular—as in, "my" panic. A few weeks after the "Olympics Explosion" was aired for late-night viewing, another screen(ed) scene caught my televisual eye. Everything again is red, white, and blue. There's an actor onstage. He's in a wheelchair and nothing moves except his mouth, his eyes, the lump in his throat rising up, then down. It's the 1996 Democratic National Convention, and the opening speaker used to be Superman but now he's a quadriplegic. Addressing the United States of America through a television screen, the actor says, "If we can conquer outer space, we can conquer inner space. And that's the region of the brain, and the central nervous system."[62]

Christopher Reeves's spectacular call from within the confines of an almost complete paralysis, amongst the nationalist paraphernalia of prime-time democratic capitalism, to conquer that most elusive sphere of cyberspace—"our" inner space—is a telling symptom. What story, precisely, it tells remains to be seen. "The history of battle," Virilio writes, "is primarily the history of radically changing fields of perception."[63] The battle for the command-control-communication-information centers of human behavior, emotion, desire, and memory is on. We are traveling through the Decade of the Brain, toward unchartered postmillennial futures.[64] How to navigate the political imaginaries and power networks of such a fantastic voyage is a panicky question that saturates my perceptual field.

Notes

My thanks for the careful reading and comments from Roddey Reid, Charles Sarno, Ron Day, and members of the 1997–98 Townsend Center for the Humanities Fellowship Group at the University of California, Berkeley.

1. Jean Baudrillard, *The Ecstasy of Communication* (New York: Semiotext(e), 1983).
2. Ibid., 132.
3. See Baudrillard, *In the Shadow of the Silent Majorities* (1978; reprint, New York: Semiotext(e), 1983); *Simulations* (1981; reprint, New York: Semiotext(e), 1983); and *Symbolic Exchange and Death* (1975; reprint, London: Sage, 1993). For an interesting, psychoanalytically informed reading of the relations between technology, televised catastrophe, death, and political economy, see Mary Ann Doane, "Information, Crisis, Catastrophe" in *Logics of Television: Essays in Cultural Criticism*, ed. Patricia Mellencamp (Bloomington,: Indiana University Press, 1990), 222–39.
4. Walter Benjamin, *Illuminations* (New York: Schocken Books, 1968).
5. For a sociological elaboration of postmodern forms of social control that has influenced my own thinking, see Stephen Pfohl, *Death at the Parasite Cafe: Social Science (Fictions) & the Postmodern* (New York: St. Martin's Press, 1992).
6. Baudrillard, "The Ecstasy of Communication," in *The Anti-Aesthetic: Essays on Postmodern Culture,* ed. Hal Foster (Port Townsend, Wash.: Bay Press, 1983), 133. My suggestion that the schizoid subject-screen might be a self-portrait is not only a cheap shot at raising the question of just who the subject of Baudrillard's theoretical speculations might be—at the very least, perhaps, a situated social subject and not a convulsive global nightmare—but plays off his own suggestion that the narcissism of a techno-subject situated within the screenings of capital is itself an important theoretical and political condition: the title of the original French version of *The Ecstasy of Communication* is *L'Autre par lui-meme* (*The Other by Himself*).

7. Coronado, California, for the curious.

8. For Mills's most eloquent and economic formulations of the relations of biography and history, see C. Wright Mills, *The Sociological Imagination* (London: Oxford University Press, 1959), 3–18.

9. Judith Butler, "The Imperialist Subject," *Journal of Urban and Cultural Studies* 2, no. 1 (1991):75–76.

10. Ibid., 76.

11. I am not thinking here exclusively of surveillance technologies whose overt purpose is to track and record human (and nonhuman) behaviors, but also of the more benign technologies like the toilets and faucets that perform on cue, voice-activated software, automated diagnostic systems, and so on. To refer to these techno-activities as "perception" and "interpretation" of human behavior is of course to suggest that perception and interpretation are precisely *not* necessarily defined in relation to human un/consciousness. I would argue that there is much to learn about the nonhuman qualities of perception and interpretation (as performed by humans) by understanding how they are simulated by technological devices.

12. Arturo Rosenblueth, Norbert Wiener and Julian Bigelow, "Behavior, Purpose and Teleology," *Philosophy of Science* 10, no. 1 (1943):18–24.

13. Ibid., 19.

14. Ibid., 23–24. For a summary and interesting analysis of the essay and its implications see Steve J. Heims, *The Cybernetics Group* (Cambridge, Mass.: The MIT Press, 1991), 15–16.

15. Steve J. Heims, *John Von Neumann and Norbert Wiener: From Mathematics to the Technologies of Life and Death* (Cambridge, Mass.: MIT Press, 1987), 183–84. See also Norbert Wiener, *Cybernetics; or, Control and Communication in the Animal and the Machine* (New York: Technology Press, 1948), 11. For a brief history of the significance of "gunnery control" in the cybernetic coupling of artillery and humans, and a call for a more nuanced investigation of the "history of gunnery control as the surface of emergence of great swaths of material, social, and conceptual transformation," see Andrew Pickering, "Cyborg History and the World War II Regime," *Perspective on Science* 3, no. 1 (1995):21–23.

16. Warren McCulloch and Walter Pitts, "A Logical Calculus of the Ideas Immanent in Nervous Activity," *Bulletin of Mathematical Biophysics* 5, no. 4 (December 1943):115–33.

17. Heims, Cybernetics Group, 33.

18. Ibid., 19–20.

19. McCulloch and Pitts, "Logical Calculus," 132.

20. For the application of cybernetic concepts of communication and control to the social group, see Talcott Parsons, "Some Reflections on the Problem of Psychosomatic Relationships in Health and Illness," in *Social Structure and Personality* (London: Free Press, 1964), 112–26; also Parsons, "Cause and Effect in Sociology," in *Cause and Effect: The Hayden Colloquium on Scientific Method and Concept*, ed. Daniel Lerner (New York: Free Press, 1965), 51–73.

21. Jurgen Ruesch, "Social Communication and the Information Sciences," in *American Handbook of Psychiatry*, ed. Silvano Arieti, 2d ed., vol. 6 (New York: Basic Books, 1975), 899.

22. See Donna Haraway, "Signs of Dominance: From a Physiology to a Cybernetics of Primate Society, C. R. Carpenter, 1930–1970," in *Studies in History of Biology*, edited by William Coleman and Camille Limoges, vol. 6 (Baltimore: Johns Hopkins University Press, 1983), 130–219; and Haraway, "The High Cost of Information in Post–World War II Evolutionary Biology: Ergonomics, Semiotics, and the Sociobiology of Communication Systems," *Philosophical Forum* 13, nos. 2–3 (winter–spring 1991-92):244–78.

23. Heims, *Van Neumann and Wiener*, 182–83, 211.

24. Heims, *Cybernetics Group*, 19.

25. Wiener, *Cybernetics*, 19.

26. Wiener quoted in Heims, *Cybernetics Group*, 50.

27. McCulloch quoted in Heims, *Cybernetics Group*, 133.

28. The burial of the mind/body dualism is a quite explicit achievement announced by cybernetics. See Geof Bowker, "How to Be Universal: Some Cybernetic Strategies, 1943–70" *Social Studies of Science* 23 (1993): 114, 117–19; and Ruesch, "Social Communication," 901.

29. Ruesch, "Social Communication," 901.

30. Parsons, "Some Reflections," 114.

31. Ibid.

32. Ibid., 125.

33. Parsons, "Definitions of Health and Illness," in *Social Structure and Personality* (London: Free Press, 1964), 259.

34. See Donna Haraway, "A Manifesto for Cyborgs: Science, Technology, and Socialist Feminism in the 1980s," *Socialist Review* 80 (1985):65–107.

35. Nathan S. Kline and Manfred Clynes, "Drugs, Space, and Cybernetics: Evolution to Cyborgs," in *Psychophysiological Aspects of Space Flight*, ed. Bernard E. Flaherty (New York: Columbia University Press, 1961), 348. Thanks to Chris Hables Gray, editor of *The Cyborg Handbook* (New York: Routledge, 1995), who did the historical footwork to track down this origin story for the cyborg.

36. Ibid., 347.

37. Ibid., 369–70.

38. Ibid., 346.

39. Nathan Kline, Preface to *Psychopharmacology* (Washington, D.C.: American Association for the Advancement of Science, 1956), v.

40. Harold A. Abramson, ed., *Neuropharmacology*, vols. 1–5 (Madison, N.J.: Madison Printing Company, 1955–1959).

41. For a discussion of the Macy conferences as a front for CIA-sponsored research on LSD, see Heims, *Cybernetics Group*, 167–68.

42. An important step toward connecting psychotherapeutic treatments with cybernetic models of mental dys/function is being made through research on the "actual" or

"biological" changes in the human brain and its neural functioning effected during the course of psychotherapy. See book review for Susan C. Vaughan, M.D., *The Talking Cure: The Science behind Psychotherapy, New York Times,* July 31, 1997, B6.

43. Description of a local New England TV talk show, *The Nancy Merill Show,* which aired this segment on panic disorder on July 30, 1987.

44. J. Sidari, phone interview by author, Anxiety Research Unit, Massachusetts General Hospital, August 14, 1987.

45. For a thorough historical documentation and analysis of the construction of *DSM-III,* and of the debates and power stakes surrounding it, see Stuart A. Kirk and Herb Kutchins, *The Selling of DSM: The Rhetoric of Science in Psychiatry* (New York: Aldine de Gruyter, 1992).

46. Robert L. Spitzer, Introduction to *Diagnostic and Statistical Manual of Mental Disorders,* 3d ed. (Washington, D.C.: American Psychiatric Association, 1980), p. 1.

47. Gerald Klerman, "Historical Perspectives on Contemporary Schools of Psychopathology," in *Contemporary Directions in Psychopathology: Toward the DSM-IV,* ed. Theodor Millon and Gerald Klerman (New York: Guilford Press, 1986).

48. Donald Klein, Rachel Gittelman, Frederic Quitkin, and Arthur Rifkin, *Diagnosis and Drug Treatment of Psychiatric Disorders: Adults and Children,* 2d ed. (Baltimore: William and Wilkins, 1980), 814.

49. Robert L. Spitzer et al., "Constraints on the Validity of Computer Diagnosis." *Archives of General Psychiatry* 31 (August 1974):202.

50. Ibid., 203.

51. Jean Endicott, director, Department of Research Assessment and Training, New York State Psychiatric Institute, interview by author, March 25, 1996.

52. Robert L. Spitzer, director, Biometric Research, New York State Psychiatric Institute, interview by author, April 1, 1996.

53. Donald Klein and Max Fink, "Psychiatric Reaction Patterns to Imipramine," *American Journal of Psychiatry* 119 (November 1962):432.

54. Donald Klein, "The Importance of Psychiatric Diagnosis in Prediction of Clinical Drug Effects," *Archives of General Psychiatry* 16 (1967):118–26.

55. For a brief history of the construction of psychiatric nosology prior to the 1980 *DSM-III,* see Kirk and Kutchins, *Selling of DSM,* 25–37.

56. I'm drawing this fictional scenario from an interview with Dr. Myrna Weissman of the New York State Psychiatric Institute, March 26, 1996. Weissman worked with the Upjohn Company to help develop a software package for computerized diagnosis of mental disorders in primary care settings.

57. Interview with Robert Spitzer, who reported that, according to Pfizer's own market research, regional sales of Pfizer's popular antidepressant Zoloft increase significantly after the company conducts local workshops to train primary care physicians how to administer PRIME-MD in their offices.

58. Allen Frances, Introduction to *Diagnostic and Statistical Manual of Mental Disorders,* 4th ed. (Washington, D.C.: American Psychiatric Association, 1994) xxi.

59. Spitzer interview.

60. The money spent by the pharmaceutical industry on direct-to-consumer advertising for prescription drugs is estimated to have increased from $35 million in 1987 to $357 million in 1995. Historically, direct-to-consumer advertising for prescription products was closely regulated by the U.S. Food and Drug Administration (on the assumption that the appropriate audience for any marketing or advertising activity was medical doctors). But during the 1990s, although no formal changes in FDA policy had been made, the FDA moved toward giving an unofficial nod to the new advertising practices. See Bruce Mirken, "Ask Your Doctor," *San Francisco Bay Guardian*, October 23, 1996, 47.

61. Paul Virilio, *War and Cinema: The Logistics of Perception* (1984; reprint, London: Verso, 1989), 6.

62. Christopher Reeves, speech broadcast on NBC-TV from the Democratic National Convention, Monday, August 26, 1996.

63. Virilio, *War and Cinema*, 6.

64. The "Decade of the Brain" is a National Institute of Mental Health initiative in the 1990s to promote research, public education, and funding for brain research connected to mental disorders.

The Rationality of Mania

Emily Martin

> Even when silenced and excluded, madness has value as a language, and its contents assume meaning, on the basis of that which denounces and rejects it as madness.
> —Michel Foucault, Mental Illness and Psychology

> Nature is, above all, profligate. . . . [Its schemes] are the brainchild of a deranged manic depressive with limitless capital.
> —Annie Dillard, Pilgrim at Tinker Creek

The category "rationality" has often been taken to be a cornerstone of "modern" views of the world and what science can know about it. For example, many scholarly accounts describe a widespread consensus in many parts of the Western world in the first part of this century that rational thought would produce order, knowledge, and scientific truth; rational arrangements of time, space, and bodies would yield efficient and productive societies. In this view, often taken as emblematic of modernity, irrationality could have no place inside scientific practice and could yield only senseless and dangerous results if it were allowed a place in other social practices. When scholars use the terms *rationality* and *modern* in such accounts, they usually refer to categories of the mind, collections of traits and abilities that people in particular times and places believe to be powerfully linked and commonly define in relation to their opposites. Schematic oppositions such as rational/irrational are overly simple devices for capturing the immense complexities of thought in any historical epoch. But the very simplicity of oppositions like these means people can use them to put into play (at times consciously, and at times unconsciously) powerful and insidious beliefs about what constitutes valued conduct, and who should be trusted to do it. On the modern view, to give one example, women, often culturally associated with the irrational side of things, would be likely to

seem less capable of producing rational scientific knowledge or holding an office entrusted with keeping rational order in society.

An important first step in undercutting the ability of dichotomous categories like rational/irrational to serve as invidious means of ordering the world is to show that on close inspection, the opposed terms are in practice rarely neatly separated. The production of scientific knowledge, for example, might turn out to entail irrational processes; the activities of orderly, efficient people might turn out to rely on irrational elements. This step is the focus of the first part of this article. An equally important second step, one that is the focus of the second part of this article, is to understand the significance of a recent movement, one grounded in diverse cultural sites, in which modernist categories (such as rationality) and dichotomies (such as rational/irrational) are shifting and dissolving. In connection with the intense global competition and capital accumulation that began in the 1970s, a number of crises have affected most Euro-American social institutions from the level of the family to that of the nation, as well as most economic practices from the level of the individual to that of the corporation. To see the implications of these profound changes for concepts of the person, my current research focuses on a contemporary domain: that form of irrationality known as mental illness, and within mental illness, the diagnosis and experience of being manic-depressive. In this domain, the irrational (madness) is coming to seem highly valuable even in that most "rational" of institutions, the market. My account, meant to be suggestive rather than definitive, relies on a literary text by William Faulkner for insight about how the categories of rationality and irrationality could blur into each other in one "high modernist" text, and on my own research into manic-depression for insight into how the relationship between these categories is being redefined today.[1]

A quite mundane part of my fieldwork in Orange County, California, led me to Faulkner's text. People I met in Orange County often told me they don't read books, they hear them, in the form of unabridged tape recordings produced by Books on Tape, whose corporate headquarters are centrally located in Orange County. Through the disembodied voices of actors on the tapes, people sometimes seem to become almost "possessed" by the characters in the books they are listening to, characters who whisper in their ears as, unable to turn off the Walkman or car tape player, they listen on and on while driving, walking, biking, washing the dishes, or sitting in the car long after arriving at their destination. I saw the pervasiveness of this practice as an example of how a simple technology can combine with the necessity of a great deal of car travel on the region's immense freeway system to produce a daily context for the ex-

perience of a minor form of dissociation that could erode the edges of the single-minded and aware self, make its borders permeable to other selves, or allow it to be in discontiguous psychic spaces simultaneously.

Rationality in *The Sound and the Fury*, 1929

So it happened that, hooked by Books on Tape myself, I listened to and felt inhabited by the characters in William Faulkner's *The Sound and the Fury*, a novel I chose to hear because some literary critics cite it as exemplifying elements of "high modernism" ("the quintessential American high modernist novel" [Polk 1993a, 4]) and other critics can seen in it "postmodern" multiple voices and discontinuous consciousness (Trouard 1993). This experience led me to wonder whether a fictional narrative written at the time of the last great crisis of capitalism, the 1929 depression, could serve as a kind of meditation on how we might understand ways in which the meaning of "rational" is changing in the present.[2]

In broad strokes, each of the first three sections in the novel is narrated by a different member of the Compson household. Benjy Compson, a character Faulkner is said to have modeled on a local Mississippi child with Down's syndrome, narrates the first section (Bérubé 1996, xv). Benjy's brother, Quentin (who becomes a college student at Harvard), narrates the second section on the day he finally commits suicide, and their malicious younger brother, Jason (who runs the family business), narrates the third. The three brothers trace radically different views of their sister, Caddy, who never speaks in her own voice. Together with their mother, father, and uncle, these Compsons live in a household with the Gibsons, a large family of blacks they hire to cook, clean, and nurse. The Gibsons who appear in the excerpts below are Dilsey, the matriarch of the Gibson family, her son T. P., and her grandson Luster.

Literary commentators have often noted that Faulkner handles the question of the novel's characters' rationality by varying the degree to which they are fixed in a regular and orderly way in time and space. Faulkner said he explicitly intended to mark rationality by how well a character was placed in time. "To that idiot [Benjy], time was not a tomorrow, it all is this moment, it all is [now] to him. He cannot distinguish between what was last year and what will be tomorrow, he doesn't know whether he dreamed it, or saw it." The difficulty of conveying slippage in time using linear prose led Faulkner to use italics: "I had to use some method to indicate to the reader that the idiot had no sense of time. That what happened to him ten years ago was just yesterday. The way I wanted to do it was to use different colored inks, but that would have cost so

much, the publisher couldn't undertake it" (Faulkner 1968, 22). When asked whether the use of italics meant the same thing in Quentin's section, Faulkner said, "Yes, because he was about half way between madness and sanity. It wasn't as much as in Benjy's part, because Quentin was only half way between Benjy and Jason. Jason didn't need italics because he was quite sane" (22).

As Faulkner indicated, in the first and second sections, the narrator's stream of consciousness meanders about in time and space. For example, in the course of one page, Benjy's thoughts slip backward and forward in time from a gate near his house in 1928, to the same gate in 1910, to the same gate later in 1910, and then back to 1928 again.[3]

[In the present, 1928] I went along the fence, to the gate, where the girls passed with their booksatchels. "You, Benjy." Luster said. "Come back here."

[May, 1910] *You can't do no good looking through the gate, T.P. said. Miss Caddy done gone long ways away. Done got married and left you. You cant do no good, holding to the gate and crying. She cant hear you . . .*

"You, Benjy," T.P. said. "What you doing, slipping out. Dont you know Dilsey whip you."

"You cant do no good, moaning and slobbering through the fence." T.P. said. "You done skeered them chillen. Look at them walking on the other side of the street."

[Some time after June 1910 , after Benjy accosted the Burgess girl, which led to his castration] *How did he get out, Father said. Did you leave the gate unlatched when you came in, Jason.*

Of course not, Jason said. Dont you know I've got better sense than to do that. Do you think I wanted anything like this to happen. This family is bad enough, God knows. I could have told you, all the time. I reckon you'll send him to Jackson [state asylum] *now. If Mr Burgess dont shoot him first.*

Hush, Father said.

[. . .]

[Present, 1928] *Here, looney, Luster said. Here come some* [golfers]. *Hush your slobbering and moaning, now.* (Faulkner 1984, 51–52).

Quentin's thoughts skitter off twice as many times in his section as Benjy's do in his, and as they skitter in both time and space, they leave behind fragments of sentences and shards of images (Volpe 1968).

[1909 Jefferson, Mississippi] *It is because there is nothing else I believe there is something else but there may not be and then I you will find that even injustice*

is scarcely worthy of what you believe yourself to be [Present, June 2, 1910, near
Cambridge, Massachusetts] He paid me no attention, his jaw set in profile,
his face turned a little away beneath his broken hat.
 "Why dont you go swimming with them?" I said. [April 22, 1910, in Jeffer-
son, Mississippi] *that blackguard Caddy*
 Were you trying to pick a fight with him were you
 *A liar and a scoundrel Caddy was dropped from his club for cheating at
cards got sent to Coventry caught cheating at midterm exams and expelled.*
(122–23)

Quentin's memories torture him: "all of Quentin's past tries to crowd in on
him at once, every painful episode tries simultaneously to elbow its way past
all the others into consciousness. . . . Quentin cannot control the chaos of his
amoebalike memory and he finally succumbs to it. The protective walls he
builds with his formal eloquence are constantly breached by visual intrusions
from his past" (Polk 1993B, 149). Though the effort culminates in his suicide,
Quentin tries to stop the intrusion of painful memories by stopping time it-
self: "All day long Quentin tries various dodges in his attempt to forget time.
Though he breaks [the hands off] his watch, the watch continues to tick, and
time keeps on going, and he finds he can escape neither time's passing nor his
coming death" (Lowrey 1968, 56).

 I went to the dresser and took up the watch, with the face still down. I
 tapped the crystal on the corner of the dresser and caught the fragments of
 glass in my hand and put them into the ashtray and twisted the hands off
 and put them in the tray. The watch ticked on. I turned the face up, the blank
 dial with little wheels clicking and clicking behind it, not knowing any better
 (Faulkner 1984, 80).

 Jason narrates his section mostly in the present, but he also casts back and
forth in time. As literary commentators point out: "While Jason's monologue
seems much more superficially 'oral' than Benjy's or Quentin's, and while
there are none of the visual markers like italics or unconventional punctuation
to signal his immersion in the past, Jason nonetheless loses himself in memo-
ries he can control only slightly better than his brothers can control theirs"
(Ross and Polk 1996, 158). Typically, he begins with a complaint about other
people or his life, changes to a remembered conversation, and makes the con-
versation more vivid by using direct quotes, at which point "he is fully im-
mersed in the past."

Although Faulkner described Jason as "quite sane," he also said that Jason "represented complete evil. . . . He's the most vicious character in my opinion I ever thought of" (Faulkner 1968, 14). Jason's way of being is so stripped of any sign of compassion or consideration for other people, so saturated with steely cold calculation and cruelty, that numerous commentators have described him as insane.[4] His is the insanity of the *hyperrational.* For example, Evelyn Scott refers to his "petty, sadistic lunacy. . . . Jason is going mad. He knows it . . . Madness for Jason is a blank, immediate state of soul, which he feels encroaching on his meager, objectively considered universe" (Scott 1968, 27–28). Another critic says, "For all the apparent `logic' of his outpourings, [Jason] too is driven by irrational forces buried deep in his unconscious that are battering at the boundaries of articulation. His monologue is a long loud agonizing cry — Benjy's howling rage made verbal — which he sustains at such a frenetic pace to drown out the voice of his unconscious, to silence its insistent pounding at the edges of consciousness with the earsplitting volume of the sound of his own voice' (Polk 1993b, 155).

In sum, Benjy's insanity resides in his roaming loose in time, Quentin's in his desperate attempts to stop time, and Jason's in his calculated efforts to control time. Unlike his brothers, Jason aggressively and compulsively attempts to accumulate both time and money, which are much the same thing to him. "Though he attempts to steal and hoard time just as he does money — and in a sense Jason thinks of time as money — he is always just a little too late . . . he is eternally late in getting cotton market reports; when the market falls, he finds out too late to save his capital" (Lowrey 1968, 58–59). Writing virtually on the eve of the stock market crash of 1929, Faulkner aptly depicts the irrationality of behavior dedicated to the single purpose of collecting money, whatever the human cost, something Karl Marx, in an earlier era, described also:

> This boundless greed after riches, this passionate chase after exchange value, is common to the capitalist and the miser; but while the miser is merely a capitalist gone mad, the capitalist is a rational miser. The never-ending augmentation of exchange-value, which the miser strives after, by seeking to save his money from circulation, is attained by the more acute capitalist, by constantly throwing it afresh into circulation. (1967, 153)

Jason tries to be both a miser, hoarding money, and a capitalist, throwing it endlessly into circulation, but he fails on both counts. His bad timing causes him to lose profits in his capitalist schemes and his ill-humored duplicity within his family leads him to lose his miser's hoard (see Ross and Polk 1996, 156).[5]

In *The Sound and the Fury*, madness and irrationality are inseparable from sanity and rationality. Faulkner's characters could be (and most were) half sane, half mad, or somewhere in between. Not only was there no sharp divide between sanity and madness, there was no medium in which degrees of rationality could be measured. Each character is placed in a common time frame, but each moves through it in a different way. For Benjy time does not exist, for Quentin time should be obliterated, and for Jason time cannot move fast enough. Although parts of the novel have been described as "outside of space as outside of time" (Polk 1993b, 141), I think it is more accurate to describe the novel's time sense as "a time without clocks" (Sartre 1994, 266). In describing temporal concepts in different cultures, Alfred Gell (1992) argues that despite their differences, all share a common conception of order in which event A precedes event B in time. The differences consist in that the relationship between the events of time A and B can be "unaffected by the durational interval A/B. There is priority, there is order, but there is *no measure*" (22, italics added). In *The Sound and the Fury*, each character is *in* time, but each is in a time frame that moves with a different speed. A degree of order and stability is provided in the story because each character consistently occupies a time frame going at the speed he desires. The isolation of each character in his own frame is enhanced also by Faulkner's preference for a Freudian depth model of the self over a model of the self modeled on William James's theories (ascendent in American psychology in Faulkner's day), which would have emphasized external experience and sensation (Ross and Polk 1996, 78).[6] Perhaps as a way of marking this preference, it could be William James whose class at Harvard Faulkner imagined Quentin would miss on the day of his suicide (77–78).

Although Faulkner creates interior depth in which he anchors each of the main characters, he also links them in a dense web of social experience. In a manner of speaking, there is considerable tension in the novel between Freudian and Jamesian views of the self. Context, position, and experience within a particular set of social (community and kinship) interactions are as profound a matrix of *The Sound and the Fury* as its Freudian depths. Characters are framed by a rich cultural context, inflected with the nuances of a particular time, place, and its history, unique, idiosyncratic, and not easily comparable. In some ways the set of characters who narrate sections delineate the shape of social interaction by standing where it is attenuated just short of disappearing altogether: Benjy cannot speak in language, but he hears, utters many sounds, and responds acutely to smell. In an incident interpreted by some as his attempt to molest a girl, Benjy is, in his words, continually "trying to say": "I was trying to say, and I caught her, trying to say, and she screamed

and I was trying to say and trying . . . " (Faulkner 1984, 53). Quentin kills him-
self, but out of pain at events involving the lost honor of his sister, Caddy; and
although Jason emotionally tortures everyone around him, he also continues
to provide economic support for the household. The Compsons embody a va-
riety of forms of the limits of rationality that are most starkly thrown into
light by contrast with the family of black servants who feed them, keep track of
them, and endure the Compsons' complacent racism:

> Juxtaposed to the various kinds of lunacy demonstrated by the Compsons are
> the Gibsons—practical, "common-sense variety" blacks whose individual and
> collective voices create an eloquent contrast to the white world and form, on a
> level of emotion and reason, a more viable approach to life. (Davis 1994, 395)

Faulkner might be said to have devised a way to upset modernist values, which
would more likely have placed rationality, order, and reason on the side of the
white Compsons, with their secure social position and interests in the stock
market, than on the side of the black Gibsons, with their subordinate position
in society, lack of education, and very limited resources. Speaking of the uses
Raymond Williams made of the novel form, David Harvey comments,

> The novel is not subject to closure in the same way that more analytic forms
> of thinking are. There are always choices and possibilities, perpetually unre-
> solved tensions and differences, subtle shifts in structures of feeling all of
> which stand to alter the terms of debate and political action, even under the
> most difficult and dire of conditions. (1996, 28)

The lack of closure in the novel form may have enabled Faulkner to explore
the presence of irrationality in unexpected places—among those in secure so-
cial positions at the top of the racial hierarchy and among even those, like
Jason, involved in that most "rational" of activities, buying and selling in the
market itself. Faulkner refuses to allow any character to be completely rational
or completely irrational, whether protected by whiteness, wealth, intelligence,
or high social position or exposed by blackness, poverty, mental deficits, or
low social status.

The Irrationality of the Nonmodern

My personal point of departure in trying to understand how rationality is con-
stituted in contemporary U.S. society is what I remember of discussions

around my two grandmothers' very different kitchen tables. My southern grandmother's world in Birmingham, Alabama, was reminiscent of the world Faulkner described, her stories thickly peopled with friends, kin, and neighbors who were addicted, deformed, eccentric, delusional, or at least amusingly strange. Madness walked among us and was apt to touch everyone at least a little. At my northern grandmother's kitchen table, in her farmhouse in Lancaster County, Pennsylvania, different kinds of distinctions were made. She would tell me, wearing her long gray Mennonite dress, why sending astronauts to the moon was an offence against God's plan for the world and show me letters she had written to my father while he was stationed on a naval ship in the Pacific, trying to convince him that things he had learned as a science major at Franklin and Marshall College, such as Darwinian evolution, were wrong and sinful. This grandmother's Mennonite world was apparently quite uniformly of a single mind, a mind that held beliefs the outside world considered irrational.

Long after both my grandmothers' stories were stilled by their deaths, with the development of sufficient interest and technique, the Mennonite and Amish communities of Lancaster County became famous as a site for a different kind of clash between rationality and irrationality, between people who are mentally normal and people who are mentally abnormal, and by dint of that irrational. Geneticists made extensive efforts to locate the gene responsible for manic-depression by investigating the members of large extended families in Lancaster County who had clusters of kin with symptoms of manic-depression. The putative gene, if one could be found, was thought to provide a sign and a cause for manic-depression in the general population too, even though the manifestations of manic-depression in these religious communities were surely idiosyncratic. For example, the official psychiatric (*DSM-IV*) definition of a manic episode is "excessive involvement in pleasurable activities that have a high potential for painful consequences (e.g. engaging in unrestrained buying sprees, sexual indiscretions, or foolish business investments)" (American Psychiatric Association 1994).[7] The geneticists modified this for the Amish setting to be "racing one's horse and carriage too hard or driving a car (recklessness not implied), buying or using machinery or worldly items forbidden by church rules (e.g. dressing up in worldly clothes), flirting with a married person (indeed any overt sexuality), treating livestock too roughly, excessive use of the public telephones (telephones are forbidden in homes), going on a smoking binge, and desiring to give gifts or planning vacations during the wrong season (because the agrarian principle and frugality confine these activities to a given time and place)" (Egeland 1986, 68).

As Jeffrey Longhofer et al. (1997) have argued, the medical researchers who sought (and are still seeking) the genes responsible for manic-depression see

Anabaptist communities like the Amish as naturally occurring laboratories for scientific research. They see these communities as places where "culture" is held constant across all individuals and across time by the force of strong community and religious bonds. Everyone shares the same values, social network, level of education, income level, and occupation. Since the community is also imagined as closed to the outside world, frozen in time, it is possible to see how the geneticists might plausibly interpret any individual variation that appeared in such a setting as a result of the action of genes.

It is surely no accident that the condition thrown into relief by a supposedly constant cultural environment involves mental illness, for religious communities like the Anabaptists are defined in large part by their distance from modernity, and hence their distance from modern rationality. They are said to submit unquestioningly to authority of the church and family head (Hostetler 1993; Kraybill 1989). They seek to submerge the individual in collectivity, through humility, submission, and avoidance of individual adornment. They have no room for questioning thoughts about this social order: "Critical thought for its own sake has no function in the little community" (Hostetler 1993, 13–14). They seemingly reject technological development and its results, and hence, progress, change, and growth. A little like Benjy in Faulkner's triad of characters, they are thought to be oblivious to time or out of it altogether.

The features of the Anabaptists that seem most salient to outside observers are precisely traits that appear to place them outside of modernity. To paraphrase William Connolly (1988, 1), they are "darker, more superstitious, less free, less rational, less productive, less civilized, less comfortable, less democratic, less tolerant, less respectful of the individual, less scientific and less developed technically" than those who embrace the modern epoch. How unsurprising, then, that they would seem to be an appropriate population to search for genetic markers of mental illness, by virtue of their nonmodern organic solidarity and homogeneity.

Critics of the increasing emphasis on genes as the most important sign of health and illness conditions fear that in the world coming into being on the heels of genetic markers for all kinds of conditions, comparisons on a common scale are not only invited, they rush to the forefront. Common measures of value seem to compel everything to be figured in their terms, to be thrown into what Marx called the "great social retort."[8] The "retort" boils out particular flavors and leaves only measurable abstract qualities, such as degrees of sanity, modernity, or rationality. The gene is particularly efficacious in leading the shift to an abstract measure of life: the modern emphasis on "the 'priority' of the body of the organism as the site of reference for life" is overcome and re-

placed by an "economy of sequences"—"constantly changing and growing databases" of sequences of DNA (Doyle 1997, 24).

> "Life" materialized as information and signified by the gene, displaces "Nature," preeminently embodied in and signified by old-fashioned organisms. From the point of view of the gene, a self-replicating autogenerator, "the whole is not the sum of its parts, [but] the parts summarize the whole." (Franklin 1995, 67)

The ability of the gene to stand in for the whole of the organism, to instantiate pure information, gives it a function much like other measures of value in highly rationalized capitalistic societies: genes are the gold standard of life. Hence, this standard of value, it appears, can be abstracted from its contingent and accidental form (persons) without loss of anything significant.[9] What would actually be lost in the Anabaptist case is the importance of the particular meaning of manic-depression in the Amish and Mennonite context.

My previous discussion of how Faulkner describes the Compsons gives us a way to imagine differently the division assumed in the genetic study of the Amish, which compares the nonmodern/irrational on one side to the modern/rational on the other. In the world Faulkner imagined, comparisons on a common scale with others are not invited: no such scale exists. Faulkner insistently dislodged links between rationality and modern qualities, by finding rationality in the idiot Benjy and irrationality in the hyperrational market speculator Jason: that he could do so, even in the context of a high modernist novel, might lead us to question the link between irrationality and nonmodern qualities the genetic study seems to encourage.

Irrationality Cultivated

The search for the genes responsible for manic-depression (and the assumption they will be found) has the effect of giving the category *manic-depression* concreteness, timelessness, and facticity. In Euro-American cultures generally, the more a condition is attached to particular physical causes that lie behind and explain its presence, the more real and substantial it becomes. But in a contradictory manner, there are simultaneously other ways manic-depression is growing less substantial, instead becoming understood as a cultural construct, a category that only exists in relation to its immediate context, and hence liable to change and shift accordingly.[10] Below, I will consider how the

tension between these views (manic-depression as culturally constructed vs. manic-depression as physically determined) bears on a recent shift in the value attached to manic-depression—from a liability to an asset. Manic states in particular are being colonized in a way, perhaps to aid in the valorization of a labile self who seems best "fit" for the environment of late capitalist development.

There is no doubt that my personal vantage point contributed to my noticing that the value attached to some categories of madness (manic states) is changing from negative to positive. By the time I became aware of how the Anabaptists in Lancaster County had apparently joined the ranks of the mad, uncivilized, and premodern, I had myself been diagnosed with manic-depression and had become convinced that the label could rightly be applied to my Anabaptist-raised father as well. Nothing else seemed to fit his oscillating moods inside the family and his phenomenally energetic drive in the outside world, which led him to pile up patents when he worked for DuPont, start his own company, and become a successful entrepreneur. Given this history, I was bound to notice when traits associated with certain forms of mental illness began to be valorized in a strange way. Among these was the very malady, manic-depression, that placed me and my father "outside reason."

In manic-depression, valorization, or redefinition from a liability to an asset, is happening in part by way of psychiatrist Kay Jamison, who in her recent memoir *An Unquiet Mind* "came out" as manic-depressive herself. Jamison (1995) describes the positive aspects of manic-depression eloquently: it entails a "finely wired, exquisitely alert nervous system" (3). "With vibrissae twinging, antennae perked, eyes fast-forwarding, and fly faceted" (3), and "fast-scanning eyes" (113), "I took in everything around me." These thought processes are characteristic of the manic phase: "Fluency, rapidity, and flexibility of thought on the one hand, and the ability to combine ideas or categories of thought in order to form new and original connections on the other . . . rapid, fluid, and divergent thought" (1993, 105).

Participating to some extent in an older tradition of seeing madness as heroic, Jamison compiles lists of famous and influential people whose diaries, letters, and other writings indicate that manic-depression played a role in the enormously creative contributions they made to society. Jamison lists over 200 composers, artists, and writers who arguably had some version of manic-depression, from T. S. Eliot and Edna St. Vincent Millay to Georgia O'Keeffe, Edvard Munch, and Jackson Pollack (1993, 267–70). But Jamison does not simply see these famous people as heroes who did great things despite the terrible handicap of madness. At least in part, as I argue below, she sees their madness itself as a social good, because it produces an immense and potentially creative lability of mind.

Echoing Faulkner's treatment of insanity, for Jamison, manic-depression is said to entail a "distorted" sense of time and space. "Delusions" abound in the manic phase. Objects seem to merge, to flow into each other. Shapes shift. Any ordinary thing can change into something else and then something else again. The process happens unbidden and is not necessarily sinister at all. It can be as interesting as watching things morph in a movie! Inside and outside the self are blurred (Jamison 1995, 80). Thought is rapid and flighty, jumping from one thing to another (Goodwin and Jamison 1990, 23). She cites a classic description by Kraepelin (1921), "His surroundings appear to the patient to be changed; he sees St. Augustine, Joseph with the shepherd's crook, the angel Gabriel, apostles, the Kaiser, spirits, God, the Virgin Mary" (Goodwin and Jamison 1990, 24).

Manic-depression, for all the pain it entails, keeps one moving in time and space. Jamison (1995) uses many metaphors to convey what it is like: "I now move more easily with the fluctuating tides of energy, ideas, and enthusiasms that I remain so subject to. . . . My high moods and hopes having ridden briefly in the top car of the Ferris wheel will, as suddenly as they came, plummet into a black and gray and tired heap . . . then at some unknown time, the electrifying carnival will come back into my mind" (213).

Other manic-depressives concur about the rapidity of movement in the manic phase. Unica Zürn (1994) describes her state of mind just before she entered a mental hospital, Wittenau. In the manic phase, she makes everything around her circulate rapidly; she circulates so rapidly, she lifts off the earth.

> Whenever she [Zürn is speaking of herself] enters a shop to purchase some-thing, she leaves behind far more money than her purchase costs, and de-parts the shop with the words: "Happy birthday and many happy returns." Naturally the people in the shops are enchanted. And from now on she en-counters one large smile whenever she goes. She also starts to walk in a com-pletely new way: very fast and incredibly nimble. It seems to her as if she were floating two centimetres above the pavement—she's flying! (43)

Later, frenetic activity in sped-up time is replaced by torpor in time that has stopped:

> She marches in the grey fifth column of the mortally depressed. . . . She spends weeks and months in her bed with her eyes closed, just as at Witte-nau. She no longer wishes to wash herself, comb her hair or speak. (113)

Because it entails being out of control in the time-space matrix, many people must have breathed a sigh of relief when manic-depression got its first internal

manager, lithium. When one takes lithium, there is an "other" inside governing one's lack of discipline. In my recent fieldwork in support groups for manic-depression, people frequently say they can feel "the pill within." The reasons are certainly more complex than I can indicate here, but it is striking that this "manager" is regarded in highly ambivalent ways by patients themselves. Lithium as an internal manager for manic-depression is resisted more ferociously than any other drug psychiatrists prescribe. Widespread informal consensus labels lithium the drug that elicits by far more "failure to comply" than any other: "I'd rather stand in front of a moving train than tell my psychiatrist I am manic, because I know she will make me take more lithium" (patient narrative). People who are not manic-depressive cannot understand why there is this resistance to lithium, which promises you can "be normal" (Jamison 1995, 91). "But if you have had stars at your feet and the rings of planets through your hands, are used to sleeping only four or five hours a night . . . it is a very real adjustment to blend into a three-piece-suit schedule, which, while comfortable to many, is new, restrictive, seemingly less productive, and maddeningly less intoxicating" (92). If manic-depression "destroys the basis of rational thought," and lithium restores it, then it is highly significant that many patients who have experienced being "irrational" refuse lithium as a kind of agent of the rational/modern, despite the agonies manic-depression can produce.[11]

I suspect that people with manic-depression—mercurial of mood, always in motion, scanning the interface, eyes flickering—may be coming to be regarded as capable even when they refuse their medications. Time and space distortions become assets in an environment that is in many ways stretching, condensing, speeding, warping, and looping linear time and space. Perceptual abilities to contend with temporal and spatial instability can easily seem to be talents in accord with new realities instead of irrational delusions. If concepts of the ideal person are changing in such contexts as work, life, and value, demanding restless change and development of the person at all times, in all realms, then manic-depression might readily come to be regarded as normal—even ideal—for the human condition under these historically specific circumstances. Just as Connolly could see reason, rationality, and control as desirable in the context of modernity's demand for order, so Jamison can see manic-depression as desirable in the context of late modernity's demand for continuous change. It is in this context we need to see the rash of confessions by successful contemporary people from Patty Duke to Ted Turner that they are manic-depressive. The caption to a *Saturday Evening Post* photograph of Turner, venture capitalist par excellence (and recently diagnosed as manic-depressive) warns his competitors to watch out: he has stopped taking his medication—

not because he was about to go beserk, but because he was liable to launch another zany but possibly wildly successful venture.

It almost seems as if the reservoir of "irrationality" in the condition of manic-depression is being tapped, mined even, for reasons that might be related to the premium placed in a period of economic growth on innovation and creativity as sources of still greater growth. This possibility became more vivid for me when I realized that the Anabaptists are, rather like manic-depressives, being newly claimed as part of the modern world. There are numerous very recent books and articles, both academic and popular, written by historians, anthropologists, sociologists and journalists, that claim these communities have been misunderstood. We thought they were rigid and closed; actually they are open to new ideas, welcoming of innovation and technological change (within limits). Most importantly, they are good at taking risks in business. They are astoundingly successful entrepreneurs. Headlines proclaim that "New Studies by Anthropologists Indicate Amish Communities Are Much More Dynamic and Diverse Than Many Believed" (Raymond 1990); newspapers describe how Amish-run businesses fail less often than most businesses in the United States ("Amish Values" 1996; Brende 1996; Olshan 1991).

Colonization of the irrational in marginal people also makes sense because certain forms of irrationality (which are in fact an intrinsic part of daily life in late capitalism) are emerging into greater visibility. Perhaps the irrationality of the market and what you have to do and be to succeed in it is being more openly recognized: to be good at playing this crazy game, it helps to be a little crazy. "Rational choice" contains within it "irrational" impulses and desires. From this vantage point, we can look at the excess in Ted Turner as capitalist and as yacht captain (depicted and experienced as talent) as signs of apprehension: greater knowledge of what capitalism entails and greater fear of what it may require of people. A new book that analyzes the workings of late capital is even called *One World, Ready or Not: The Manic Logic of Global Capitalism* (Greider 1997). It is filled with references to "manic capital," oscillating with depression, and the calamitous consequences of both. The recent drop and rapid recovery of the stock exchange in October 1997 inspired a flurry of domain-crossing remarks:

Monday was an awful day on Wall Street. Stock prices went straight down. Tuesday was wonderful. Prices went straight up. Wednesday, they went both ways and ended in the middle. If Wall Street were a person we'd think he was mentally ill. (Uchitelle 1997, 1)

In a section titled "The Manic Markets" and subheaded "Wacky Week Mixed Greed and Fear," we read that "Sensing that the stock market was displaying classic signs of manic-depression, Alfred Goldman, the director of market analysis for A. G. Edwards & Sons, counseled investors on Monday to remain bullish" (Abelson 1997, 1).

Rationality Reconsidered

The colonizing of the irrational in the mentally ill and the religious nonmodern would make sense if common-sense conceptions of rationality were changing in certain ways. The ideal of a bounded, unitary, singular self seems to be giving way, allowing various kinds of separation within the self to be considered "normal" and sometimes desirable. These separations include dissociation of the self into parts, each of which has some autonomy from the others; experiencing the body as an object; experiencing the body as an object that shifts its dimensions in time and space. William James and the early gestalt psychologists like Schilder, writing near Faulkner's time, thought that all these experiences were in some measure part of ordinary daily life for everyone. Only extreme cases produced an abnormal inability to function. Perhaps the currency of their views at the time enabled Faulkner to see rationality in a continuum with irrationality. But until recently, views that made fragmentation and dissociation of experience an ordinary part of experience, such as William James's description of the "many me's" of a normal person, have been eclipsed by the dominance of depth models of the self and of normal psychological functioning that require a greater integrity of the parts of the self, held together by hierarchical control. Faulkner's insertion of irrationality at the heart of the rational and modern upsets the tidy lineup of categories in the rational/irrational dichotomy and undercuts its ability to relegate some kinds of people (such as the mentally retarded) to the undesirable status of the nonmodern.

We cannot know in advance whether the shifting value sign attached to mania will produce new invidious distinctions or help eradicate old ones. As I pursue my research, I expect to follow closely a central tension in how mania is being refigured: for mania to be colonized (to become an asset for Wall Street and its employees), it must seem stable and real. Pharmaceutical labs would ask nothing less before investing in drugs to dampen mania in some people or heighten it in others. But simultaneously mania must shift its meaning to somehow traverse the conceptual divide between the irrational and rational,

either making the irrational come to seem rational, or forging a new category of sense somewhere in between. Out of this dual movement arises an important tension between manic-depression, the genetic condition, and manic-depression, the cultural category. Understanding the new lines of power that might be opened up by this tension will require me to consider many settings, from genetics laboratories through corporate boardrooms and the stock market to religious communities and psychiatric clinics. In so doing, my research joins the consensus of many of the other authors in this volume, that cultural studies of science need to be situated at junctures between scientific and technological research settings on the one hand, and related cultural settings that reveal changing concepts of self and society on the other. Only in this way can they hope to illuminate the lines of power, stretching from one edge of a cultural field to the other, that are making something like mania seem both more real, fixed, and known and more fictional, unstable, and unknowable at the same time.

Notes

1. In my fieldwork, I am moving among a variety of contexts in which the category *manic-depression* has social meanings. These contexts include research laboratories studying the neurophysiology of manic-depression, support groups run by and for people who have manic-depression, and pharmaceutical companies marketing drugs for treatment of manic-depression. I am participating in these contexts as a participant observer in two areas of the United States, Baltimore/Baltimore County in Maryland and Orange County in southern California; because I also live and take part in the ordinary activities of life, including work, leisure, and education, in these two areas, I will hopefully be in a position to understand the different meanings attached to manic-depression in the context of everyday life in Baltimore, a rust-belt city surrounded by affluent suburbs, and Orange County, a postsuburban conglomerate of planned communities heavily involved in the entertainment and high-tech industries. My focus is on contexts in which people experience the contained, stable, unitary self who moves through time in an orderly, linear fashion (the "modern" self) under pressure to become "postmodern," for example by undergoing continuous change, allowing the intrusion of foreign entities into the core of the self, or tolerating fragmentation of the self into discontinuous parts.

2. See Warren 1994 for discussion of Faulkner's important awareness of issues raised by the Great Depression.

3. The time shifts below follow Volpe 1968 and Ross and Polk 1996.

4. Brooks 1994 (293) describes Jason as sadistic, perverse, inhuman, brutal, cold hearted, and self-righteous.

5. His cache of partly stolen money ($3,000), hidden in a locked box beneath the floorboards of his room, is in due course taken by the niece whose rightful property at least some of it was.

6. This is ironic, given that James was ascendent in American psychology at the time (Ross and Polk 1996, 78).

7. For lack of space, I will not deal with the complicated history of diagnostic categories that culminate in the *DSM-IV* classification for manic-depression.

8. The context of this phrase is, "Everything becomes saleable and buyable. The circulation becomes the great social retort into which everything is thrown, to come out again as a gold-crystal. Not even are the bones of saints, and still less are more delicate res sacrosanctae, extra commercium hominum able to withstand this alchemy" (Marx 1967, 132).

9. This paragraph is informed by Jackie Orr's work (1990) on panic disorder and panic markets: "And while I believe that a dominant, dangerous feature of the panic market is that it is becoming ONE—one universal marketplace desiring to powerfully equalize all our exchanges, social sexual symbolic—I do not believe every body finds its self yet the same within these market exchanges. Some people will grow more hungry than some others, die more quickly than some others" (480).

10. This point is indebted to Mary Poovey's recent work (1998) on the history of the concept of the fact.

11. Very recently other drugs have been developed that manage manic-depression, such as Depakote.

Works Cited

Abelson, R. 1997. "A Sudden Breakout of Mad-Bull Disease." *New York Times*. November 2:1, 12.

American Psychiatric Association. 1994. *Diagnostic and Statistical Manual of Mental Disorders*. Washington, D.C.: American Psychiatric Association.

"Amish Values Help in Business." 1996. *News for You* 44, no. 19:3.

Bérubé, M. 1996. *Life As We Know It: A Father, a Family, and an Exceptional Child*. New York: Pantheon.

Brende, E. 1996. "Technology Amish Style." *Technology Review* 99, no. 2: 26–33.

Brooks, C. 1994. "Man, Time and Eternity." In *The Sound and the Fury: An Authoritative Text, Backgrounds, and Context Criticism*, edited by David Minter, 289–97. New York: W. W. Norton.

Connolly, W. E. 1988. *Political Theory and Modernity*. Oxford: Blackwell.

Davis, T. M. 1994. "Faulkner's 'Negro' in *The Sound and the Fury*." In *The Sound and The Fury: An Authoritative Text, Backgrounds, and Context Criticism*, edited by David Minter, 383–97. New York: W. W. Norton.

Doyle, R. 1997. *On Beyond Living: Rhetorical Transformations of the Life Sciences*. Stanford, Calif.: Stanford University Press.

Egeland, J. 1986. "Cultural Factors and Social Stigma for Manic-Depression: The Amish Study." *American Journal of Social Psychiatry* 6, no. 4:279–86.

Faulkner, W. 1968. "Faulkner Discusses *The Sound and the Fury.*" In *Twentieth Century Interpretations of The Sound and The Fury: A Collection of Critical Essays*, edited by M. H. Cowan. Englewood Cliffs, N.J.: Prentice-Hall.

——— . 1994. "Class Conferences at the University of Virginia." In *The Sound and the Fury: An Authoritative Text, Backgrounds, and Context Criticism*, edited by David Minter, 234–37. New York: W. W. Norton.

——— . 1984. *The Sound and the Fury.* New York: Vintage.

Flower, M. J., and D. Heath. 1993. "Micro-anatomo Politics: Mapping the Human Genome Project." *Culture, Medicine, and Psychiatry* 17:27–41.

Franklin, S. 1995. "Romancing the Helix: Nature and Scientific Discovery." In *Romance Revisited*, edited by L. Pearce and J. Stacey. London: Lawrence and Wishart.

Gell, Alfred. 1992. *The Anthropology of Time: Cultural Constructions of Temperal Maps and Images.* Oxford: Berg.

Goodwin, F. K., and K. R. Jamison. 1990. *Manic-Depressive Illness.* New York: Oxford University Press.

Greider, W. 1997. *One World, Ready or Not: The Manic Logic of Global Capitalism.* New York: Simon and Schuster.

Haraway, D. J. 1997. *Modest_Witness@Second_Millenium.FemaleMan©_Meets_Onco-Mouse™: Feminism and Technoscience.* New York: Routledge.

Harvey, D. 1996. *Justice, Nature, and the Geography of Difference.* Oxford, England: Blackwell.

Hostetler, J. A. 1993. *Amish Society.* Baltimore: Johns Hopkins University Press.

Jamison, K. R. 1993. *Touched with Fire: Manic-Depressive Illness and the Artistic Temperament.* New York: Free Press.

——— . 1995. *An Unquiet Mind.* New York: Knopf.

Kraepelin, E. 1976. *Manic-Depressive Insanity and Paranoia.* New York: Arno Press.

Kraybill, D. B. 1989. *The Riddle of Amish Culture.* Baltimore: Johns Hopkins University Press.

Longhofer, Jeffrey, Jerry Floersch, and Kristine Latta. 1997. "Writing Culture into Amish Genes: Biological Reductionism in the Study of Manic Depression." *Culture, Medicine and Psychiatry* 21, no. 3:137–159.

Lowrey, P. 1968. "Concepts of Time in *The Sound and the Fury.* In *Twentieth Century Interpretations of The Sound and The Fury: A Collection of Critical Essays*, edited by M. H. Cowan. Englewood Cliffs, N.J.: Prentice-Hall.

Marx, K. 1967. *Capital.* Edited by F. Engels. Vol. 1, 1887; reprint, New York: International Publishers.

Olshan, M. A. 1991. "The Opening of Amish Society: Cottage Industry as Trojan Horse." *Human Organization* 50, no. 4: 378–84.

Orr, J. 1990. "Theory on the Market: Panic, Incorporating." *Social Problems* 37, no. 4: 460–84.

Polk, N. 1993a. Introduction to *New Essays on* The Sound and the Fury, edited by N. Polk, 1–21. Cambridge: Cambridge University Press.

————. 1993b. "Trying Not to Say: A Primer on the Language of *The Sound and the Fury.*" In *New Essays on* The Sound and the Fury, edited by N. Polk, 139–75. Cambridge: Cambridge University Press.

Poovey, M. 1998. *A History of the Modern Fact: Problems of Knowledge in the Sciences of Wealth and Society.* Chicago: University of Chicago Press.

Raymond, C. 1990. "New Studies by Anthropologists Indicate Amish Communities Are Much More Dynamic and Diverse than Many Believed." *Chronicle of Higher Education* 37, no. 16:A7, A9.

Ross, S. M., and N. Polk. 1996. *Reading Faulkner:* The Sound and the Fury. Jackson: University of Mississippi Press.

Said, E. W. 1985. *Beginnings: Intention and Method.* New York: Columbia University Press.

Sartre, J.-P. 1994. "On *The Sound and the Fury:* Time in the work of Faulkner." In *The Sound and the Fury: An Authoritative Text, Backgrounds, and Context Criticism,* edited by David Minter, 265–71. New York: W. W. Norton.

Scott, E. 1968. "On William Faulkner's *The Sound and the Fury.*" In *Twentieth Century Interpretations of The Sound and The Fury: A Collection of Critical Essays,* edited by M. H. Cowan, 25–29. Englewood Cliffs, N.J.: Prentice-Hall.

Trouard, D. 1993. "Faulkner's Text Which Is Not One." In *New Essays on* The Sound and the Fury, edited by N. Polk, 23–69. Cambridge: Cambridge University Press.

Uchitelle, L. 1996. "1995 Was Good for Companies and Better for a Lot of C.E.O.s." *New York Times,* March 29, .

Volpe, E. L. 1968. "Appendix: Chronology and Scene Shifts in Benjy's and Quentin's Sections." In *Twentieth Century Interpretations of The Sound and The Fury: A Collection of Critical Essays,* edited by M. H. Cowan, 103–10. Englewood Cliffs, N.J.: Prentice-Hall.

Warren, R. P. 1994. "Faulkner: Past and Future." In *The Sound and the Fury: An Authoritative Text, Backgrounds, and Context Criticism,* edited by David Minter, 243–46. New York: W. W. Norton.

Zürn, Unica. 1994. *The Man of Jasmine and Other Texts.* London: Atlas Press.

Mainstreaming Feminist Critiques into the Biology Curriculum

Scott F. Gilbert

with collaboration from the Biology and Gender Study Group

I. Introduction

Why introduce feminist critiques into the biology curriculum? In short, they are needed to make students better biologists at a time when biology is becoming increasingly important in our social discourse. Today's biology students will be given more physical and social power than any group of people before them. Biologists will soon be able to alter the course of evolution, cure or cause epidemic disease, and create new forms of life. Moreover, our culture itself is asking biologists to address society's major issues—gender, aggression, health, poverty, legality, land use, and water use. Even legality amd educatability are being given biological status. These were not always biological questions, but society is now asking biologists to answer them. And biologists are giving answers. Thus it is crucial that biologists be educated for social responsibility. I have been using feminist critiques of biology as one means of teaching students to become critical of themselves and of biologically based stories in the scientific and popular literature. I hope that these exercises will make the students better scientists at the laboratory bench, in the classroom, and in public forums. Feminist critique identifies some of the underlying social assumptions that inform the way scientists perform and interpret their experiments, but the uncovering of

199

these stories does not lead to a relativistic stance toward biology. As we will see, one of the main functions of feminist critiques in biology has been to make the science "more objective." To be relativistic is to be irrelevant. Some scientific stories are far more probable and supported by far more evidence than others.

This approach comes from a very privileged perspective. First, the other members of the Swarthmore College Biology Department have been supportive of this endeavor, and several of them are also involved in introducing various critiques into their own classes. I am not even the only man in the science departments who teaches courses in women and science. Second, the college administration believes that educating socially responsible citizens is a major priority of this Quaker-founded school (Bloom 1993). It has even obtained funding for a group of scientists to read books in science studies. (Yes, a group of a dozen real scientists—men and women—actually sat around a table and rationally discussed *Laboratory Life.* I was there. It happened.) Third, at a liberal arts college, material from one subject is expected to be integrated with other areas of knowledge. It is not unusual to have music majors or women's studies concentrators in biology courses, and the students in the advanced biology seminars are demanded to teach the other members of the seminar (including the faculty members). Fourth, my area of expertise, developmental biology, is a field that involves describing how fertilization occurs, how sex is created in the embryo, and how the brain is formed—issues that have been considered central to defining one's maleness or femaleness. Indeed, when a woman does feminist critique of biology, she is often revising her autobiography, and when a man engages in feminist critique of biology, he often revises his perceptions (and his relationships) to women, nature, and society. Because of the importance of developmental biology to one's self-definition and to the problems of reproductive technology, several individuals and groups have scrutinized this area and have written excellent critiques of its language, its narratives, and its interactions with society (Biology and Gender Study Group 1988; Bleier 1985; Doane 1976; Eicher and Washburn 1986; Fausto-Sterling 1985; Haraway 1976; Hubbard 1982; Hubbard and Wald 1993; Keller 1995; Martin 1991; Schatten and Schatten, 1983). This means that there is a literature in this area that can sustain interest and active participation. This is not the case in all areas of biology.

Many of the above-mentioned people who have written feminist critiques of developmental biology have been trained as scientists. Thus, developmental biology has seen a remarkable reform from within. The scientific data themselves

have not been questioned so much as the types of questions thought important and the interpretations drawn from experiments and observations. In most instances, feminist critiques have been used to make the science "better" in the normative sense. Feminist critiques were used as a control. Just as a good scientist would control for temperature, pressure, and solvent effects, so the scientist should also control for social biases and cultural assumptions. The Biology and Gender Study Group (1988) has called this "controlling for social biases"; Sandra Harding (1992) calls it "strong objectivity."

As with normative science, feminist critiques of developmental biology are based on evidence. When I lecture on feminist critiques of biology, I often start with the following quotation, reading directly from the book:

> In all systems that we have considered, maleness means mastery, the Y-chromosome over the X, the medulla over the cortex, androgen over estrogen. So physiologically speaking, there is no justification for believing in the equality of the sexes. (Short 1972)

This evidence for social biases comes from a textbook published in 1972, when I was a postdoctoral fellow (see Spanier 1984; this paragraph and others like it are not to be found in the 1982 revision of this book). If nothing else, this type of quotation shocks the students, jarring open the possibility that feminist critique may have something to say to them.[1]

We usually discuss feminist critiques during the laboratory rather than in the classroom. There are several reasons for this. First, the entire class is together in a more informal setting. Second, there is a lot of downtime in a developmental biology laboratory: hurry up and wait is the norm. Third, the laboratory studies often open themselves directly to feminist critique. So we discuss feminist critiques of fertilization narratives after just having seen fertilization taking place in sea urchins, while we wait ninety minutes for the first cell division to occur. Fourth, since laboratory grades depend on notebooks and projects, students can discuss these issues without fear of being graded on their views. Sometimes I have assigned the students to read certain articles, and we have discussion immediately; other times, I have lectured to them about the articles, and then we discuss them. In no cases were the students tested on this material. I feel that it is important to introduce feminist critiques so that the students will be challenged to look at their assumptions and the assumptions of the literature. I do not ask for their agreement with it.

II. Sperm Tales and Other Narratives

In the developmental biology laboratory, our first discussion of feminist cri-
tique involves fertilization. I usually will ask the students to have read two arti-
cles, "The Importance of Feminist Critique for Contemporary Cell Biology"
(Biology and Gender Study Group [BGSG] 1988) and "Sperm Wars" (Small
1991), before the laboratory period. After a general discussion of metaphors
(after Lakoff and Johnson, 1980), we discuss the sperm and the egg. They are,
after all, gametes, that is, marriage partners (from the Greek *gamos*, "mar-
riage"). The BGSG paper looks specifically at the analogy sperm: man = egg:
woman, and it is an obvious analogy for all the students to see. They instantly
bring up the *Look Who's Talking* movies with the anthropomorphized sperm. I
sometimes point out the incredibly important difference between simile
(which, like analogy, is logical, explicit, and appeals to the brain) and
metaphor (which is magical, implicit, and appeals to the emotions). One never
hears someone say that the sperm is like a man and the egg is like a woman.
Rather, one hears about the "passive egg" being fulfilled by "the dynamic, ac-
tive masculine vector of life." (The quotation here [referenced in BGSG 1988]
is from a speech by an important Dutch minister who used the fertilization
story to show how females are naturally passive and men are naturally active.)
The BGSG paper has documented an evolution of sperm stories that parallels
the roles that men and women were expected to play in society. In the 1800s,
the sperm was the egg's suitor. Later the sperm and the egg are depicted as
characters in a self-congratulatory origin myth. Here, the sperm, like Joseph
Campbell's paradigmatic hero, is expelled, tested, challenged, and befriended,
and after a perilous journey wherein all but a few are lost, joins in a final con-
test to see who gets the princess and founds a new kingdom. The egg is a pas-
sive princess, the prize given to the victor. It even has a corona and vestments!
Schatten and Schatten (1983) have likened this story to the Sleeping Beauty
legend, wherein the passive princess is activated by the kiss of the prince (who
has survived the briars and brambles of the zona pellucida). If one wishes a
wonderful illustration of this nuptial view (where the sperm-man puckers his
lips and arouses the dormant egg-woman), check out the cover of the journal
Cell Differentiation and Development 29, no. 1 (January 1990).[2]

In yet another modeling of fertilization on human interactions, the egg is
raped by the sperm (Russell 1977). The egg is depicted as turning a corner in
the oviduct, only to be attacked by the "army of spermatozoa" who "lie in wait
for the ovum." The egg isn't innocent, either. It attracts the sperm like "a pow-
erful magnet." And here is where the "Sperm Wars" paper comes in. Written in

1991, it depicts the sperm as the ultimate warriors in the never-ending battle against female promiscuity. Sperm are described as "tactically smart," "well-armed," and "a formidable .00024-inch weapon, tipped with a chemical warhead"! These "hardy footsoldiers" are depicted as overcoming challenge after challenge, and "casualties in the sperm war are staggering." In a sociobiological origins myth, the sperm are also said to be the evolutionary descendants of the first warrior-raiders, who "broke into larger, more passive cells and captured their neighbors." The distinction between active sperm and passive, larger, more stable eggs is explicitly stated, and throughout the article the sperm's weaponry is seen as directed both against other sperm and against the egg. The egg is described as being "fortified" (against the "well-armed sperm") and as the ultimate source of all this warfare: "The problem of sperm—and thus of males—is, of course, the fault of females." Female philandering (and the worry that this gives the male, who is, of course, concerned that any offspring be his alone) caused these "sperm wars." For the same reason that Helen caused the launching of a thousand ships, human males now launch 280×10^6 sperm per ejaculation! Here, the active male/passive female dichotomy is joined with the notions of warrior sperm/males and whorish females/eggs who are their prizes and victims. This idea of sperm as missile also sets up the adolescent, militaristic, and unproductive metaphor of the penis as missile launcher, gun, and so on—that is, as an organ of power. It takes the focus away from alternative models such as seeing the mammalian penis as an organ that has evolved the capacity for simultaneously giving and receiving pleasure. Needless to say, class discussion on this can become pretty heated. Having the students read the two papers together is also an interesting exercise in perception. Those who read the BGSG paper first report that they found the material in "Sperm Wars" ludicrous. Those who read "Sperm Wars" first accepted it more readily until they read the BGSG essay. The end result, however, is usually the same: no matter where the students started or ended, they have become aware of the storytelling component of developmental biology texts.

And this is when I get to ask the important question: "What story am I telling in my textbook?" It takes them a while, but the students usually come to the conclusion that I am telling a story about the interaction of equals. The sperm and the egg mutually activate one another, and by a series of these activations, the drama of fertilization is completed. This model is based on compelling biochemical data involving signal transduction pathways. And then I can ask the most important question: "Is my story any less socially constructed than the others we've discussed? Perhaps I'm just modeling my sperm and egg after what I think a marriage should be. After all, I went to college in the 1960s,

and my wife has her own name and her own career." Yes, what's in their text-book (which I wrote; Gilbert 1997) may be a story, too. I believe it to be an accurate account of fertilization, a better, more biochemical, and more balanced story than what I had learned as a student.[3]

I find that our laboratory discussions have been brought up in other classes and in dormitory hallways. I have also found that the students do very well on the fertilization portions of their examinations. My guess (and it is only that) is that once the students become aware that there is a social component to science, they realize that they too can become scientists and that there is nothing wrong with bringing a sense of commitment and aesthetics into the laboratory with them. Science is not for apersonal robots but for real people, and it always has been so.

III. Creating Sex: Bound by the Great Chain

Later in the semester, the developmental biology course discusses sex determination. During the laboratory period (which is not about gonadal development), we get to talk about models of how sex is determined. This enables us to debate the roles of one of the central paradigms of Western culture (and many other cultures, for that matter), the Great Chain of Being. This is the chain of the natural world that stretches from pure matter to pure mind. As A. O. Lovejoy (1942) points out, this paradigm has been one of the most ancient and important ways to order our perceptions of the universe. In this scheme, all the objects of the universe are thought to be arranged linearly, from the most material to the most spiritual. At the bottom of the Great Chain lies rocks and dirt; at the top are the orders of angels, leading to God. Between bottom and top are linked all the rocks, plants, and animals. The eighteenth-century biologist Charles Bonnet (1764) wrote that the chain extended without interruption from "the first term, the atom" to "the highest of the Cherubim." The only being that stands outside it, according to Bonnet, was "He who made it." Lovejoy documents that "Man" was usually depicted in the middle, torn between the rationality of the angels and the material urges of his animal nature. While this doctrine is a discredited antievolutionary mode of organizing nature, it is still with us and still causes our minds to elevate certain elements of nature (those associated with the masculine) and denigrate others (those usually associated with the feminine). In popular culture, even evolution is still often seen as being a chain going from protists to "Man."[4]

The assignment is to read and to be prepared to discuss a handout prepared by the Biology and Gender Study Group (basically an earlier version of this

essay) concerning sex determination and the Great Chain of Being. It starts with the formulation of this paradigm in ancient Greece. Aristotle inherited and propagated the Athenian view of the world wherein women were kept out of public and were thought to be merely the incubators of the masculine seed. In this society "the mother is not the parent of that which is called the child, but only nurtures the seed that grows. The parent is he who plants the seed" (Aeschylus, *Eumenides* [c. 475 B.C.E.]). Aristotle, in *Generation of Animals* (c. 330 B.C.E.) put this agricultural myth on a "scientific" basis, and he established that the male was superior to the female: "For the female is, as it were, a mutilated male, and the menstrual fluids are semen, only not pure, for they lack the principle of soul" (737a27–29). For Aristotle, "the female *qua* female is passive, and the male *qua* male is active and the principle of movement comes from him" (729b13–14). This is extremely important for Aristotle and links gender to hierarchy. Aristotle claims (732a3–9) that the goal of semen (= seed, = *sperma*) is to produce a male. Semen gives the body its animating souls, while females provide the lowest cause, matter. However, if the coldness of the woman into which the semen is implanted overcomes the heat of the semen, this *telos* is frustrated. Matter prevails over spirit, and the embryo becomes more material, that is, a woman.

Thomas Aquinas (*Summa Theologica*, esp. 1.92.1, 2.70.3 [c. 1258]) modified this notion in his theory of sexuality: "Just as God can perfuse matter with form, so can seminal power infuse form into the corporeal matter supplied by the mother." Man produces the form, women supply the matter to be formed. In so doing, the spirit infuses matter, and man reenacts God's Creation of Adam. Aquinas, too, saw the production of females as a defect in the production of men and viewed women as having as much claim to reason as a child or imbecile.

What has this to do with today's science? First, we show that Aquinas's trope linking women to children and imbeciles would be continued until the early twentieth century. Second, we show that both Aristotle's model and Aquinas's model would be influential in directing scientific research. When Anton Leeuwenhoek discovered and named sperm, he was convinced that it was indeed as much a seed as those of plants. The notion that the sperm did not physically interact with the egg but rather produced an *aura seminalis* that acted on the egg at a distance was a dominant view in early modern science (see Pinto-Correia 1997).

Third, this agricultural myth of planting the seed in the furrow is more than just academically important. In a remarkable passage, Joseph Needham (1959) provides many further examples of this denial of maternal inheritance in Greek culture and notes, "Such an idea would have been a natural concomitant of the

practice—widespread in antiquity—of putting captured males to death, and retaining the females as concubines. The conquerors would thus have no fear of corrupting the race with alien blood. The whole matter affords an excellent illustration of the way in which an apparently academic theory may have the most intimate connections with social and political behavior, and Aristotle far from being remote from practical affairs . . . is seen to be laboring at their very root." During the recent "ethnic cleansing" in Bosnia, our discussions of this view of life took on more immediacy than before.

Fourth, the inferiority of women was a major assumption linked to racism until very recently. In some classes (especially classes in feminist critiques where I give one or two lectures concerning the sciences) I ask the students to think of cases where the Great Chain may have influenced their thinking. Usually, three stand out. One example is religion (viewing Christianity as "higher" than Judaism, rather than seeing a branched chain of evolution from a common precursor), and the others are race and gender. Here, I bring in concrete examples to show that science has been used to bolster the claim that white men are higher than white women or people of color. For example, Carl Vogt (1864), professor of natural history at the University of Geneva, foreign associate of the Anthropological Society of Paris, and honorary fellow of the Anthropological Society of London, claimed, "By its rounded apex and less developed posterior lobe, the Negro brain resembles that of our children, and by the protruberance of the parietal lobe, that of our females" (81–82). Thus, blacks and women are like immature white males. He concluded this paragraph by stating that the brain characteristics together "assign to the Negro brain a place by the side of that of a white child," while "the female European skull resembles much more the Negro skull than that of the European male." Nor was Vogt alone. He quoted numerous studies, including that of the anthropologist Hushke, who concluded that "in the Negro brain, both the cerebellum and the cerebrum, as well as the spinal cord, present the female and infantile European as well as the simious type" (Vogt 1864, 172–83). Blacks, women, and children thus link the apes to adult white males. Women and people of color were routinely seen as being between white males and the rest of nature.[5]

G. W. F. Hegel (1821) makes the analogy that women are to men as plants are to animals. That is, they approach the level of individuality but do not cross into it:

> Women are capable of education, but they are not made for activities which
> demand a universal faculty such as the more advanced sciences, philosophy,
> and certain forms of artistic production. Women may have happy ideas, taste,
> and elegance, but they cannot attain to the ideal. The difference between men

and women is like that between animals and plants. Men correspond to ani-
mals, while women correspond to plants because their development is more
placid and the principle that underlies it is a vague unity of feeling. . . . The
status of manhood, on the other hand, is attained only by the stress of
thought and much technical exertion. (263–64)

Lloyd and others show that throughout Western thought, the dominant view
was that women are like men but have not fully developed the capacity for ra-
tional thought. Indeed, this is still the attitude inculcated into students by cer-
tain medical school professors (see Fugh-Berman 1992). Thus, women are
depicted as something between animals and man.

Although evolutionary theory went directly against the notion of a Great
Chain of Being, the early evolutionary biologists did not realize this, and their
anthropology remains full of Great Chain imagery. Evolutionists Thomas Hux-
ley, Ernst Haeckel, E. D. Cope, and Herbert Spencer still held the Aristotelian no-
tion that women were like men, but their development or evolution had been
truncated (see Sayers 1982). Sigmund Freud and other psychiatrists and psychol-
ogists similarly theorized that femininity was an immature stage of male devel-
opment, and some of the world's leading sexologists proclaimed that femaleness
was the default state for humanity, and that maleness was pushing beyond that
state into a new condition. As Money and Tucker (1975) have written,

> Nature's first choice is to make Eve. Everybody has one X chromosome and
> is surrounded by a mother's estrogens during prenatal life. Although not
> enough for full development as a fertile female, this gives enough momen-
> tum to support female development. Development for a male requires effec-
> tive propulsion in the male direction at every critical stage. Unless the
> required "something more," the Adam principle, is provided in correct pro-
> portions and at the proper times, the individual's subsequent development
> follows the female pattern.

Horowitz (1976) has noted that theories of sex determination are influenced
by the Great Chain of Being, and it wasn't until two biologists, Linda Wash-
burn and Eva Eicher (1986), demonstrated the social assumptions behind this
story that biology could study the development of the sexual phenotype as
branching from an indifferent origin. Washburn and Eicher fought against the
notion, common in many textbooks, that femaleness was the "default state" of
mankind. Rather, they contended, maleness and femaleness are both active,
gene-directed processes that originate from a bipotent gonad. They pointed

out that "sex determination" had equaled "male determination," and that this was a social view, scientifically invalid. They showed where the mistake had been made and showed the evidence against it. They also wrote that as long as this view so dominated biology, the search would be for testis-forming genes, and there would be no reason to search for the genes that directed the bipotent gonad to form the ovaries. While the search for testis-forming genes had been an ongoing research project for decades, it was only in the 1990s that the first ovary-forming genes were looked for and discovered. Paradigms such as the Great Chain of Being can influence what research projects are feasible. And we are now discussing contemporary biology. The female-as-default state model is still explicit in some textbooks (Müller 1997, 305).

It is important to discuss these mythological paradigms because we have reason to believe they still lie buried within our science and influence the way we perceive the natural and cultural worlds. These biases of the intellectual landscape must be identified if we are to free ourselves from them.

IV. It Is Reigning DNA

In my course in developmental genetics, we talk a great deal about regulation (from the Latin *regulare*, "to rule"), one of the principal concepts in molecular biology. The concept need not be hierarchical, as components from one level can interact with those "above" or "below" it in a form of self-regulatory feedback. Indeed, there are many examples of dialectical regulation in biology. Embryologists and molecular biologists have long known that just as the genes determine the proteins of the cytoplasm, the cytoplasm determines which genes are to be expressed. However, in the case of the cell, much of the imagery of regulation concerns only the rule of the nucleus over the cytoplasm.

In previous papers (BGSG 1988; Gilbert 1988), we documented the historical modeling of sperm-egg interactions on cultural paradigms of male-female relationships: courtship and marriage, conquest and consummation, rape, and dialogue. It seems that the cells were doing on a micro-level just what their respective humans were expected to do on the macro-level. In these papers, we also attempted to show that this male/female, husband/wife imagery continued to be placed on the zygote. In four models of the cell published in the 1930s, the roles of the nucleus and the roles of the cytoplasm mirrored the roles of the husband and the wife, respectively, in four family-based models of the cell. In what was probably an unconscious appropriation of gender (and class) ideology, each researcher projected a version of a husband-wife relationship onto

the nucleus and cytoplasm. However, returning to this issue in the late 1980s and early 1990s, we no longer find the cell being modeled after the family. Rather, the cell has become a business enterprise. The nucleus is still masculine and the cytoplasm still feminine; but the mode of analogy has become the rationality/matter dichotomy. In this view, the nucleus is depicted as the rational component of the cell, the cytoplasm as the material part of the cell.[6] Here is one depiction of the cell as a factory (Baltimore 1984; quoted in Keller 1995):

> The factory whose structure preoccupies biology today is the cell. . . . Cells are incredibly complicated, and it was not immediately apparent how they were organized and integrated. Biologists needed to find the cell's brain.

This brain, we are then told, is the nucleus. Thus, the rationality of the body's brain has been transferred into the nucleus of the cell. So has the executive function of the factory's manager:

> The approach of genetics . . . is to ask about the blueprints, not the machines; about decisions, not mechanics; about information and history. In the factory analogy, genetics leaves the greasy machines and goes to the executive suite, where it analyses the planners, the decision makers, the historical records. It is the business school approach rather than the engineering approach.

In this story, the nucleus is the brain, the cytoplasm the body; the nucleus is the executive suite, the cytoplasm the factory floor. Rationality over matter. This metaphor of nucleus as executive accords very well with both the "master molecule" theory of molecular biology (see BGSG 1988; Hubbard 1982; Hubbard and Wald 1993; Keller 1985; Spanier 1995) and with the sociobiologists' belief that the body is only the vehicle for the propagation of more DNA. Sociobiologist Richard Dawkins (1986), looking at the willow seeds falling outside his window, says,

> It is raining DNA outside. . . . The cotton wool is made mostly of cellulose, and it dwarfs the capsule that contains DNA, the genetic information. The DNA content must be a small proportion of the total so why did I say that it was raining DNA rather than raining cellulose? The answer is that it is the DNA that matters. . . . The whole performance—cotton wool, catkins, tree and all—is in aid of one thing and one thing only, the spreading of DNA around the countryside. . . . It is raining instructions out there; it's raining programs; it's raining tree-growing fluff-spreading algorithms. This is not

metaphor, it is plain truth. It couldn't be plainer if it were raining floppy discs. (111)

Of course it's metaphor, and it comes right off the Great Chain of Being. It is rationality dominating matter. It is looking at the executive suite and believing that the factory floor is of no consequence except as a reflection of executive decisions. It is looking at information as being superior to the material that "carries" it. It is seeing the phenotype as a mere elaboration of the genotype, of the nucleus as ruler. It is the information economy rather than the production economy. It is the Human Genome Project, whose goal, according to its former director, Nobel Laureate James Watson, is "to find out what being human is." It is reigning DNA.

V. Gender, the Chain, and the Disciplines

The Great Chain concept can cause more immediate problems, as well. A few years ago, a student confided that she had trouble convincing herself to major in biology. Biology, she declared, was "so far down on the hierarchy," and she didn't think that the best minds would work there. When asked, "What hierarchy?" her answer was, "You know. There's math on the top, then physics, then chemistry, then, down at the bottom, biology."

Of course. *That* hierarchy. We have all heard of that hierarchy, and many of us have accepted it, internalized it unthinkingly. "What is it a hierarchy of"? Her answer was the one expected: "Hardness." The real sciences at the top of the hierarchy were the "hard sciences," and everything else was "softer," "less rigid." Math and physics were hard and rigid, biology was soft (not "easy"— the other antonym of hard). Indeed, physics, math, and chemistry are seen as masculine domains, whereas biology seems somewhat friendlier to women. What we are seeing is a playing out of the Great Chain of Being.

While the Great Chain had originally circumscribed the universe, we now see it extending across the university. We are dealing with the superiority of abstraction over material, with the masculine souls over the feminine matter. The "progression" from biology to mathematics is the abstraction of rationality from nature. Biology deals with dirty matter: blood, guts, menstrual fluid, semen, urine, leaf mold, frogs, jellyfish, lions, tigers, and bears. Chemistry deals with matter purified and quantified: $2M$ $NaHCO_3$, 4 mg/ml KCl. Physics deals with idealized matter (when it deals with matter at all): ideal gases, electron probability clouds, frictionless surfaces. (If physics deals too much with

material, it falls down the Chain to become engineering.) Finally, mathematics claims to have escaped matter altogether!

> In the pure mathematics we contemplate absolute truths which existed in the divine mind before the morning stars sang together, and which will continue to exist when the last of their radiant host shall have fallen from the heaven. (E. Everett, quoted in Bell 1931, 20).

In a similar vein, Oswald Spengler (1927) celebrated "the liberation of geometry from the visual, and of algebra from the notion of magnitude." The levels of mathematics, it would seem, have replaced the orders of angels in our modern hierarchy. There are, as expected in such a Chain, bridge disciplines. According to this view, molecular biology and biochemistry are the highest biology and the lowest chemistry, respectively. Physical chemistry is the highest chemistry, and theoretical physics the highest physics. Thus, as one rises on the Chain, matter becomes more and more abstracted until even the idea of matter is no longer present.[7]

As mentioned above, even within a field there are successive links in the Chain. In biology, the "higher" disciplines are those in which abstraction predominates. Molecular biology is an excellent example, since it abstracts the underlying unity of the disparate living species and thereby cares little about the actual organs of the plant or beast. It sets a premium on "information," not substances. On the other hand, those disciplines concerned with the actual phenotypic organism (such as taxonomy, invertebrate biology, mammology, or anatomy) are considered low in both prestige and funding. Within a subdiscipline such as developmental biology or physiology, the more abstract, the "higher" the area appears. A. J. Levine and Jay Geller (personal communication) have commented that another reason that certain disciplines and subdisciplines are at the bottom of the hierarchy is that in those fields there is more dependence upon matter in experimentation. There is more variability in the matter used, and experiments take time, as control over that matter has not been achieved. Anyone who has designed experiments for undergraduates can appreciate this. Moreover, as Spanier has pointed out, some biology courses (such as nutrition and human biology), concerned exclusively with material things as opposed to theoretical models, are accorded low esteem and are seen as female areas of specialization.

So as one moves up the chain, one has more rationality and less base matter. Not accidentally, the adjectives are coded as masculine: "harder, more rigorous." Genevieve Lloyd (1984) has documented the historical associations between

mind, reason, and maleness, on one hand, and body, matter, and femaleness on the other: "Matter, with its overtones of femaleness, is seen as something to be transcended in the search for rational knowledge" (5). She continues by noting that "this Platonic theme recurs throughout the history of Western thought in ways that both exploit and reinforce the longstanding associations between maleness and form, femaleness and matter." Transcendence means the transcendence of the body, of matter, and of the female. Thus in the "rational" sciences, the abstract disciplines are seen as more male, while those involved primarily with the matter at hand are seen as more female. To move a science up the Chain in biology, add some molecular biology to it (as is presently being done with botany). To move a profession up the Chain, add training in the abstractions of the discipline (as was done to separate obstetrics from midwifery). To attract graduate students and funding, change the departmental name from a phenotypic science (anatomy, zoology, botany, physiology) to the appropriate cellular or molecular science. In all these cases, the change appears masculinizing. It is not surprising if women perceive the more abstract sciences as less friendly or less congruent with the norms that they have internalized: "This is the pattern in all fields. The higher the level of mathematics required, the greater the proportion of men" (Cole 1991, 7). One of the main obstacles to women entering into careers in the abstract sciences may be our subscribing to the paradigm of the Great Chain.[8] By identifying this myth, we can more readily ask why some disciplines seem more "masculine" than others and whether that is merely a socially accepted perception.

VI. Coda: What Can We Do?

Educating scientists for social responsibility is an enormous undertaking, and introducing biology students to feminist critiques of science is only one way of trying to accomplish this. The ability to recognize and deconstruct social agendas in science will help the student to be both a better scientist and a better citizen. Feminist critique is not out to politicize science—quite the reverse, it documents that there already are social values in science. The first step is to identify which social paradigms and narratives are being used to constrain science. Here, the humanities can play an important role in scientific education. The myth of the hero, the Great Chain of Being, the paradigms of progress and salvation, are all stories that are part of our culture, and science must not accept these "default" conditions on its interpretations. The humanities can provide alternative sources of interpretation, alternative stories. My own research

as a scientist has been influenced by courses in Japanese culture (which enabled me to write a paper criticizing a particular theory of evolution as being predicated on a specifically Western view of individuality; Gilbert 1992), philosophy (where my having read Whitehead predisposed me to think in terms of process rather than structure; Gilbert et al. 1996), and feminist critiques (which encourage multilevel networks of causation).

The second step is to problematize those stories once one has seen them. There are at least three strategies for doing so. The first is to simply identify them and deconstruct them. When the interpretation of scientific data on sperm is seen to be based on a myth, it loses its "objectivity" and its scientific hold on us. The second is to identify the metaphors and to make them into similes and analogies. When one has taken an implicit metaphor ("the master gene") and turned it into an analogy (genes are to masters as other genes and proteins are to servants or slaves), some of the social values become apparent. Third, one can try to find alternative metaphors. In one sense, the embryo might "burrow" into the uterus. In another sense, it "invades" the uterus. It also "embeds" within the uterus and "implants" within the uterus. All these verbs give a different image to that embryonic-maternal interaction. None is precisely correct (see Ballantyne 1905). All have their places. (We will never be able to avoid metaphors. It is important to see several metaphors and to recognize what facets of the phenomena they are privileging).

It is difficult to introduce such social critiques into science. Certainly, it is difficult for science textbooks to do so. The textbooks have become larger and larger as the amount of information accumulates. Similarly, teachers have to decide what topics they are going to abandon in order to teach the newer material. If anything, it has become more difficult to bring historical and other cultural matters into science books and classes. We have been experimenting with a hybrid media textbook, a textbook that includes URLs within it. Thus, the current edition of *Developmental Biology* connects to a website (http://zygote.swarthmore.edu) that contains (in addition to updates in this rapidly moving field) debates on gendered metaphors in fertilization and on when human life begins, essays about alcohol and the fetus, discussions of germline genetic manipulation, cloning, and sex selection, and an overview of feminist critiques of sex determination. We hope that these will enrich the curriculum in ways that a standard textbook cannot.

Feminist critique matters. First, it challenges the assumptions of students in the best Socratic tradition. Second, it makes them examine evidence critically. These are in the best traditions of science education. One of the definitions of liberal arts education is "to recognize quality when you see it." I contend that

much of science education in the liberal arts is "to recognize garbage when you see it." When newspapers uncritically report a "cure for" cancer or a "gene for" some behavior, one should be able to criticize the reportage. Feminist critique in developmental biology is especially important, since developmental biology has so much to say about what sex and gender is. One of the first critiques of developmental biology was a pamphlet published by the Woman's Caucus of the Society for Developmental Biology (Doane 1976; see Gilbert and Rader, in press), which merely reprinted verbatim some of the sexist quotations in the literature and made cartoons of them. The pamphlet noted that "Male chauvinistic views of ancient times are still to be found among the presumably objective writings of our scientific colleagues." Feminist critique is being used to make the science better. It also attempts to make it less harmful. A theory about the stars doesn't affect the being of the stars, but a theory about men and women can determine who we think we actually are and what behaviors are normal or permissible.

The language of science can also determine who enters it. This is also important in science education. Bonnie Spanier (1992) has introduced Judith Fetterley's notion of the "resisting reader" into discussions of feminism and science. Why should a woman enter a field that tells her she is a default state, a passive entity that is a failed version of a man? Again, feminist critique is important in opening possibilities to women.

While feminist critiques of biology often look at the rhetoric and narrative elements of the discipline, this does not mean that one theory or one set of words is as good as any other. As said earlier, relativism has no place in either science or feminist critiques of science. Science is not going to go away, and if it were to be destroyed, we would spend generations trying to build it again. However, feminist critiques can play a major role in opening up students to the social dimensions of science in the hope that they can use their knowledge and power in ways that will allow biology to be liberating and not oppressing. In the first decades of the next millennium, biology will have enormous power, and its practitioners have to know about its possible abuses.

Notes

1. As noted by Barbara Tomlinson (1995), I tend to use irony, humor, and light mockery to make my points. My aim is to make the students question their assumptions, and this is often best done by reading the text in the light of other contexts. For instance, looking at the metaphors in a science text in the light of feminist critique

should make one more critical of the creative language of science. I mean, what are we to make of a biology book (published in 1996) that calls the contribution of the oocytes their "dowries," informs us that the acrosome of the sperm is "a chemical drill," and tells us that the activation of the egg is "Sleeping Beauty awakened with a kiss"? If I repeat any particular words or phrases during the class debates over feminist critique in biology, they would have to be, "What is the evidence?" and "Can you think of another interpretation of the data?" These phrases will be all too familiar to any person who has had graduate training in biology. Feminist critique is being used as a control.

2. In addition to the *Look Who's Talking* movies, the male sperm and female eggs are depicted in many jokes and cartoons. In these depictions (such as those of Gary Larsen), each sperm is trying hard to enter the egg, sometimes by stealth, sometimes by outboard motor, and sometimes just by adolescent speed. Recent versions show some interesting feminist modifications. One of these (Long, 1994) shows dozens of sperm surrounding the egg, but staying around a half inch away. The caption reads, "Scientists prove that men's fear of commitment begins at an early age." In one joke, the question is raised as to why it takes 300 million sperm to fertilize an egg. The answer is that none of them will ask directions. I should point out that just as there are some feminists who are interested in equal wages and who are not interested in critique, there are some scientists who use "sexist" representations of sperm and egg, but who nevertheless have been extremely supportive of women in their professional careers.

3. Martin (1991), for instance, contends that the narratives of equals may not be appropriate, since the egg has not only a nucleus but all the cytoplasmic apparatus for cell division and development. The sperm is only a motile nucleus. On the biochemical level, though, the sperm-and-egg story can be told as the interaction between two different cells with remarkable underlying similarities. Martin (1992), I am very glad to say, has found that this textbook (Gilbert 1997) has brought some of her students to see the value of feminist critique in biology.

4. To emphasize that this conceit is still very much with us, I bring in a 1998 Continental Bank advertisement from *Newsweek* and a Strategene advertisement from a 1994 issue of *Cell*. The evolutionary text of the bank copy is undercut by its straight Great Chain from protist to white male banker. The Strategene "A Bold Leap in Cloning" advertisement for its new vector resembles anthropology textbook illustrations from a hundred years earlier, representing the progressive evolution of plasmids by (in order of complexity) a woman of color, a man of color, a white woman, and a white man. (Again, I point out that this may have nothing to do with the hiring or promotion practices of these companies concerning women and minorities.) The evolutionary figure would be a branched bush with all extant forms having equal "height." In the Great Chain, one leads into the other.

5. In 1799 surgeon and biologist Charles White published a treatise on the Great Chain of Being in which he spent much energy looking at the links between animals and humans. To view the chain as complete, he elevated the apes while degrading women and black Africans. The apes are given traits such as the ability to perform simple medical

operations, and White claims that orangutans "have been known to carry off negro-boys, girls, and even women with a view of making them subservient to their wants as slaves" (see Gould 1985, 281–90). Haraway's *Primate Visions* (1989) shows that modern science is capable of the same trick, depicting women and blacks as the evolutionary and developmental links between white men and apes. In discussing the women whose research on nonhuman African primates was covered by *National Geographic,* Haraway remarks,

> Gender in the western narrative works simply here: Woman is closer to nature than Man and so mediates more readily (Ortner, 1972). Positioned by the symbology, real women are put into the service of culturally reproducing Woman as Man's channel.... Women and animals are set up as body with depressing regularity in the working of the mind/body binarism in story fields, including scientific ones. The man/animal binarism is crosscut with two others which structure the narrative possibilities: mind/body and light/dark. White women mediate between "man" and "animal" in power-charged historical fields. Colored women are often so closely held by the category *animal* that they can barely function as mediators in texts produced within white culture.... The body is nature to the mind of culture; in primate narratives, white women negotiate the chasm. (149–50)

6. Here is one of the differences between genetics and embryology. Embryologists have long known that just as the nucleus controls the cytoplasm, the proteins of the cytoplasm regulate which genes are expressed. This was stated succinctly by Hans Driesch in 1894 (see Gilbert 1997, 595). Embryological phenomena regulated by the cytoplasm include (1) cells of mosaic embryos wherein the cytoplasm directly determines the gene expression of the cells acquiring different cytoplasmic entities; (2) regulative embryos wherein the determination of cell fate depends upon the location of the cell; and (3) DNA synthesis wherein the creation of new DNA helices and subsequent cell division is controlled by enzymes within the cytoplasm. In the operon model of gene regulation, the state of the cytoplasm determines whether or not particular sets of genes shall be transcribed. Scientists such as Paul Weiss and C. H. Waddington likened the nucleus to a library or a toolbox rather than a command center (see Gilbert 1991), and Waddington explicitly reversed the geneticists' imagery by writing about the "activation of the genome." As early as 1887, embryologist C. O. Whitman noticed the link to Aristotle. The nucleus, he said, is being misrepresented as Aristotle's primum mobile, the ultimate source of unchanging rationality. It should be noted that ideas change. The linkage between sociobiology and molecular biology is forcefully made in Spanier 1991. The quotation from David Baltimore seems more indicative of his views in the 1980s than his much more integrative views of the 1990s.

The cell is not the only entity undergoing a transition from family metaphor to factory metaphor. The laboratory is also experiencing this shift. This can be very important for women, since many women (and men) can probably envision themselves as the heads of families better than they can see themselves as heads of factories. (Salome Waelsch Cole [1991] notes that the skills needed to run a family are very similar to

those needed to run a laboratory). There are also other differences. In the family, production is important, but so is the education of the subordinate members to become heads of their own families. In the factory metaphor, such education is not as important a goal. Also (as pointed out by a reviewer of this manuscript) the incest taboo may be stronger under the model of family than factory.

7. According to Patricia Phillips (1991), science was not always accorded this position. In the eighteenth and early nineteenth century, science was perceived to deal with material things, while knowledge of classics marked the true gentleman. To deal with science meant having "too close an acquaintance with the artisan or industrial classes, which in turn cast doubts on a man's social and intellectual status." Classics was higher in spirituality and rationality than base science. Thus, men monopolized the classics, allowing women to enter the lesser sphere, science. According to Phillips, this association of women and science lasted until reforms in education enabled women to study classics in the mid-nineteenth century. Only when science became identified with rationality and abstract thought did it, too, become off-limits to women. While the Great Chain may be readily evident in the sciences, it seems that departments in the humanities and social sciences divisions also put a premium on the theoretical rather than the practical areas of their disciplines.

8. It could be argued that the raison d'être of science was to force rationality upon nature, and that Francis Bacon and others saw nature as a female form to be acted upon by masculine reason (Lloyd 1984; Keller 1985). While the notion of science being a rational abstraction of nature certainly has its masculinist elements and conforms all too easily with the Great Chain of Being paradigm (see also the related nature/culture paradigm discussed in Ortner 1972 and Gilbert 1979), I doubt that the notion that nature must be subdued or conquered is a typically masculinist idea. I ask my students for evidence to support or refute this idea, and I point out that until this century, nearly one out of every two European children died before adolescence. Even in upperclass families, the mortality through childhood was close to 50 percent. Nature was not seen as fragile and benevolent except by a few poets. Before antibiotics and the population explosion of this century, nature was seen as indomitable and harsh. Women routinely died in childbirth or shortly thereafter. I doubt that conquering nature was something that only men wanted done.

Acknowledgments

We would like to thank the following people for sharing their thoughts and criticisms with us: Jay Geller, Donna Haraway, Evelyn Fox Keller, Amy-Jill Levine, Bonnie Spanier, Anne Fausto-Sterling, and Sara Tjossem. The Biology and Gender Study Group is an ongoing credited course of the Swarthmore College biology department. This paper has been written by Scott F. Gilbert in consultation with Laura Cleland, Seija Surr, Tatyana Rand, and Barbara West.

Works Cited

Aeschylus, *circa* 465 B.C.E. *Eumenides,* in *The Oresteia,* edited by A. H. Sommerstein. New York: Cambridge University Press, 1991.

Aristotle, *circa* 330 B.C.E. *Generation of Animals* 737a 27-29; 729b 13–14; 732a 3–9. In *On the Generation of Animals,* edited D. M. Balme. Oxford: Clarendon Press.

Aquinas, T. circa 1258. *Summa Theologica,* esp. I, Q 92, art 1; II, Q 70, art. 3.

Ballantyne, J. W. 1991. *Manual of Antenatal Pathology and Hygiene: The Embryo.* 1905. Reprint, Clinton, S.C.:Jacobs Press,

Baltimore, D. 1984. "The Brain of a Cell." *Science* 84 (November): 149–51.

Bell, E. T. 1931. *The Queen of the Sciences.* Baltimore: William and Wilkins.

Biology and Gender Study Group. 1988. "The Importance of Feminist Critique for Contemporary Cell Biology." *Hypatia* 3:61–76.

Bleier, R. 1985. *Science and Gender: A Critique of Biology and its Theories on Women.* New York: Pergamon Press.

Bloom, A. H. 1993. "A New Mandate for American Education." *The Swarthmore Papers* 1:1–16.

Bonnet, C. 1764. Quoted in S. J. Gould, *Ontogeny and Phylogeny.* (Cambridge: Belknap Press, 1977), 23.

Cole, J. R. 1991. "Interview with Salome Waelsch." In *The Outer Circle: Women in the Scientific Community,* edited by H. Zuckerman, J. R. Cole, and J. T. Bruner, 77. New York: W. W. Norton.

Dawkins, R. 1986. *The Blind Watchmaker.* New York: W. W. Norton.

Doane, W., ed. 1976. *Sexisms Satirized: Quotations from the Biological Literature.* Cartoons by B. K. Abbott. Washington D.C.: Pocketbook Profiles/Society for Developmental Biology.

Eicher, E. M., and L. Washburn. 1986. "Genetic Control of Primary Sex Determination in Mice." *Annual Review of Genetics* 20: 327–60.

Fausto-Sterling, A. 1985. *Myths of Gender: Biological Theories about Women and Men.* New York: Basic Books.

Fugh-Berman, A. 1992. "Tales out of Medical School." *Nation,* January 20, 1992, 1, 54–56.

Gilbert, S. F. 1979. "The Metaphorical Structuring of Social Perceptions." *Soundings* 62: 166–86.

———. 1988. "Cellular Politics: Just, Goldschmidt, and the Attempts to Reconcile Embryology and Genetics." In *The American Development of Biology,* edited by R. Rainger, K. Benson, and J. Maienschein, 311–46. Philadelphia: University of Pennsylvania Press.

———. 1991. "Cytoplasmic Action in Development." *Quarterly Review of Biology* 66: 309–16.

———. 1992. "Cells in Search of Community: Critiques of Weismannism and Selectable Units in Ontogeny." *Biology and Philosophy* 7: 473–87.

———. 1997. *Developmental Biology.* 5th ed. Sunderland, Mass.: Sinauer Associates.

Gilbert, S. F., J. Opitz, and R. A. Raff. 1996. "Resynthesizing Evolutionary and Developmental Biology. *Developmental Biology* 173:357–72.

Gilbert, S. F., and Rader, K. In Press. "How Does Gender Matter? Revisiting Women, Gender, and Feminism in Developmental Biology." In *Science, Medicine, and Technology in the Twentieth Century: What Difference Has Feminism Made*, edited by L. Schiebinger.

Gould, S. J. 1985. *Flamingo's Smile*. New York: Norton.

Haraway, D. J. 1976. *Crystals, Fabrics, and Fields: Metaphors of Organicism in Twentieth-Century Developmental Biology*. New Haven, Conn.: Yale University Press.

———. 1989. *Primate Visions: Gender, Race, and Nature in the World of Modern Science*. New York: Routledge.

———. 1997. *Modest_Witness@Second_Millenium.FemaleMan©_Meets_Oncomouse™: Feminism and Technoscience*. Routledge, New York.

Harding, S. 1992. *Whose Science? Whose Knowledge? Thinking from Women's Lives*. Ithaca, N.Y.: Cornell University Press.

Hegel, G. W. F. 1945. *Philosophy of Right*. Translated by T. M. Knox. Oxford: Clarendon Press.

Horowitz, M. C. 1976. "Aristotle and Woman." *Journal of the History of Biology* 9:183–213.

Hubbard, R. 1982. "The Theory and Practice of Genetic Reductionism—from Mendel's Laws to Genetic Engineering." In *Towards a Liberatory Biology* (S. Rose, ed.), Allison and Busby, London.

Hubbard, R., and E. Wald. 1993. *Exploding the Gene Myth*. Boston: Beacon Press.

Keller, E. F. 1985. *Reflections on Gender and Science*. New Haven, Conn.: Yale University Press.

———. 1991. "The Wo/Man Scientist: Issues of Sex and Gender in the Pursuit of Science." In *The Outer Circle: Women in the Scientific Community*, edited by H. Zuckerman, J. R. Cole, and J. T. Bruner, 227–36. New York: W. W. Norton.

———. 1995. *Refiguring Life: Metaphors of Twentieth Century Biology*. New York: Columbia University Press.

Lakoff, G., and M. Johnson. 1980. *Metaphors We Live By*. Chicago: University of Chicago Press.

Latour, S., and L. Woolgar. 1979. *Laboratory Life: The Social Construction of Scientific Facts*. Thousand Oaks, Calif.: Sage.

Lloyd, G. 1984. *The Man of Reason*. Minneapolis: University of Minnesota Press.

Long, J. 1994. Postcard. Chicago: Recycled Paper Greetings.

Lovejoy, A. O. 1942. *The Great Chain of Being*. Cambridge, Mass.: Harvard University Press.

Martin, E. 1991. "The Egg and the Sperm: How Science Has Constructed a Romance Based on Stereotypical Male-Female Roles. *Signs* 16:485–501.

———. 1992. *The Woman in the Body*. Boston: Beacon Press.

Money, J., and P. Tucker. 1975. *Sexual Signatures: On Being a Man or a Woman*. Boston: Little, Brown.

Müller, W. A. 1997. *Developmental Biology.* New York: Springer-Verlag.

Needham, J. 1959. *A History of Embryology.* London: Abelard-Schuman.

Ortner, S. 1972. "Is Female to Male as Nature Is to Culture?" *Feminist Studies* 1:5–31.

Oudshoorn, N. 1994. *Beyond the Natural Body: An Archeology of Sex Hormones.* New York: Routledge.

Phillips, P. 1991. *The Scientific Lady.* New York: St. Martin's Press.

Pinto-Correia, C. 1997. *The Ovary of Eve.* Chicago: University of Chicago Press.

Russell, K. P. 1977. *Eastman's Expectant Motherhood.* 6th ed. New York: Little, Brown.

Sayers, J. 1982. *Biological Politics.* London: Tavistock.

Schatten, G., and H. Schatten. 1983. "The Energetic Egg." *The Sciences* 23, no. 5: 28–34.

Short, R. V. 1972. "Sex Determination and Differentiation." In *Reproduction in Mammals: Embryonic and Fetal Development,* edited by C. R. Austin and R. V. Short, 70. Cambridge: Cambridge University Press.

Small, M. F. 1991. "Sperm Wars." *Discover,* July, 48–53.

Spanier, B. 1991. "Gender and Ideology in Science: A Study of Molecular Biology." *National Women in Science Association Journal* 3:167–98.

———. 1984. "The Natural Sciences: Casting a Critical Eye on 'Objectivity.' " In *Toward a Balanced Curriculum,* edited by B. Spanier, A. Bloom, and D. Boroviak, 49–57. Cambridge, Mass.: Schenkman Publishing.

———. 1992. "Encountering the Biological Sciences: Ideology, Language, and Learning." In *Writing, Teaching, and Learning in the Disciplines,* edited by A. Herrington and C. Moran. New York: Modern Language Association.

———. 1995. *Im/partial Science: Gender Ideology in Molecular Biology.* Bloomington: Indiana University Press.

Spengler, O. 1927. "The Meaning of Numbers." In *The World of Mathematics,* edited by J. R. Newman, 2315–47. New York: Simon and Schuster.

Tomlinson, B. 1995. "Phallic Fables and Spermatic Romance: Disciplinary Crossing and Textual Ridicule." *Configurations* 2:105–34.

Vogt, C. 1864. *Lectures on Man.* London: Longman, Green, Longman, and Roberts.

Whitman, C. O. 1887. "The Kinetic Phenomena of the Egg During Maturation and Fecundation (Oökinesis)." *Journal of Morphology* 1:227–52.

Waelsch, S. 1991. In *The Outer Circle: Women in the Scientific Community,* edited by H. Zuckerman, J. R. Cole, and J. T. Bruer. New York: W. W. Norton.

Wolffers, et al. 1989. *Marketing Fertility: Women, Menstruation, and the Pharmaceutical Industry.* Amsterdam: Wemos.

Reconceiving Scientific Literacy as Agential Literacy

Or, Learning How to Intra-act Responsibly within the World

Karen Barad

Joe Smith is a truck driver who knows nothing about inertia. So he throws the hammer onto the shelf right behind his head and loads his truck behind the cab with some heavy iron ingots, stacked up high. Then and there, a knowledge of inertia and the principles of motion may mean the difference between life and death to Joe Smith. On a sudden, short stop that hammer may hit him in the head and kill him.

His load of ingots may crash through the cab and crush him. This lesson should be driven home to our pupils. Physics is a life and death subject."

—Hyman Ruchlis, "New Approaches Needed in Physics"

One physics teacher reported on his offering of "Kitchen Physics" as a response to dealing with "the wail from the feminine members of . . . physics classes, 'Gee! I'll never get this. And what good would it be to me, anyway? It's a boy's subject; boys are more mechanically inclined than girls.'" Examples included tips on keeping the coffee warm and distinguishing eggs that had been hard-boiled from uncooked ones. He explains, "All this merely points out that one may live more graciously and understandingly with a small amount of knowledge acquired in a high school physics course, even if one happens to be of the feminine sex."

—James B. Davis, "For the Ladies, Kitchen Physics"

Relevance and context. These are the ingredients that are supposed to make science more palatable to students—the cultural coatings specially formulated to ease the digestion of physics, which, like castor oil, is as good for you as it is notoriously difficult to swallow. The "relevancy-coated" approaches to teaching science promoted today are no less well-intentioned—and no more successful—than they were nearly half a century ago. The very limited success of such approaches should not be surprising: there's something paradoxical about the notion that something can be "made" relevant—as if relevancy could be imposed or added onto an existing structure. The starting point is all wrong: taking an existing course and contemplating superficial alterations to it in an effort to make it relevant is a poor substitute for designing a relevant course or curriculum. Another important limitation is that "relevancy"

is undertheorized. Relevant for/to whom? is a crucial question that needs to be addressed; but it is insufficient if posed in isolation from the issue of how the "whom" is to be understood. Questions of relevancy are intertwined with questions of subjectivity and epistemic responsibility. For example, although the physics teacher who creatively suggests a "kitchen physics" approach for the "ladies" has clearly thought about the fact that relevancy has different meanings for different audiences, his approach is essentializing: it fixes what is considered "feminine" in particular ways (historically, culturally, and so on) and erases an array of socially relevant differences. Implicit in the example are numerous cultural assumptions, including the following presumptions: that girls and women can identify with and are responsible for cooking and other aspects of gracious living; that keeping coffee at an appropriate equilibrium temperature and distinguishing the different states of matter of eggs (as opposed to learning the preparation of chapati or strategies for feeding children on poverty level wages) are useful skills; that "ladies" don't want to be mechanics or, heaven forbid, pursue careers in physics.[1]

Alternatively, some approaches attempt to place science in its historical, philosophical, sociological, or cultural context by adding snippets from other disciplines, such as the history and philosophy of science, which seem appropriate to the topic at hand. But these approaches often reenact the very problem they are trying to address by pulling only single strands of history or philosophy out of a complex cloth in order to patch together a background against which to view science. Or, to switch back to the coated caplet metaphor, the approach is to first fabricate an idiosyncratic cultural shell around the curricular content and then explain the molding of the malleable interior—the selfsame scientific content—in terms of the shell's form. The science-in-context perspective, in its single-minded focus on providing historically situated explanations for particular accounts of "nature," presents a rigidified and oversimplified view of "culture," and the relationship between them. It also gives students a distorted view of the history and philosophy of science and their respective disciplinary trajectories and intricate and interlocking structures. Presuming science to be embedded in a given cultural context—fixed in a specific surrounding—places a particular limitation on our understanding of science, of culture, and of their heterogeneous and multiple interactions.[2]

Whether the focus is on the influence of culture on science, or vice versa, these "context-coated" approaches play off an assumed nature/culture dualism, reifying one pole or the other in an attempt to identify linear causal lines of influence between science and culture. Courses that explain the development of science on the basis of cultural factors alone (culture unilaterally influences science) are just

as problematic as those which paint a picture of the modern world as the direct descendant of the triumphant victory of the scientific worldview (science unilaterally influences culture). Treating either nature or culture as a determining factor or holding one or the other as fixed and self-evident fudges on presenting a realistic view of both science and culture. Clearly, this deficiency cannot be addressed by adding the results of separate unidirectional examinations.

Often even more problematic is the genre of courses carrying the designation "Physics for Poets." These courses are often random and idiosyncratic pastiches of the "relevancy-coated" and "context-coated" approaches in which a host of different topics are presented with a uniform disregard for rigor. Entertainment is often accorded high value in such courses; however, entertainment often becomes a substitute for, rather than a way of promoting, learning. The glassy-eyed "gee isn't that neat" look on students' faces may be less a sign of enthusiasm for the subject matter and more an indication of their disempowerment. What is it that students really learn to appreciate in these so-called science appreciation courses?

And in all of this where is the science student? No doubt some readers will have assumed that I was referring all along to the teaching of science to non-science majors. Although some courses for majors enjoy a "splash" of relevancy and/or context here and there, generally speaking, no serious efforts are made in this direction. The standard response is that attention to these "peripheral issues" would rob the course of precious time needed for the "important stuff," which there simply isn't enough time as it is to adequately cover. As a physicist, I appreciate the responsibility we have to our majors, and I think that matters of content are real and important. But I also think that this goes hand in hand with another responsibility: to teach science in a way that promotes an understanding of the nature of scientific practices. This will make for better, more creative, more responsible participation in the various technoscientific enterprises in which we are all implicated at this historic moment. If science students do not learn that doing responsible science entails thinking about the connection of scientific practices to other social practices, then what is the justification for our current confidence as a society in the ability of scientists to make socially responsible decisions?

What other approaches are possible? How do we design pedagogies that go beyond these "coated caplet" methods of acknowledging relevancy and context? What approaches might be employed in the interest of capturing something of the complex nature of the relationship between science and culture, rather than seeking causal explanations for one strictly in terms of the other? Approaches that take account of discursive *and* material constraints on knowledge production?

Approaches that contest the conception of the nature/culture dichotomy as transhistorical, transcultural, and self-evident? Approaches that teach students to think reflexively about the nature of science and about what it means to do responsible science while teaching them the science as well? Approaches that enable students to see the beauty, power, and delight in doing science, without placing science at a distance from other human practices? Approaches that inspire students to a mature love of science growing out of a respect for its strengths and its limitations, rather than a form of puppy love in which the infatuation is held hostage to one of two modes of expression: complete awe and blindness to its vulnerabilities, or disillusionment and wholesale rejection? Approaches by which all students, majors and nonmajors alike, can come to understand how important it is to participate in making decisions about the technoscientific world within which we live and the responsibility and accountability that must accompany technoscientific endeavors?

In this paper, I will outline one pedagogical approach, in the early stages of development, that seeks to speak to each of these issues. This approach is based upon a reconceptualization of scientific literacy as "agential literacy." It also pushes the boundaries of current discussions concerning the nature of (inter)disciplinarity.

A need for joint conceptual shifts in our understanding of scientific literacy and the nature of disciplinary knowledge may not be obvious from the academically segregated discussions of these issues. Generally speaking, these issues have been the separate province of noncommunicating sectors of the academy. Questions of disciplinarity are not a common preoccupation of scientists, and neither is scientific literacy a pressing issue for nonscientists. Why is this so? Why isn't it common for scientists to concern themselves with questions of disciplinarity? (For example, What are the means by which particular knowledge relations among otherwise disparate elements develop? And what is the nature of the epistemic constraints and enabling conditions constituting particular disciplines?) Similarly, why is scientific literacy generally taken to be a curricular responsibility of science departments, and not other academic disciplines? What assumptions go into supporting these particular divisions of intellectual labor?

In recent efforts to examine and intervene in how knowledge is disciplined a variety of closely related approaches have been suggested. Multi-, inter-, trans-, cross-, extra-, counter-, post-, and anti- are among the prefixes that have been appended to "disciplinarity" in these attempts at border crossing. Which of these versions, if any, speak to the imbrication of epistemology, ontology, and ethics? Reflections on the nature of knowledge and knowledge production alone just won't do; rather, as I will argue here, what is required is the study of

something we might call "epistem-onto-logy" or "ethico-epistem-onto-logy" in rethinking a concept that is expected to do as much work as "scientific literacy."

To attempt to talk across disciplinary divides as wide and as deep as the gulf separating the humanities from the sciences comes with certain risks. Nonetheless, I want to offer a joint reconsideration of scientific literacy and disciplinarity here, based upon the framework of agential realism (Barad 1996, 1998a). From the perspective of agential realism, technoscientific practices are particularly potent sites in which epistemological, ontological, ethical, and other issues are richly interwoven. This assertion has implications for science pedagogy as well as science policy. It also pushes the boundaries of current discussions concerning the nature of disciplinarity that have focused solely on the disciplining of knowledge, to the exclusion of other important dimensions. In particular, the reconceptualization of scientific literacy and disciplinarity that I will offer here takes account of the ontological as well as epistemological dimensions of boundary drawing practices, and material as well as discursive constraints. The notion of responsible science that is offered turns on questions of agency, accountability, and objectivity.

I begin with a brief overview of the recent history of scientific literacy conceived as a national priority. I then suggest a reformulation of the notions of scientific literacy and disciplinarity based on insights from agential realism. I conclude with a brief description of a course that I have taught with this new understanding of scientific literacy in mind.

Scientific Literacy

There has been no shortage of rationales given on behalf of the national need for scientific literacy. Scientific literacy has been hailed as: the basis for democratic decision making about public issues; necessary for global economic competitiveness and national security; crucial for the promotion of rational thinking; a condition for cultural literacy; necessary for gainful employment in an increasingly technological world; the basis for personal decision making about health-related issues; and necessary for the maintenance of the public image of science. But what does it mean to be scientifically literate? Is it a matter of knowing a sufficient number of scientific facts? understanding the scientific method? having an appropriate respect for and appreciation of science?

Despite the fact that scientific literacy is called upon to perform a host of vital tasks concerning the future well-being of the nation and its individuals, by any of the standard measures, it remains an illusive goal. Billions of dollars

have been spent on science education since the Sputnik panic of 1957, and yet only as much as 3 to 6 percent (including the 3 percent of the U.S. population who are trained scientists and engineers) of the population qualify as scientifically literate (Shamos 1995, 191).

Most commonly, scientific literacy is thought of in terms of the successful transmission of knowledge about scientific facts and methods from knowing scientists to the ignorant masses. Viewed in this way, the problem of scientific illiteracy is seen as a massive transmission failure. Curriculum reforms from the 1960s through the 1990s have focused on potential defects in the receiver, the transmitter, and even the modulation of the signal, all to very little avail. In light of the extraordinary monetary and intellectual resources that have been and continue to be committed to solving this problem, it is perhaps not unreasonable to ask if the metaphor itself isn't sending the wrong signal. Before proposing an alternative model, I will present some of the recent history of the discourse on scientific literacy in the United States.

The onset of the Cold War and the widespread growth of U.S. industry in the post–World War II era prompted major curriculum reforms in the sciences. A primary consideration behind the curriculum reforms of the 1950s and 1960s was the perceived need to increase the number of students interested in pursuing science-related careers. In response to the U.S. embarrassment over Sputnik, the President's Science Advisory Committee warned that "the country's most 'critical' problem was the need for scientists, 'thousands more' in the next ten years than the nation was . . . planning to produce" (Kevles 1971, 385). In 1958, Eisenhower signed the National Defense Education Act (NDEA), and the National Science Foundation (NSF) budget for education and for basic research skyrocketed. Support for science and for science curriculum innovation was plentiful.[3]

The reforms of this period were specifically designed to address the "manpower" need, but an additional goal for science education was articulated on a national level: the goal of scientific literacy, conceived of as the development of an informed public equipped to make decisions about matters involving science and technology. The sense of urgency surrounding the public understanding of science began immediately after the end of World War II in direct response to the wartime development of nuclear technologies, and specifically as a result of lobbying efforts on the part of atomic scientists for a civilian-controlled program of peacetime uses for the atom. In particular, it was shaped by scientists' expressed concern that science be guarded from future misuse. Theirs was not a plea for public regulation of scientific research, but rather recognition of the importance of public opinion concerning the potential applications

of scientific knowledge and its future funding. In his account of the history of the U.S. physics community, Daniel Kevles (1971) points to an important aspect of the relationship between scientists and the public following the war:

> Most Americans—liberals, conservatives, and the millions who were not particularly either—had been willing to tolerate [a] *lack of accountability* [on the part of the science community] since Hiroshima. They identified the scientific elite with the industrial machine that produced the goods and prosperity of the affluent society. During the Cold War, they counted the same elite as indispensable to the national defense. The leaders of the Los Alamos generation also commanded respect as *paragons of social responsibility*, seeking to maintain the nation's nuclear arsenal while attempting to control, if not end, the nuclear arms race. (395, italics added)

Since scientists had acquired the reputation of being "paragons of social responsibility"—guardians of the national interests who were "socially responsible" by definition—the burden of social responsibility (i.e., the responsibility to become socially responsible) was placed asymmetrically on nonscientists.

The particular relationship between scientific literacy and social responsibility that developed during this period continues to influence our thinking about scientific literacy today. A specific version of the equivalence relation between the possession of scientific knowledge and being socially responsible is often implicit in discussions about scientific literacy: this is the notion that familiarity with the facts and methods of science is all that is required for socially responsible decision making concerning science- and technology-related issues. While it is probably the case that, when pressed, most proponents of this view would quickly acknowledge the need for other kinds of knowledges as well, the sentiment that scientific knowledge is sufficient does get expressed and often forms part of the unspoken background. In fact, despite the recent explosion of efforts dedicated to rethinking how best to achieve the goal of scientific literacy, spawned by the latest round of injections of government and private moneys beginning in the mid-1980s, this conception is continually reiterated. For example, consider the following statement from the AAAS (American Association for the Advancement of Science) Project 2061 guidelines on scientific literacy:

> *Technological principles . . . give people a sound basis for assessing the use of new technologies and their implications for the environment and culture;* without an understanding of those principles, people are unlikely to move be-

yond consideration of their own immediate self-interest." (Rutherford and
Ahlgren 1989, vi–vii, italics added)

The resiliency of these presuppositions concerning scientific literacy and
social responsibility through the intervening years may seem surprising given
the fact that during the "tumultuous years of the war in Vietnam, millions of
Americans doubted the social responsibility of any group so closely identified
with the military-industrial complex as the nation's physical scientists" (Kevles
1971, 395). On the other hand, as I mentioned earlier, the curricular division of
labor in the academy relegated the issue of scientific literacy to the science de-
partments, thereby effectively insulating it from the kind of critical reflection
that prompted other kinds of curriculum reform. Despite the fact that during
the 1970s there was widespread recognition of the failure of the reforms of the
1950s and 1960s to improve scientific literacy, the notion itself was not criti-
cally examined. In fact,

> during the height of the reformist surge in the 1960s and 1970s, the least
> amount of change took place in science education: Change faced its greatest
> resistance in this area. . . . What changes were allowed to occur did so on the
> level of form, and could be easily dumped when the time came for a return
> to "basics." (Montgomery 1994, 241)

Return to former times came quickly enough and it came with a vengeance.
During the Reagan era of renewed conservatism,

> the idea of science was firmly reattached to a variety of nationalistic goals,
> via concrete funding priorities. . . . Science was viewed as the ultimate source
> of the economic and military power the United States required to ensure its
> world preeminence. . . . In the public mind, . . . science regained a measure of
> the heroism it had lost prior to 1980. Not only was it again tied directly to
> economic and military advantage, but it was constantly associated with
> many "positive" ongoing "revolutions"—in computer technology, in med-
> ical research, in biotechnology, and in cosmology." (249–51)

In these post–Cold War times, as globalization manifests itself in the forma-
tion of strategic transnational alliances in the corporate world and a frenzied
search for new markets, global economic growth has become increasingly de-
pendent on technoscientific innovation and expansion. A confluence of politi-
cal, demographic, and economic factors in the United States has spawned a

new level of corporate interest in colleges and universities as "untapped markets." Science and technology are tools in the increasing corporatization of the academy.[4] And so not surprisingly, corporate pressures on curriculum reform have not been particularly conducive to critical examinations of the traditional construal of scientific literacy.[5] For the most part, the legacy of the post–World War II asymmetrical accounting of social responsibility remains intact.

One problem with this inherited notion of scientific literacy is that the "public" no longer considers scientists to be paragons of social responsibility. Scientists are not given immunity from public scrutiny, suspicion, or distrust levied against anyone who stands to be the beneficiary of government, corporate, or other institutional interests. In fact, conservative scientific literacy expert Morris Shamos (1995, 203), a vehement opponent of science studies, argues that it is the overinflated image of scientific authority that feeds the public's lack of confidence in science, especially in cases where there is disagreement among scientific experts. The fact that scientists have testified both on behalf of and counter to the interests of the tobacco industry is just one example that gets offered as justification for the current distrust in the authority of science. Today, science is more likely to be associated with technological efficacy than with disinterestedness. (We would be well advised in this regard to heed Lorraine Daston's reminder (1992, 604–5) that objectivity has a history, that it has not always been associated with aloofness towards public opinion and public issues; on the contrary, this particular relationship has rather recent origins in the context of a particular set of social concerns in the eighteenth century.[6] Science's authority has been weakened, in large part, not by the highly specialized and generally inaccessible academic writings of postmodernists, but because the public senses that scientists are not owning up to their biases, commitments, assumptions, and presuppositions, or to base human weaknesses such as the drive for wealth, fame, tenure, or other forms of power. Furthermore, concern has been expressed that the scientist's constructed isolation from the vagaries of the everyday world is a liability when it comes to finding viable solutions to scientific problems in the real world. Sometimes the idealized assumptions inherent in a scientific solution are all too transparent to a public that knows more about the local circumstances than the scientists. While it is common in some circles to blame public mistrust of science on the scientific illiteracy of the public, some recent studies indicate an association between increased scientific literacy and increased skepticism toward science (Irwin and Wynne 1996). Public trust in science will not be gained by wowing the masses with impressive scientific facts or by continuing to insist on the value-free nature of scientific inquiry. In today's world,

public trust in science must be *gained* by making science more accountable
and by setting the standards for literacy on the basis of understanding what it
means to do responsible science.

The viewpoint of responsible science espoused here is based on the frame-
work of agential realism. Agential realism is an epistem-onto-logical frame-
work that takes as its central concerns the nature of scientific and other social
practices; the nature of reality; the role of natural, social, and cultural factors
in scientific knowledge production; the contingency and efficacy of scientific
knowledge; the nature of matter; the relationship between the material and
the discursive in epistemic practices; the co-constitution of "objects" and "sub-
jects" within such practices; the material conditions for intelligibility and for
objectivity; the nature of causality; and the nature of agency. Agential realism
takes its inspiration from the general epistemological framework of physicist
Niels Bohr. Bohr's search for a coherent interpretation of quantum physics led
him to more general epistemological considerations that challenge some of
our most basic assumptions. His careful analysis of the relationship between
the conceptual and physical apparatuses involved in scientific practices has
relevance for contemporary efforts to understand the nature of science. Build-
ing on Bohr's insights, agential realism theorizes the relationship between the
material and discursive, and human and nonhuman dimensions of these prac-
tices, moving us beyond the dichotomized realism and social constructivism
positions and the accompanying well-worn debates between these positions.[7]

In the next section, I outline Bohr's general epistemological framework.[8] I
then present some of the key features of agential realism and explore its impli-
cations for thinking about scientific literacy. Finally, I offer a specific example
of a course specifically designed to increase the level of agential literacy.

Bohr's Epistemological Framework[9]

Bohr's careful analysis of the process of observation led him to conclude that
two implicit assumptions needed to support the Newtonian framework and its
notion of the transparency of observations were flawed: (1) the assumption
that observation-independent objects have well-defined intrinsic properties
that are representable as abstract universal concepts, and (2) the assumption
that the measurement interactions between the objects and the agencies of ob-
servation are continuous and determinable, ensuring that the values of the
properties obtained reflect those of the observation-independent objects, as
separate from the agencies of observation. In contrast to these Newtonian as-

sumptions, Bohr argued that *theoretical concepts are defined by the circumstances required for their measurement.* It follows from this fact, and from the fact that there is an empirically verifiable discontinuity in measurement interactions, that there is no unambiguous way to differentiate between the "object" and the "agencies of observation." As no inherent cut exists between "object" and "agencies of observation," measured values cannot be attributed to observation-independent objects. In fact, Bohr concluded that observation-independent objects do not possess well-defined inherent properties.[10]

Bohr (1963c) constructs his post-Newtonian framework on the basis of quantum wholeness, that is, the lack of an inherent distinction between the "object" and the "agencies of observation." He uses the term *phenomenon*, in a very specific sense, to designate particular instances of wholeness: "While, within the scope of classical physics, the interaction between object and apparatus can be neglected or, if necessary, compensated for, in quantum physics *this interaction thus forms an inseparable part of the phenomenon.* Accordingly, the unambiguous account of proper quantum phenomena must, in principle, include a description of all relevant features of the experimental arrangement" (4, italics added).

Bohr's insight concerning the intertwining of the conceptual and physical dimensions of measurement processes is central to his epistemological framework. The physical apparatus marks the conceptual subject-object distinction: the physical and conceptual apparatuses form a nondualistic whole. That is, descriptive concepts obtain their meaning by reference to a particular physical apparatus, which in turn marks the placement of a constructed cut between the "object" and the "agencies of observation." For example, instruments with fixed parts are required to understand what we might mean by the concept "position." However, any such apparatus necessarily excludes other concepts, such as "momentum," from having meaning during this set of measurements, since these other variables require an instrument with movable parts for their definition. Physical and conceptual constraints and exclusions are co-constitutive.

Since there is no inherent cut delineating the "object" from the "agencies of observation," the following question emerges: What sense, if any, should we attribute to the notion of observation? Bohr suggests that "by an experiment[,] we simply understand an event about which we are able in an unambiguous way to state the conditions necessary for the reproduction of the phenomena" (quoted in Folse 1983, 124). This is possible on the condition that the experimenter introduces a constructed cut between an "object" and the "agencies of observation."[11] That is, in contrast to the Newtonian worldview, Bohr argues that no inherent distinction preexists the measurement process, that every

measurement involves a particular choice of apparatus, providing the conditions necessary to give definition to a particular set of classical variables, at the exclusion of other equally essential variables, and thereby embodying a particular constructed cut delineating the "object" from the "agencies of observation." This particular constructed cut resolves the ambiguities only for a given context; it marks off and is part of a particular instance of wholeness.

Especially in his later writings, Bohr insists that quantum mechanical measurements are "objective." Since he also emphasizes the essential wholeness of phenomena, he cannot possibly mean by "objective" that measurements reveal inherent properties of independent objects. But Bohr does not reject objectivity out of hand; he reformulates it. For Bohr, objectivity is a matter of "permanent marks—such as a spot on a photographic plate, caused by the impact of an electron—left on the bodies which define the experimental conditions" (1963c, 3). Objectivity is defined in reference to bodies and, as we have seen, reference must be made to bodies in order for concepts to have meaning. Clearly, Bohr's notion of objectivity, which is not predicated on an inherent distinction between objects and agencies of observation, stands in stark contrast to a Newtonian sense of objectivity as denoting observer-independence.

The question remains: What is the referent of any particular objective property? Since there is no inherent distinction between object and apparatus, the property in question cannot be meaningfully attributed to either an abstracted object or an abstracted measuring instrument. That is, the measured quantities in a given experiment are not values of properties that belong to an observation-independent object, nor are they purely artifactual values created by the act of measurement (which would belie any sensible meaning of the word *measurement*). My reading is that the measured properties refer to phenomena, remembering that phenomena are physical-conceptual "intra-actions" whose unambiguous account requires "a description of all relevant features of the experimental arrangement." I introduce the neologism *intra-action* to signify *the inseparability of objects and agencies of observation* (in contrast to *interaction*, which reinscribes the contested dichotomy).

While Newtonian physics is well known for its strict determinism—its widely acclaimed ability to predict and retrodict the full set of physical states of a system for all times, based upon the simultaneous specification of two particular variables at any one instant—Bohr's general epistemological framework proposes a radical revision of such an understanding of causality.[12] He explains (1963b) that the inseparability of the object from the apparatus "entails . . . the necessity of a final renunciation of the classical ideal of causality and a radical revision of our attitude towards the problem of physical reality"

(59–60). While claiming that his analysis forces him to issue a final renuncia-
tion of the classical ideal of causality, that is, of strict determinism, Bohr does
not presume that this entails overarching disorder, lawlessness, or an outright
rejection of the cause and effect relationship. Rather, he suggests (1963a) that
our understanding of the terms of that relationship must be reworked: "The
feeling of volition and the demand for causality are equally indispensable ele-
ments in the relation between subject and object which forms the core of the
problem of knowledge" (117). In short, he rejects both poles of the usual dual-
ist thinking about causality—freedom and determinism—and proposes a
third possibility.[13]

Bohr's epistemological framework deviates in an important fashion from
classical correspondence or mirroring theories of scientific knowledge. For ex-
ample, consider the wave-particle duality paradox originating from the early-
twentieth-century observations of experimenters who reported seemingly
contradictory evidence about the nature of light: under certain experimental
circumstances, light manifests particle-like properties, and under an experimen-
tally incompatible set of circumstances, light manifests wave-like properties.
This situation is paradoxical to the classical realist mind-set because the true on-
tological nature of light is in question: either light is a wave or it is particle, it
can't be both. Bohr resolves the wave-particle duality paradox as follows: "wave"
and "particle" are classical descriptive concepts that refer to different mutually
exclusive *phenomena* and not to independent physical objects. He emphasizes
that this saves quantum theory from inconsistencies, since it is impossible to ob-
serve particle and wave behaviors simultaneously because mutually exclusive ex-
perimental arrangements are required. To put the point in a more modern
context, according to Bohr's general epistemological framework, referentiality is
reconceptualized: the referent is not an observation-independent reality, but
phenomena. This shift in referentiality is a condition for the possibility of objec-
tive knowledge. That is, a condition for objective knowledge is that the referent
is a phenomenon (and not an observation-independent object).

Agential Realism

Bohr's notion of science is limited by an underdeveloped account of the social
dimensions of scientific practices. The framework of agential realism elaborates
upon Bohr's epistemology, taking particular inspiration from his insights con-
cerning the nature of the relationship between subject and object, nature and
culture, and the physical and conceptual, and articulates a notion of practices

as processes involving the intra-action of multiple material-discursive appara-
tuses. According to agential realism, apparatuses of observation are not simple
instruments but are themselves complex material-discursive phenomena, in-
volved in, formed out of, and formative of particular practices. This elabora-
tion is accomplished in part through the theorization of an ontology and the
specification of its relationship to the epistemological issues. I will not give a
complete account here.[14] Rather, my focus in this section will be on the nature
of apparatuses and questions of ontology, agency, and accountability.

Apparatuses, in Bohr's sense, are not passive observing instruments. On the
contrary, they are productive of (and part of) phenomena. However, Bohr
leaves the meaning of "apparatus" somewhat ambiguous. He does insist that
what constitutes an apparatus only emerges in the context of specific observa-
tional practices. But while focusing on the lack of an inherent distinction be-
tween the apparatus and the object, Bohr does not directly address the
question of where the apparatus "ends." In a sense, he only establishes the "in-
side" boundary and not the "outside" one. For example, is the "outside"
boundary of the apparatus coincident with the visual terminus of the instru-
mentation? What if there is an infrared (that is, a wireless connection) be-
tween the measuring instrument and a computer that collects data? Does the
apparatus include the computer? the scientist performing the experiment? the
scientific community that judges the value of the research and decides upon
its funding? What precisely constitutes the limits of the apparatus that gives
meaning to certain concepts at the exclusion of others?[15]
 A central focus in Bohr's discussion of objectivity is the possibility of "un-
ambiguous communication," which can only take place in reference to "bodies
which define the experimental conditions" and which embody particular con-
cepts, to the exclusion of others. This seems to indicate Bohr's recognition of
the social nature of scientific practices: making meanings involves the interre-
lationship of complex discursive and material practices. What is needed is an
articulation of the notion of apparatuses that acknowledges this complexity.
 Theorizing the social and political aspects of practices is a challenge that is
taken up by Michel Foucault. Like Bohr, Foucault is interested in the condi-
tions for intelligibility and the productive and constraining dimension of
practices embodied in "apparatuses."[16] Significantly, for both Bohr and Fou-
cault, apparatuses are productive, constraining but nondetermining, specific
material and discursive arrangements. Reading Foucault's and Bohr's analyses
of apparatuses through one another provides a richer overall account of appa-
ratuses: it extends the domain of Bohr's analysis from the physical-conceptual

to the material-discursive more generally; provides a further articulation of Foucault's account, extending its domain to include the natural sciences and an account of the materialization of nonhuman bodies; and offers an explicit analysis of the inseparability of the apparatus from the objects and subjects of knowledge practices, and of the co-constitution of material and discursive constraints and exclusions. As I will indicate below, an agential realist acount entails the following important points: apparatuses of observation are not simple instruments but are themselves complex material-discursive phenomena, involved in, formed out of, and formative of particular social processes, including technoscientific ones. Power, knowledge, and being are conjoined in material-discursive practices. I briefly summarize a few of the main points of the analysis in what follows.[17]

How does this recognition of the material-discursive character of apparatuses matter to the ontological issues at stake in debates between realism and social constructivism? Petersen (1985) notes an important aspect of Bohr's response to such questions:

> Traditional philosophy has accustomed us to regard language as something secondary, and reality as something primary. Bohr considered this attitude toward the relation between language and reality inappropriate. When one said to him that it cannot be language which is fundamental, but that it must be reality which, so to speak, lies beneath language, and of which language is a picture, he would reply "We are suspended in language in such a way that we cannot say what is up and what is down. The word 'reality' is also a word, a word which we must learn to use correctly." (302)

Unfortunately, Bohr is not explicit about how he thinks we should use the word *reality*. I have argued elsewhere (Barad 1996) that a consistent Bohrian ontology takes phenomena to be constitutive of reality. Reality is not composed of things-in-themselves or things-behind-phenomena, but things-in-phenomena. Because phenomena constitute a nondualistic whole, it makes no sense to talk about independently existing things as somehow behind or as the causes of phenomena.

The ontology I propose does not posit some fixed notion of being that is prior to signification (as the classical realist assumes), but neither is being completely inaccessible to language (as in Kantian transcendentalism), nor completely of language (as in linguistic monism). That reality within which we intra-act—what I term *agential reality*—is made up of material-discursive phenomena. Agential reality is not a fixed ontology that is independent of

human practices, but is continually reconstituted though our material-discursive intra-actions.

Shifting our understanding of the ontologically real from that which stands outside the sphere of cultural influence and historical change to agential reality allows a new formulation of realism (and truth) that is not premised on the representational nature of knowledge. If our descriptive characterizations do not refer to properties of abstract objects or observation-independent beings, but rather describe agential reality, then what is being described by our theories is not nature itself, but our participation *within* nature. That is, realism is reformulated in terms of the goal of providing accurate descriptions of agential reality—that reality within which we intra-act and have our being—rather than some imagined and idealized human-independent reality. I use the label *agential realism* for both the new form of realism and the larger epistem-onto-logical framework that I propose.[18]

According to agential realism, reality is sedimented out of the process of making the world intelligible through certain practices and not others. Therefore, we are responsible not only for the knowledge that we seek, but, in part, for what exists. Scientific practices involve complex intra-actions of multiple material-discursive apparatuses. Material-discursive apparatuses are themselves phenomena made up of specific intra-actions of humans and nonhumans, where the differential constitution of "nonhuman" (or "human") itself designates a particular phenomenon, and what gets defined as an "object" (or "subject") and what gets defined as an "apparatus" is intra-actively constituted within specific practices. Intra-actions are constraining but not determining.[19] The notion of intra-actions reformulates the traditional notion of causality and opens up a space for material-discursive forms of agency, including human, nonhuman, and cyborgian varieties. According to agential realism, agency is a matter of intra-acting; it is an enactment, not something someone or something has. Agency cannot be designated as an attribute of "subjects" or "objects" (as they do not preexist as such). Agency is about the possibilities and accountability entailed in refiguring material-discursive apparatuses of production, including the boundary articulations and exclusions that are marked by those practices.[20]

Reconceiving Scientific Literacy as Agential Literacy

What are the implications of agential realism for thinking about scientific literacy? Agential realism provides an understanding of the nature of scientific

practices that recognizes that objectivity and agency are bound up with issues of responsibility and accountability. We are responsible in part for what exists not because it is an arbitrary construction of our choosing, but because agential reality is sedimented out of particular practices that we have a role in shaping. Which material-discursive practices are enacted matters, for ontological as well as epistemological reasons: a different material-discursive apparatus materializes a different agential reality, as opposed to simply producing a different description of a fixed observation-independent world. Agential realism is not about representations of an independent reality but about the real consequences, interventions, creative possibilities, and responsibilities of intra-acting within the world. Hence, according to agential realism, *scientific literacy becomes a matter of agential literacy—of learning how to intra-act responsibly within the world.*

What kind of education is needed to work toward the goal of agential literacy? *Agential literacy requires understanding the nature of our intra-actions within the world.* Therefore, it will be necessary to have the ability to analyze the intra-action of multiple material-discursive apparatuses. A partial list of skills that will be required includes:

- the ability to identify the relevant apparatuses entailed in particular practices;
- the ability to analyze the material-discursive nature of each apparatus (including each apparatus's specific enfolding and sedimenting history);
- the ability to analyze the mutually constitutive relationship among intra-acting apparatuses (in their local specificity as well as their global intra-connectivity);
- the ability to analyze the intra-active constitution of "objects" and "subjects" (including, for example, the differential constitution of "human");
- the ability to recognize the boundaries drawn in the enactment of particular practices;
- the ability to imagine and understand the possibilities for reconfiguring apparatuses and reconstituting boundaries; and
- the ability to analyze, as best as possible, the consequences of new practices.

In turn, these analyses will require:

- understanding and taking account of the multiple forms of agency;
- attention to the requirements of objectivity (including attentiveness to marks on bodies);

- ongoing development of new methods for exposing background assumptions, including attention to the active inclusion of communities affected by different technoscientific practices;
- attention to issues of responsibility and accountability; and
- ongoing reflection on the nature of scientific knowledges and practices as part of the practice of doing science.

Although it may seem that agential literacy raises the standards so high as to make the goal unreachable, introducing a notion of literacy with more complexity does not mean that it is less achievable. On the contrary, an oversimplified model may be an important cause of the lack of progress that we have seen in achieving the goal of scientific literacy, not only because such a model misses the mark when it comes to understanding our complex intra-actions within the world—undermining much of what it is hoped that scientific literacy will achieve—but also because the goal of scientific literacy may not be compelling to many of the "scientifically illiterate" who have already grasped its irrelevance. One common complaint by students taking science courses is that what they are learning does not seem relevant to their lives. According to the conception of agential literacy presented here, one does not make the subject matter relevant by starting with an unchanged traditional curriculum and coating scientific facts with "relevant examples" to make them go down easier. *In teaching for agential literacy, science is understood (not "in context" but) in complex intra-action with other practices.*

If, unlike multidisciplinary or interdisciplinary approaches, a transdisciplinary approach "does not merely draw from an array of disciplines but rather inquires into the histories of the organization of knowledges and their function in the formation of subjectivities . . . mak[ing] visible and put[ting] into crisis the structural links between the disciplining of knowledge and larger social arrangements" (Hennessy 1993, 12), then the latter approach contains some of the elements of the methodology that is needed in teaching for agential literacy. Additionally, agential realism suggests that these considerations be supplemented by insights that follow from an appreciation of the nature of the disciplining of knowledge as particular material-discursive practices. This approach inquires into:

- the material-discursive nature of boundary-drawing practices as both the enabling and exclusionary workings of power;

- the co-constitution of different domains of knowledge through the intra-action of multiple apparatuses;
- the intra-active constitution of "objects" and "subjects" within practices;
- the epistem-onto-logical consequences of particular boundary cuts; and
- questions of agency and accountability in terms of the possibilities of refiguring apparatuses and the constitutive boundary cuts through which knowledge is disciplined.

I will use the term "trans/disciplinary" to signify this enlarged set of considerations, where the slash is inserted as a physical marker,[21] a visual symbol, of the material nature of boundary-drawing practices (a crucial dimension of disciplinary practices too often omitted in discussions of disciplinarity), and to emphasize the fact that the intra-action of different disciplinary apparatuses does not negate the epistem-onto-logical import of the different histories and institutional structures of various disciplinary practices that it draws upon, nor does it constitute an undoing of the disciplinary nature of knowledge—boundaries are always necessary for making meanings.

Teaching Agential Literacy

The mass of our children should be given something which may not be terribly strenuous but should be interesting, stimulating and amusing. They should be given science appreciation courses just as they are sometimes given music appreciation courses.
—Edward Teller, testifying at a hearing of the Senate Armed Services Committee, November 1957 [Shamos 1995, 197]

The epitome of the general education course for nonscience students, the so-called Physics for Poets course, puts the philosophy expressed by Edward Teller into practice. This genre of courses misses the mark completely when it comes to teaching students about responsible science. In fact, these courses can actually result in the further mystification of science and the disempowerment of students.[23] What kind of pedagogy would help students to learn about practicing responsible science?

In this section, I describe a course that I specifically designed to advance the agential literacy of my students, called "Situated Knowledges: Cultural Studies of Twentieth-Century Physics." I chose twentieth-century physics as the subject matter on the basis of my own interests and expertise and because it brings to the fore crucial epistemological issues, though the basic pedagogy

can be adapted to other subject matters. Since twentieth-century physics is a popular choice of topic for non-science-major physics courses, this also allows an easier comparison between pedagogies that teach with the traditional notion of scientific literacy in mind and a pedagogy that has agential literacy as a goal. For starters, these pedagogies differ in motivation, audience, and methodology. What often motivates the choice of this subject matter in "Physics for Poets" courses is its "sexiness" (Stephen Hawking's best-seller litters coffee tables across the country, and *quantum leap, chaos theory, blackhole,* and *quark* are terms that circulate in the popular culture), its shock value (the counterintuitive findings about the universe), and the fact that it is fairly easy to draw (weak, surface) parallels to the humanities (i.e., the work of the "poets"). Furthermore, "Physics for Poets" courses are directed at nonscience majors and generally only offer a handwavy presentation of the main ideas. In contrast, the course that I will briefly describe is motivated by the desire to challenge both nonscience *and* science majors to a greater understanding of the nature of scientific practices and of what it means to do responsible science. Every attempt is made to be as rigorous as possible in the presentation of the physics and the other related issues.

This course carries three different course identifications (designating it as a physics course, as an interdisciplinary women's studies course, and as a science, technology, and society course) at the Claremont Colleges, where it was originally taught. It has a laboratory component and satisfies a science distribution requirement for the liberal arts colleges and a humanities distribution requirement for the science and engineering college. It is also cross-listed with the Five-College Women's Studies and the Science, Technology, and Society (STS) programs. The course is open to all undergraduates.

The approach used is trans/disciplinary, and the readings are drawn from a range of literatures including anthropology, philosophy, history, sociology, feminist theory, cultural studies, and physics. This approach is different from those that merely attempt to place physics in its historical, philosophical, sociological, or cultural "context" by adding tidbits from other disciplines (such as the history and philosophy of science) that seem appropriate to the topic at hand.[24] To begin with, unlike the "science in context" approaches, the agential literacy approach does not play off an assumed dualism between culture and science—trying to then draw out definitive causal lines of influence between one and the other—a fact that may be as disconcerting to social constructivists as it is to realists. Rather, the approach used is to examine the intra-action of different apparatuses constituting different knowledge practices. Emphasis is placed on an examination of different boundary cuts enacted in the formation

of particular categories of analysis and how they relate to one another. For example, contrary to some Science, Technology, and Society approaches, it is *not* presumed that the question of how physicists make sense of the world can be answered by simply identifying appropriate cultural influences, treating nature as mediated by culture, and treating culture as itself an implicitly transparent and separate surrounding or context. Rather than presuming some inherent demarcation between nature and culture as the starting point for the analysis, an agential realist analysis includes an examination of the way different disciplinary cultures define what counts as "nature" and what counts as "culture." Furthermore, it privileges neither the material nor the discursive dimensions of scientific practices, but seeks to understand the relationship between material and discursive constraints and conditions. In this way, the role of (human and nonhuman) agency in the production of objective knowledge can be appreciated and students can begin to see the importance of their own participation in doing responsible science: of learning how to intra-act responsibly within the world.

It is not possible to give a complete account of the course here, but I offer brief descriptions of a few different moments from the course to illustrate the kinds of pedagogical methods that were utilized.[25]

1. In her cross-cultural ethnographic study of the high-energy physics community, Sharon Traweek (1988) characterizes the culture of science as a "culture of no culture, which longs passionately for a world without loose ends, without temperament, gender, nationalism, or other sources of disorder—for a world outside human space and time" (162). The course began with a student exercise designed to help make scientific cultures visible. Students were asked to do their own "miniethnographies." They were expected to spend several hours over the course of a week observing and identifying specific features of a particular scientific culture of their choosing.[26] This exercise was empowering and revealing to nonscience and science students alike. In addition to making the culture of science visible, it opened up discussion of the different disciplinary cultures and practices in the academy (including different ways of making arguments and constituting evidence), the existence of multiple scientific cultures and the disunity of science, the differences between science and other disciplinary pedagogies, the continuities and discontinuities between teaching and research practices, and the effects of disciplinarity on a range of epistemological questions (including the constitution of knowledge

and knowers, and the role of authority). This exercise also laid the groundwork for later discussions of multiple apparatuses and their intra-actions in the making of science, scientists, and society.

2. A common way to think about science is as a body of knowledge. In this course, we talked about the limitations of this common conception, and the different implications that follow from thinking about science as particular kinds of open-ended and ongoing practices. To illustrate this point we read two accounts of the development of the field of quantum mechanics and compared them to one another. One book is a Bantam paperback written primarily as a popular account of modern physics: Heinz Pagels's *Cosmic Code* was chosen for its pedagogical usefulness in conveying key ideas and its fairly accurate portrayal of mainstream views of quantum mechanics (this account by a respected, thoughtful, and active research physicist is to be contrasted with a plethora of idiosyncratic popular accounts of questionable validity).[27] The other, *Niels Bohr's Times*, written by physicist Abraham Pais, is an autobiography of Bohr that includes a detailed account of the development of his ideas and the physics that engaged him. Pais is interested in historical accuracy. Unlike Pagels, his presentation is not designed to make the subject matter generally accessible. Consequently, Pais's book is much more difficult for students to read than that of Pagels. Indeed, Pais's book includes a significant number of details of science in its development—but this is also its value. Furthermore, Pais is concerned with presenting science in its social, political, and historical context. These two accounts, written by physicists, provide strikingly different presentations of the enterprise of science and the development of quantum mechanics. Students remarked upon many different aspects of the contrasting portrayals, but perhaps the most poignant was between science presented as a linear progression based upon the work of a few great men and science presented as a complex array of intersecting, reinforcing, and contestatory practices embedded in particular social contexts. We talked about the different pedagogical implications and the role of disciplinarity in the writing of these accounts (with an eye toward questions of what gets included, what doesn't, and how exclusions as well as inclusions come to matter). This approach also highlighted an important dimension of scientific practices: the formation and re-formation, as opposed to the simple testing, of concepts. It connected up nicely with the laboratory emphasis on thinking about material dimensions of scientific practices and the specific embodiment of concepts.

3. "Cookbook" laboratory exercises reinforce the notion that science is a body of knowledge progressively acquired through an array of predetermined skills. They completely occlude the fact that science is a changeable, open-ended set of practices. Consequently, these exercises are not only uninspiring (as judged by most students), but give the wrong impression of what science is about. (Needless to say, this is not to deny the necessity of obtaining a knowledge and skills base for doing science, or the responsibility of educators to assist students in such acquisitions.) On the other hand, it is often difficult to come up with tractable "mini-research" projects appropriate for every student and for the subject matter at hand.

New pedagogical approaches to laboratory education are constantly being proposed and debated. I am not prepared to pose general answers to the multidimensional challenges that educators face in thinking about the best ways to teach labs. Rather, my specific goal for this course is to find ways to present students with opportunities to learn the science while simultaneously learning about the changing nature of scientific practices.[28]

My idea for trying to make the practice-based nature of science evident is to have students conduct a series of experiments highlighting different ways in which phenomena are defined and explored at different historical moments.[29] More specifically, this approach is a variation on the "history of physics" approach where students perform experiments using historically specific methodologies and replicas of the original equipment.[30] The variation involves the addition of a time dimension: instead of only doing the "original" experiment, students perform a series of historically specific experiments from different periods of history. This approach highlights the changing nature of practices *and* phenomena.

A specific example might be helpful. Suppose that students are investigating the nature of light. In addition to performing traditional contemporary experiments, students read about and perform experiments similar to those conducted by Malus and others from the early nineteenth century (during which time the nature of light was being hotly debated). This brings to light the fact that, contrary to what students are often taught, Thomas Young's (1773–1829) two-slit experiment was not the singular defining moment that brought the nineteenth-century debate to a close.[31] In fact, closer examination of the physics of the nineteenth century reveals that the rise of the wave theory of light depended upon several major changes in the theoretical concepts, the mathematics

employed in calculations (from a geometric approach to an algebraic one), and the basic nature of experimental optics itself (including shifts in methodology, in the constitution of evidence, in the nature of comparison between theory and experiment, in the accepted standards of experimental reporting, and in the analysis of experimental errors).[32] In this way students come to appreciate important material-discursive aspects of scientific practices, including corresponding shifts in physical and conceptual apparatuses, the role of different constraints, the intra-action of these different constraints, and so on. More precisely, this "history of physics—time series" approach makes apparent the changing nature of science as practice: as agential shifts in the intra-action of multiple material-discursive apparatuses. It promotes agential literacy, helping students to acquire the kinds of skills mentioned in the previous section, including identifying the material-discursive nature of apparatuses and the multiplicity of apparatuses that come into play, analyzing their intra-action, analyzing the ways in which phenomena get enfolded as parts of apparatuses back into scientific practices, and so on.[33] Needless to say, there are significant limitations to this approach as well; perhaps most evident, it does not provide an understanding of the real-time development of practices.

4. Niels Bohr's philosophy-physics circulates at several different levels in this course. This provides an interesting opportunity to consider the complex interrelationship of his views on quantum mechanics and those on epistemology.[34] In the history and philosophy of science literature this relationship is usually probed by asking about the influence of his philosophical views on his physics. But Bohr did not develop these ideas separately, and even a bidirectional influence model is too limiting. A different dynamics—one suggested by the framework of agential realism—was explored in the course: the dynamics of intra-action rather than influence. This enabled a more far-reaching analysis of the practices by which "science," "scientists," and "society" are intra-actively co-constituted. In particular, we were able to form a rich, multidimensional, and dynamic understanding of the development of Bohr's ideas and of the culture of which he was a part. This was contrasted with views built from one-dimensional projections, tracing individual lines of influence in which one factor is taken to be determining of another, presuming that agency resides in reified entities we call Politics or Philosophy or Culture.[35]

We also took advantage of the fact that Bohr's philosophy-physics is the inspiration and starting point for the development of the framework

of agential realism itself. This presented an opportunity for self-reflexive analysis, including a critical examination of the course framework. We spent time identifying and analyzing some of the more important material-discursive apparatuses that were operative in the course.

Inspired by the reflexive connectivity among the different levels through which Bohr's views circulate in this course, and a desire to further contemplate alternative accounts of science and alternative views of quantum mechanics that we had studied, we also used a "diffractive" method of analysis. The methodology of diffractive analysis is not merely one of reflexivity, but rather entails an exploration of the difference that different boundary-drawing practices make.[36] I will briefly sketch some of the key features of the analysis. During the semester different views of the nature of science were considered, Bohr's being one of them. The strengths and limitations of his views were examined, with attention focused as well on interesting resonances and dissonances between his views and those of some contemporary science studies scholars. (Students came to appreciate the heterogeneous approaches that make up the "field" of science studies, exploring their strengths and weakness, while being encouraged to develop their own views.) Furthermore, different interpretations of quantum mechanics were considered. (Considerable effort was made to give a rigorous presentation of basic ideas of quantum theory, the interpretative issues, and the development of those ideas.) In the interest of exploring the effects of using different models for the nature of the relationship between science and society, the class examined different interpretations of quantum mechanics as *diffracted* through different understandings of science. Although we found the case where Bohr's philosophical framework is used as the theoretical basis for considering his own scientific practices particularly interesting, the method of diffractive analysis enabled us to expand our considerations to explore a range of possible models. (This approach was particularly helpful in making apparent different material-discursive apparatuses and the nature and consequences of different boundary drawing practices. It also provided an opportunity for students to critically reflect on the boundary drawing practices of their instructor.)

This course was designed to have students learn science while thinking about science, and to learn that thinking about science is part of doing science. Students did calculations and laboratory exercises, experienced the power and efficacy of science, and learned to appreciate the value of doing responsible

science, while thinking about the nature of scientific practices and its relationship to other social practices. In a sense the course itself was a meditation on scientific literacy, disciplinarity, and the consequences of particular boundary practices. I believe that the success of the course is in part due to the fact that agential literacy is the kind of literacy that is achievable because it is more realistic—it has more to do with the world within which we intra-act and students know it. (See the appendix for assessment details.)

Conclusion

The teaching of scientific literacy has been considered to be the sole responsibility of scientists. If by scientific literacy we simply mean knowledge of scientific facts and methods, then this seems reasonable. But if our goal is *agential literacy*—knowing how to intra-act responsibly within the world—then we must all share the responsibility for preparing future generations to meet the challenges that lie ahead. Agential literacy cannot be taught in one course or even within one curriculum. It is a responsibility that cuts across disciplinary boundaries in the academy and beyond.

The making of science is not separate from the making of society. Scientific practices are not just any kinds of doings; they are material-discursive intra-actions with intertwined epistemological and ontological significance. The making of what we call science and what we call society are mutually constitutive, not because they impact one another, but because the constitutive intra-actions do not honor the arbitrary boundaries we construct between one and the other. The multiple material-discursive apparatuses that are consciously or unconsciously mobilized and implicated in particular practices are not isolatable pieces of instrumentation contained within the walls of a laboratory. The apparatuses that are constitutive of practices (be they "scientific" or "social") are themselves material-discursive phenomena with particular sedimenting histories.

The fact that Luis Alvarez, a physicist who worked on the Manhattan Project at Los Alamos during the war, mined the postwar thermonuclear bomb project for equipment to be used in the construction of his bubble chamber at Berkeley to do high-energy physics experiments is not sufficient reason, in and of itself, to condemn or to desist from engaging in experimental particle physics. After all, appropriation can prove to be an effective intervention in the structures of power. But knowing this history *is* important for understanding the nature of the material cultural that brings pieces of Los Alamos to Eniwetok and back to northern California (Galison 1997, 4). And understanding the

flow of materials, information, concepts, styles of engagement,[37] and more across the leaky boundary between pure and applied science is important for getting at the "genealogy of instruments [that] helps to explain how they became certified as legitimate keys to the domain of the subvisible" (5) and how, I might add, the scientific authority of such projects lends legitimization to other cultural endeavors that share pieces of these sedimenting histories. What we need more generally is to understand the construction, circulation, and enfolding of elements of material-discursive culture: a genealogy of apparatuses (experimental, theoretical, pedagogical, economic, and so on), not simply of instruments. For apparatuses are themselves phenomena—the result of particular material-discursive practices—and the enfolding of phenomena into subsequent iterations of particular situated practices (which may be traded across space, time, and subcultures) constitutes important shifts in the nature of the intra-actions that result in the production of new phenomena, and so on. Which shifts occur matters for epistemological as well as ontological reasons. We are responsible for the world within which we live, not because it is an arbitrary construction of our choosing but because agential reality is sedimented out of particular practices that we have a role in shaping. To understand what it means to do responsible science, to engage in responsible actions more generally, requires that we learn how our practices come to matter.

Appendix: Assessment

The first offering of this course was in the spring of 1997. The student enrollment drew from a very broad cross section of the college community, from first-year students to graduating seniors, and from students who identified themselves as science-phobic to senior physics majors.[38]

Needless to say, one offering of a course doesn't prove anything about its effectiveness in promoting the overall goal of agential literacy. However, the results of this one offering are striking. The rate of return of course evaluation forms was very high, and nearly every student who handed one in expressed great enthusiasm for the course.[39] Students who had not previously had any interest in science, and/or any confidence in their abilities in science, said that they felt empowered by the course to engage more with science. Science majors expressed uniform satisfaction with the course, many commenting on the fact that they had previously found something lacking about their science education. Science majors also commented on the fact that after taking the course

they felt a responsibility to think about science as material-discursive practices and to do responsible science. Four students said that were now planning to major in one of the sciences as a result of taking this class. Below is a sample of quotes taken from student evaluations:

> Physics 6 has been a challenging and inspiring class. Over the course of the semester we criticized the widespread belief that physicists discover a world that is independent of human beings and human culture. We explored new definitions of objectivity and reality that allow for contextual knowledge yet steer away from complete relativism. I have not yet formed a definite opinion on these matters, but this course has convinced me that a thorough understanding of the origins and meaning of scientific knowledge is an essential part of the scientific enterprise. Because of this course, I have chosen science, technology, and society as my humanities concentration. I believe that this course will have long-term effects on the way that I think about and practice physics. (from a senior physics major at the science and engineering college)

> I am thrilled to see that a course like this has finally been offered. For as long as I have been studying the sciences, I have felt that a class like this is absolutely crucial. It covers an area much glossed over: science, what it means, ethics & thought. I am truly honored to have been able to take this class and hope it is offered again in the near future. This is one of the class types that I was hoping for/expecting when I came to college.

> This class also taught me about myself and the world in which we live. I was never really interested in science in general but this class changed my outlook and showed how science has been and is an integral part of our society, and that it has also been influenced by events in history. It was a tough course that stretched my mind and one that I thoroughly enjoyed." (from a student who was never very interested in science)

> I never knew that science could actually interest me. Now I am fascinated with physics, the history of science, epistemology, and feminist theory.... I have never experienced the sheer joy of knowledge like I did in this class."

> While I'm still wary of science, I feel much more confident and motivated to continue learning about the issues raised this semester. Now when I see a

copy of a science publication, I actually pick it up instead of feeling intimidated." (from a student who entered the course "hating science")

My faith in myself as an intelligent and contributing member of a community and of society has grown stronger during the course of this semester, and it is not attributable to being able to pass some test about the microscopic processes of food absorption in the colon. I cannot summarize what it is that I have learned from physics, but I feel that I have incorporated much understanding into my very being—and it is not in the form of verbal knowledge that I can readily regurgitate. This is a much deeper sense of well-being and understanding of the universe on every level.

By far the best class I've taken in college. It strongly influenced my thinking for other courses. I became very aware of the difficulties involved in any academic discipline. . . . The ideas were presented so as to enable students to question and discuss the implications of science without trivializing science as a discipline. It provided me with new standards for evaluating ideas. Whereas before, I felt "science" was beyond my realm—I now feel that I have the tools to consider the validity of these ideas." (from a graduating senior who expressed a reorientation in her relationship to her major discipline as a result of taking this course)

Acknowledgments

I want to thank the wonderful students of Physics 6 for a rich and rewarding spring semester of 1997. I thank Michael Flower, Lisa Heldke, Laura Liu, Jennifer Rycenga, and Roddey Reid for their helpful comments on earlier drafts. I am grateful for the honor of having been selected as the tenth occupant of The Blanche, Edith, and Irving Laurie New Jersey Chair in Women's Studies at Rutgers University and for the hospitality and support I received during the writing of this paper. I gratefully acknowledge support from the Irvine and Mellon Foundations for funding related to the development of the course.

Notes

1. This is not an isolated example. And while certain specific futures mark it as a cultural product of the 1950s, it would be wrong to think that the approach (or even the theme: I can see it now—a Martha Stewart segment on the physics of gracious living!) is a relic of that era. Similar examples—that rely upon fixed and homogeneous

notions of gender, race, nationality, sexuality, and class, and other social variables—
continue to be offered today, with the best of intentions, by both women and men,
feminists and nonfeminists.

2. Their heterogeneous and multiple "intra-actions," rather than "interactions," are
more to the point here, as explained below.

3. The National Aeronautics and Space Administration (NASA) was also established
in 1958. It was during this time as well that President Dwight D. Eisenhower got behind
the languishing Stanford Linear Accelerator (SLAC) proposal and took it to Congress,
requesting a sum of $100 million on behalf of the physicists.

4. Grants promoting the integration of computer and Internet technologies in the
classroom are being made available to colleges and universities at an expanding rate.
For many faculty, this plethora of funding ironically places them in the previously un-
thinkable position of being burdened by a surplus of resources during a time of deep
funding cutbacks. Hungry for additional resources, faculty participate in this game of
funding "Jeopardy," where the objective is to come up with the right problem for the
solution being offered. Of course, these efforts only displace rather than solve the
problems faculty originally wanted funding to investigate. (In other words, the burden
derives from the temporal reversal of the more usual mode of grant acquisition, where
need precedes supply.) Furthermore, faculty are coming under increasing pressure to
develop webpages for their courses, and colleges and universities are exploiting the In-
ternet for the purpose of developing new "distance learning" programs. See David
Noble's articles (1998 and unpublished) on the "digital diploma mills" for an in-depth
examination and analysis of these new corporate links to academia.

5. While corporate pressure is commonly exerted by strategic use of corporate
grants (see n. 4 above), it is important to note that the constraints placed on corporate
grants are not fully determining and enable a variety of interventions and alternative
uses. Support for the development of the course that I describe in this article—which
is based on an alternative understanding of scientific literacy—came from two private
funding agencies, the Irvine and Mellon Foundations.

6. Objectivity cannot be brokered by insisting on the existence of an impermeable
boundary insulating science from other human concerns. Some scholars, like Sandra
Harding (1991) and Helen Longino (1990), for example, have argued that the constitu-
tion of evidence itself depends upon the inclusion of background beliefs, values, and
assumptions, and therefore the basis for objectivity comes not from some form of pu-
rity but from a critical recognition and incorporation of this fact. Feminist science
studies scholars challenge traditional conceptions of objectivity, but they have been
unwilling to reject the notion of objectivity out of hand. Instead, they have sought
meaningful alternatives to aperspectivity. In fact, one feature that has consistently
characterized the diversity of approaches that fall under this rubric is the search for a
better, more realistic, more meaningful understanding of objectivity—not its rejec-
tion. Given this fact, it is particularly ironic that feminist science studies has recently
been painted by those with conservative stakes in the current culture wars ("science

wars") as taking a stand against objectivity and science. Nothing could be further from the truth. Philosopher of science Joseph Rouse explains, "Feminist science studies scholars most evidently differ from the new sociologists in their opposition to relativism, their normative stance toward particular scientific claims, and their willingness to retain and employ suitably revised conceptions of evidence, objectivity, and a distinction between belief and knowledge" (Rouse 1996b, 202).

Lorraine Daston's genealogy of the term *objectivity* includes the following point that is relevant to this discussion: "Hume recommends that the critics cultivate perspectival suppleness, the ability to assume myriad other points of view, rather than the total escape from perspective implied by the 'view from nowhere.' . . . scientists were held to be exemplary by the eighteenth-century perspectival philosophers, but not because science was presumed free of particular perspectives—that is, 'objective' in our latter-day sense. Rather scientists were revered as *paragons of the virtue of disinterestedness*, both in the immediate sense of forsaking the motives of selfish gain, and in the more remote sense of remaining serene in the face of public apathy or contempt" (1992, 604–5, italics added). It is quite interesting to compare the eighteenth-century view of scientists as "paragons of the virtue of disinterestedness" to the post–World War II view of scientists as "paragons of social responsibility."

7. For more details on agential realism see Barad 1996, 1998a, 1998b, forthcoming (b).

8. Before I present my reading of Bohr's general epistemological framework, I want to be clear about the precise focus of the discussion concerning Bohr. As Bohr scholar and philosopher Henry Folse (1985) points out,

> While Bohr himself understood from the beginning that he was concerned with philosophical issues extending far beyond his proposed solution to the specific quantum paradoxes that have held the center of attention since 1927, unfortunately, history has not been altogether kind to his philosophical endeavors. Instead of being understood as a general framework within which the new physics was to be justified as an objective description of nature, complementarity came to be identified with the so-called "Copenhagen Interpretation" of quantum theory. (6)

It is Bohr's general epistemological framework, and *not* the interpretation of quantum mechanics, that is of interest here.

Although Bohr has been called a positivist, an idealist, an instrumentalist, a (macro)phenomenalist, an operationalist, a pragmatist, a (neo)Kantian, and a realist by various scholars, I would argue that Bohr's philosophy does not fit neatly into any of these categories because it questions many of the dualisms upon which these philosophical schools of thought are founded. For example, while Bohr's understanding of quantum physics leads him to reject the possibility that scientists can gain access to the "things-in-themselves," that is, to the objects of investigation as they exist outside of human conceptual frameworks, he does not subscribe to a Kantian noumena/phenomena distinction. And while his practice of physics shows him to hold a realist attitude toward his subject matter, he is not a realist in any conventional sense, since he believes that the nature of the interaction between the objects of investigation and what he calls "the

agencies of observation" is not determinable, and therefore cannot be "subtracted out," leaving us with a representation of the world as it exists independently of human beings.

A separate issue of importance should be noted at this juncture as well. Bohr did not see the epistemological issues with which he was concerned as being circumscribed by Planck's constant. That is, he did not see them as being applicable solely to the microscopic realm. In fact, if Planck's constant had been larger, Bohr insists that the epistemological issues that concern him would have been more evident (and we wouldn't have been as inclined to being fooled into representationalism).

Finally, I want to be clear that I am not interested in mere analogies but rather widely applicable philosophical issues such as the conditions for objectivity, the appropriate referent for empirical attributes, the role of natural as well as cultural factors in scientific knowledge production, and the efficacy of science (especially in the face of increasingly numerous and sophisticated demonstrations of its contingent nature).

9. This section and the next are excerpted from Barad 1998.

10. For more details see Barad 1995. Note: *Agencies of observation* is Bohr's term, which he seems to use interchangeably with *apparatus*. Because of the usual association of agency with subjectivity, "agencies of observation" hints at an ambiguity in what precisely constitutes an apparatus for Bohr. For further discussion see the section "Agential Realism."

11. Bohr called this cut "arbitrary" to distinguish it from an "inherent" cut. But the cut isn't completely arbitrary, and so I use "constructed" as a contrast to "inherent."

12. According to Newtonian physics, the two variables that need to be specified simultaneously are position and momentum. According to Bohr, our understanding of causality as Newtonian determinism must be revised because mutually exclusive apparatuses are required to define position and momentum.

13. For more details see Barad 1998b, forthcoming (b).

14. Ibid.

15. For quantum mechanics aficionados this issue may seem to have resonances with the "collapse problem." However, there are significant differences. The concern here is with Bohr's general epistemological framework, not with his interpretation of quantum mechanics. (Note: The notion of the collapse of the wavefunction was von Neumann's contribution, which Bohr never embraced. Some scholars have argued that Bohr's interpretation does not require a collapse-type mechanism; others see this as a failure of Bohr's interpretation.) Once again, the concern here is not with Bohr's interpretation of quantum mechanics, but with his general epistemological framework.

16. See especially Foucault 1977, particularly the discussion of "observing apparatuses" such as the panopticon.

17. For more details see Barad 1998b, forthcoming (b). See Rouse 1987, 1996a for a detailed philosophical analysis of the extension of Foucault's notion of power/knowledge to the domain of the natural sciences.

18. I use the term *epistem-onto-logy* here instead of *ethico-epistem-onto-logy* only because this latter neologism is too unwieldy, not because the ethical issues are not central—on the contrary.

19. See Barad 1998b, forthcoming (b) for details on how to understand the notion of intra-action as a reworking of the traditional notion of causality.

20. Questions of agency, responsibility, and accountability are central to the framework of agential realism (see Barad 1996). For further elaborations see Barad forthcoming (b), Heldke 1998, forthcoming; and Rowe 1999.

21. The inclusion of the slash is inspired by Leela Fernandes's construction "trans/national." Fernandes inserts the slash to emphasize the fact that the production of boundaries has different political and material effects in different national contexts, that the boundaries drawn in one national context have simultaneous material effects in other national contexts, and that the "crossing" of national boundaries symbolized by "trans" does not negate the historical importance of what is constituted as "nation" (i.e., the material effects of national boundaries). Fernandes' notion of the "trans/national" was discussed during the presentation of her work at the Institute for Research on Women's seminar at Rutgers University on March 12, 1998. Fernandes 1997 is a brilliant exposition on the material and structural dimensions of boundary-making practices; see Barad 2000, forthcoming (b) for a discussion of this work in relation to agential realism.

22. The hearing from which this quote is taken took place shortly after the launching of Sputnik. Perhaps more importantly, it took place a few years after Teller's hydrogen bomb was built and tested, and a few years after Teller, a militant anti-Communist, testified against Oppenheimer at the McCarthy hearings (some believe as retaliation for Oppenheimer's opposition to building the hydrogen bomb). The Stars Wars program was another brainchild of Teller's.

23. What, after all, were the goals that Teller was actually interested in promoting? Conformity of nonscience students to the social order? The transformation of students into pliant consumers of science-related goods? Continuing unquestioning public support of future science projects? Teller was certainly sensitive to the fact that even in good economic times, proactive public relations efforts are required to ensure the continued support of "Big Science."

24. I taught such a course in the mid-1980s at Barnard College. The course was called "Physics in Historical Perspective"; its originator was experimental physicist Samuel Devons (a student of Rutherford). One of the first of its kind, the "History of Physics" Laboratory at Barnard was the realization of this Columbia University professor's vision and labor. As Sam explained to me, the lab was built at Barnard because such a project lacked legitimacy on the "east side of Broadway" and because he wanted to inspire young women to major in physics. When I first inherited the course and the laboratory, as a newly minted recipient of a doctorate in theoretical physics, I hardly knew anything about the history of physics and its value to understanding physics (not just pedagogically, but epistemologically speaking). Though I naturally tailored the course and the laboratory to my own interests, I am indebted to Sam Devons for making this historic and pedagogically visionary project a reality at Barnard, and for teaching me some very far-reaching lessons about the disciplining of knowledge and pedagogy. (Sadly, the lab and the course are now defunct.)

25. I have begun work on a "textbook" for the course (Barad forthcoming[a]).

26. Several students took the assignment a step further and did "cross-cultural" studies: (1) by taking advantage of the five college system in Claremont to compare departments of the same scientific discipline at different colleges, or (2) by comparing two or more different science departments at the same college.

27. I chose Pagels's account because it provides a fairly accurate portrayal of quantum mechanics as it is most commonly understood by the majority of physics students and physicists. However, this is not to suggest that Pagels's account of quantum mechanics is rigorous or definitive. There's plenty for the careful and informed reader to bristle over, and some of these issues were taken up in class. For example, though the interpretative issues in quantum mechanics are given center stage by Pagels, these issues are often not covered with sufficient care. (Students often found such errors on their own. This fact is not insignificant: while students are generally hesitant to pit their understanding against that of an authority figure, the prospect is usually more frightening when it comes to science.)

28. Of course, this goal need not, and should not, preclude other desirable functions of laboratory exercises, such as the opportunity to make classroom concepts "real" in a laboratory setting; have students get their hands "dirty"; and teach measurement techniques, the proper use of instrumentation, error analysis, and so on.

29. Many science instructors face restrictions of space, support, time, and other resources, which means that the development of a new laboratory can take many years. As a result of different constraints, the initial offering of the lab component of the course fell well short of my goal. Rather than describe exercises from the initial offering, I describe a few aspects of the lab as I would like to develop it given sufficient support. (My budget for the course was $300. Labs were mostly put together from whatever equipment I could scavenge around the department. I shared laboratory space with the introductory physics course, which meant that labs had to be set up and taken down each time. I did receive some support for course development from the Irvine Foundation but this did not include laboratory equipment.)

30. For example, rather than investigating the motion of an object sliding down an inclined plane using air tracks, digital spark timers, and other contemporary equipment that tries to maximize the accuracy of the measurement, students use metal balls, molding, "water clocks," and other instruments that Galileo used in his original investigation of this motion. See n. 24, above. NB: The traditional history of physics approach assumes that the same phenomena are simply being investigated differently over time; it doesn't acknowledge the changing and emergent nature of phenomena. This limitation can be overcome with the time series variation approach.

31. In the Whiggish presentation of key moments in the history of science found all too commonly in physics courses, Thomas Young's two-slit experiment (demonstrating his "principle of interference") is represented as the definitive empirical moment in the triumph of the wave theory of light over Newton's corpuscular theory. Despite the prevalence of this contemporary account of the two-slit experiment, Young strategically

distanced himself from any explicit advocacy of a wave theory of light. Being sensitive to the authority that Newton still held over the scientific community in the century following the publication of *Opticks*, Young remained purposefully agnostic on the nature of light, and presented his law of interference as an empirical law before the Royal Society on July 1, 1802. The two-slit experiment (which can arguably be considered to be the simplest demonstration of the interference of light) is not even mentioned in the paper, but rather is described in his *Lectures* of 1807. Although historians of science disagree as to the cause of the immediate negative reception that Young's ideas on interference received, his account was not accepted before 1816 (Kipnis 1991, 86–89, 119, 138–64). Ironically, historians of science claim that Young either never performed the two-slit experiment (Worrall 1976) or that he used slits that were too far apart and actually concentrated his observations on diffraction fringes from a single slit rather than the interference fringes produced by the effect of both slits (Kipnis 1991).

32. See Buchwald 1989.

33. The enfolding of phenomena into apparatuses over time is a function of the fact that apparatuses themselves are phenomena (see Barad 1998b, forthcoming). For example, as new phenomena become accepted over time they often become part of the apparatus in practices that go on to explore other phenomena.

34. My use of "philosophy-physics" is in deference to Bohr, who did not see these views as separable. However, the disciplining of knowledge being what it is, it is sometimes useful to separate his views on quantum mechanics from his general epistemological framework (and scholars have taken great pains to do so): the latter being of interest in its own right for its interesting philosophical view of science, and the former all too often being conflated with the so-called Copenhagen interpretation of quantum mechanics, which is more accurately understood as a linear superposition of the views of Bohr (complementarity), Heisenberg (uncertainty), Born (probability), and von Neumann (collapse), to name a few of the key players. The physicists who are seen as the contributors of this "interpretation" had strong philosophical/interpretative differences, and so while physicists talk of *the* Copenhagen interpretation, in a sense there are really many Copenhagen interpretations, or to put it another way, this particular combination of views does not constitute a well-defined viewpoint. Some would argue that a complete and coherent Copenhagen interpretation does not exist (despite the fact that the overwhelming majority of physicists subscribe to "it" and teach "it" to their students).

35. Recall that according to agential realism, agency is a matter of intra-acting; it is an enactment, not something someone or something has. Recall, also, that intra-actions entail a nondeterministic causality.

36. In *Modest_Witness*, Haraway (1997) suggests that "diffraction, the production of difference patterns, might be a more useful metaphor for the needed work than reflexivity" (34). "Reflexivity has been recommended as a critical practice, but my suspicion is that reflexivity, like reflection, only displaces the same elsewhere, setting up worries about copy and original and the search for the authentic and really real. Reflexivity is a

bad trope for escaping the false choice between realism and relativism" (16). Barad 1997 offers the beginnings of an elaboration of diffractive analysis.

37. "A bubble chamber of the 1950s came with an industrial and military notion of how to partition teamwork in the laboratory" (Galison 1997, xviii).

38. At the beginning of the course, 13 students identified themselves as science or science-related majors (including biology, biological anthropology, chemistry, math, pre-med, psychology, and science, technology and society majors); nonscience majors included history, women's studies, modern languages, education, international relations, art history, philosophy, sociology, literature, organizational studies, Russian, prelaw, politics, economics, and American studies; many first year students were undecided. Of the 33 students who enrolled (one person dropped late in the semester due to illness); 12 were first-year students, 5 were sophomores, 8 were juniors, and 8 were seniors. Twenty of the students were female, 13 were male. Over a quarter of the students self-identified as nonwhite.

39. Students evaluations are not turned over to the professor until after the grades are submitted. Students had the option of identifying themselves. The vast majority of students handed in evaluation forms. (The few students who didn't return the form were graduating seniors, which is not at all unusual with spring courses; graduating seniors have other things on their minds at that time of year.) Of the students who turned in the evaluation forms, all but two said that they would take a sequel to this course if it were offered, and all but one said they would recommend this course to other students. A third of the students stated that it was one of the best courses they had taken in college.

Works Cited

Barad, Karen. Forthcoming(a). *Cultural Studies of Twentieth Century Physics.* Book manuscript.

———. Forthcoming(b). *Meeting the Universe Halfway.* Book manuscript.

———. 2000. "Feminist Dislocations and Reconfigurations of Space, Time, and Matter at the End of the Twentieth-Century." In *Feminist Locations: Global/Local/Theory/Practice,* edited by Marianne DeKoven. New Brunswick, N.J.: Rutgers University Press.

———. 1998a. "Agential Realism: Feminist Interventions in Understanding Scientific Practices." In *The Science Studies Reader,* edited by Mario Biagioli. New York: Routledge.

———. 1998b. "Getting Real: Technoscientific Practices and the Materialization of Reality". In *differences: A Journal of Feminist Cultural Studies,* 10, no. 2 (summer).

———. 1997. "Towards a Diffractive Reading of Diffraction: On Donna Haraway's *Modest_Witness.*" Paper presented at The Society for the Social Studies annual conference, Tucson, October 24.

———. 1996. "Meeting the Universe Halfway: Realism and Social Constructivism Without Contradiction." In *Feminism, Science, and the Philosophy of Science,* edited by Lynn Hankinson Nelson and Jack Nelson, 161–94. Dordrecht, Netherlands: Kluwer.

———. 1995. "A Feminist Approach to Teaching Quantum Physics." In *Teaching the Majority: Breaking the Gender Barrier in Science, Mathematics, and Engineering,* edited by Sue V. Rosser, 42–75. New York: Teachers College Press.

Bohr, Niels. 1963a. *The Philosophical Writings of Niels Bohr.* Vol. 1: *Atomic Theory and the Description of Nature.* Woodbridge, Conn.: Ox Bow Press.

———. 1963b. *The Philosophical Writings of Niels Bohr,* Vol. 2: *Essays, 1932–1957, on Atomic Physics and Human Knowledge.* Woodbridge, Conn.: Ox Bow Press.

———. 1963c. *The Philosophical Writings of Niels Bohr,* Vol. 3: *Essays, 1958–1962, on Atomic Physics and Human Knowledge.* Woodbridge, Conn.: Ox Bow Press.

Buchwald, Jed. 1989. *The Rise of the Wave Theory of Optics: Optical Theory and Experiment in the Early Nineteenth Century.* Chicago: University of Chicago Press.

Daston, Lorraine. 1992. "Objectivity and the Escape from Perspective." In *Social Studies of Science* 22:597–618.

Davis, James B. 1951. "For the Ladies, Kitchen Physics." In *Science Teacher* 18 (October).

Fernandes, Leela. 1997. *Producing Workers: The Politics of Gender, Class, and Culture in the Calcutta Jute Mills.* Philadelphia: University of Pennsylvania Press.

Folse, Henry. 1985. *The Philosophy of Niels Bohr: The Framework of Complementarity.* New York: North Holland Physics Publishing.

Foucault, Michel. 1977. *Discipline and Punish: The Birth of the Prison.* Translated by Alan Sheridan. New York: Vintage Books.

Galison, Peter. 1997. *Image and Logic: A Material Culture of Microphysics.* Chicago: University of Chicago Press.

Haraway, Donna. 1997. *Modest_Witness@Second_Millennium.FemaleMan©_Meets_OncoMouse™ : Feminism and Technoscience.* New York: Routledge.

Harding, Sandra. 1991. *Whose Science? Whose Knowledge? Thinking from Women's Lives.* Ithaca, N.Y.: Cornell University Press.

Heldke, Lisa. Forthcoming. "Responsible Agents: Connections between Objectivity as Responsibility and Agential Realism." In *enGendering Rationalities,* edited by Sandi Morgan and Nancy Tuana.

———. 1998. "Responsible Agents: Objectivity as Responsibility and Agential Realism." Paper presented at the 20th World Congress of Philosophy, Boston, August 13.

Hennessy, Rosemary. 1993. *Materialist Feminism and the Politics of Discourse.* New York: Routledge.

Irwin, Alan, and Brian Wynne, eds. 1996. *Misunderstanding Science?* New York: Cambridge University Press.

Kevles, Daniel J. 1971. *The Physicists: The History of a Scientific Community in Modern America.* Cambridge, Mass.: Harvard University Press.

Kipnis, Nahum. 1991. *History of the Principle of Interference of Light.* Boston: Birkhäuser Verlag.

Longino, Helen. 1990. *Science as Social Knowledge: Values and Objectivity in Scientific Inquiry.* Princeton, N.J.: Princeton University Press.

Montgomery, Scott L. 1994. *Minds for the Making: The Role of Science in American Education, 1750–1990.* New York: Guilford Press.

Noble, David. 1998. "Digital Diploma Mills: The Automation of Higher Education." In *Monthly Review* 49, no. 9 (February):38–52.

———. "Wag the Dog: Will Private Companies Reshape Higher Education in Their Image?" Manuscript.

———. "The Bloom is off the Rose." Manuscript.

Pagels, Heinz. 1982. *The Cosmic Code: Quantum Physics as the Language of Nature.* New York: Bantam Books.

Pais, Abraham. 1991. *Niels Bohr's Times In Physics, Philosophy, and Polity.* Oxford: Clarendon Press.

Petersen, Aage. 1985. "The Philosophy of Niels Bohr." In *Niels Bohr: A Centenary Volume,* edited by A. P. French and P. J. Kennedy. Cambridge, Mass.: Harvard University Press.

Rouse, Joseph. 1999. "Feminism and the Two Poles of Naturalism." Paper presented at Feminism and Naturalism Conference, St. Louis, September, 25.

———. 1996a. *Engaging Science: How to Understand Its Practices Philosophically.* Ithaca, N.Y.: Cornell University Press.

———. 1996b. "Feminism and the Social Construction of Scientific Knowledge." In *Feminism, Science, and the Philosophy of Science,* edited by Lynn Hankinson Nelson and Jack Nelson, 195–215. Dordrecht, Netherlands: Kluwer.

———. 1987. *Knowledge and Power: Toward a Political Philosophy of Science.* Ithaca, N.Y.: Cornell University Press.

Ruchlis, Hyman. 1953. "New Approaches Needed in Physics." *Science Teacher* 20 (February).

Rutherford, James F., and Andrew Ahlgren. 1990. *Science for All Americans.* New York: Oxford University Press.

Shamos, Morris H. 1995. *The Myth of Scientific Literacy.* New Brunswick, N.J.: Rutgers University Press.

Traweek, Sharon. 1998. *Beamtimes and Lifetimes: The World of High Energy Physicists.* Cambridge, Mass.: Harvard University Press.

Worrall, John. 1976. "Thomas Young and the 'Refutation' of Newtonian Optics: A Case-study in the Interaction of Philosophy of Science and History of Science." In *Method and Appraisal in Physical Sciences,* edited by C. Howson. Cambridge: Cambridge University Press.

Engineering Cultural Studies
The Postdisciplinary Adventures of Mindplayers,
Fools, and Others

Anne Balsamo

This article discusses the construction of an educational program in the cultural studies of science and technology. In the hopes of stimulating a discussion of what remains, for the most part, a local saga of curriculum construction and faculty maneuvering, I weave together two narratives—one institutional and the other fictional. The first describes the institutional context of the program in science, technology, and culture offered in the School of Literature, Communication and Culture at the Georgia Institute of Technology; the second poaches on the work of cyberpunk science fiction author Pat Cadigan, as her novels offer a set of fictional tropes for describing the identity labor of cultural studies scholars who work in unconventional academic settings. In offering this admittedly partial account of the "settling" of a particular institutional landscape, I hope to suggest some of the issues and questions that must be negotiated by postdisciplinary scholars as they seek new institutional spaces to build programs in cultural studies of science, technology, and medicine.

We're All Mindplayers of One Sort or Another

Cadigan's novel *Mindplayers* (1987) offers several pulp fiction episodes about a character who is drafted into psychological service as a "pathos-finder." Cadigan's

cosmos is populated by several different kinds of mindplayers—those known as pathos-finders are trained to massage the psyche of clients by directly interfacing mind to mind; mind access is accomplished by popping out the client's eyes and making a connection directly with the optic nerve—the channel to the brain. Other mindplayers do other types of mental labor: "dreamfeeders" serve up images and fables; "fetishizers" specialize in fantasy trips, and are cheaper to hire than "neurosis peddlers." "Mind criminals" are the those who get caught fencing stolen memories. The "brain police" stalk mind criminals to avenge memory crimes. The economy of this Cadigan world is based on the "information standard": memory, experience, and knowledge are the currency of choice. Bodies don't have much stock in this "Age of Fast Information"—eyes that wear out from being popped in and out too many times are easily replaced with designer biogems: cat's eyes, tiger eyes, spiderwebs. In this version of the future, the body is a costume and every identity is a performance.

Whereas the novel *Mindplayers* is structured like a conventional science fiction narrative, *Fools*, published in 1992 moves into the realm of the hypertextual postmodern. Fractured story lines testify to the fractured subjectivity of the central character—Marva/Marceline—who, at the beginning of the novel, wakes up in a holographic club, thinking she's a method actress whose personality has just been franchised. Layers of identity make Marva/Marceline a schizoid mess. Her subjectivities change like rapidly switching television channels; first she's a "Famous," then a memory junkie, another time an escort hired to get rid of a troublesome personality. Subject positions switch every few paragraphs, and as in the conventional plots of video games such as *Déjà vu* and *Flashback*, the narrative goal is to assemble the main character's story piece by piece. Wading through the fragments of identity leakage, the reader eventually learns that Marva/Marceline is, at her truest, one of the brain police in deep undercover looking for a lead on a bootlegging mindsucking operation. Cadigan develops the notion of "character imprinting" that suggestively describes the practice of identity-switching between related, but often contradictory, subject positions.

To teach in the School of Literature, Communication and Culture (LCC) at Georgia Tech requires the construction of several identities that faculty wear, like Cadigan's character imprints. The "humanist imprint" has a long tradition in LCC. In 1990 the School of Literature, Communication and Culture was formed out of the faculty and curriculum that belonged to the former Department of English.[1] This transformation was part of an institute-wide restructuring that focused on the creation of several interdisciplinary units in the sciences, social sciences and engineering. So although the school is structured

as an interdisciplinary unit, as the former English Department it continues to provide the required undergraduate courses in composition and technical communication, as well as delivering virtually all of the required courses in the humanities. Because most of LCC's courses continue to carry "humanities" credit, there is a guaranteed stream of students from all over the institute, so that the forty LCC faculty teach more than 11,000 students a year. Although it is not an English department in name or form, LCC continues to occupy a similar institutional position.

This *institutional* position often requires that LCC faculty maintain what looks from the outside like an uncritical and unwavering stance on the enduring value of the traditional humanities. The issue at stake in this particular institutional arrangement is that if LCC faculty are seen to waver in their commitment to the humanities, colleagues in other departments — especially the engineering schools — would welcome the opportunity to reduce the humanities requirement or do away with it altogether. There is not always malice in this opposition. The engineering faculty are also subjected to institutional pressure, not so much to defend or justify their curriculum — Georgia Tech has always defined its primary identity as an engineering institute — but rather to expand the engineering curriculum to accommodate new areas of technical knowledge, which would necessitate expanding the number of required engineering courses in various majors. Given that the institute continues to mandate that undergraduate students be able to graduate in four years, every credit hour required of students becomes a site for contestation.

The struggle over required course hours is only one site among many that compel LCC faculty to take on an identity often at odds with their own theoretical commitments. When LCC faculty find themselves cast as the "humanists" on various institute committees, they compulsively reenact a variation of the "Culture Wars" — where, this time around, they are the ones arguing for the enduring pedagogical value of literature, ethics, and the grand tradition. Taking on this identity causes consternation for some faculty, who — in other contexts and speaking from different subject positions — have publicly criticized the political and philosophical limitations of a traditional humanities curriculum based on a canon of great books and great ideas. Although not all LCC faculty members adopt this critical stance to the traditional humanities, there are a number of those who question the ideological "work" of such a curriculum, and our role in it. Such an "antihumanist" imprint is only one of several in circulation in LCC.

In the course of the past decade, the perspectives that previously defined the dominant frameworks of the Department of English have been refashioned

into what may be called a "new humanist" position that works very effectively within the Georgia Tech climate. This imprint rests on the belief that "high culture" and "high science" are the proper subject matter for LCC's new undergraduate humanities curriculum. In that this "imprint" draws on a strong rhetorical tradition, it resonates strongly with the other tradition-bound educational programs at Georgia Tech—even those that remain somewhat skeptical of the value of humanities education for engineering students. In fact, the "new humanist" imprint is created in part through the reactions of colleagues in other areas of the institute, who are often deeply invested in the concept of "high literature" as the basis for a humanities program. Thus it is the case that both to the skeptics and the supporters, the "proper" imprint for LCC faculty is some variation of "humanist." But I wonder how this imprint is actually read by colleagues in other departments. To invoke Cadigan's cosmology, this imprint allows LCC faculty to assume the rather traditional humanistic role of the institute's "brain police"—on the look out for "mind criminals" who would erase cultural memories, intellectual traditions, and other humanistic concerns pertaining to the ethics and politics of technological and scientific practice; and certainly faculty have reported experiences along these lines. But I also know that from the other side of the campus, metaphorically speaking, it sometimes looks quite different, as if LCC faculty function as "neuroses peddlers," or worse, "dreamfeeders," who merely serve up fables and symbols instead of substantial intellectual stimulation. Caught between two suspicious imprints, I comfort myself with the assertion that at least neuroses *are* intellectually interesting. What emerges is a host of contradictions between the various "humanist" imprints that mark LCC faculty.

A Postdisciplinary Curriculum in Science, Technology, and Culture

Switching between the humanist and the antihumanist imprints—the "brain police" and "neurosis peddler"—-has actually provoked interesting educational and pedagogical experimentation. Faculty work to invent ways to teach literary texts, historical periods, and expressive genres (the traditional concerns of a proper humanist) in a way that is meaningful both to colleagues and students from technological and scientific fields, who are often deeply invested in the concept of "high literature," and to colleagues and students trained in critical approaches and cultural studies. The object is to find a way not to jettison the humanities but rather to situate LCC's humanities courses within an interdisciplinary framework that would provide a rationale for the redesign of

the humanities curriculum in the context of scientific and technological culture. The faculty in LCC have addressed this objective by redesigning the curriculum based on a framework informed both by cultural studies and by critical work in science and technology studies (STS).

One of the consequences of the reconfiguration of the "department" into a "school" has been that the faculty were invited not only to develop a new interdisciplinary humanities curriculum but also to construct a new undergraduate program that would be the first humanities-based major ever offered in the 110-year history of Georgia Tech. By 1999 most of the courses students take belong within the school's recently revised curriculum in science, technology, and culture. First offered in 1991, the undergraduate major in science, technology, and culture (STAC) merged the interests and perspectives of recent literary theory and cultural studies with the topics and issues central to the emergent field of technoscience studies. The STAC major then provided the framework for a wholesale curriculum revision during the year 1997–98.[2] The result is that the LCC faculty designed a curriculum that reflects the increasing interest in humanistic studies of science and technology and draws on a mix of disciplinary influences.

The undergraduate courses that make up the STAC curriculum bridge the traditional disciplines in several ways: (1) in terms of interpretive frameworks and analytical perspectives that inform the design of the course; (2) in terms of course topics and pedagogical methods; and (3) in terms of the type of educational objectives constructed for each course and methods of assessment used to evaluate student learning outcomes. One of the goals of this mutant curriculum is to identify a coherent set of courses in the cultural studies of science and technology. In my own courses, I translate the goals of the curriculum into the following course-specific objectives: To provide students an opportunity to acquire (1) a basic understanding about the social production of scientific knowledge; (2) an appreciation for the cultural consequences of the deployment of technological expertise; (3) an understanding of the role of science and technology in everyday life; and (4) experience in applying analytical frameworks for the assessment of the cultural impact of science and technology throughout history and across contemporary global cultures.

In redesigning the STAC curriculum, the LCC faculty in fact had to negotiate a similar disciplinary divide that marked the emergence of cultural studies in the 1960s, namely the divide between literature and society, or between literary studies and sociology. These disciplinary influences were evident in the structure of courses first proposed for the STAC curriculum in 1991; one set, the *historical period* courses, showed the influence of traditional classificatory logic

of literary history courses, while a second set, the *issues courses*, addressed more sociological topics such as science, technology, and gender and science, technology, and ideology.

But just as cultural studies itself has come to engage a more complex disciplinary terrain, so too has the STAC curriculum. Trained in such fields as communication, anthropology, STS, American studies, comparative literature, women's studies, film, drama, and performance studies, as well as the field of literary studies, the forty faculty in LCC now represent a wide range of disciplinary perspectives. And just as Cadigan leaves the reader questioning how Marva/Marceline, a professional mindplayer, can have a "true identity," so must LCC faculty suspend the search for a true or singular disciplinary identity as members of this academic unit.

Even with its history as a former English department, the current mix of disciplinary backgrounds of LCC faculty means that there are multiple disciplinary sensibilities in circulation among characters on the faculty. Some faculty members have come to appreciate that the project of interdisciplinarity is not one of building tolerance for marginal perspectives; in one sense, all perspectives represented in the school are marginal in numbers and in terms of disciplinary identity. Rather, the project of interdisciplinarity for LCC involves inventing a coherent new identity for the field of dispersion represented by faculty interests and course topics. The problems that vexed me as a faculty member in this interdisciplinary school were provoked not by encounters with reified disciplinary boundaries, but rather by the lack of them. In most cases, the faculty's adventures in postdisciplinarity raised rather mundane issues— for example, what professional associations faculty should participate in, where LCC's benchmark programs are, and the perennial debate about whether the school's hiring schedule should remain tied to the Modern Language Association's conference schedule.

But at other times this encounter with postdisciplinarity provoked more substantial concerns. The mix of disciplinary perspectives enables different practices of research, of writing, of pedagogy, and of service. And, as we know, different practices demand different forms of assessment and evaluation. Increasingly there is recognition of the need to develop new guidelines on how to evaluate diverse forms of knowledge production. Moreover, LCC's curriculum (at both the undergraduate and graduate levels) now includes courses in new media studies, digital media production, and performance studies. Faculty who teach these courses produce research and professional work that encompass a variety of media forms:, digital video, multimedia applications, web-based pedagogical applications, performances, and curated video exhibitions

as well as more traditional online and print-based articles and books. The central question that emerges for those engaged in such research projects, especially among untenured faculty, concerns the methods of assessment, or the lack of them, that will be used to evaluate such research efforts during the tenure or posttenure review process. While it is clear that this issue will have to be addressed by both internal and external faculty promotion and tenure committees, it is unclear what disciplinary conventions could be used to construct such assessment methods when the research practices of the faculty *within* a given school vary one from another.

The issue of assessment also raises questions about student performance and the educational objectives that guide pedagogical practice. Students too are increasingly producing work in new media forms—as online documents, electronic discussion contributions, and video pieces. Even though several of the faculty who teach new media production courses are active participants in the recent discussions going on in the field of computers and writing about topics relating to the evaluation practices of nontraditional student coursework, they are not necessarily in a position to guide the administration's efforts to evaluate their own work as it too crosses disciplinary boundaries and conventional research forms.

In this sense, some LCC faculty wear another Cadigan imprint—a "synner," a human synthesizer whom she describes as a "hot-wired socket-jockey hooked on artificial reality and virtual spaces." In an odd way, this character imprint provides a strong sense of stability for LCC faculty in a rapidly changing landscape. Whether it means teaching students how to synthesize material from various technological sources, or teaching them how to synthesize information across disciplinary boundaries for the purpose of constructing new forms of knowledge, many LCC faculty could claim to be highly "original synners."

The curriculum for the M.S. program in information, design, and technology (IDT) most completely embraces a "synner" logic. This curriculum requires that students gain production skills in digital video, screen-based graphic design, and hypertext theory. They also take a number of seminars in the history of new media and cultural theory. The multimedia applications they create for their final projects must be informed by the historical and cultural theory they read in their seminars. By combining theoretical seminars with production courses, the IDT program aims to produce "synners" who can adapt new forms of electronic media to changing social, cultural, and economic contexts. For example, IDT students I worked with were required to include in the analysis of their final "digital projects" an assessment of the theoretical issues that inform and constrain their electronic and digital work.

The relevant theoretical framework may come from cultural theory, cognitive theory, or rhetorical theory, but the guiding objective is that students articulate the humanistic motivations for their digital productions.

The work of a department full of Original Synners is not easygoing. The lack of a stable, unchanging identity makes it difficult to represent the intellectual and educational coherence of the school to a broader Georgia Tech audience and sometimes even to the students themselves. In one sense, the difficulties stem from the fact that LCC's educational programs do not reproduce (in the students) the identity of the faculty who teach them. This is one of the most significant consequences of the postdisciplinary curriculum: to teach in LCC is to admit from the outset the impossibility of the perfect reproduction of students in our own (disciplinary) image. Although this nonreproductive educational process would be unthinkable in many academic contexts, it makes a great deal of sense for LCC as it is situated within the Georgia Tech environment, even as it creates new anxieties. Among the more mundane anxieties are those that emerge in discussions about students' job prospects and graduate program choices. More significant is the way in which faculty trained in the humanities learn to negotiate the Georgia Tech hierarchy of disciplines—where the economy of the institute values the technological programs and preprofessional programs over the humanities and social sciences. Instead of enjoying a position closer to the central mission of the university—as humanities departments do in traditional liberal arts or research universities—the humanities and social science units at Georgia Tech struggle (sometimes, but luckily not often, against one another) for resources and institutional authority. In that humanities departments in traditional university settings have been hit hard by recent financial cutbacks, especially at public, state-supported institutions, LCC is not unique in having to live with decreasing resources for humanities education. But because Georgia Tech is so saturated with science and engineering programs that continue to demand a significant level of budgetary support, the relative lack of resources for the humanities at Georgia Tech is all the more pronounced.

Most would probably agree that opportunities presented to develop innovative education programs far outweigh the anxieties provoked. Typically, the students who enroll in Georgia Tech come with a keen interest in its technological programs. This means that the student population available to take LCC courses and to major in the STAC program have strong interests in technological education. (Although there are now students enrolling in the STAC program as freshmen, the majority of the students who end up as STAC majors are transfer students from other majors across campus.) What the LCC

curriculum contributes to the general education of Georgia Tech students is critical study of the cultural and social implications of the technological practices and professions that they will go on to pursue.

Engineering Cultural Studies

During the most recent revision of the LCC curriculum it became clear that the faculty were embroiled in a full-blown identity crisis prompted by the school's development into a mature postdisciplinary educational unit. A seemingly simple question such as, Should the courses be organized historically or topically? engendered a lengthy debate about appropriate discipline-based curricular models. More specifically, while many faculty have come to identify their area of research interest as cultural studies, it is not clear that such a designation actually identifies a common intellectual framework or even a set of agreed-upon educational objectives. While there is certainly a discernible cultural studies influence built into the LCC curriculum, LCC courses do not offer a cultural studies curriculum. This may be a cause for disappointment for someone trained in a particular tradition of cultural studies, but it is, from another perspective, one of the best ways to ensure the continuing influence of cultural studies—especially now that ethnic and minority studies programs are coming increasingly under attack, as a climate of backlash and retrenchment takes root in institutions of higher education across the United States. While some argued for an organizational rationale for the curriculum that would have recognized the key areas of cultural studies work in subculture studies, audience studies, and ethnographic studies, what was finally negotiated was a hybrid curriculum that shows the influence of cultural studies as it is applied to questions of science, technology, and culture. Thus, the curriculum that emerged in LCC—as a process of lengthy faculty discussion and negotiation—is an example of an *engineered* cultural studies curriculum, articulated within a particular institutional context.

What could not be mandated for the entire curriculum was a particular set of critical frameworks: that is, antiracist, feminist, Marxist, or postcolonialist. Nor could the faculty as a whole agree to completely abandon a literary studies sensibility that suggested courses constructed according to a particular logic of periodization and a list of traditional genres. The influence of cultural studies can best be seen in the incorporation of several media studies courses, courses on communication and culture, and courses that address issues pertaining to ideology, gender, race, postcolonialism, and environmentalism. The influence

of cultural studies also can be seen in other courses; the historical courses, in particular, have been significantly redesigned during the past five years based on new work in cultural history as well as in cultural theory. When the STAC major was first approved in 1991, the period courses drew on a sense of history influenced both by literary studies and by the history of science. Typical courses then had titles like "Writers in the Age of . . . Ptolemy," "Writers in the Age of Galileo"—or of Newton, of Darwin, or of Freud/Einstein. More recently, these courses have been recast to conform to a different taxonomy of cultural history. In the 1999 curriculum they have titles such as "The Age of Discovery," "The Age of Scientific Revolution," "Science, Technology, and the Enlightenment," and "Evolution and the Industrial Age." Among the reasons for this change was a desire to get rid of the authoritative white (scientific) man as the defining figure of an era. Renaming and redesigning the courses was meant to shift the focus from individual agents to social and cultural networks that have given rise to developments in scientific and technological knowledge and practices.[3]

An equally important contribution of this curriculum is that it also revises the horizon of cultural studies. Cultural studies scholars and critics need to take seriously the challenge and responsibility for transforming the educational system wherein new scientists, technologists, and global citizens are educated. Although not many institutions will present similar opportunities for wholesale curriculum revision, it is possible to think of several ways to engineer a place for cultural studies in the interfaces between disciplines. In fact, in the United States, one of the significant ways in which cultural studies has grown and developed is through new alliances with scientific and technological partners—in technical writing programs, medical humanities programs, and scientific ethics and technological policy courses. These alliances represent interesting institutional opportunities for cultural studies scholars and teachers. Forging these new alliances—with technologists, scientists, and medical educators—offers the possibility of staking a claim on a territory that has been previously off-limits to the nonscientist cultural theorist. As with other political struggles, the project of alliance building is not without its risks and dangers.

As cultural studies scholars actively seek to contribute to debates about the structure of scientific and technological education, they find themselves in the position of having to navigate a highly charged and contested zone of cultural authority. These debates have garnered a fair share of media attention under the banner of the "science wars" and have in the past several years included a number of well-publicized skirmishes between scientists and cultural critics. At issue are questions of authority and intellectual territory, not only in the

academy but also in the classroom.[4] While some scientists contest the right of cultural scholars to critique the practices of technoscience on the basis of a (putative collective and individual) lack of scientific training and professional socialization, cultural critics counter that science, technology, and medicine represent the central institutionalized sites of cultural and intellectual work in contemporary culture. As such, these technoscientific institutions and practices implicate all of us in global arrangements that we have a right, and in fact a duty, to debate, contest, modify, and perhaps even transform. These institutions and practices are therefore important areas of investigation—even for the supposedly untrained critic. Although scientific training and the related professional socialization clearly bestow upon science "producers" a range of intellectual privileges—including the privilege of speaking the discourse of truth—the lack of such training and socialization does not insulate anyone from the consequences of the deployment of scientific authority or technological rationality, nor does it disqualify a critic or a teacher from understanding the intricacies of the social matrix within which technoscientific knowledge is produced and disseminated. In fact, one could argue, in the anthropological tradition, that the "outsider" status of the cultural critic engenders an incisive (albeit perspectival) insight on the actions under consideration. While the debates are still ongoing among participants in the science wars, these skirmishes represent a significant chapter in the history of cultural studies in that they testify to the increasing influence of cultural studies within the U.S. academy now not only in the traditional humanities but also in the sciences and other professional fields.

The Hazards of Being Multiple

Although Georgia Tech has been an engineering institute from its inception, it is by now an elaborate network of research centers, laboratories, and technoscience classrooms. Significant areas of funded research include manufacturing processes, materials engineering, and bioengineering. Less well funded but uniformly well regarded are several programs in computer science and microelectronics. Insofar as LCC faculty have access to the students, the colleagues, and the research monographs that issue forth from these programs, the entire institute serves as a laboratory for those trained in the critical studies of science and technology, wherein we are offered the opportunity to study the production, circulation, and eventual marketing of technoscientific discourse. Some of us also appreciate our position in this institutional matrix as offering

the opportunity to intervene in the reproduction of the social relations of science and technology. The labor involved in this form of educational service is much more complex than the process of curriculum construction. As I've described above, it also requires skill in the fashioning of new identities and the ability to *tactically* maneuver between them. As Cadigan's main character, Marva/Marceline, complains, "the hazards of being multiple sometimes overwhelm even the most rigorous brain police training" (93).

Several LCC faculty are engaged in new research projects informed by critical approaches to technoscience; while some situate their work in the social constructivist approach of Bruno Latour, Steve Woolgar, and the Edinburgh school, others base their scholarship in the feminist critiques offered by Donna Haraway and Sandra Harding and others. Sidestepping the differences between these perspectives as a topic for another paper, what is shared is a *critical* approach to the analysis of practices of technoscience research and the deployment of technoscientific knowledge. When they wear the "technoscience critic" character imprint, LCC faculty are contradictorily identified as scholars with a particular "academic" expertise and as marked by their "difference" from the students who enroll in LCC classes, who more often than not know the ins and outs of the technoscience scene better than most faculty. Thus LCC faculty are simultaneously experts and nonexperts. We may write articles and books, and some of us may even have a modicum of institutional authority, but students know that we do not produce "science." Although many engineering students are curiously skeptical about the nature of science, it still holds a more valued position on their "mattering maps" than do the humanities. Engineering students often hold the belief that the practice of laboratory science provides scientists the luxury of living in an unreal world of theoretical abstraction; in contrast, their understanding of the nature of their technical, professional world is that it is governed by concerns for practicality and real-world unpredictability that force them to confront the harsh limitations imposed by the "real world." Science for them is a set of theoretical guidelines; the highest authority for them is the objective, material world that serves as the final judge of the usefulness and applicability of abstract theory of whatever flavor, humanist or scientific. In this sense, several vectors of difference actually must be negotiated among faculty and students: the difference between humanist and scientist, the difference between scientist and engineer, and the difference between technoscience critic and technoscience advocate.

As happens every quarter, with each new class, faculty must seek creative ways to engage the ontological and technological conservatism that runs quite deep in some students. Supported by their education virtually everywhere else

in the institute, this belief system is structured by three axioms: (1) that objective reality is beyond question; (2) that more technology is always the answer; and (3) that the logic of the marketplace provides the infrastructure of technological rationality. These students challenge LCC faculty to develop pedagogical methods for presenting alternative understandings of the role of science and technology in contemporary culture—and to do so in a way that avoids reinforcing students' preconceptions about technoscience critics: that we are, at worst, neo-Luddites who reject technology outright and dismiss the significance of applied theory, or at least hopelessly naive "academics" out of touch with the objective reality of the real world. Thus faculty have to constantly switch among often contradictory identities: the humanist and the antihumanist, the technoscience critic and the technoscience advocate, the scholar-teacher and the research fund-raiser. And just as is the case for Cadigan's characters, it is easy to become disoriented by the practice of constant imprint switching.

Feminist teachers in particular juggle several identities as technoscience critics. When Paul Gross and Norman Levitt took on the project of "debunking" the academic left's critique of the natural sciences, several prominent feminist scholars were singled out as unduly influential in provoking the left's hostility to science. Donna Haraway's famous last line ("I'd rather be a cyborg than a goddess.") notwithstanding, Gross and Levitt lumped feminists together as issuing an "ecofeminist harangue from the Goddess-worshipping camp."[6] From the other side of the political divide, feminists who teach technoscience studies have been accused by other feminists of doing women a disservice by contributing to their disillusionment with science and turning them away from careers in scientific and technological fields. Treated as stigmatized advocates of either an aggressive hostility or an ecological utopianism, feminists who teach technoscience studies often find themselves dancing between impossible identity imprints.

As a feminist scholar, I certainly don't want to abandon the epistemological critique of the construction of scientific knowledge as patriarchal knowledge. Nor do I want to give up on the pursuit of social justice through scientific and technological means. This becomes another occasion for the practice of identity-switching—this time not simply between the humanist and the critic, but between the teacher and the advocate. Whereas the teacher demands that students engage the philosophical critique of an epistemological worldview and construct their own assessment of the value-laden nature of a particular scientific worldview, the advocate continues to guide them toward careers in science and technology and encourage them to find a way to make a difference. To this end, the purpose of my course "Science, Technology, and Gender" was

never to turn women away from science by detailing the many ways women have been ill-treated (although I do spend considerable class time on this history), but rather to illuminate for them the process whereby technoscience accrues cultural authority so that they may be better equipped to recognize abuses of this authority and to intervene in its social reproduction through their professional practice and throughout their careers.[7]

Anxious Technophiles

Pedagogically LCC's location in a technological institute provides both an incredible opportunity and a dangerous minefield. One term to describe the collective sensibility of LCC faculty is "anxious technophiles"—a label that comes from Michael Benamou, director of the Center for Twentieth-Century Studies at the University of Wisconsin, Milwaukee, in the 1970s and a scholar who had been working on the cultural studies of science and technology since the mid-1960s. In Benamou's terms, "anxious technophiles" appreciate the acute contradictions in technoscientific culture but keep their faith in the possibility of democratic control over technology. Their moral, according to Benamou, is Don't leave science and technology to the technocrats. To this I would add: Don't leave the education of technocrats to the academic professionals in science and technology. This translates into two pedagogical commitments that I held as a faculty member within LCC: the first, a belief that teaching technologically oriented students provides a unique opportunity to have an impact on future generations of technological leaders; the second, a belief in the possibility of incomplete determination—in short, in the possibility of subversion. Forces of determination, whether they be technological, institutional, economic, or ideological are not always perfectly replicated. As a participant in the education of technologically trained students, I often consciously sought ways to reproduce imperfect subjects and agents of technocratic rationality. In so doing, I was less like a member of Cadigan's *brain police* and more like one of her *fools,* who in making use of the tools of science and technology knowingly works to produce monstrous mutations of subjects, agents, and forms of consciousness. From my perspective, the significant implication of the STAC program (whether fully articulated by all LCC faculty or not) has been to contribute to the development of a model curriculum in "scientific and technological literacy." As one centrally involved in forging this postdisciplinary curriculum, both within LCC and across the broader institute environment, I often found myself in the position of reaffirming the importance of the traditional

humanities—especially for students trained in science and engineering—because it provides the intellectual frameworks for the development of skills in critical thinking, communication and interpretation, and social analysis. At the same time, my students were required to critically investigate the consequences of the deployment of scientific authority and the application of technological rationality. I did so not to discourage them from their chosen career paths in science and technology, but rather to suggest new roles they could play as mediators of scientific and technological knowledge.

Although I no longer teach at Georgia Tech, I believe in the enduring value of LCC's educational programs and continue to hold up those programs as exemplars of how cultural studies can serve as the framework for the rearticulation of traditional humanistic topics—ethics, social justice, and the construction of knowledge claims within new scientific and technological contexts. This is, I believe, one of the ways that cultural studies will continue to demonstrate its enduring value as a transformative, and not simply an academic, enterprise.

Notes

I would like to thank Jay Bolter, Hugh Crawford, and Roddey Reid for comments on earlier versions of this paper.

1. The transformation of the English Department into the School of Literature, Communication and Culture was only one of the many structural changes that happened during Georgia Tech's institute-wide reorganization from 1988 to 1990. The previous College of Science and Liberal Arts (COSALS) was disbanded in favor of the construction of two new colleges: the College of Sciences and the Ivan Allen College of Management, Public Policy and International Affairs. The result was that LCC now resides in a college that, until early 1998, also included the School of Management. As of July 1, 1998, the Ivan Allen College consists of the Schools of Public Policy, International Affairs, and Economics, and the Department of Modern Languages, as well as the School of History, Technology and Society, which was formed out of the two previous departments of history and sociology. Elsewhere in the institute, a new College of Computing was formed, as were new interdisciplinary engineering programs.

2. This latest curriculum revision was mandated by the Georgia State Board of Regents as part of the plan whereby all the public schools of higher education in the state would move from a quarter-based academic system to a semester system.

3. For example, of the historical courses, the one I taught most often, "Science, Technology, and Postmodernism," focused on the relationship between postmodern literature and the development of new technosciences such as cybernetics, bioengineering, and

chaos theory. The broad aim of this course is to encourage students to investigate the relationship between contemporary scientific knowledge and postmodern forms of cultural expression. In the process they are taught basic techniques of textual interpretation: semiotics, content analysis, discourse analysis. This course explicitly discusses the relationship between language and material reality as it manifests in the popularization of a technological worldview. A key aspect of this course is the study of popular cultural forms that poach on contemporary discourses of science and technology; thus students read recent science fiction novels, popular magazines and 'zines, Usenet scientific discussion lists, films, and other new forms of electronic media. The point is to investigate the cultural practices whereby scientific and technological knowledge circulates in everyday life.

4. For an insightful analysis of the implications (specifically) for cultural studies of one recent skirmish in the Science Wars, see Jennifer Daryl Slack and M. Mehdi Semati, "Intellectual and Political Hygiene: The 'Sokal Affair,'" *Critical Studies in Mass Communication* 14, no. 3 (1997). See also the volume edited by Andrew Ross, *Science Wars* (Durham, N.C.: Duke University Press, 1996).

5. Donna Haraway, "A Manifesto for Cyborgs: Socialist Feminism in the 1980s." *Socialist Review* 80, no. 2 (1985):65–108.

6. Paul R. Gross and Norman Levitt, *Higher Superstition: The Academic Left and Its Quarrels with Science* (Baltimore: Johns Hopkins Press, 1994), 10.

7. I discuss in more detail the organization of the course "Science, Technology, and Gender" in an essay called "Teaching in the Belly of the Beast: Feminism in the Best of All Places," in *Wild Science: Feminism, Medicine, and the Media,* ed. Kim Sawchuk and Jeannine Marchessault (Routledge, forthcoming).

Calling the Future(s) with Ethnographic and Historiographic Legacy Disciplines

STS @the Turn []000.mit.edu

Michael M. J. Fischer

Delay Call Forwarding[1]

Fifty years ago, Winston Churchill gave the keynote address at MIT's 1949 Mid-Century Convocation on the Social Implications of Scientific Progress and the place of the Humanities and Social Sciences in the education of engineers and scientists (Burchard 1950). The calls then for something like a science, technology, and society perspective as central for the conduct of professional lives, as well as for the basic education of citizens in a technological society, have continued to repeat in the succeeding decades. Easy generalities (and even disagreements) about humanistic or civilizational values (about which much was said at that three-day convocation, which celebrated the inauguration of a new president of MIT) do not necessarily mesh smoothly with empirical investigations into the operations of the sciences and engineering, their social worlds, the worlds they transform, and the worlds within which they unfold (about which almost nothing was said). Fifty years later, at the turn of a new century and a new millennium, even if many of the pieties remain the same, the conditions of the university, the composition of student bodies and faculties, and the nature of knowledge bases and their constituencies have shifted dramatically; and a field of science, technology, and society

(STS) has begun to emerge, making available for citizens and professionals just such empirical investigations as basic everyday knowledge.

Among other tasks in the coming decades, science, technology, and society (STS) might become a canary discipline (as in the canaries taken into the mines to warn of deadly gases, thereby showing where the mines need to be vented or reworked): bringing together the sciences and technologies around which modernities have been built, together with the social sciences and humanities that constitute analytic and cultural commentaries about the social organizations and meaning structures of technoscientific (post)modern societies, with a view also to helping provide at least some of the conceptual wherewithall for informed and democratic deliberative processes where all are expert in something, but none are expert in everything.

Students attracted to an STS program are likely to be a very diverse set. In the Ph.D. program at MIT in History and Social Studies of Science and Technology (HSSST) are students with master's degrees or Ph.D.s in physics, biochemistry, electrical engineering, brain and cognitive science; others pursuing law degrees as well as Ph.D.s; others with joint undergraduate degrees in literature and math or a science; engineers with interests in the history of technology; students with journalism backgrounds or journalistic goals; those with interests in sociology and the new media; or those with history or history of technology undergraduate degrees. Students have come from China, Taiwan, Korea, Russia, Germany, Turkey, and India. In such a program, one can assume commonality neither of background nor of specific interests. Various models for building an STS program come to mind: the professor-disciple model, where faculty compete to attract students and try to bind them to their own research interests; a providing of tool kits of methodological and disciplinary approaches or questions with which students may find their own creative pathways; a pedagogy of building an interdisciplinary conversation. All of these compete at MIT. The present paper is a report on the latter two.

In spring of 1996 I convened a faculty retreat to think through a core course and a curricular structure that would both bring into conversation the disciplinary approaches of the history of science, history of technology, and sociocultural studies of science and technology; and to survey the key scientific and technological arenas of the past two centuries using these approaches to test whether an interdisciplinary conversation might be possible. Interdisciplinary research, after all, is a trademark of MIT's creativity in the sciences and engineering: could it be possible in an STS setting as well? Included was a call for an international component. MIT has long had, and increasingly recognizes itself as having, an international faculty, student body, and global role. An STS

program should deal not only with the politics and ethics of science in the United States but also with national competitions in science and technology, and the complications of exacerbating uneven, unjust global development. It should be empowered to explore the claims of proliferating, often conflicting "alternative modernities," constructed with different goals, values, and cultural understandings. Interdisciplinary engagement, finally, might turn out to be most pedagogically enriching not so much between history and the social sciences but with the sciences and engineering fields themselves, and with collaborative professional schools of medicine, business, and law.

The STS program at MIT has a history that can be recounted only partially here.[2] Its efforts at interdisciplinarity do not only include attempts to reconnect the "two cultures" (humanities and sciences) or the "five cultures" (sciences, engineering, arts, humanities, and social sciences), to provide engineers and applied scientists with tools for implementing their work in real life social worlds, or more generally to broaden their education. They also work toward countering the specialization, compartmentalization, even secrecy or lack of ability to communicate among subfields of science and components of big engineering projects, both to allow checks and balances to operate and to prevent the privatization of moral judgment, the enfeeblement of public discussion, and the obscuring of how hierarchies of power and knowledge operate. In this sense the STS program contributes to the creation of a vital civil political culture for an increasingly differentiated technological society both within the nation-state and on a global scale. The presence of international students in the classroom often helps ground this effort, providing an immediacy of differential experiential contexts for discussions.

Science and technology is often thought of as having a center-periphery structure. A focus on (and from) the peripheries can often also ipso facto be a focus on the histories of exchanges in scientific knowledges (the Kerala toddy tappers who provided the Portuguese materia medica/botanica compiler Garcia da Orta, and his Dutch successor Hendrick van Reede, with the knowledge that Linnaeus was trained on at Leiden [Grove 1985]), on hierarchies and access to centers of calculation (strategies used by Japanese women physicists to get resources from their international mentors to circumvent their lack of leverage within the patriarchal Japanese system [Traweek 1992, 1995]), and on alternative genealogies of knowledges that are codified in textbook histories as universal, as if one could simply build science modularly in any place (a kind of naive trickle-down modernization theory of science) without attention to the embeddedness of sciences and technologies within both sociopolitical factors and cultural imaginaries (Fischer 1998). The scientists and politicians who

built the elite science institutions of India, China, Russia, or Brazil in the post–World War II period were acutely aware of leveraging comparative advantages, of playing off one power against another, and of building particular kinds of niches. In India, there were rationales in physics for beginning with cosmic ray physics and radioastronomy, or in developmental biology with *Drosophila* experimental systems. Attention to these modes of development throws general light on the challenges of building science institutions. It also throws light on the contemporary struggles over international agreements and treaties regulating environmental issues, intellectual property rights, and other differences of interests among the inhabitants of planet earth.

The question is thus raised, Should STS be integrally woven into the technoscientific curriculum as a kind of recombinant reagent, or might it operate better as marginal critic, maintaining its distance from the vortex of money and power that increasingly drives the sciences and technologies? The tension itself is important: not becoming absorbed by the institutions under investigation versus not becoming marginalized, unheard, unattended. Marginal critics are easily dismissed as off to the side, not fully competent, impractical intellectual luxuries; often they gain legitimacy only through alliance with powerful scientists or engineers, who themselves have legitimacy only in particular arenas. Is the recombinant reagent metaphor a better way to develop a technological civil society, to develop technically informed sociocultural critiques of the biosciences, bioengineering, and biomedicine, to do so together with their leading practioners? Five or so exemplars of such efforts are recounted below.

Core Course

In spring of 1996 we held an off-campus faculty retreat, with the help of a team of professional facilitators, to consider proposals for restructuring the graduate program. The protocols for the ritual process of this retreat—and the various productive and unproductive tensions the retreat was designed to negotiate and overcome—can be read elsewhere (Fischer 1996). The results included an architecture for the graduate program: a modular core course to help forge the interdisciplinary ethos of the program; a second tier of foundation courses to provide in-depth disciplinary tools (historiography and historical methods, social theory and ethnographic methods, history of science, history of technology, and history of medicine); and a third tier of topical graduate seminars. A desire was endorsed for practica that would place graduate students in

science and engineering laboratories to gain hands-on-experience, especially for those who come into the program without such experience.

This cross-field desire extended in two more general directions: the positioning of STS vis-à-vis the discussions at MIT and elsewhere of the changing structure of education for engineers and applied scientists, and the changing relationships between ethnographers and their colleagues in the sciences and engineering (see Fischer 1995; Fischer and Marcus 1999; and, for a similar exploration at Virginia Tech, Downey 1998).

The core course had several key functions, but most central was to construct a framework for cross-discipline intelligibility by identifying an evolving reference canon of texts to which first-year students would be introduced, and which advanced students and faculty would constantly rework with new commentary and insight. The emergent nature of this textual canon would be constantly renewed by placing emphasis each year on newly published texts that were helping to define cutting-edge debates in the STS field, reading them in dialogue with older canonical texts. The core course was to frame substantive areas of expertise and inquiry, as a platform for more detailed attention in advanced seminars, research programs, dissertations, and workshops.

Toward this end, the architecture of the core course was built around three- to four-week long modules. Modules would allow more in-depth, cumulative discussion than a "parade of stars" class where each faculty member would lead only a session or two, and provided the flexibility to include more than a few foci of the program's expertises to be developed. Each module would be led by at least two faculty members from differing disciplines. The aim was to develop richly informed interdisciplinary discussions, that is, to learn how to ask questions and elicit complementary and/or troubling information across disciplines, to bring the systematic, rigorous techniques and tools of different disciplines to bear on the same substantive arenas. While modules might differ from year to year (in content, as well as rotating in entirely different modules), the original idea was to build upon the foci of expertise of the program, and upon key issues that a contemporary STS program ought to cover.

Modern biology, the computer revolution, and ecology and environmental issues seem at the top of the contemporary agenda as well as being central research concerns across the MIT campus. Within the STS program in 1996, two of these—biology and computers—were central, and a third—environment—a growing if as yet less powerful focal interest. In addition, it is hard to conceive of the twentieth century without the modern physics revolutions. These four areas—physics, biology, computers, environment—made a set of four relatively obvious modules for the second semester. Three other topics

seemed equally obvious as first-semester introductions to the interdisciplinary work of an STS program: the scientific revolution; bacteriology and the medical sciences; and technology.

First-Semester Modules—Scientific Revolution, Bacteriology and
Medical Sciences, and Technology

"The Scientific Revolution" seemed a useful first module less because of either its temporal priority or its presumptive content (scientific methods, creation of modern scientific institutions, relations between science and nation-states), but because the seventeenth century had become within the world of STS a central arena for social theory and mutual borrowing between historians and anthropologists (Shapin and Schaffer 1985; Hallyn 1987/90; Biagioli 1993; Newman 1994; the older work of Robert Merton [1938], who drew on Max Weber and Karl Mannheim, and whose arguments about the relation between democracy and science generated an important and continuing debate [on communist Russia, Graham 1972; on post-Mao China, Miller 1996; on big-science physics and venture-capital-transformed biology in the 1990s, Galison 1997; Gottweis 1998; Rabinow 1996; Knorr-Cetina 1999]; and the older work of Thomas Kuhn [1962], which the so-called sociologists of scientific Knowledge (SSK) in England claimed as their ancestor, sometimes to Kuhn's discomfort, and even more to the discomfort of some historians of other traditions of inquiry who also claimed Kuhn). We were able to begin our first year with a focal discussion on China enlivened by the presence of Wenkai He, a graduate student from China, Roger Hart, a postdoctoral fellow working on science in seventeenth-century China, Peter Perdue, our China historian, and Leo Lee, professor of Chinese language, literature, and culture, thereby making the arguments about science and political institutions work both cross-civilizationally, cross-historically, and across institutional and policy analysis.

More generally, the period of "scientific revolution(s)" is also a central arena for discussions about the formation of disciplinary knowledges (Foucault 1966/71; Blumenberg 1975/87; Alpers 1983), as well as for some first rate literary investigations (Banville 1976, 1981). The work of Mario Biagioli (1993) on courtier science in Italy, Jonathan Hart (1997) on patronage of science in seventeenth-century mandarin China, Steven Shapin and Simon Schaffer (1985) on gentlemanly science in England, Bruno Latour (1988) and Gerald Geison (1995) on public science in France, and Peter Galison (1997) on the transition from craft to big science in Europe and the United States provides a schema for contrastive

institutional social analysis (an analogue of comparative social structures or social organizational analysis in traditional social anthropology).

Simon Schaffer's notion of an eighteenth-century "period eye" built around virtuosi, curiosi, and savants (see also now Daston and Park 1998 on "wonder," Findlen 1994 on early modern Italian museums), if pluralized, becomes a homophonic pun drawing attention to contrasting epistemes. Such "period eyes" (periodizations) point to a major problem in traditional accounts of the voyages of discovery of imperial and colonial sciences: the failure to (stereoscopically) include the period eye of the various native interlocutors, pilots, guides, informants, draftsmen, preparers of specimens to be sent back to "centers of calculation" in Europe. Michael Bravo (1998) invokes the dispute between the anthropologists Marshall Sahlins and Gananath Obeysekere over the apotheosis of Captain Cook to raise this crucial issue, and argues that ethnography provides a tool in evaluating the degree to which genres of writing about early modern scientific encounters with other worlds can be disambiguated.

The discussions of the scientific revolution(s) provided a locus where the presumptive division between the work of historians and anthropologists (and other social scientists) had already broken down. We had, within our program, some historians who claimed that they could easily dismiss this work by sociologists and social historians; what better way, I thought, to initiate an interdisciplinary discussion than to publically, in front of and with students, work out what was at stake?

The second module—on bacteriology, epidemics, and medical sciences—followed naturally. It would be hard to conceive of modern biology without its medical contexts (although again some of our historians of science have insisted on excluding history of medicine from the "status" of history of science). Thus it seemed that a key bridge between the scientific revolution discussions and a module on contemporary molecular biology and genetics could be turn-of-the-century work in bacteriology and public health. Here two or three other key texts work like the texts for the "sci rev" module in bridging—or interrogating the different tools of inquiry in—the fields of history and anthropology/sociology: Ludwig Fleck's *Genesis and Development of a Scientific Fact* (1935), and Bruno Latour's *The Pasteurization of France* (1988), together with Gerald Geison's *The Private Science of Louis Pasteur* (1995), which last had drawn a vituperative attack from the crystallographer Marx Perutz in the pages of the *New York Review of Books* (1997, 1998).

Not only did Fleck's monograph inspire Thomas Kuhn's *Structure of Scientific Revolutions* (1962)— so that reading Fleck along with Kuhn's text could disentangle Kuhn from some of the later readings of Kuhn, which claimed him

either as a relativist or an antirelativist—but more importantly, Fleck's text could have been written by a member of *L'Année sociologique,* the journal of Emile Durkheim's school of sociology. Fleck explicity placed himself between the Durkheimeans and the Vienna Circle logical positivists, who would later sponsor Kuhn (although bashers of "positivism" in the 1970s would misrepresent Kuhn as a reaction against Carnap and the Vienna Circle).[3] Here, then, was a text on the boundary between philosophy of science, sociology of science, and history of science. Moreover, Fleck's life and career is deeply resonant with the ethical problems of science in the twentieth century. Not only was he on the right side in the sad story of the self-destruction of German and Central European science during the Nazi period, but his dedication and his formulation of epistemological puzzles are again resonant in our own era of AIDS, mutating viral infectious agents, and illnesses whose definitions seem to change with every effort to place them under inspection, such as multiple chemical sensititivity syndrome, and chronic fatigue syndrome.

The second module, thus, began with Fleck and the renewed discussions about Louis Pasteur and the rise of bacteriology over and against the hygenics movement (Latour 1988, Geison 1995, Roll-Hansen 1982, 1983). It moved next into a reading together of ethnographic, political economy, and cultural accounts of AIDS (Farmer 1992; Treichler 1987; Hammonds 1999) and historical and anthropological accounts of previous epidemics around the globe (smallpox, cholera, diphtheria, plague), looking at both the scientific and the public sphere understandings of these epidemics, especially when complicated by cross-cultural, class and immigrant, or colonial contexts (Charles Rosenberg's dramatological model [1992] of responses to epidemics; Ralph Nicholas [1982] and Frederique A. Marglin [1999] on smallpox, the smallpox goddess, and the differential responses to variolation and British campaigns for vaccination; Evelynn M. Hammonds' work [1990] on the conflicts between different groups of professionals in "the search for perfect control" by bacteriologists, physicians, public health officials, politicians, and the media in the first public health campaigns in New York around diptheria, and Judith Leavitt's account [1996] of Typhoid Mary; and Carol Benedict [1996] on bubonic plague and demographic and economic growth in China, or more generally on populations, demography, and cross-cultural contact and imperialism [McNeill 1976; Watts 1997]).

This module was also a natural place to introduce problems of ethics in research, and the complications of ethics through legal and definitional shifts in meanings and in material incentives. We read, watched documentary video, and discussed the Tuskeegee syphilis experiment (Jones 1981) and AIDS in Haiti (Farmer 1992) and the United States (Hammonds 1995; Treichler 1987)

and used the class as a forum to explore a piece of Hannah Landecker's dissertation-in-progress (1999) on shifts in understanding of the HeLa immortal cell line from neutral tool for biological research, to symbolic attractor of anxieties about race, miscegenation, and contagion, to symbolic attractor of interest competitions over patents and rights of patients versus those of clinical researchers, universities, and pharmaceutical companies. The module also provided a quick and easy exercise in the contrast between (historically important for generating public support for research) narratives of heroic scientist-geniuses (e.g., de Kruif 1926) versus sociological or anthropological and historical accounts.

The four sessions of this second module thus were on the construction of bacteriology as an "obligatory point of passage" for authoritative science; on the public sphere and scientific understandings and responses to epidemics; and on ethics and commoditization in research with human populations. In all sessions, there was a productive interplay between ethnographic and historiographic methodologies.

The third introductory module interrogated ways of foregrounding technology. The ground was prepared in both previous modules by the centrality of the roles of instrumentation, of technologies of communication, and of control over laboratories whose results are granted authority in both scientific and public arenas. But both the nature of the industrial revolution(s) and the cultural imaginaries invested in technologies—and indeed the epistemological and sociological implications of the historicized term *technology* itself, and its successors—should not be left to unexamined assumptions or background. Involved in the notion of industrial revolutions is a questioning of systemic interrelations across different parts of society, of periodizations and the structural social changes that modern societies have undergone, however unevenly over the past three centuries. As in previous modules, sessions included presentations of graduate student work in progress, including that of experts from outside the program, notably Ted Medcalfe's work on Fordism, capital accumulation, and commoditization for which he brought along Michael Piore from economics and James Livingston from the Rutgers University history department.

Technology is not just objects plus social organization; it also is powerfully invested with fantasies, aspirations, hopes, anxieties, and fears. Technological imaginaries are rich cultural fields of literary, philosophical, symbolic, and psychological production. The analysis of technological imaginaries is now producing some of the most exciting new work not only in STS (Haraway 1998; Latour 1993/96) but also in German studies (Ronell 1989, 1994; Kittler 1990, 1999; Rickels 1991; Felderer, ed., 1998), in French philosophy after 1968 (Deleuze and Guattari 1980/87), in postcolonial and Third World studies

Table 1 Genres and Threads

Key: Ethnographies and historiographic monographs are two of the basic disciplinary genres, complements like a double helix. Journalists' accounts often pioneer the territory; and autobiographies occasionally serve a similar function (Fischer 1995). Without claiming any completeness, the process of making charts of this sort is one way of beginning to see where there are relative lacunae and relative density.

Several of the STS/HSSST* dissertations that were being worked on and were part of the graduate student discussions in the core course are included. Several of these are interdisciplinary, crossing this chart's genre categories: e.g., Clancey 1999, Landecker 1999, and Mnookin 1999. Others either comment upon language (Gerovitch 1999) or experiment with new media formats (Kelty 1999).

Modules	Physics	Biology	Computers
ethnographies	Collins 1974, 1975 Traweek 1988 Gusterson 1996 Nowotny and Felt 1997 Knorr-Cetina 1999 Rabinow 1996, 1999	Latour and Woolgar 1979 Cambrosio and Keating 1995 Fujimura 1996 Martin 1987, 1994 Loewy 1996	Dumit 1995 MacKenzie 1995 Turkle 1995 Stone 1995 Kelty 1999
historiographies	Galison 1987, 1997 Pickering 1995 G. Jackson 1996 Kevles 1978 Crease 1999	Rheinberger 1997 Kay 1993, 1999 Keller 1995 Kohler 1994 Abir-Am 1980, 1985, 1992 Gottweis 1998 Morange 1994/98 Judson 1979	Emmche 1994 Kelly 1994 Mindell 1996
visual thread	Nersessian 1995 Carius 1996	Greisemer and Wimsatt 1989 Lynch and Woolgar 1988	Glasgow et al. 1995 Ian Hunter 1995

literary thread	McCormmach 1982 Lightman 1993	Powers 1998 Djerassi 1989, 1994 Dukes 1993 Bear 1985	Coupland 1995 Constantine 1993 Powers 1992 Gibson 1984
cross-cultural thread	Traweek 1988	Fujimura 1996	Gerovitch 1999
Module	*Environment*		
ethnographies	Crawford 1996 Harr 1995 Davis 1998 Lahsen 1998 Reich 1991 K. Fortun 2000		
historiographies	White 1995 Wildavsky 1995 Grove 1995 Shulman 1992 Bowler 1992		
visual thread	Mizrahi 1990 Nagatoni 1991 Davis 1993		
literary thread	Powers 1998 Stephenson 1988		
cross-cultural	Reich 1991 K. Fortun 2000		

Modules	Sci Rev	Medicine	Technology
ethnographies	Shapin and Schaffer	Fleck Farmer 1992 Latour 1988	Downey 1998 Bucciarelli 1994 Kidder 1981 Latour 1993/96
cultural studies			Ronell 1990, 1994 Haraway 1997 Kittler 1990 Rickels 1991
historiographies	Newman 1994 Biagioli 1993 Foucault 1966 Merton 1938 Kuhn 1962	Geison 1995 Jones 1981 Hammonds 1999	Graham 1998 Hughes 1998 Hart 1998 Buderi 1997 Klein 1996 (to compare with Latour 1996)
visual thread	Alpers 1983 Crary 1990	Cartwright 1995 Avery 1997	Ronell 1990 Jones 1996, 1998 Mnookin 1998 Landecker 1999
literary thread	Banville 1976, 1981	Ghosh 1996	Powers 1998 Latour 1993/96
cross-cultural thread		Marglin 1990 Nicholas 1982	

* The official name of the graduate program is History and Social Studies of Science and Technology (HSSST). It is a joint graduate program of the Department of History, Anthropology, and STS.

(Nandy 1988; Abraham 1998; Bailey 1996), feminism and film/media studies (Penley 1997; Cartwright 1995), and the study of visual and computer mediated technologies (Turkle 1995; Dumit 1999).

Avital Ronell's *The Telephone Book: Technology, Schizophrenia, Electric Speech* (1989), supplemented by her essays in *Finitude's Score* (1994), provided one touchstone text for the technology module to explore how one might analyze the cultural imaginaries of a set of technologies. The book ranges from fascinating biography (reading autobiographical and biographical canonical texts in their cultural and historical contexts) to wonderful accounts of the development of the telephone (the well-known nugget that Alexander Graham Bell could hardly read the German of his Helmholtz "master text," could not make Helmholtz's experiments work, but could tinker from the diagrams and experiment with human ears smuggled out of Harvard Medical School, as well as with magnets, electromagnets, diaphrams, and resonators; or the well-known tours to promote the technology that mixed seances and vaudeville). The chapters "Watson," "Autobiography," "Tuning the Fork," "God's Electric Clerk," "The Bell Translator," "Micrographia," and "The Biography" provide rich and easy access, opening up the imagination by paying close attention to the behavioral quirks of those approaching telephones for the first time (embarassment, assuming telepathy is involved or that mediums might help transmission, forgetting to hang up). The brilliant opening pages ("Delay Call Forwarding") require students to do some close reading, registering a series of themes: (1) using technologies: here the several telephonic technologies, as "objects to think with,"[4] against Martin Heidegger's philosophical laments about modernity, including (2) the ethical embedded in uses of technology, here not just the troubling failure of Heiddegger to answer the call, or rather his choosing only to answer an early wrong number ("no such thing as a free call . . . accept the call . . . accept the charges"; and "Heidegger is not identical to National Socialism . . . operate as synechdoche . . . decryptage has become our task insofar as we are still haunted by National Socialism and threated by its return from the future"), but also "how to achieve a free relation to technology" ("disconnect, teach you to hang up, dial again"); (3) alternative hermeneutics: different ways of archiving information, registering and deciphering names, interpreting what is in the "telephone book(s)," here the Bible and the tradition of hermeneutics and ethics associated with Emmanuel Levinas, Walter Benjamin, Jacques Derrida, and Franz Kafka ("had already prefigured the dark side of the telephonic structure in *The Trial*, *The Castle*, and *The Penal Colony*"); (4) speech/communicative acts as ethical relations, here inserting interpretation into the ethical relation between self and other—Ronell and her brother,

Alexander Graham Bell and his brother, technologies to aid the deaf; (5) speech/communicative acts as physical acoustics, as spiritual(ist) desire (and as the uncanny in cultural interconnectivity, here relations between spiritualist circles and Thomas Watson, hardly the rationalist of myth, participant in table-tapping seances and a walking "catalogue of aversions" and neurotic phobias), sonic vibrations and various amplifiers (Bell), the unconscious ("always a child left behind or the face of a distant friend").

Second-Semester Modules: Physics, Biology, Computers, Environment

First-semester modules were conceived as an introduction to the central questions, methods, and approaches of an interdisciplinary STS inquiry. The second semester turned to modern physics, modern biology, computers, and environmental issues, four arenas that have transformed general consciousness, research strategies, and social institutions in this century. Pedagogically double-structured, retrospectively they were intended to build upon the modules of the first semester, and prospectively to be platforms for the active research arenas in the STS program at MIT.

Module 4: Modern Physics

The physics module ought in some way to take up the questions of the transformed world that McCormmach's *Nightthoughts of a Classical Physicist* describes, the transformed philosophical and literary worlds that quantum mechanics and relativity stimulated (e.g. as alluded to in Alan Lightman's *Einstein's Dreams*), and the rise of big science, the military-industrial complex, and the nuclear state. In the first year, when I taught the module with Jed Buchwald, our stand-in for the claims of physicists for a role in the transformations of general cultural consciousness was to look at the so-called Forman thesis. Paul Forman (1971) attempted to locate the sudden appearance of "acausal quantum mechanics" after Germany's defeat in World War I in a wider Weimar culture hostile to reductions of the physical world to mechanical determinism. The various commentaries on this thesis provide a neat case study for a play of arguments about the relation between internal developments in physics versus physics being part of larger intellectual trends and interests, between localist versus internalist accounts of physics, among different models of how social constraints and resources can shape a technical field, and

about how one draws discontinuities and continuities in historiographies. We then moved back into the nineteenth century to the establishment of the optical lens industry in Germany, exploring (as we had with George Starkey, Hobbes, and Boyle in the sci rev module, and the bacteriologists in the Pasteurian module) the boundaries between artisanal skills and entrepreneurial protection of those skills (secrecy, patents, carefully controlled public "demonstrations," and standards) on the one hand, and university development of optical theory (open science, theoretical exploration vs. empirical skill) (Jackson 1996).

Gradually emerging are a small number of ethnographically rich accounts of doing physics (Traweek 1988; Collins 1974, 1975; Knorr-Cetina 1999) which are in conversation with historians of physics such as Peter Galison (1997) and Andrew Pickering (1995), who themselves borrow from and give insight back to anthropologists and sociologists, as well as focusing attention on issues of continuing contemporary concern. Although a rich module on a crucial set of topics for understanding the contemporary world, due to space limitations, this module will not be described more at length here, except to note that two of the program's ongoing projects provided rich materials: Hugh Gusterson used his work on nuclear weapons designers to frame discussions on nuclear culture, and Roberta Brawer offered her dissertation work on the anthropology of cosmology, a field composed of particle physicists and astrophysicists, as a methodological example of how to do ethnography in contemporary science studies.

Module 5: Modern Biology

The biology module has a richness of new ethnographies, as well as histories, that few of the other module topics can yet claim. Moreover, when we began the core course, we had four faculty with expertise in the history of the biological sciences. We were arguably the most impressive site for the discussion of the contemporary history of molecular biology, genetics, developmental biology, neurobiology, and medicine in the country. In the three preceding years, we had hosted three Mellon workshops on the history of the life sciences, focusing on molecular biology (organized by Lily Kay and Charlie Wiener).

Evelyn Fox Keller's recent set of lectures *Figuring Life* (1995), Lily Kay's *Molecular Vision of Life* (1993), Emily Martin's *Flexible Bodies* (1994), Paul Rabinow's *Making PCR* (1996), and Donna Haraway's *Modest_Witness@Second_ Millennium. FemaleMan©_Meets_OncoMouse™* (1997) provided one interesting preliminary

grid for this module. They all, in differing ways, present accounts of the emergence of new institutional settings, and of a new configuration of prestige and power among subfields of modern biology. Keller is concerned with the relative deemphasis of embryology and developmental biology under the hegemonic rise of genetics over the course of the twentieth century, and the reemergence of embryology and developmental biology in a quite changed world in which the body is experienced and interacted with quite differently, now as a "multimedia spectacle," visually available via gene tagging and fluorescent labels. Her story involves the "trafficking across borders" of genetics and embryology, physics and biology (the entry of physicists into molecular biology in the post–World War II era), computer science and molecular biology, and between metaphors and rhetorics used by scientists to formulate both theories for themselves and proposals to non-scientists for funding (e.g. "the gene" or "gene action" and their changing referents over the course of the century) and the reworking of such understandings by experimental systems. Lily Kay provides an account of the rise of molecular biology under the funding umbrella of the Rockefeller Foundation, analyzing why the particular configuration of subfields at CalTech proved to be the most fertile ground for building this subfield among the six universities that were given the most funding in the 1930s to the 1950s. She places her work as well in a maturing historiographic field, evolving from insider accounts of intellectual history, to institutional and social histories, and accounts that weave together the science, the institutional histories, and the broader social and cultural politics of their times (Kohler 1994; Abir-Am 1980, 1985, 1992).

Emily Martin's books (1987; 1994) chart the trafficking across borders in a different way. She deploys the anthropologists' ethnographic methods of tracking how metaphors, rhetorics, and understandings circulate among their several distinctive loci in the social world: scientific laboratories, clincs in different ethnic and class neighborhoods, the media (print, film) changing decade by decade. Like most anthropologists she finds that people are not stupid or passive, that understandings of science do not divide simply into lay and expert, and that probing understandings in different settings uncovers a great deal about how society is structured. More provocatively—and similarly to Keller's or Haraway's efforts to unpack the use of terms like master molecule or gene action—Martin notes, and then questions, the relations (reflection? synergy? "objective correlative") between the metaphors and rhetorics used in science and political economy—immunology and flexible capitalist accumulation in the case of Martin's second book.

Lily Kay's book on the history (and historiography) of DNA as the "code of life" (1999), Richard Doyle's (1997) book on the rhetorics of discourses in genetics since physicist Erwin Schroedinger's 1944 book *What Is Life?* and Hans-Jörg Rheinberger's book (1997) on experimental systems all push the analysis of scientific rhetorics much further in three quite different directions. Rheinberger's case study ties in both to studies of the history of experimental systems and to the series of ethnographies of laboratories involved in developing understandings of oncogenes (Fujimura 1996), interleuken molecules and the relation between clinical trials and experimental systems in laboratories (Löwy 1996), the trajectories of alternative cancer theories and therapies (Hess 1997b), monoclonal antibodies and hybridoma technology (Cambrosio and Keating 1995), and polymerase chain reaction or PCR (Rabinow 1996).

Rabinow's ethnography of Cetus Corporation provides an ethnographic site for reconsidering the dramatically changed institutional and patronage environments of the 1970s–1990s and draws attention to the role of the scientist-manager who coordinates teams of technicians and scientists as well as to the shape-shifting objects of scientific production (compare Galison's "entities," Rheinberger's "epistemic objects"). PCR is alternatively a *technique* (whose provenance as prior art became the subject of a patent challenge by DuPont citing the work of H. Gobind Korana on cloning), a *concept* (for which Kary Mullis won the Nobel Prize) having to do with the iteration process for amplification, an *experimental system* (designed and made to work by Henry Erlich and others), and a *kit* sold as a commodity by Cetus. Parallel ethnographic case studies on genomics in the United States, Europe, and Japan are currently in process by Michael Fortun, Joan Fujimura, Steven Hilgartner, Paul Rabinow, and others.

If Rabinow's ethnography attempts to reinsert a detailed understanding of new scientific experimental systems, biological product marketing, and changes in the patronage and role models for science back into larger sociological frameworks, Donna Haraway (1998) reinserts these same changes into a cultural grid of significance, probing the cultural and ethical challenges similarly to ways we used Avital Ronell's *The Telephone Book* in the technology module. Copyright, patent, trademark, and brand names, she points out in her resonant book title, are the "genders" (generic marks, "directional signals on maps of power and knowledge") of "asymmetrical, congealed processes which must be constantly revivified in law and commerce" in a world of transuranic elements and transgenic organisms. Like Doyle, she is interested in the "chimeras" and "wonderful bestiary" of new objects, and obligatory passage

points in our technoscientific culture of cyborgs, chips, genes, bombs, fetuses, seeds, brains, ecosystems, and databases. These terms are cultural points of "implosion," which "bend our attention, warp our certainties, sustain our lives" and collapse categories that once were separate into one another. Like Rabinow, she is fascinated by changing legal and corporate structures, tracing the role of DuPont in synthetic organic chemistry (nylon), transuranic nuclear generation (building and running the Hanford reactors in Washington State), and genetic engineering. Like Martin, she is fascinated by the multiple loci in which technoscientific objects and rhetorics circulate. Like Rheinberger, she is fascinated by experimental systems that are themselves hybrid settings and generate transforms of themselves in ever-shifting generation of ethically, politically, and socially challenging new objects. Like Doyle, she is fascinated by the utopian and dystopian rhetorical grammars, not just metaphors but ever-productive semioses and grammatical processes of technoscience, now transmuting as well through the software programming and Internet address protocols (as indicated by the title of her 1998 volume).

Module 6: Computers and Society

The computer revolution module is one of the topic areas where MIT's STS program has been adding strength, encompassing the ethnographic study of computer useage (Turkle 1995), the history of computing (Mindell 1996), the prehistory of computing in automata (Riskin n.d.), cultural studies of mediated technologies and computer-assisted imaging devices (Dumit 1995a), and law, ethics, and social politics surrounding the Internet and cyberspace (Fischer 1995/1999).

As with physics and biology, there have been profound transformations: in computer science; in the simple and not-so-simple ways the Internet is changing the public sphere, the economy, and modes of "literacy" and knowledge; in the way users relate to computers and computer metaphors have infiltrated language and common sense (the *sensus communis*); in the speeding up of time and compression of space not just in the real world but in the kinds of simulation modules that lead to new science and technological applications; and in the way in which computerization has become almost a biological medium for sciences such as nanotechnology and genomics (e.g. the increasing shift in biotech companies from producing physical biochemical products to producing databanks).

This module divides, for me, into four parts (or weeks): seeking maps or frameworks for reading and research in (1) ethnographies or empirical grounds

for assessing these transmuting social worlds; (2) historiographies of the several fields of AI, computer science, theoretical biology, and so forth; (3) cultural readings of this new technological arena; and (4) political economy, with both law and ethics both driving the contingent outcomes, and the more difficult object of regulatory, market, and normative (or values we wish to build in) features of different architectures of these technologies.

1. *Ethnographies.* Given the pervasiveness of computer-mediated-communication, and the ubiquity of ethnographic and sociological research (by anthropologists but also by others), it is surprising how few richly developed ethnographies of these worlds exist, and how much of what does exist is focused on the relatively narrow area of consumer entertainment, e-mail, or MUDs (multi-user domains). Still, there are a few ethnographic and journalistic studies of computer programmers (Hakken 1993); of producing equipment (although Kidder's still classic account [1981] is now equipment-wise, if not sociologically, generations old); of safety, health, gender, and minority labor issues in production (Hayes 1989); of effects on family and social structure of cottage or flex-time niches for female heads of family (Stacey 1990); and of workplace ecologies (Nordi and O'Day 1999). The culture of hacking has attracted lively writing by Bruce Sterling (1992), Katie Haffner and John Markoff (1991), and many others, and is of increasing interest as documents from a bygone age of panic among unprepared law-enforcement agencies. Indeed, one of the most interesting aspects of the richest and most sustained (over two decades) ethnographic corpus on cyberspace, by Sherry Turkle (1984, 1995) is its charting of dramatic historical shifts (a) in the thinking of computer scientists (e.g. from hierarchical, rule-governed procedures to distributed, modular play and testing), and (b) in the consciousness of users, philosophers, and children, from anxiety over how humans are in principle different from machines (e.g., Dreyfus 1979) to intense interest in computers as evocative, interactive objects and interfaces.

2. *Historiographies.* This is a wonderful arena for STS-style historical studies of competing subfields and cross-disciplinary alliances within the large arena of computer sciences (now the largest undergraduate major at engineering schools like MIT). An interestingly conceived STS course for a few years, "Machines and Organisms" (taught by Evelyn Keller, Evelynn Hammonds, and David Mindell), explored some of these cross-disciplinary nexi. Among the most interesting of these recent nexi are the evolutionary possibilities of computers evolving "autopoetically," of allowing computers to evolve algorithms and "worlds" (artificial or a-life), both for what this teaches us about computer science and for the fields of chaos and complexity theory opened up as models for processes in biology, ecology, and the microworlds of quantum engineering

294 Michael M. J. Fischer

and computing. There are obvious contact points here to the physics, biology, and ecology modules (Emmeche 1994; Bear 1985; Hayes 1989; Kelly 1994) and to imaging technologies and their interpretation (Dumit 1995).

3. *Cultural readings of technology.* The cultural arena occupied by this module—literary, science fiction, film, journalism, popular science, advertising, and speculative writing by computer scientists themselves—is perhaps today the richest of all the modules, beginning with William Gibson's *Neuromancer* (1984), which popularized the word *cyberspace,* and the obsessively reanalyzed film *Blade Runner* (and its interesting difference from the book on which it was based, Philip Dick's *Do Androids Dream of Electric Sheep?*) and Douglas Coupland's novelistic account of what it is like to work for Microsoft, *Microserf* (1995). Scott Butakaman in *Terminal Identity* (1993) suggests that science fiction in this arena often exploits a distinctive writerly and playfully paradoxical style that requires active inferential work by readers, and that indeed "it has fallen to science fiction to repeatedly narrate a new subject that can master cybernetic technologies," a kind of *fort-da* learning game. For the anthropologist, it is of interest to specifically locate, within the general efflorescence of this cultural reading of and speculation about cybertechnologies, those discourses that are, as a lovely collection is subtitled, "stories about the future by the people creating it" (Constantine 1993). Some of this writing is revealing of gendered (male) desires to escape the body (e.g. Hans Moravec for computer science, and not dissimilarly Wally Gilbert for genomics), but much of it pokes fun at the butler bots, agents, smart things, and paradoxical desires generated by software designers, providing mirror worlds set to reflect at useful oblique angles.

4. *Politics economy.* A final arena equally fast-changing, and equally fundamental, is that of the political economy—the market, law, ethics, and social norms debates over the kinds of architectures we wish to structure our future worlds. The stories of the shakeouts of the semiconductor industry, for instance, are a window into the emergent global economy, and one of several ways in which this module is also an inquiry into the postmodern world, here at a material level quite different from the often purely metaphorical way in which the postmodern is discussed. Authors like George Gilder (1989) provide useful histories framed in terms of the transformations of laws of economics by a technology based upon light, where value is often created by giving things away for free; but on the other side is classic labor reorganization, deskilling, jobs lost, and disciplining of the labor force. The law is an important player in this economy, through intellectual property (patent, copyright) as well as legislation about privacy, digital identity architectures, and encryption. Here it is important to recognize that not only does the law often lag behind technology,

and sometimes new laws must be written to fit new technological realities, but that technologies are not "given", but can be designed in many different architectures (the subject of the class "Law and Ethics on the Electronic Frontier," see below).

Module 7: Ecology and Environmental Issues

Ecology is reemerging after a century of slightly shifting usages to become a word that indicates interconnectivities (both obvious and not), especially those between the natural environment, technologies, and social systems. Most simply, it is the methodological rule, "You cannot change only one thing," that is a search device that allows you to follow the cascade of other things that also change with any initial change. As such, *ecology* can serve as a set of mapping techniques for connectivities. It is thus a basic framework for approaches to environmental issues, a topic that has become a major initiative across the MIT campus, as it has elsewhere in society, as well as a slogan ("the greening of") for industry, management schools, government regulatory agencies, and politics. The STS program has not yet formed a coherent set of teaching and research projects, although we have pursued a series of initiatives includes the "Down and Dirty" course/workshop described below; a four-year Mellon Workshop on Environment and the Humanities (Conway, Keniston, and Marx 1999) with an associated course; a course offered by Harriet Ritvo in environmental history; and two dissertation projects, one in Kerala, India, and one in Central Asia (Khazakhstan, Uzbekistan, Turkmenistan). The module is thus a potential platform for new initiatives.

As a group,[5] divided the module into three parts: (1) landscapes, ecologies, and society; (2) extractions, markets, and environmental change; and (3) politics, environmental movements, and new grass-rooted and intermediate institutions or reflexively modernized social modes of governance.

1. *Landscapes, ecologies, and sociology.* This part was framed by a review of Ulrich Beck's *Risk Society* and by an introduction to histories: of ecology as field sciences of historical landscapes (Bloch 1966; Good 1998; Hoskins 1992), of colonial networks of apothecary and acclimatization gardens (Grove 1995), colonial forestry and meterological knowledges (Grove 1997), and other modes of gaining ecological knowledge from peasants and others not usually acknowledged in professional histories of science (Koerner 1996); of efforts at agrarian intensification (Allen 1965; Dumont 1957; Geertz 1963; Gupta 1998); of efforts to trace radioactivity through food chains and the lifeworlds of American

citizens (Bocking 1997); and of efforts to create a complete ecosystem in Biospheres I and II (Kelley 1994). At issue in all of these were notions of systematicities or the finding of unexpected interconnections; threshholds, feedback, and discontinuities of new succession patterns, and collapse; and the long historicity of human reworkings of the environment. It is quite noticeable that histories of the earth sciences seem quite naturally to include reflections on their own sociologies of knowledge: institutions, disciplinary formations, rival models and their patrons.[6]

As a key text, we read Richard White's *The Organic Machine: The Remaking of the Columbia River* (1995), a beautiful account, among other things, of how changing technological efforts at controlling the river and salmon runs each time led to yet more complications. As a cultural counterpoint or supplement reminding of a historical stratum of ecological knowledge carried by mythological armatures and narrative hermeneutics, I suggested we read at least Claude Levi-Strauss's "La Geste d'Asdiwal" (1960/67; see also Levi-Strauss's 1972 lecture at Barnard on "Ecology and Structuralism"; Detienne 1977 on Greek mythological armatures for botany and zoology; and Zimmerman's similar effort [1982] for India). Selections from these texts not only provide histories of research programs, and of different conceptual structures for environments, landscapes, or ecologies, but also can serve to illuminate the presuppositions of empirical methods that historians, social scientists, and humanists use.

2. *Extractions, markets, and environmental change.* For the market and extractions segment, the key text was William Cronon's *Nature's Metropolis,* an account of the way in which the city of Chicago and its hinterland reworked one another. A favorite of historians of technology, Cronon's book fits among other similar historical geographies from the spatial analysis tradition of the 1960s in geography (e.g., Berry and Marble 1968; Haggett 1965); the "radical geographers" of the 1980s and 1990s (M. Davis 1992, 1998; Harvey 1985, 1989, 1996; Soja 1989; and M. Watts 1983); accounts of multinational corporations' extraction of resources from around the globe (Karlinger 1997; Tsing 1993) and the environmental depredations of the military and nuclear industries (Kuletz 1998; Shulman 1992; Wilson 1992, ch. 8). An important complementary arena for analysis is the effort to change market incentives, and regulatory structures, so as to encourage green production. John Graham and Jennifer Hartwell 1997 provide a first serious look at how regulatory incentives are working, and how one goes about doing the analysis that allows for the drafting of effective regulations and evaluation of their effects beyond (non)compliance.

3. *Politics and social movements.* One of the central case studies in the "Down and Dirty" course (see below)—of Woburn, Massachussetts' problems with leukemia clusters and their alleged causation by two drinking water wells owned by the W. R. Grace and Beatrice Foods companies—provided an excellent way to examine grassroots environmental movements. *A Civil Action,* by journalist Jonathan Harr (1995), gives a riveting introduction by way of the court case but leaves out the citizen action group (now in its twentieth year of organizing), part of whose story can be found in Brown and Mikelson 1990. Comparative contexts for both the court case and the difficult transformation of citizen concern into political action is provided in Michael Reich's (1991) cross-cultural set of three cases (Italy, Japan, the United States) and Kim Fortun's transnational ethnographic, multilocale analysis (1999) of "the second Bhopal disaster" and struggles over environmental justice and safety issues surrounding the chemical industry in both India and the United States. Crawford 1996 provides another richly textured account of the fight against a waste disposal site, involving Mississippi race politics, the environmental justice movement, and the interstate trade in toxic waste (a topic that in the nuclear industry has focused upon Native American reservations [Hansen 1998]).

Aaron Wildavsky's *But Is It True? A Citizen's Guide to Environmental Health and Safety Issues* (1995) reviews the scientific reports that have fueled or damped public concerns since 1962, and illustrates the difficulties of decision-making with inconclusive evidence. His message is conservative; for the most part suspicions cannot be proved, and money spent in banning these agents is mispent. In tandem one might read Graham and Hartwell 1997 on the U.S. experience with green regulation; Douglas Powell and William Leiss 1997 on the dilemmas of communicating risks and appropriate solutions; Edward Grefe and Martin Linsky 1995, which provides a manual for corporations on how to organize grassroots organizations for their own purposes; David Helvag 1994 on the deceptive corporate war against the Greens; Carl Safina 1997, for the struggles of fishmen and marine biologists over the management of fish reserves; Margit Mayer and John Ely 1998 on the dilemmas of the German Greens in turning social movement politics into party politics; and Charles Sabel et al. 1999 on consolidating U.S. experiments with local governance linked to "rolling rule regime" national regulatory coordination.

Richard Power's novel *Gain* (1998) provides a literary vehicle for some of these issues, including the kinds of math or statistics skills individual citizens need to operate in such increasingly politicized, probabalistic, and statistically profiled information worlds.

Weft to the Core Courses Warp: Threads, Cross-School Courses

While this is not the place to explore the entire architecture of the STS graduate program envisioned at the spring 1996 retreat, the account of how the core course was intended to function as one part of a larger interweaving fabric would be incomplete without a brief thematization of three threads woven across the modules (visual, literary, and cross-cultural) and three calls for interdisciplinarity (across disciplines, across schools, and across the globalizing world).

Visual, Cross-Cultural, and Literary Threads

1. *Visual.* Images are often powerful emblematic, mis-en-scène, even mis-en-abîme, ways of signaling the paramenters of arguments or fields of debate. Michel Foucault, for instance, begins his 1966 book *The Order of Things* (1971) with a now famous meditation on the Diego Velasquez painting *Las Meninas* as an emblem of the shift between Renaissance and modern thought. The literary critic Walter Benjamin even suggested that effective history is composed of images rather than of narratives, particular kinds of images that flash up in charged contexts, juxtaposing two historical time periods, reminding of the hopes and fantasies with which banalized technological objects as well as ruins of the past were once invested, making those aspirations available for redemption under changed circumstances.

Might one stage a thought experiment contrasting Foucault's deployment of *Las Meninas,* along with the commentaries by Norbert Elias, Svetlana Alpers, William Mitchell, Jonathan Crary, and others) for thinking about the transitions to the modern period, with a photograph of a computer- and robot-assisted, virtual reality surgical operating room, prototyped in Ian Hunter's laboratory at MIT, as an emblem of the transition to the science-and-technology-based knowledge and action systems within which we now increasingly live? Could we use this to orient us toward history, and toward ethnography, as complementary techniques of data collection, analysis, comparison, and understanding? Situated at MIT, can we use this pairing to draw students into the rich worlds of the academic laboratories, startup companies, hospitals, environmental regulatory agencies, and corporate research worlds that surround them as ethnographic sites, using the historical record as a set of grounds against which these contemporary settings can be contrasted and compared, both to show how our inherited "wisdoms" (philosophy and ethics included)

may be quite bound to their historical contexts, but also to temper the euphoria of the "new" with recognitions of significant predecessors?

As teasers in this project, I've sought as logos for the STS colloquia series and program brochures puzzle logics that draw attention to the work that visuals and diagrammatic thought do. The first was a cartoon by the Armenian anthropologist Levon Abrahamian of a bishop on a chessboard being burned at the stake with a thought bubble over his head, in which he is seeing the world as a globe (it is also a checkerboard). The world may be round—ethnic conflict in the Caucusus may be archaic and irrational—but not at the moment, not in this case. It is a nod toward traditional histories of science (and Module 1), toward our feelings about the burning of Giordorno Bruno at the stake, and a hint that more might be at stake. The second was one of a set of four transforms of a Ming dynasty woodcut done for a production of the avant-garde Hong Kong performance troupe Zuni Isocahedron, in which five women use communication technologies (tape deck, newspaper, video, megaphone). The logo was intended to index the need for an STS that can deal with science and technology around the world, attentive to its cultural localizations, politics, and production, not merely to the abstract mathematical residues said by some to be the "essence" of science.

We have several dissertation research projects that focus upon the visual, notably Jennifer Mnookin's historical exploration (1999) of the forms of visual evidence—from charts to photographs to videos and animation reconstructions nowadays—that have gradually, and with careful hedging against their illusionary force for persuasive misleading, been allowed into the courts; Hannah Landecker's chapters (1999) on microcinematography in her history of tissue culture in experimental biology in the twentieth century, and more generally the focus on making visible processes in the body; Chris Kelty's work (1999) on informatics and software systems for managing diagnostic visuals, important parts of how medical centers and their patient catchment areas are rapidly being transformed; and the Japanese building craftsmen's geometries, and the visual clues that helped construct early seismology, that figure in Greg Clancey's dissertation (1999) on seismology and architecture (and which provided one year's STS logo).

2. *Literary.* The literary thread takes several forms, including (a) the partnering of historiographic and ethnographic accounts with novelists such as John Banville (1976, 1980, 1986, 1987), for issues in the scientific revolution module, or Richard Powers (1992, 1995, 1998) for the biology, computer, and technology modules; (b) the ethnographic use of creative writing by scientists and engineers as an access to their imaginaries (e.g. Constantine 1993); (c)

popular culture explorations, especially those that take on a "models of, models for" function for the wider public sphere (e.g. Gibson 1984);[7] (d) the exploration of different genres of writing (science journalism, scientists writing popular science books, scientists' autobiographies, biographies, institutional histories); (e) narrative techniques employed by professional historians and anthropologists; and (f) the analysis of metaphors, tropes, semiotics, and sociolinguistic pragmatics within scientific communications. We often held a first session of our colloquium as a book discussion, and a number of these have focused on narrative techniques (Beck 1986/92; Cohen 1994; Cronin 1991; McCormmach 1982; Latour 1993/6; Powers 1998).

In an innovative history of technology dissertation that cuts across fields that are often radically separated, Gregory Clancey (1998) writes, "One can arrange a text analytically if speaking to an audience that accepts the terms of an analysis, and owns common analytical tools" (9); but if one is writing across fields, one often finds it useful to adopt a narrative form so one can capture the historical realities where "chisel-wielding Japanese carpenters burst into a meeting of seismologists examining seismograms, architects find themselves dancing with politicians at a costume ball, zoologists declare themselves to be achitectural historians, and seismologists turn out to be ethnographers" (10).

3. *Cross-cultural.* The cross-cultural thread began in the first module in 1996, as noted above, with a lively session on 1980s China and the Merton-Weber thesis, using Lyman Miller's (1996) book *Science and Dissent in Post-Mao China* as a stimulus to discussion, and a chapter from Loren Graham's (1972) *Science and Philosophy in the Soviet Union* as a counterargument. In the room to help were four active researchers on China. For what is arguably the world's leading engineering university, one with an international faculty and student body, it would be anomalous for the STS program to be exclusively focused on America and Western Europe. For reasons telegraphically adduced in the opening of this paper, it is not the case that adding international expertise merely extends geographical or civilizational coverage but not serious intellectual content. On the contrary, some contributions to STS can be best made from the perspective of other places than the West. Graduate students in the STS program currently work in India, China, Japan, Central Asia, and the Middle East.

Cross-School Courses

One of the originary goals of STS programs in engineering schools around the country has always been to provide spaces for discussions of the social-cultural,

historical, political, and ethical environments of doing science and engineering. The history of this ambition is interesting in its own right, but the current renewed debates about reforming the curriculum for engineers may be a little different than earlier debates. The nature of pedagogy itself is changing because of the changing nature of the technological worlds we inhabit. The speed and ability to access information also changes the relations between teachers' knowledge base and that of their students. This is perhaps not unlike the changing structure of oedipal and patriarchal authority relations described for an earlier generation by Max Horkheimer (1972) and Theodor Adorno (1969) that no longer do sons wait for fathers to give them access to land, no longer do fathers' long experience in the fields translate into the knowledge that gives sons the skills they need in wage, education, and skill-based economies. Fathers look to sons for knowledge about computer-mediated society. In a course like "Law and Ethics on the Frontier" (http://mit.edu/6.085), young lawyers and engineers are capable of coming up to speed almost as fast as their professorial elders in part because they and their professors are changing the technologies and the laws as they go along. We are, in many arenas, in this together, so that as Gary Downey puts it, "Pedagogy becomes the model of and basis for research rather than the other way round" (1998: viz. again Geertz's "models of, models for," n. 9).

Five STS courses illustrate variants on this modality of pedagogy: with the School of Engineering, with the Medical School, with the Law School, and with the Media Lab.

"Down and Dirty: Technical Experts, Citizens, Cleanup Controversies"
Designed as a workshop/course, taught by Charlie Wiener (historian) and Michael Fischer (anthropologist) and with the support of Tina Voelker and Charles Harvey (both of the Parsons Lab at MIT's Civil and Environmental Engineering Department) for STS and environmental engineering graduate students, this course brought together technical experts, community activists, and government regulatory agencies involved particularly at two well-known Massachusetts sites: Woburn (a highly publicized legal case involving drinking water contamination and its possible connection to childhood leukemia) and Cape Cod (a military Superfund site at the Massachusetts Military Reservation, and its possible connection to elevated breast cancer rates.) It was intended to bring the field into the classroom, send students to the field, and allow actors in environmental negotiations to talk to each other in a neutral setting.

For myself these were cases for thinking through the recent sociological and anthropological literature on "risk society" and "reflexive or second order

modernization" (Beck 1986/92), on how market forces and regulatory agencies can be leveraged, and how communities might establish mechanisms for learning from one another in dealing with both complex technical issues and everyday health care. For some of our visitors, it was an unusual opportunity to learn about each others' backgrounds and a space in which to exchange perspectives outside the normal almost scripted roles of agonism and skepticism vis-à-vis one another on Citizen Advisory Panels. For environmental engineering students who do technical work in sites such as Woburn or Winchester on issues of chemical transport (e.g., arsenic into the Mystic River system), it was an opportunity to talk to people in these communities, sometimes even to help them formulate the appropriate technical questions, and to experience the larger contexts in which their technical work is or is not put to use.

"Social and Ethical Issues in the Biosciences and Biotechnologies"
Taught at the Harvard Medical School for the joint MIT–Harvard Health, Science, and Technology (HST) program, this is in its fourth year as a formal course, and its sixth year as an ongoing workshop collaboration between myself and Byron and Mary-Jo Good of the Harvard Medical School's Department of Social Medicine. Intended to serve the three of us anthropologists (and a fourth colleague, Jim Weaver, an MIT biophysicist) as a vehicle for interviewing some of the leading bioscientists and bioengineers in the Boston area, the course also fulfills a social medicine requirement for HST medical students. The class has grown in size to some thirty-five medical, M.D./Ph.D., and STS students, who bring to the table a wealth of their own experiences in a rapidly changing research and clinical environment.

Usually two presentations are specifically on the changing funding structures of medical science research and biotechnology. Most presentations are about technologies and basic sciences backstage, behind the therapeutic, clinical setting, and about how these come into the clinic and market. We probe for emergent ethical issues. We hope to draw into the discussion the different experiences M.D./Ph.D students have in the labs at MIT versus the clinical settings at the medical school, as well as their experiences in industrial labs, and occasionally the venture capital or health investment worlds. We have been told by a number of our students that this is the place in the busy professional curriculum where social and ethical questions can be explored, where the cocoon experience of their intense technical and clinical training is exposed to outside contexts.

"Law and Ethics on the Electronic Frontier"
A joint STS course with the School of Engineering, taught for three years with Hal Abelson and Joanne Costello, in 1998 and 1999, this course was taught

jointly also with the Harvard Law School professors Larry Lessig and Jonathan Zittrain. In 1998 thirty MIT students and thirty Harvard Law students were divided into teams of six, each team responsible for presenting the state of play today on issues from encryption and digital signatures to how democratic structures might be enhanced. This is an extraorinarily fast-changing arena. Even if the law does not change as fast as the technology, court cases have moved the legal playing field quite considerably from the time when the course began five years ago. The MIT students are often involved in managing and developing the technological changes while students at MIT—e.g., working for the World Wide Web Consortium, or working on encryption technologies. Similarly, the law students are often involved in clerking for firms, or doing work for law school professors, who are involved in both litigation and legislation. The setting up of teams in the class is intended to allow law students and engineers to teach one another the thought styles of each others' disciplines, but also to instill in engineers a sensibility about the trade-offs between technical standards and ethical, social, legal, and "policy" issues.

The course has evolved from a model, like that used in the Medical School course above, of bringing in key actors—prosecutors, former heads of the National Security Agency or CIA, FBI computer crime agents, defense and civil liberties lawyers, software engineers from the creators of PGP, RSA, and PICS, a founder of Lotus and the Electronic Frontier Foundation—to a pedagogy of role playing and mutual teaching among engaged disciplines. In both models, the basic reading is actual legal cases. In both models, most of the resources are accessed through a web page, and discussions are held online between class sessions. All of this cyberspace component of the course—except the online discussion—is available publicly. Final papers have been published on the Web, and the ethos of the paper writing is that they are contributions to state-of-the art knowledge (http//:ai-swiss/mit/6.085).

"The Structure of Engineering Revolutions"
Taught in its first iteration, with twenty-five students, by David Mindell (a historian of computer technology) and Charles Lieserson (a computer scientist), this course is targeted primarily for, and fulfills a requirement for, fifth-year engineering students. It is intended to teach them to use the archival tools of a historian to understand the complex social and political negotiations needed to complete a complex engineering project. This is part of a general charge that the School of Engineering has been posing to itself to change the way engineers are educated.

"Loosely modeled on the famous 2.70/6.270 subjects at MIT where students receive a box of parts and have to build a robot, here students receive a box of

documents, technical reports, drawings, technical artifacts, and engineers' names and addresses. From these diverse materials, they research and write a case history of an important technology, project, or company, taking into account its technical, political, and social dimensions. It is analogous to the case method of teaching in business schools, but instead of pre-packaged cases, students research and write their own cases" (Mindell 1996, 2). Final project presentations were critiqued by experts from STS and engineering faculties.

"Systems and the Self"

Taught by Sherry Turkle of STS and Mitch Resnick of the Media Lab, this is targeted both for those with computational backgrounds who have little vocabulary or opportunity to talk about their relationships with the objects they create except as obsessions or money-making ventures, and for humanists who have little opportunity to experience what it is like to create objects. Two sorts of relationships are focal: cognitive and affective. Students are asked to build objects and to write two papers, one about their own personal relationship with an object, either cognitive Piagetian ones, or affective Winnicottian ones; and another paper about other people's relations with objects. The Piagetian stance is that children (and all of us) use objects to develop thinking skills. Children, for instance, place the same objects repeatedly under the table and take them out to develop notions of permanence and continuity; or they learn the equivalence of geometric shapes as in the famous experiments with a tall, thin glass of water and a short, wide one. The position of the MIT Media Lab (Marvin Minsky, Seymour Papert, Mitch Resnick, and Sherry Turkle) has been that this learning process is enhanced not merely by manipulating objects but by actually making them ("constructivism"). The Winnicott affective questions ask why relationships with objects feel so compelling, and provide a language for talking about affect via analogies with psychodynamic "transitional objects" (blankets, teddy bears) that children use to establish a sense of separate identity (music, sex, or motion are other transitional vehicles). The computer programmer who spends hours before a screen is encouraged to develop a language that can say much more than just being lost in an obsession or addiction. One student paper investigated the differences for diabetics of having insulin pumps embedded in their bodies (lucometers measuring blood sugar levels continuously and adjusting the insulin) versus pricking their fingers repeatedly during the day and thus exercising control over the levels of insulin supplied. This gives concrete reality to the contemporary fascination with, and fear of, becoming cyborgs. Another paper explored what would be acceptable as chips embedded in oneself—maybe yes for learning 6.001 (the

basic computer programming course at MIT) or learning a language, but no for engaging with Dostoyevsky—and how these different affective relationships relate to the question, What is it to feel human?

From Papert's Logo Program of building blocks for learning (learning how things work) to different styles of operating systems (learning to make the things do it your way) to cyborgian aids for self and social relations (from a diabetic's ability to self-adminster appropriate insulin dosages to wearable interactive computers and perhaps to chips embedded in the body), the positioning of the course is not merely an intellectual exercise for MIT students but more like an architect's studio, where design work is being experimented with by those who will be designing the next generation of smart objects. It is also a place for teachers who actually put these ideas to work in community schools (e.g. Hooper 1998).

Other Pieces of the Fabric

STS at MIT also has an undergraduate program, and many of those courses also actively serve a cross-school pedagogy. Workshops provide further alternative forums for cross-school work. One, "Changing Conceptions of 'Race' in the Histories of Biology, Medicine, Public Health, and Anthropology," run by Evelynn Hammonds and Everet Mendelsohn, is a joint MIT-Harvard working group (also hosting a website) investigating the ways in which race concepts have in the past and to this day bedeviled scientific and public-sphere arguments and literatures even where race is disavowed as an analytic category. The Deep Water Archaeology Group, led by David Mindell, draws together engineers, archaeologists, and historians working on current projects in the Black Sea and elsewhere to pioneer a new kind of archaeology. The "Control in Contexts: High Hazard Technologies in Operation" workshop (led by anthropologist Constance Perin) involves engineers, historians of science and technology, sociologists, and anthropologists, and has held sessions that contrasted safety cultures and risk management across different industries.

Legacy Worlds and Promissory Futures

The core course described in this paper is an effort to provide a survey of the intellectual fields that make up STS, the arenas of science and technology that have been transforming our intellectual, material, and social worlds, the research

arenas of the program, and the basic vocabulary and genres of STS. Such vocabulary includes social, material and literary technologies (Shapin and Schafer 1985), managing public/private or skill/procedural techniques (Biagioli 1993; Newman 1994), points of obligatory passage and asymmetric and reversable ratios of power/legitimacy relations (Latour 1985, 1988), subculture rivalries (Galison 1997; Hammonds 1998), the semiotics and semiosis of cultural technologies (Haraway 1997; Ronell 1989), the circuits of knowledge dissemination and differential practical responses to technologies (Martin 1994; Traweek 1988), alternative histories of instruments, theories, entities, or sociologies and their pidgin languages and trading zones (Galison 1987); political economy changes surrounding patents, publishing, and regulation (Gottweis 1999; Rabinow 1996), experimental systems (Kohler 1994; Rheinberger 1997), transitional objects and alternative operating systems (Turkle 1995), alternative incentive structures and rational versus reflexive social institutions (Beck 1986/1992), and the procedural and organizational differences among the experimental sciences (Galison and Stump 1996; Knorr-Cetina 1999), not just differences among field, laboratory, and simulation sciences. And such genres include not only historiographic monographs and ethnographies but also science journalistic books, which have often prepared the way for more academic genres; as a particular kind of source, autobiographies and (with quite different functions and caveats for readers) biographies; as genres of speculative and narrative reflection, literature, science fiction, documentary film, and video; and as a source for circuits of discourse and image transformations, narrative popular film, popular science written by scientists, and photographic essays.

On a larger sociological and cultural scale, the core course and the STS program are part of a changing pedagogical regime. It makes sense that part of this shift should be toward courses that are placed in interdisciplinary settings across Schools with students and faculty who together are deciphering the technoscientific worlds that they are at the same time engaged in helping to produce and modify, an almost Möebius strip–like structure of education. Perhaps the core course itself should undergo parallel changes, for instance, by seeking a new life as a platform that is more (inter)active, in the form of either a book (dated) or a webpage document that can easily be updated, modified, and shaped to other settings.

Modifications, though potentially infinite, yet need to be constrained to achieve the purposes intended: I could easily imagine a biology module focused on the neurosciences—that increasingly interesting mix of imaging technologies, experimental systems, evolutionary speculation, and clinical interviewing—that might rotate with the current module that focuses on the

rise of genetics and genomics. For the moment, however, I suspect neither the histories nor the ethnographies are in place to easily create a module to provide the methodological exemplars that could serve both as introduction to conceptual vocabulary, genres, and methods and as platforms on which to build better exemplars or a complementary mosaic of understandings. Yet the making of precisely such exemplars might be the work of an interdisciplinary group of students creating the next module.

At the public sphere level, this changing pedagogy is part of a pressure toward what Ulrich Beck (1986/1992) calls secondary modernization or reflexive social institutions, or what Bill Readings (1998) calls an important new function for the university of learning to experiment in practical ways with social diversity (and institutional flexibility, not just ethnic identity politics diversity), in and among the disciplines.

Notes

This is an abbreviated version of a paper appearing in *Late Editions*, vol. 8: *Zeroing In*, ed. G. Marcus (Chicago: University of Chicago Press, 2000). Thanks to Joe Dumit, Evelynn M. Hammonds, and Constance Perin for comments and suggestions on an early draft.

1. I take this section title from Avital Ronell's *Telephone Book* (1989; see the technology module below), and mean to indicate with it the temporality of desire, constraint, blockage, and belatedness with which pedagogical goals are often installed.

2. STS departments and programs constitute repeated gestures by engineering schools to train engineers and applied scientists in more than technical skills, to look to the moral, social, economic, communicative, interpretive, and political contexts needed if any project is to be built and inserted in the real world. The efforts at MIT have ranged from the ambitious to the ordinary, from the purely pedagogical to the professional. Jerome Wiesner, when he succeeded to the presidency of MIT, envisioned a college of Science, Technology, and Society, a powerful school on par with the existing Schools of Engineering or Science, and even obtained promise of funding from Arthur T. MacArthur, who unfortunately died before the agreement could be signed, and instead those funds went toward the new MacArthur Foundations. The Program in Science, Technology, and Society, founded in the 1970s with professorial luminaries as staff, found itself increasingly merely offering service and elective courses to undergraduates, a marginal supplement rather than a central focus of their education. In 1988, however, a Ph.D. program was initiated; in 1993 five new staff were recruited; and in 1996 a retreat was held to rethink the curriculum for this new professional academic degree. In 1997 and 1998 three more staff were added, and various moves were made to

do more teaching across Schools, especially with Engineering. In both 1998 and 1999 attempts were made to hire staff in the international field.

3. The historian of science Robert Cohen, in a conference on the (still narrowly conceived) legacy of the Vienna Circle, held at Harvard in spring 1997, noted that members of his generation of American philosophers of science never actually read much of the Vienna Circle, and so their downplaying of the deep relations between pragmatism, operationalism, and the Vienna Circle, and their ridiculing of one of the projects of the Vienna Circle that attempted to rebuild the world from sense impressions and logical relations, by way of protocol sentences, was based on a kind of ignorance, a downplaying of the sociopolitical context of that project, and an almost willful misreading. As Robert Westman and others have reclaimed from the historical record, Carnap commissioned Kuhn's *The Structure of Scientific Revolutions*, intending to include it in the Unity of Science publication series: it is more a conversation with than a repudiation of the Vienna Circle or Carnap. In any case, Carnap was only one of the several vying political and philosophical strands among the members of the Vienna Circle from Neurath on the more socialist left to Schlick on the more liberal right, and from Carnap on the more analytic end to Schlick on the more pragmatist end.

4. An ordinary language phrase, resonant from Levi-Strauss's *Savage Mind* (1966), which has been elevated as a useful slogan at MIT in Seymour Papert's "constructivist" approach to learning and used effectively by Sherry Turkle in her studies of computers, which add to Papert psychological and psychodynamic dimensions from Piaget, from object relations theories, and from Lacan.

5. Deborah Fitzgerald, Harriet Ritvo, Charlie Weiner, and myself.

6. The new Encyclopedia of the Sciences of the Earth (Good 1998)—written by geodesists, geographers, geophysicists, oceanographers, historians and even one contributor from an STS program in Japan and two from history and philosophy of science programs in the British Commonwealth—includes entries on Michel Foucault, Imre Lakatos, historiography, sociological/constructivist approaches to geoscience, and entire sections on institutions and the study of the earth and social perspectives and the earth. See also Bowler 1992 and Bocking 1997.

7. "Models of, models for" is a phrase from Clifford Geertz's 1966 essay, "Religion as a Cultural System" (reprinted in Geertz 1973), which became popular in anthropological analyses of symbol systems in the 1960s and 1970s.

Works Cited

Abir-Am, Pnina. 1980. "From Biochemistry to Molecular Biology: DNA and the Acculturated Journey of the Critic of Science Erwin Chargaff." *History and Philosophy of the Life Sciences* 2:3–60.

———. 1985. "Themes, Genres and Orders of Legitimation in the Consolidation of New Scientific Disciplines: Deconstructing the Historiography of Molecular Biology." *History of Science* 23:74–117.

———. 1992. "The Politics of Macromolecules: Molecular Biologists, Biochemists, and Rhetoric." *Osiris* 7:164–91.

Allen, William. 1965. *The African Husbandman*. New York: Oxford.

Alpers, Svetlana. 1983. *The Art of Describing: Dutch Art in the Seventeenth Century*. Chicago: University of Chicago Press.

Avery, Eric. 1997. "Art of Medicine/Medicine of Art." STS colloquium, MIT.

Banville, John. 1976. *Doctor Copernicus, A Novel*. New York: Seeker and Warburg.

———. 1981. *Kepler*. New York: Vintage/Random House.

———. 1986. *Mefisto*. New York: Seeker and Warburg.

———. 1987. *The Newton Letter*. New York: Godine.

Bayly, C. A. 1996. *Empire and Information: Intelligence Gathering and Social Communication in India, 1780–1870*. Cambridge, England: Cambridge University Press.

Bear, Greg. 1985. *Blood Music*. New York: Ace.

Beck, Ulrich. 1986. *Risikogesellschafr: auf dem Weg in eine andere Moderne*. Berlin: Surkampf. Translated by Mark Ritter as *Risk Society: Towards a New Modernity*. London: Sage, 1992.

Benedict, Carol. 1996. *Bubonic Plague in Nineteenth Century China*. Stanford, Calif: Stanford University Press.

Benjamin, Walter. 1969. *Illuminations*. New York: Schocken.

Berry, Brian, and Duane F. Marble. 1968. *Spatial Analysis*. Englewood Cliffs, N.J.: Prentice-Hall.

Biagioli, Mario. 1993. *Galileo Courtier*. Chicago: University of Chicago Press.

Bloch, Marc. 1966. *French Rural History: An Essay on Its Basic Characteristics*. Berkeley and Los Angeles: University of California Press.

Bocking, Stephen. 1997. *Ecologists and Environmental Politics*. New Haven, Conn.: Yale University Press.

Bravo, Michael. 1998. "The Anti-Anthropology of Highlanders and Islanders." *Studies in the History and Philosophy of Science* 29, no. 3:369–89.

Broad, William. 1985. *Star Warriors*. New York: Simon and Schuster.

———. 1992. *Teller's War*. New York: Simon and Schuster.

Brown, Phil, and Ed Mikelson. 1997. *No Safe Place: Toxic Waste, Leukemia and Community Action*. 2d ed. Berkeley and Los Angeles: University of California Press.

Bucciarelli, Louis L. 1994. *Designing Engineers*. Cambridge, Mass.: MIT Press.

Buderi, Robert. 1996. *The Invention that Changed the World*. New York: Simon and Schuster.

Bukatman, Scott. 1993. *Terminal Identities: The Virtual Subject in Postmodern Fiction*. Durham, N.C.: Duke University Press.

Burchard, John Ely. 1950. *Mid-Century: The Social Implications of Scientific Progress*. Cambridge, Mass.: MIT and John Wiley and Sons.

Cambrosio, Alberto, and Peter Keating. 1995. *Exquisite Specificity: The Monoclonal Antibody Revolution*. New York: Oxford University Press.

Carius, Andor. 1996. "The Sounds of Plasma Physics." STS colloqiuum, MIT.

Carson, Rachel. 1962. *Silent Spring*. New York: Houghton-Mifflin.

Cartwright, Lisa. 1995. *Screening the Body: Tracing Medicine's Visual Culture*. Minneapolis: University of Minnesota Press.

Clancey, Gregory. 1998. *Foreign Knowledge or Art Nation, Earthquake Nation: Architecture, Seismology, Carpentry, the West and Japan, 1876–1923*. Ph.D. diss., MIT.

Clarke, Adele. 1998. *Disciplining Reproduction: Modernity, American Life Sciences, and the Problems of Sex*. Berkeley and Los Angeles: University of California Press.

Cohen, David W. 1994. *The Combing of History*. Chicago: University of Chicago Press.

Collins, Harry. 1974. "The TEA Set: Tacit Knowledge and Scientitic Networks." *Science Studies* 4:165–86; reprinted in Barry Barnes and David Edge, eds., *Science in Context* (Cambridge, Mass.: MIT Press, 1982).

———. 1975. "The Seven Sexes: A Study in the Sociology of a Phenomenon, Or the Replication of Experiments in Physics." *Sociology* 9:205–24; reprinted in Barry Barnes and David Edge, eds., *Science in Context* (Cambridge, Mass.: MIT Press, 1982).

Collins, Harry, and Trevor Pinch. 1993. *The Golem: What Everyone Should Know about Science*. London: Cambridge University Press.

———. 1998. *The Golem at Large: What You Should Know about Technology*. London: Cambridge University Press.

Constantine, Larry, ed. 1993. *Infinite Loop: Stories about the Future by the People Creating It*. San Francisco: Miller Freeman.

Conway, Jill, Kenneth Keniston, and Leo Marx, eds. 1999. *Earth, Air, Fire, Water: Humanistic Studies of the Environment*. Amherst: University of Massachussetts Press.

Coughlin, Kevin. 1997. "The Cutting Edge: Images and Maybe Sound Will Allow Surgeons to Enter the Brain Without Second Thoughts." *Newark, N.J., Star Ledger*, September 8, 59, 62.

Coupland, Douglas. 1995. *Microserfs*. New York: HarperCollins.

Crary, Jonathan. 1990. *Techniques of the Observer: On Vision and Modernity in the 19th Century*. Cambridge, Mass.: MIT Press.

Crawford, Colin. 1996. *Uproar at Dancing Rabbit Creek: Battle Over Race, Class and the Environment*. Reading, Mass.: Addison-Wesley.

Crease, Robert P. 1999. *Making Physics : A Biography of Brookhaven National Laboratory, 1946–1972*. Chicago: University of Chicago Press

Cronin, William. 1991. *Nature's Metropolis*. New York: W. W. Norton.

Dallenbach, Lucien. 1977. *Le récit spéculaire: essai sur la mise en abîme*.) Edition du Seuil. Translated by Jeremy Whitely with Emma Hughes as *The Mirror in the Text*. Chicago: University of Chicago Press, 1989.

Daston, Lorraine, and Katharine Park. 1998. *Wonders and the Order of Nature, 1150–1750*. New York: Zone Books.

Davis, Lee N. 1984. *Corporate Alchemists: Profit Takers and Problem Makers in the Chemical Industry*. New York: William Morrow.

Davis, Mike. 1992. *City of Quartz*. New York: Vintage.

———. 1993. "Dead West: Ecocide in Marlboro Country." *New Left Review*, no. 200.

———. 1998. *Ecology of Fear*. New York: Holt/Metropolitan.

Delany, Samuel. 1998. Transcript of discussion with Samuel Delaney and Octavia Butler at MIT, 19 February. (http://media-in-transition.mit.edu/science_fiction/transcripts/butler_delany_index.html).

Deleuze, Gilles. 1983. *L'image-movement.* Paris: Edition de Minuit. Translated by Hugh Tomlinson and Barbara Habberjam as *Cinema, 1: The Movement Image.* Minneapolis: University of Minnesota Press, 1986.

———. 1983. *L'image.* Paris: Edition de Minuit. Translated by Hugh Tomlinson and Barbara Habberjam as *Cinema, 2: The Image.* Minneapolis: University of Minnesota Press, 1989.

Detienne, Marcel. 1972. *Les Jardins d'Adonis.* Paris: Gallimard. Translated by Janet Lloyd as *The Gardens of Adonis.* Atlantic Highlands, N.J.: Humanities Press, 1977.

Djerassi, Carl. 1989. *Cantor's Dilemma.* New York: Doubleday.

———. 1994. *Burbaki Gambit.* Athens, Ga.: University of Georgia Press.

Douglas, Mary, and Aaron Wildavsky. 1982. *Risk and Culture.* Berkeley and Los Angeles: University of California Press.

Downey, Gary. 1998. *The Machine in Me: An Anthropologist Sits among Computer Engineers.* New York: Routledge.

Doyle, Richard. 1997. *On Beyond Living: Rhetorical Transformations of the Life Sciences.* Stanford, Calif.: Stanford University Press.

Dreyfus, Hubert. 1979. *What Computers Can't Do.* New York: Harper and Row.

Dukes, Carol Muske. 1993. *Saving St. Germ.* New York: Viking.

Dumit, Joseph. 1995a. "Twenty-first Century PET: Looking for Mind and Morality through the Eye of Technology." In *Late Editions,* Vol. 2, *Technoscientific Imaginaries,* edited by G. E. Marcus. Chicago: University of Chicago Press.

———. 1995. *Mindful Images: Brains and Personhood in Biomedical America.* Ph.D. diss., University of California, Santa Cruz.

Dumont, René. 1957. *Types of Rural Economy.* London: Methuen.

Edwards, Paul. *The Closed World: Computers and the Politics of Discourse in Cold War America.* Cambridge, Mass.: MIT Press.

Elias, Norbert. 1983. *Engagement und Distanzierung.* Berlin: Suhrkamp.

Emmeche, Claus. 1994. *The Garden in the Machine: The Emerging Science of Artificial Life.* Princeton, N.J.: Princeton University Press.

Farmer, Paul. 1992. *AIDS and Accusation.* Cambridge, Mass.: Harvard University Press.

Felderer, Brigitte. 1996. *Wunschmaschine Welterfindung.* Vienna: Springer.

Findlen, Paula. 1994. *Possessing Nature: Museums, Collecting, and Scientific Culture in Early Modern Italy.* Berkeley and Los Angeles: University of California Press.

Fischer, Claude. 1992. *America Calling—A Social History of the Telephone to 1940.* Berkeley and Los Angeles: University of California Press.

Fischer, Michael M. J. 1995a. "Eye(I)ing the Sciences and their Signifiers (Language, Tropes, Autobiographers): InterViewing for a Cultural Studies of Science and Technology." In *Late Editions,* Vol 2., *Technoscientific Imaginaries,* edited by G. Marcus. Chicago: University of Chicago Press.

————. 1995b. "Worlding Cyberspace: Toward a Critical Ethnography in Time, Space, and Theory." In *Critical Anthropology Now*, edited by George Marcus. Sante Fe, N.M.: School for American Research.

————. 1996. *Whence From?—Where To? Prospectus for the 1996 Retreat. A Self-Study Document.* http://stsfac.mit.edu/Core Course/Documents

————. 1998. "Satellites, Parallel Processing, and Malarial Parasites: Tracking Sciences and Technologies in India for What They Can Tell Us about Science and Technology in the Middle East." Paper presented to the Conference on Science and Technology in the Middle East, American University of Beirut, November.

Fischer, Michael M. J., and George Marcus. 1999. Introduction. In George Marcus and Michael M. J. Fischer, *Anthropology as Cultural Critique*. 2nd ed. Chicago: University of Chicago Press.

Fleck, Ludwig. 1935. *Enstehung und Entwicklun geiner wissenschaftlichen Tatsache. Einführung in die Lehre vom Denkstil und Denkkolectiv.* Basel: Benno Schwabe. Translated by Fred Bradley as *Genesis and Development of a Scientific Fact*. Chicago: University of Chicago Press, 1979.

Ford, Henry [and Samuel Crowther]. 1925. *My Life and Work.* New York: Doubleday, Page, and Company.

Forman, Paul. 1971. "Weimar Culture, Causality and Quantum Theory, 1918–1927." *Historical Studies in the Physical Sciences* 3:1–115.

Fortun, Kim. Forthcoming. *Advocating Bhopal: Environmentalism, Disaster, New Global Orders.* Chicago: University of Chicago Press.

Fortun, Michael, and Herb Bernstein. 1999. *Muddling Through: Pursuing Science and Truths in the Twenty-First Century.* Washington, D.C.: Counterpoint.

Foucault, Michel. 1966. *Les Mots et Les Choses.* Paris: Editions Gallimard. *The Order of Things.* New York: Random House, 1971.

Fujimura, Joan H. 1996. *Crafting Science: A Sociohistory of the Quest for the Genetics of Cancer.* Cambridge, Mass.: Harvard University Press.

Funk, J. 1993. "Reflections of a Design Engineer at NASA, Interviews with M.M.J. Fischer." Unpublished tapes and transcripts.

Galison, Peter. 1987. *How Experiments End.* Chicago: University of Chicago Press.

————. 1997. *Image and Logic: The Material Culture of Microphysics.* Chicago: University of Chicago Press.

Galison, Peter, and David J. Stump, ed. 1996. *The Disunity of Science.* Stanford, Calif.: Stanford University Press.

Geertz, Clifford. 1963. *Agricultural Involution.* Berkeley and Los Angeles: University of California Press.

————. 1966. "Religion as a Cultural System." In *Anthropological Approaches to the Study of Religion*, edited by M. Banton. London: Tavistock.

Geertz, Clifford. 1973. *The Interpretation of Culture.* New York: Basic Books.

————. 1983. *Local Knowledge.* New York: Basic Books.

Geison, Gerald. 1995. *The Private Science of Louis Pasteur.* Princeton, N.J.: Princeton University Press.

————. 1996. Reply to Max Perutz. *New York Review of Books*, April 4, 68–69.

Gerovitch, Yyacheslav. 1999. *Speaking Cybernetically: The Soviet Remaking of an American Science*. Ph.D. Diss., MIT.

Ghosh, Amitav. 1996. *The Calcutta Chromosome*. Delhi: Ravi Dayal.

Gibson, William. 1984. *Neuromancer*. New York: Ace.

Gilder, George. 1989. *The Quantum Revolution in Microcosm: Economics and Technology*. New York: Simon and Schuster.

Glasgow, N., H. Narayan, and B. Chandrasekaran, eds. 1995. *Diagrammatic Reasoning*. Cambridge, Mass.: MIT Press.

Good, Gregory, ed. 1998. *Sciences of the Earth*. New York: Garland.

Goody, Jack. 1977. *The Domestication of the Savage Mind*. London: Cambridge University Press.

Gottweis, Herbert. 1998. *Retextualizing Life: Genetic Engineering and the State in Western Europe*. Cambridge, Mass.: MIT Press.

Graham, John D., and Jennifer K. Hartwell, eds. 1997. *The Greening of Industry*. Cambridge, Mass.: Harvard University Press.

Graham, Loren. 1972. *Science and Philosophy in the Soviet Union*. New York: Knopf.

————. 1998. *What Have We Learned about Science and Technology from the Russian Experience*. Palo Alto, Calif.: Stanford University Press.

Grefe, Edward, and Martin Linsky. 1995. *The New Corporate Activism*. New York: McGraw Hill.

Greisemer, J. R., and W. Wimsatt. 1989. "Picturing Weismannism: A Case Study of Conceptual Evolution." In *What the Philosophy of Biology Is*, edited by M. Ruse. Dordrecht: Kluwer.

Grove, Richard. 1995. *Green Imperialism: Colonial Expansion, Tropical Island Edens and The Origins of Environmentalism, 1600–1860*. London: Oxford University Press.

————. 1997. *Ecology, Climate and Empire: Colonialism and Global Environmental History, 1400–1940*. Cambridge: White Horse Press.

Gupta, Akhil. 1998. *Postcolonial Developments: Agricultural Culture in the Making of Modern India*. Durham, N.C.: Duke University Press.

Gusterson, Hugh. 1996. *Nuclear Rites: A Weapons Laboratory at the End of the Cold War*. Berkeley and Los Angeles: University of California Press.

————. 1999. "The Virtual Nuclear Weapons Laboratory in the New World Order." *American Ethnologist* 26.

Haffner, Katie, and John Markoff. 1991. *Cyberpunk: Outlaws and Hackers on the Computer Frontier*. New York: Simon and Schuster.

Hakken, David. 1993. *Computing Myths, Class Realities*. Boulder, Colo.: Westview.

Hallyn, Fernand. 1987. *La structure poétique du monde: Copernic, Kepler*. Paris: Edition du Seuil. Translated by Donald Leslie as *The Poetic Structure of the World: Copernicus and Kepler*. New York: Zone Books.

Hammonds, Evelynn M. 1995. "Missing Persons: African American Women, AIDS, and the History of Disease." In *Words of Fire: An Anthology of African-American Feminist Thought*, edited by B. Guy-Scheftall. New York: New Press.

————. 1999. *Childhood's Deadly Scourge: The Campaign to Control Diptheria in New York City, 1880–1930*. Baltimore: Johns Hopkins University Press.

Hansen, Randall. 1998. *From Environmental Bads to Economic Goods: Marketing Nuclear Waste to American Indians*. Ph.D. diss., University of Minnesota.

Haraway, Donna. 1991. *Simians, Cyborgs, and Women*. New York: Routledge.

————. 1997. *Modest_Witness@Second_Millenium.FemaleMan©_Meets_OncoMouse™: Feminism and Technoscience*. New York: Routledge.

Harding, Sandra. 1991. *Whose Science, Whose Knowledge? Thinking from Women's Lives*. Ithaca, N.Y.: Cornell University Press.

Harr, Jonathan. 1995. *A Civil Action*. New York: Vintage.

Harvey, David. 1985. *Consciousness and the Urban Experience*. New York: Oxford University Press.

————. 1989. *The Condition of Postmodernity*. New York: Oxford University Press.

————. 1996. *Justice, Nature and the Geography of Difference*. London: Blackwell.

————. 1998. *Forged Consensus: Science, Technology, and Economic Policy in the United States, 1921–1953*. Princeton, N.J.: Princeton University Press.

Hayes, Dennis. 1989. *Behind the Silicon Curtain*. Boston: South End Press.

Heilbron, John. 1985. "The Earliest Missionaries of the Copenhagen Spirit." *Revue d'histoire des sciences* 38:194–230.

Helvag, David. 1994. *The War against the Greens*. San Francisco: Sierra Club.

Hendry, John. 1980. "Weimar Culture and Quantum Causality." *History of Science* 18:155–80.

Hess, David. 1997a. *Science Studies*. New York: New York University Press.

————. 1997b. *Can Bacteria Cause Cancer? Alternative Medicine Confronts Big Science*. New York: New York University Press.

Hooper, Paula Kay. 1998. *They Have Their Own Thoughts: Children's Learning of Computational Ideas from a Cultural Constructivist Perspective*. Ph.D. diss., MIT.

Hoskins, W. G. 1992. *The Making of the English Landscape*. London: Hodder and Stoughton.

Horkheimer, Max. 1972. *Critical Theory*. New York: Herder and Herder.

Horkheimer, Max, and Theodor Adorno. 1969. *Dialectic of Enlightenment*. New York: Herder and Herder.

Hughes, Thomas. 1998. *Rescuing Prometheus*. New York: Pantheon.

Hunter, Ian. 1995. "Opthalmic Microrobots and Surgical Simulator" Electrical Engineering Colloquium, MIT, April 3.

————. 1997. "Microworld Engineering." HST class on social and ethical issues in the biosciences and biotechnologies, spring.

Jacob, François. 1987. *La statue intérieure*. Paris: Seuil. Trans. by Franklin Philip as *The Statue Within: An Autobiography*. New York: Basic Books, 1998.

Jackson, Myles. 1996. "Buying the Dark Lines of the Solar Spectrum: Joseph von Frauenhofer's Standard for the Manufacture of Optical Glass." *Archimedes* I.

Jardine, N., J. A. Secord, and E. C. Spary, eds. 1996. *Cultures of Natural History*. London: Cambridge University Press.

Jasanoff, Sheila. 1995. *Science at the Bar: Law, Science, and Technology in America*. Cambridge, Mass.: Harvard University Press.

Jasanoff, Sheila, et al. 1995. *Handbook of Science and Technology Studies*. Thousand Oaks, Calif.: Sage.

Jones, Caroline. 1998. "The Sex of the Machine: Mechanomorphic Art, New Women and Francis Picabia's Neurasthenia." In *Picturing Science, Producing Art*, edited by C. Jones and P. Galison. New York: Routledge.

Jones, James. 1981. *Bad Blood: The Tuskeegee Experiment*. New York: Free Press.

Judson, Horace. 1979. *The Eighth Day of Creation*. New York: Simon and Schuster.

Hayles, N. Katherine. 1990. *Chaos Bound*. Ithaca, N.Y.: Cornell University Press.

Karliner, Joshua. 1997. *The Corporate Planet: Ecology and Politics in the Age of Globalization*. San Francisco: Sierra Club.

Kay, Lily. 1993. *The Molecular Vision of Life: Caltech, the Rockefeller Foundation, and the Rise of the New Biology*. New York: Oxford University Press.

———. 1999. *Who Wrote the Book of Life? A History of the Genetic Code*. Stanford, Calif.: Stanford University Press.

Keller, Evelyn Fox. 1995. *Refiguring Life: Metaphors of Twentieth Century Biology*. New York: Columbia University Press.

Kelly, Kevin. 1994. *Out of Control: The Rise of NeoBiological Civilization*. Reading, Mass.: Addison-Wesley.

Kelty, Chris. 1999. *Scale and Convention: Programmed Language in Regulated America*. Ph.D. diss., MIT.

Kevles, Daniel J. 1978. *The Physicists: The History of a Scientific Community in Modern America*. New York: Knopf.

———. 1998. *The David Baltimore Case*. New York: Norton.

Kidder, Tracy. 1981. *The Soul of a New Machine*. Boston: Little, Brown

Kittler, Friedrich. 1990. *Discourse Networks 1800/1900*. Palo Alto, Calif.: Stanford University Press.

———. 1999. *Grammophone, Film, Typewriter*. Palo Alto, Calif.: Stanford University Press.

Klein, Hans K. 1996. *Institutions, Innovation, and Information Infrastructure: The Social Construction of Intelligent Transportation Systems in the U.S., Europe, and Japan*. Ph.D. diss., MIT.

Knorr-Cetina, Karin. 1995. "Laboratory Studies: The Cultural Approach to the Study of Science. In *Handbook of Science and Technology Studies.*, edited by S. Jasanoff, et al. Thousand Oaks, Calif.: Sage.

———. 1999. *Epistemic Cultures: How Science Makes Sense*. Cambridge, Mass.: Harvard University Press.

Koerner, Lisbet. 1996. "Goethe and Botany." *Isis* 184, no. 3:470–96.

Kohler, Robert. 1991. *Partners in Science: Foundations and Natural Scientists, 1900–1945*. Chicago: University of Chicago Press.

———. 1994. *Lords of the Fly: Drosophilia Genetics and the Experimental Life*. Chicago: University of Chicago Press.

de Kruif, Paul. 1926. *The Microbe Hunters.* New York: Harcourt Brace.

Kuhn, Thomas S. 1962. *The Structure of Scientific Revolutions.* Chicago: University of Chicago Press.

Kuletz, Valerie. 1998. *The Tainted Desert: Environmental and Social Ruin in the American West.* New York: Routledge.

Lahsen, Myanna. 1998. *Climate Rhetoric: Constructions of Climate Science in the Age of Environmentalism.* Ph.D. diss., Rice University.

Landecker, Hannah. 1999. *Technologies of Living Substances: Tissue Culture and Cellular Life in Twentieth Century Biomedicine.* Ph.D. diss., MIT.

Lash, Scott, and John Urry. 1994. *Economies of Signs and Space.* Thousand Oaks, Calif.: Sage.

Latour, Bruno. 1985. *Science in Action: How to Follow Scientists and Engineers through Society.* Cambridge, Mass.: Harvard University Press.

————. 1984. *Les Microbes: guerre et paix suivi de Irréductions.* Paris: Editions A. M. Métaillié. Trans. by Alan Sheridan and John Law as *The Pasteurization of France.* Cambridge, Mass.: Harvard University Press, 1988.

————. 1990. "Drawing Things Together." In *Representation in Scientific Practice,* edited by M. Lynch and S. Woolgar. Cambridge, Mass.: MIT Press.

————. 1993. *Aramis ou l'amour des techniques.* Paris: Editions La Decourete. Translated by Catherine Torter as *Aramis, or The Love of Technology.* Cambridge, Mass.: Harvard University Press, 1996.

Latour, Bruno, and Steve Woolgar. 1979. *Laboratory Life: The Construction of Scientific Facts.* Thousand Oaks, Calif.: Sage.

Leavitt, Judith W. 1996. *Typhoid Mary.* Boston: Beacon.

Lee, Benjamin. 1998. *Talking Heads: Language, Metalanguage, and the Semiotics of Subjectivity.* Durham, N.C.: Duke University Press.

Lenoir, Timothy. 1997. *Instituting Science: The Cultural Production of Scientific Disciplines.* Palo Alto, Calif.: Stanford University Press.

Levi-Strauss, Claude. 1966. *The Savage Mind.* Chicago: University of Chicago Press.

————. 1967. "La Geste d'Asdiwal." In *The Structural Study of Myth and Totemism,* edited by E. R. Leach. London: Tavistock.

————. 1985. "Structuralism and Ecology." In *The View from Afar.* New York: Basic Books.

Lifton, Robert Jay. 1967. *Death in Life: The Suvivors of Hiroshima.* New York: Simon and Schuster.

Lightman, Alan. 1993. *Einstein's Dreams.* New York: Pantheon.

Livingston, James. 1994. *Pragmatism and the Political Economy of Cultural Revolution, 1850–1940.* Chapel Hill, N.C.: University of North Carolina Press.

Lock, Margaret. 1994. "Contests with Death." In *Life and Death under High Technology Medicine,* edited by Ian Robinson. Manchester: Manchester University Press.

Löwy, Ilana. 1996. *Between Bench and Bedside: Science, Healing, and Interleuken-2 in a Cancer Ward.* Cambridge, Mass.: Harvard University Press.

Lynch, Michael, and Steve Woolgar, ed. 1988. *Representation in Scientific Practice.* Cambridge, Mass.: MIT Press.

Lyotard, Jean-Francois. 1979. *La condition postmoderne: Rapport sur le savoir.* Paris: Edition de Minuit. Translated by Geoff Benington and Brian Massumi as *The Postmodern Condition: A Report on Knowledge.* Minneapolis: Minnesota University Press, 1984.

MacKenzie, Donald. 1990. *Inventing Accuracy: A Historical Sociology of Nuclear Missile Guidance.* Cambridge, Mass.: MIT Press.

————. 1995. *Knowing Machines.* Cambridge, Mass.: MIT Press.

Marglin, Frederique A. 1990. "Smallpox in Two Systems of Knowledge." In *Dominating Knowledge: Development, Culture, and Resistance,* edited by F. Marglin and S. Marglin. New York: Oxford University Press.

Martin, Emily. 1987. *The Woman in the Body.* Boston: Beacon.

————. 1994. *Flexible Bodies: Tracking Immunity in American Culture from the Days of Polio to the Age of AIDS.* Boston: Beacon.

Marx, Leo. 1997. "Technology: the Emergence of a Hazardous Concept." *Social Research* 64, no. 3: 965–88.

McCormmach, Russell. 1982. *Night Thoughts of a Classical Physicist.* Cambridge, Mass.: Harvard University Press.

McLuhan, Marshall and Quentin Fiore. 1967. *The Medium is the Massage.* New York: Random House.

McNeill, William. 1976. *Plagues and People.* Garden City, N.Y.: Anchor.

McRae, Murdo William. 1993. *The Literature of Science.* Athens: University of Georgia Press.

Mathews, Adrian. 1999. *Vienna Blood.* London: Jonathan Cape.

Mawer, Simon. 1998. *Mendel's Dwarf.* London: Harmony/Crown.

Mayer, Margit, and John Ely. 1998. *The German Greens: Paradox between Movement and Party.* Temple University Press.

Merton, Robert K. 1938. *Science, Technology and Society in Seventeenth Century England.* Bruges, Belgium: St. Catherine Press.

Milburn, Gerard. 1998. *The Feynman Processor: Quantum Entanglement and the Computing Revolution.* New York: Perseus.

Miller, H. Lyman. 1996. *Science and Dissent in Post-Mao China.* Seattle: University of Washington Press.

Mindell, David. 1996. *Datum for Its Own Annihilation: Feedback, Control and Computing, 1916–1945.* Ph.D. Diss., MIT.

Misrach, Richard. 1990. *Bravo 20: The Bombing of the American West.* Baltimore: Johns Hopkins University Press.

Mnookin, Jennifer. 1998. *Images of Truth: Evidence, Expertise, and Technologies of Knowledge in the American Courtroom.* Ph.D. diss., MIT.

Mojtabhai, A. G. 1986. *Blessed Assurance: At Home with the Bomb in Amarillo, Texas.* Boston: Houghton-Mifflin.

Morange, Michel. 1998. *A History of Molecular Biology*. Cambridge, Mass.: Harvard University Press.

Nagatoni, Patrick. 1991. *Nuclear Enchantment*. Albuquerque: University of New Mexico Press.

Nandy, Ashis, ed. 1988. *Science, Hegemony and Violence*. Delhi: Oxford University Press.

Nersessian, Nancy. 1995. "How Do Scientists Think? Capturing the Dynamics of Conceptual Change in Science." In *Diagrammatic Reasoning*, edited by J. Glasgow, N. H. Narayanan, and B. Chandrasekaran. Cambridge, Mass.: MIT Press.

Newman, William. 1994. *Gehennical Fire: The Lives of George Starkey, an American Alchemist in the Scientific Revolution*. Cambridge, Mass.: Harvard University Press.

Nicholas, Ralph. 1982. "The Goddess Sitala and Epidemic Smallpox in Bengal." *Journal of Asian Studies* 41, no. 1:20–44.

Nordi, Bonnie A., and Vicki L. O'Day. 1999. *Information Ecologies*. Cambridge, Mass.: MIT Press.

Nowotny, Helga, and Ulrike Felt. 1997. *After the Breakthrough: The Emergence of High-temperature Superconductivity as a Research Field*. London: Cambridge University Press.

Ogborn, Miles. 1995. "Knowing the Individual: Michel Foucault and Norbert Elias on Las Meninas and the Modern Subject." In *Mapping the Subject*, edited by Steve Pile and Nigel Thrift. New York: Routledge.

Ong, Walter. 1982. *Orality and Literacy: The Technologization of the Word*. London: Methuen.

Osborne, Michael. 1994. *Nature, the Exotic, and the Science of French Colonialism*. Bloomington: Indiana University Press.

Penley, Constance. 1997. *NASA/TREK: Popular Science and Sex in America*. New York: Verso.

Perutz, Max. 1995. Review of Gerald Geison's *The Private Science of Louis Pasteur*. *New York Review of Books*, December, 21.

———. 1996. Reply to Geison. *New York Review of Books*, April, 4, 69.

Petryna, Adriana. 1995. "Sarcophagus: Chernobyl in Historical Light." *Cultural Anthropology* 10, no. 2: 196–220.

———. 1998. "A Technical Error: Measure of Life after Chernobyl." *Social Identities* 4, no. 1.

———. 1999. *A Technical Error: Sciences of Life after the Chernobyl Nuclear Accident in Ukraine and in the United States*. Ph.D. diss., University of California, Berkeley.

Pickering, Andrew. 1995. *The Mangle of Practice*. Chicago: University of Chicago Press.

Poster, Mark. 1990. *The Mode of Information*. Chicago: University of Chicago Press.

Powell, Douglas, and William Leiss. 1997. *Mad Cows and Mother's Milk: The Perils of Poor Risk Communication*. Montreal: McGill-Queens University Press.

Powers, Richard. 1992. *The Gold Bug Variations*. New York: HarperCollins.

———. 1993. *Operation Wandering Soul*. New York: HarperCollins.

———. 1995. *Galatea 2.2*. New York: Farrar, Straus, and Giroux.

———. 1998. *Gain, A Novel.* New York: Farrar, Straus, and Giroux.

Principe, Lawrence M. 1998. *The Aspiring Adeopt: Robert Boyle and His Alchemical Quest.* Princeton, N.J.: Princeton University Press.

Rabinow, Paul. 1996. *Making PCR.* Chicago: University of Chicago Press.

———. 1999. *French DNA: Trouble in Purgatory.* Chicago: University of Chicago Press.

Rajchman, John. 1998. "Jean-François Lyotard's Underground Aesthetics." *October* 86:3–18.

Reich, Michael. 1991. *Toxic Politics: Responding to Chemical Disasters.* Ithaca, N.Y.: Cornell University Press.

Rheinberger, Hans-Joerg. 1997. *Toward a History of Epistemic Things: Synthesizing Proteins in the Test Tube.* Palo Alto, Calif.: Stanford University Press.

Rickels, Laurence. 1991. *The Case of California.* Baltimore: Johns Hopkins University Press.

Riskin, Jessica. N.d. *The Defecating Duck; or, Scenes from the Early History of the Idea of Automation.* Manuscript in preparation.

Roll-Hansen, N. 1982. "Experimental Method and Spontaneous Generation: The Controversy between Pasteur and Pouchet, 1859–64." *Journal of the History of Medicine and Allied Sciences* 34: 273–92.

———. 1983. "The Death of Spontaneous Generation and the Birth of the Gene: Two Case Studies of Relativism." *Social Studies of Science* 13:481–519.

Ronell, Avital. 1989. *The Telephone Book: Technology, Schizophrenia, Electric Speech.* Lincoln: University of Nebraska Press.

———. 1994. *Finitude's Score.* Lincoln: University of Nebraska Press.

Rosenberg, Charles. 1992. *Explaining Epidemics and Other Studies in the History of Medicine.* New York: Cambridge University Press.

Ross, Kristin. 1995. *Fast Cars, Clean Bodies: Decolonization and the Reordering of French Culture.* Cambridge, Mass.: MIT Press.

Rotman, Brian. 1987. *Signifying Nothing: The Semiotics of Zero.* Palo Alto, Calif.: Stanford University Press.

———. 1993. *The Ghost in Turing's Machine.* Palo Alto, Calif.: Stanford University Press.

Sabel, Charles, Archon Fung, and Bradley Karkkainen. 1999. "Beyond Backyard Environmentalism." With responses. *Boston Review* 24, no. 5:4–23.

Safina, Carl. 1997. *Song for the Blue Ocean.* New York: Henry Holt.

Sclove, Richard. 1995. *Democracy and Technology.* New York: Guilford.

Serres, Michel. 1982. *The Parasite.* Baltimore: Johns Hopkins University Press.

Shapin, Steven, and Simon Schaffer. 1985. *Leviathan and the Air Pump: Hobbes, Boyle and the Experimental Life.* Princeton, N.J.: Princeton University Press.

Shapiro, Gary. 1989. *Nietzschean Narrative.* Bloomington: Indiana University Press.

Shulman, Seth. 1992. *The Threat at Home: Confronting the Toxic Legacy of the U.S. Military.* Boston: Beacon.

Silman, Roberta. 1990. *Beginning the World Again: A Novel of Los Alamos.* New York: Viking.

Slade, Joseph, and Judith Yaross Lee. 1990. *Beyond the Two Cultures.* Ames: Iowa State University Press.

Snyder, Benson. 1972. *The Hidden Curriculum*. New York: Knopf.

Soja, Edward. 1989. *Postmodern Geographies: The Reassertion of Space in Critical Social Theory*. New York: Verso.

Sokal, Alan. 1996. "Transgressing the Boundaries." *Social Text* 46–47:217–52.

Stacey, Judith. 1990. *Brave New Families*. New York: Basic Books.

Stafford, Barbara M. 1996. *Good Looking: Essays on the Virtue of Images*. Cambridge, Mass.: MIT Press.

Steingraber, Sandra. 1997. *Living Downstream*. New York: Vintage.

Stephenson, Neal. 1988. *Zodiac*. New York: Bantam.

Sterling, Bruce. 1992. *Hacker Crackdown: Law and Disorder on the Electronic Frontier*. New York: Bantam.

Stone, Allucquere Rosanne. 1994. *The War of Desire and Technology at the Close of the Mechanical Age*. Cambridge, Mass.: MIT Press.

Suchman, Lucy. 1987. *Plans and Situated Actions*. London: Cambridge University Press.

Teitelman, Robert. 1991. *Gene Dreams: Wall Street, Academia, and the Rise of Biotechnology*. New York: Basic Books

Terdiman, Richard. 1985. *Discourse/Counter-Discourse*. Ithaca, N.Y.: Cornell University Press.

Traweek, Sharon. 1988. *Beamtimes and Lifetimes*. Cambridge, Mass.: Harvard University Press.

———. 1992. "Border Crossings: Narrative Strategies in Science Studies and Among Physicists in Tsukuba Science City, Japan. In *Science as Practice and Culture*, edited by Andrew Pickering. Chicago: University of Chicago Press.

———. 1995. "Bachigai in Ibaraki: Tsukuba Science City, Japan." In *Late Editions*, Vol. 2, *Technoscientific Imaginaries*, edited by George Marcus. Chicago: University of Chicago Press.

Treat, John Wittier. 1995. *Writing Ground Zero: Japanese Literature and the Atomic Bomb*. Chicago: University of Chicago Press.

Treichler, Paula. 1987. "AIDS, Homophobia, and Biomedical Discourse: An Epidemic of Signification." *October* 43:31–70.

Treichler, Paula, Lisa Cartwright, and Constance Penley, eds. 1998. *The Visible Woman: Imaging Technologies, Gender and Science*. New York: New York University Press

Tsing, Anna Lowenhaupt. 1993. *In the Realm of the Diamond Queen*. Princeton, N.J.: Princeton University Press.

Turkle, Sherry. 1984. *The Second Self*. New York: Simon and Schuster.

———. 1995. *Life on the Screen*. New York: Simon and Schuster.

Tyler, Stephen. 1978. *The Said and the Unsaid: Mind, Meaning and Culture*. New York: Academic Press.

———. 1987. *The Unspeakable: Discourse, Dialogue and Rhetoric in the Postmodern World*. Madison: University of Wisconsin Press.

Vincenti, Walter. 1990. *What Engineers Know and How They Know It: Analytical Studies from Aeronautical History*. Baltimore: The Johns Hopkins University Press.

Watts, Michael. 1983. *Silent Violence: Food, Famine and Peasantry in Northern Nigeria.* Berkeley and Los Angeles: University of California Press.

Watts, Sheldon. 1997. *Epidemics and History: Disease, Power, and Imperialism.* New Haven: Yale University Press.

White, Richard. 1995. *The Organic Machine: The Remaking of the Columbia River.* New York: Hill and Wang.

Wildavsky, Aaron. 1995. *But Is It True? A Citizen's Guide to Environmental Health and Safety Issues.* Cambridge, Mass.: Harvard University Press.

Wilson, Andrew. 1992. *The Culture of Nature.* New York: Blackwell.

Wise, Norton. N.d. "Forman Reformed." Photocopy.

Zimmermann, Francis. 1982. *La jungle et le fumet des viandes.* Paris: Editions du Seuil. Translated by _____ as *The Jungle and the Aroma of Meats: An Ecological Theme in Hindu Medicine.* Berkeley and Los Angeles: University of California Press, 1987.